# EYE OF THE BEHOLDER

# EYE
## OF THE
# BEHOLDER

*Johannes Vermeer,*
*Antoni van Leeuwenhoek,*
*and the*
*Reinvention of Seeing*

LAURA J. SNYDER

*W. W. Norton & Company* NEW YORK / LONDON

Pages x–xi: *The Map and Profile of Delft*, 1703. Jan Verkolje (I), Coenraet Decker, Johannes de Ram, Pieter Smith. *Collection Museum Prinsenhof, Delft, The Netherlands. Photographer: Jaap Oldenkamp.*

Quotes from *The Collected Letters of Antoni van Leeuwenhoek* used by courtesy of Swets & Zeitlinger, now Taylor and Francis.

Epigraph "Study the science of art . . ." from *Leonardo's Universe: The Renaissance World of Leonardo da Vinci* by Bulent Atalay and Keith Warmsley, National Geographic Books, 2008, p. 96, used by courtesy of National Geographic.

"Here our eyes are . . ." by Constantijn Huygens from *Ooghen-Troost* (1647), quoted in Thijs Weststeijn, *The Visible World: Samuel van Hoogstraten's Art Theory and the Legitimation of Painting in the Dutch Golden Age*, p. 334. Reprinted by courtesy of Thijs Weststeijn and Amsterdam University Press.

For information about permission to reproduce selections
from this book, write to
Permissions, W. W. Norton & Company, Inc.,
500 Fifth Avenue, New York, NY 10110

For information about special discounts for bulk purchases,
please contact W. W. Norton Special Sales at
specialsales@wwnorton.com or 800-233-4830

Manufacturing by Courier Westford
Book design by Brooke Koven
Production manager: Anna Oler

Library of Congress Cataloging-in-Publication Data

Snyder, Laura J.
Eye of the beholder : Johannes Vermeer, Antoni van Leeuwenhoek, and the
reinvention of seeing / Laura J. Snyder. — First edition.
pages cm
Includes bibliographical references and index.
ISBN 978-0-393-07746-9 (hardcover)
1. Art and science—Netherlands—Delft—History—17th century. 2. Vermeer,
Johannes, 1632–1675—Knowledge—Science. 3. Leeuwenhoek, Antoni van,
1632–1723. I. Title.
N72.S3S67 2015
701'.0509492—dc23
2014038143

W. W. Norton & Company, Inc.,
500 Fifth Avenue, New York, N.Y. 10110
www.wwnorton.com

W. W. Norton & Company Ltd.,
Castle House, 75/76 Wells Street, London W1T 3QT

1 2 3 4 5 6 7 8 9 0

*For John*

*Study the science of art. Study the art of science. Develop your senses—especially learn how to see.*
　　　　　　　　　—LEONARDO DA VINCI (1452–1519)

*Painting is a science and should be pursued as an inquiry into the laws of nature. Why, then, may not a landscape be considered as a branch of natural philosophy, of which pictures are but experiments?*
　　　　　　　　　　　　—JOHN CONSTABLE,
　　　　　"The History of Landscape Painting" (1836)

*Hold, as 'twere, the mirror up to nature.*
　　　　　　　　　　　—WILLIAM SHAKESPEARE,
　　　　　　　　　　*Hamlet*, III, II (ca. 1600)

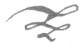

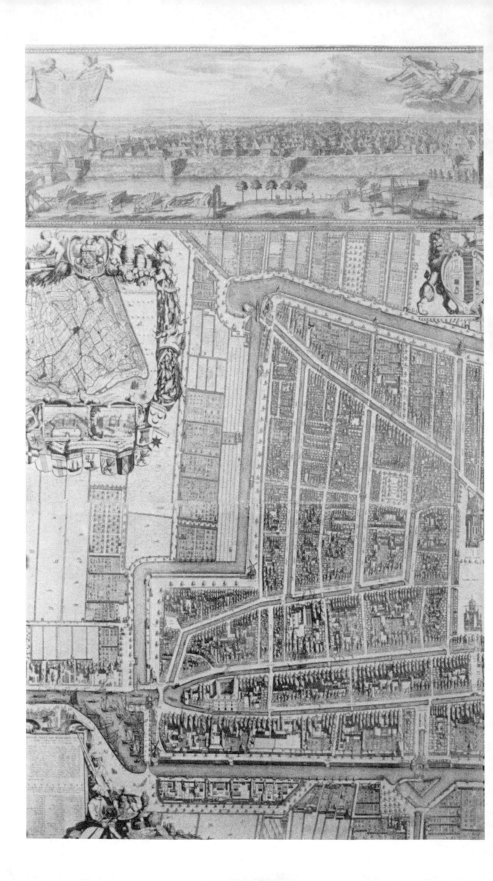

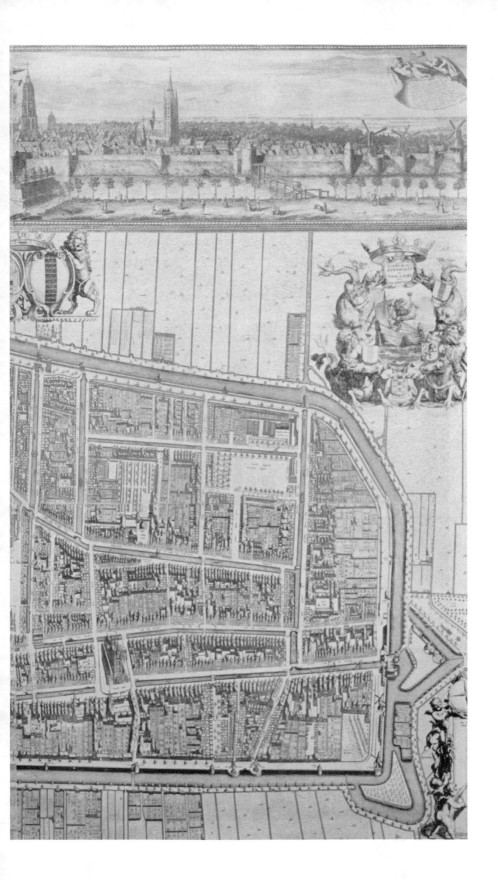

# Contents

# EYE OF THE BEHOLDER

# More Than Meets the Eye

*-1-*

$\mathcal{I}$T IS A bright day in August of 1674. In the small Dutch city of Delft, Antoni Leeuwenhoek*—a former cloth merchant, now a local bureaucrat and self-taught lens maker—sits by the large window in his study. Like most of the windows in Delft, this one is fitted with shutters that are doubly divided; each half has an upper and a lower part that opens separately, so light entering the room can be precisely regulated. Today, the entire shutter has been thrown open. If any of his neighbors happen to glance into the ground floor room as they pass by, perhaps on their way to the nearby Market Square, they might remark to each other that the "curious dabbler" is at his peculiar pursuits again.†

Leeuwenhoek is staring through a flat, oblong brass holder about three inches long. In the center of the holder is a tiny glass bead he made himself—how he did so, whether by grinding the lens or by

---

* Leeuwenhoek did not add the "van" to his signature until 1685. I will follow his usage, referring to him as "Leeuwenhoek" until the narrative reaches the mid-1680s.
† In the first few years of letters to the Royal Society of London, Leeuwenhoek addressed the members as "curious gentlemen dabblers" ("Heeren curiuse Lieffhebbers").

I

blowing it from molten glass, is a secret that Leeuwenhoek has jealously guarded. Attached to the back of the strange device is a thin metal rod supporting a small glass tube that contains a drop of water taken from the Berkelse Mere, an inland lake located a two hours' walk from Delft. Pressing the metal holder closer to one eye—so that it is almost touching his face—in order to peer at the water in the tube through the glass bead, Leeuwenhoek is shocked to see not a clear pool, but a veritable aquarium filled with minuscule, swimming creatures—about a thousand times smaller than the tiniest cheese mites, he reckons. Some of these "little animals" are shaped like spirally wound serpents, some are globular, others elongated ovals; he records that "the motion of . . . these animalcules in the water was so swift, and so various, downwards, and round about, that I confess I could not but wonder at it." Leeuwenhoek has just discovered a new world never before even imagined: the microscopic world.

-2-

In an attic diagonally across the Market Square from Leeuwenhoek's house, another of Delft's geniuses is at work. Like his neighbor, Johannes Vermeer was secretive about his methods, so we cannot be certain how he painted his mature works of exquisite luminosity, works that show an exciting intimacy with optical effects seen only through lenses. But given the evidence we may reasonably imagine that, on this fine day in August, Vermeer is bent over a table, looking at a wooden box with an open hinged top, while holding his long, dark robe over his head. On one end of the box is a short tube holding a piece of glass ground to the shape of a lentil—hence its name, a *lens*. At the top of the box sits a piece of flat glass. Vermeer has placed the tube with the lens in the direction of a scene he composed next to the room's large window, which also has its shutters thrown wide open. Vermeer has draped a curtain between himself and the window, which blocks a little of the light flooding in. A young woman, in a yellow satin skirt, a white bodice, and a brilliant blue overdress, sits at a virginal, an instrument popular with the rich merchant class in

Delft (and probably borrowed by Vermeer for the occasion). Her fingers rest on the keys while her face turns to Vermeer, as if waiting for him to tell her to begin to play. On the wall behind the woman hangs a large picture of a brothel scene by another painter, a picture that is owned by Vermeer's mother-in-law, as is the house we are in now.*

Under his robe, Vermeer gazes at the flat glass on the top of the box. The entire scene is visible on the glass, including its precise proportions and correct three-dimensional perspective rendered in a two-dimensional image. Vermeer is as astonished as ever to observe that the colors on the glass are even more jewel-like than they appear to the naked eye, the areas of shadow even more strongly contrasted with the patches of light, the contours of figures beautifully softened. He pays particular attention to the way the foreground and background are out of focus when the rest of the scene is sharp, the way the highlights appear brightly where the sun hits reflective surfaces, and how the relative tonal values—the way different colors look under different light conditions—are represented fully, more so than they are by the naked eye.

Vermeer is looking through a camera obscura, an optical device that, in earlier versions, had long been known to natural philosophers and natural "magicians"; it was employed in the past to observe solar eclipses safely and to amaze and delight audiences with "living pictures." A precursor to the photographic camera, but without the light-sensitive film, the box-type camera obscura is a light-tight wooden chamber with a hole or lens on one side. It projects an inverted and reversed image of the scene either upon a glass plate or oilpaper on the top of the device or onto a nearby wall or canvas (by the use of a mirror the image can be made upright). Earlier versions were simply a dark room—thus the name, Latin for "dark chamber"—with a tiny aperture of five to ten millimeters letting in light from the sun outside. The spectator, sitting inside the room, would see the inverted and reversed image of the outside scene pro-

---

* This painting is *Young Woman Seated at a Virginal*. Although it was not dated by Vermeer, art historians believe it was painted sometime between 1670 and 1675.

jected on the wall opposite the hole. These whole-room cameras were followed by versions in which a tented-off area or booth could be created inside to view a scene that was set up within the room. The invention of the box-type camera obscura came next.

Vermeer is looking through the camera not to trace its image onto translucent paper placed on the glass at the top of the box, or to angle the mirror so that the image is projected onto his canvas, but to experiment with the optics of the scene. By rearranging the composition, he can manipulate the type of light effects he has learned to exploit so masterfully. Vermeer sees that if the light hits the virginal just so, he will need a highlight of lead white paint there, on the right front leg. But the geometry of the picture seems to him to require another highlight on the front of the instrument, depicting a reflection of the woman's forearm, where the light is not causing a reflection. Vermeer is no slave to the optics of the camera obscura.

By looking through the camera obscura, Vermeer has become expert in the way that light affects how we see the world. He has seen the world as we do not normally see it, revealed in surprising new ways invisible to the naked eye. Like the microscope, the camera obscura disclosed to its seventeenth-century users truths about the natural world otherwise inaccessible to the senses. As the diplomat, natural philosopher, and art enthusiast Constantijn Huygens—an acquaintance of both Vermeer's and Leeuwenhoek's—put it, with the advent of the camera obscura, "all painting is dead by comparison, for this is life itself, or something more elevated, if one could articulate it."

-3-

At that moment, the scientific world was in the midst of a revolution. This so-called Scientific Revolution, today associated with the names Copernicus, Kepler, Bacon, Harvey, Galileo, and Newton, was brought about in part by a new emphasis on empirical methods—making careful observations of the natural world—as opposed to the nonempirical, logical methods preferred by many medieval follow-

ers of Aristotle. No longer would the reliance on ancient texts, or on armchair philosophizing about the world from a scholar's study, be considered adequate. The clarion call of natural philosophers (for they were not yet called "scientists") became "See for yourself!"

The new scientific societies of the age embodied this quest in their names and mottoes, from the Lyncean Academy of Florence, whose members aimed to "examine with lynx-like eyes those things which manifest themselves," to the Royal Society of London, which defiantly claimed *Nullius in Verba*—on the words of no man. The Moravian philosopher and educator John Comenius, who inspired the founding of the Royal Society through his English disciple Samuel Hartlib, commanded, "Everything should, as far as it is possible, be placed before the senses. Everything visible should be brought before the organ of sight. . . . The truth and certainty of science depend more on the witness of the senses than on anything else."

This newly pervasive interest in observing, representing, and measuring nature demanded new instruments, and inventive minds of the seventeenth century obliged; the thermometer, the barometer, the air pump, and the pendulum clock were all devised during this period. Most thrilling of all were two other novel devices: the telescope and the microscope. Never before had instruments extended the reach of the human senses. Telescopes and microscopes allowed their users to see parts of the world that were previously unseen, because they were too far away or too small. Inevitably, some investigators of nature, such as Robert Hooke in England, began to wonder about the extension of the other senses: "As *Glasses* [lenses] have highly promoted our *seeing*, so 'tis not improbable, but that there may be found many *Mechanical Inventions* to improve our other Senses, of *hearing, smelling, tasting, touching.*"

But these new visual capacities were problematic. To say that what was seen through the telescope and microscope accurately revealed parts of the world invisible to the naked eye was not a straightforward matter. With his telescope, for example, Galileo had claimed to see the impossible—at least, what was considered impossible by most astronomers at the time: new bodies orbiting Jupiter, a rough and pockmarked surface of the moon, and Venus cycling through

"phases." How could the astronomer be certain that the telescope did not create artificial images, deceiving him—that it did, in fact, allow the perception of what really existed outside the range of the naked eye? Many astronomers were skeptical—and so were authorities of the Catholic Church, who were not pleased that Galileo was using his telescope to gather evidence in support of Copernicus's heretical theory that Earth was a planet going around the sun. How much more strange would be the discovery of a whole realm of tiny creatures wriggling in the water we drink and the fluids that course through parts of our bodies: blood, saliva, semen. Leeuwenhoek, like Galileo before him, would be accused of "seeing more with his imagination than with his eyes." New optical and visual theories proposed by men such as René Descartes and Johannes Kepler were deployed in the attempt to explain how these devices worked in conjunction with the human eye so that observers could trust what they saw through microscopes and telescopes. Indeed, these new devices were often compared to the human eye, suggesting that they were as reliable as the familiar bodily instrument.

The widespread acceptance of optical instruments in science required not only optical theories explaining how they worked but also—and especially—the willingness to accept that there is more than meets the eye, that the world is not simply the way it appears to us. Behind the phenomena we see with the naked eye is an unseen world, and in this invisible world lie the causes of the natural processes we observe. This period in history is distinguished, above all, by the rampant realization that the world is not—or not only—as it seems to be.

Although glass spectacles had been worn for centuries, they had been considered means to enable the feeble-sighted to see what was visible with "normal" vision. Now, suddenly, glass lenses were being used to see *more* than what could be seen with normal vision—more even than Adam could have seen with his perfect, prelapsarian vision, as some theologically minded writers noted with varying measures of excitement and dismay. Hooke optimistically proclaimed, "There is a new visible World discovered to the understanding." This newly visible world revealed for the first time that we could have direct sen-

sory access to the hidden causes of phenomena in the natural world. The eccentric Jesuit priest and inventor Athanasius Kircher pointed to the more disconcerting aspect of this shift, noting in 1646 that the telescope and microscope revealed that everything we see with them is very different from the way it had seemed. These instruments revealed a world that was not only new but strange. Science began to be understood as a means to uncover and explain this strange new world.

During the Scientific Revolution natural philosophers accepted this task of exposing the hidden processes and causes of the natural world, and they understood that the new optical devices could help them do so. Aristotle, it is true, had made careful observations of the natural world, going so far as to open up fertilized chicken eggs every day to record the stages of development of the chick embryo. But he had no microscope to help him see beyond the realm of naked vision. Surely he would have used one if it had been available! It was time for the natural philosopher to put aside Aristotle's texts and see for himself (or, sometimes, herself), often by means of the new optical instruments. Accordingly, in this period, tiny insects were peered at through microscopes, distant planets were examined through telescopes, and human bodies were cut open in civic anatomical theaters to discover what lay inside.

A new idea of what it meant to *see* emerged: one that allowed that there was more to nature than meets the naked eye, and that lenses, and other optical instruments, could help us see a part of nature that was otherwise hidden. This new idea of what it meant to see went hand in hand with a new idea of science, one in which enhanced sense perception—not ancient texts, not logical deduction, not even raw visual experience—was the foundation of knowledge of the natural world.

The transformation of scientific ideas in astronomy, physics, biology, anatomy, and chemistry now associated with the Scientific Revolution came about in large part because of the new optical instruments, the new theories that provided the groundwork for using them, and the startling ability to see beyond what was available to the naked eye. For the first time the question of *how* we see assumed a central

place in science, and what it meant, precisely, *to* see, was radically reconceived. And in the midst of this upheaval of thought, science and art came together in a small city in the Dutch Republic to shed light on what it really meant to see the world around us.

-*4*-

The new way of seeing transformed not only science but also art, especially in the Dutch Republic, where notions of painting as the "mirror of nature" dominated contemporary art theory. Artists, too, were exhorted to really see nature—to see more than was apparent to the naked eye, and then to mirror these newly observed attributes in their pictures. The painter and foremost art theorist of the seventeenth century, Samuel Van Hoogstraten, called painting a "sister of [natural] philosophy," that is, a sister of science; indeed, he decreed that the painter should be an "investigator of visible nature." Extolling the *Adoration of the Lamb* triptych by the brothers Van Eyck, the late sixteenth-century painter Lucas de Heere had proclaimed dramatically, "They are mirrors, mirrors are they! No, they are not pictures." Optical instruments—mirrors, lenses, and camera obscuras—allowing the painter to investigate nature more carefully were bound to be of great interest.

Cornelis de Bie's admiration of the still-life painter Daniel Seghers was typical of the age: he reported that Seghers's flowers were so realistic that live bees tried to settle on them. "Life seems to dwell in his art," De Bie enthused. Similarly, of the drops of dew depicted in a flower painting by the Dutch painter Simon Pietersz. Verelst* (who was living in England), the London diarist Samuel Pepys wrote it was "the finest thing that ever, I think, I saw in my life," and that he was "forced, again and again, to put my finger to it, to feel whether my

---

* In the Dutch Republic at this time, patronymics were often used as middle names. These were composed of the father's name plus the ending *-zoon* for sons and *-dochter* for daughters, which were abbreviated as sz. and dr. Thus Simon Pietersz. Verelst was Simon, the son of Pieter.

eyes deceived me or no." Indeed, it was said approvingly of Gerrit Dou—Rembrandt's first pupil—that "his creations can hardly be distinguished from life itself."

More than ever, Leonardo da Vinci's dictum that painters should study "the science of art and the art of science" was true. Because of the perceived similarity between the science of painting and natural science, there were many intersections between these fields, which were not seen as vastly different by their practitioners. Indeed, many of the natural philosophers of the day had trained as artists and used this training in their scientific work. For example, when Galileo turned his *perspicillum* (as it was still called) to the heavens to view the moon, he was able to see what others who had previously viewed the moon with the instrument had not seen: that the blotches on the moon's face were shadows cast by mountains on its surface. Because of the way these dark patches shifted as the moon moved through its phases, Galileo realized that the surface of the moon was irregular, not perfectly smooth as most astronomers—still following Aristotle's view—believed. Galileo's conclusion was based on his understanding of the behavior of shadows at different angles of illumination both on planar and on curved surfaces, an understanding he had gained through his study of perspective theory while training to be an artist in his younger days. In short, Galileo recognized the dark patches on the moon as shadows of mountains by knowing how the painter would depict mountains and their shadows on a curved surface. In England, William Lower admitted to his friend Thomas Harriot (both men had seen the moon's spots through the telescope before Galileo), "In the moone I had formerlie observed a strange spottedness al over, but had not conceite that anie parte thereof might be shadows." Instead, Lower had compared the moon's blotchiness to his cook's treacle tart.

Leeuwenhoek's and Vermeer's acquaintance Constantijn Huygens was not only fascinated by science—he read the new scientific journals, corresponded with most of the natural philosophers of the day, and carried around his own microscope for impromptu observations—but also studied art with a cousin, the esteemed painter of miniatures Jacob Hoefnagel. Hoefnagel, like many of the other

painters of the time known for their delicately precise depictions of insects and flowers, used a convex lens, or magnifying glass, to examine his subjects. This dual interest and training allowed Huygens to recognize the power of the camera obscura for both scientific discovery and artistic creation. Huygens's son Christiaan, who became an important astronomer and physicist, also studied art. He later used his knowledge of perspective theory to look at the flat, two-dimensional field of his telescope and mentally transform the images into a three-dimensional model. This ability helped Christiaan recognize, as no one else had done, that the rings of Saturn *were* rings, and not nearby stars. Leeuwenhoek, too, was steeped in both science and art; his letters betray an in-depth knowledge of certain artistic processes, such as those involved in the engraving of prints and in the decorating and firing of the famous pottery produced in his hometown.

Across the North Sea in England, the fellows of the fledgling Royal Society of London held discussions on the science of painting and asked their "curator of experiments," the brilliant and irascible Hooke, to demonstrate a portable, box-like camera obscura that he had designed himself; the minutes of the meeting describe this demonstration as an "optical experiment" which succeeded in showing how "it was now proper for the hand to draw a picture conveniently." As a boy, Hooke had apprenticed with the Dutch-born painter Peter Lely, and was expected to become a portraitist like his master—until the fumes from the paint exacerbated Hooke's migraines and forced him to find another vocation.

At the same time, many artists were students of natural philosophy, such as those miniaturists, who often worked hand in hand with the philosophers studying the insects and flowers they depicted so precisely. Their still lifes were meant to be studied up close, rewarding the viewer with the velvety skin of plums, the extravagantly striated petals of the prized *Semper Augustus* tulip, the greenish sheen of the wings of the dragonfly. Almost by necessity, the artist became a natural historian. Jacob Hoefnagel's engravings of his father Joris's studies of insects, flowers, and other specimens—studies his father had made with a magnifying glass—are so accurate that they are consid-

ered the first published biological and botanical investigations using lenses. Another miniaturist-turned-naturalist was Johannes Goedaert of Middelburg, who published a three-volume study of insect development with more than two hundred hand-colored engravings of insects and their larvae from watercolors done from life. Constantijn Huygens bemoaned the fact that a neighbor and friend, the painter Jacob de Gheyn II, was no longer alive to produce an atlas of a "new world" of tiny creatures now seen through the microscope. Rachel Ruysch became famous for her flower still lifes, based on botanical knowledge she had gained from her father, Frederik Ruysch, the head of Amsterdam's *hortus botanicus*—and by her own careful examination of specimens from the gardens. Leeuwenhoek himself worked closely with artists who served as his "draftsmen," capturing on the page the wondrous sights he saw through his lenses; in some cases, he admitted, they were able to see more than he did himself through his microscopes, perhaps because they were more accustomed to looking through lenses. These draftsmen were, like Leeuwenhoek, and like the painters of the time, investigators of the newly enlarged visible world.

-5-

The fascination with lenses pervaded both the artistic and the scientific communities, so much so that these communities can be seen as one, united by the shared goal of investigating nature and the collective employment of optical devices. The cohesiveness of art and science in this place and time is best exemplified by the fact that Delft's greatest artist and its greatest natural philosopher were both using lenses to see the world in a new way.

It is tempting to speculate that Vermeer and Leeuwenhoek must have known each other, that they must have been friends who talked together about lenses and optical experiments. There is an intricate web of threads that draws them together—they were born the same week in 1632, they lived and worked their entire adult lives within

the area of an American football field,* they had friends in common, and, most telling of all perhaps, when Vermeer died, Leeuwenhoek was the executor of his estate. But there is no "smoking gun" proving conclusively that they were friends or even acquaintances. What we do know of the two men is intriguing enough without engaging in conjecture, no matter how agreeable it is to imagine them discussing optics and optical instruments over a beer in Vermeer's family's tavern. The true allure of the story of their lives and works is the way both men played key roles in the sea change in the notion of seeing that occurred in this time and place. Leeuwenhoek, with his superbly skillful methods of making microscopes and observing a newly visible microscopic world through them, was one of the foremost figures in bringing about the seismic shift in the way of seeing the world that occurred in the seventeenth century. Vermeer, one of the greatest painters of the age, indeed of all time, explored this new way of seeing in his paintings and helped bring it to the Delft public—to those who saw his works displayed at his house, at that of his local patron, and even, perhaps, on the wall of the town bakery when the painter was unable to pay his bread bill. The sublime work that defines Vermeer's mature style was the result of his optical investigations, which he conducted with an optical device and in accordance with the new optical theories. As the artist John Constable would later say, painters are natural philosophers, inquiring into the laws of nature by using their pictures as experiments. While Constable's landscapes were experiments in natural history, Vermeer's paintings were in no small measure experiments in optics—as were the exploits in microscopy of his neighbor Leeuwenhoek.

---

* The Delft Market Square measures 360 feet by 130 feet, which is smaller than an American football field (including the end zones). Both men lived on streets across from the square (either right across it, as Vermeer did, or just behind it, as Leeuwenhoek did) and worked in buildings on the square.

PART ONE

# Counterfeiter of Nature

||||||||||||||||||||||||||||||||||||||||||||||||||||||||||||||||||||||||||||||||||||||||||||||||||||||||||||||||||||||||||||||||||||||||||||||||||||||||||||||||||||||||||||||||||||||||||||||||||||||||||||||||||||||||||||||||||||

*O*N OCTOBER 31, 1632, an infant boy was brought to the Prot-
estant Nieuwe Kerk (New Church) in Delft to be baptized. In this
age before last names become standard, his parents were recorded
in the registry as Reynier Jansz. (Reynier, son of Jan) and Dingnum
Balthasars. (Dingnum, daughter of Balthasar). They were accompa-
nied by Pieter Brammer, a sea captain who would later skipper a ship
called the *White Unicorn* and travel with the East India Company to
Batavia; Jan Heijndricxsz., an ebony worker and frame maker; and
the boy's paternal aunt, Maertje Jans. At the church the boy was
given the name Joannis. Not Jan, the name common among Dutch
Protestants (and the name of his paternal grandfather), but the more
elegant, Latinate version, generally bestowed upon boys of higher
social status or Catholics. This boy will, much later, be known as
Johannes Vermeer.

-*1*-

Johannes was born during what is now known as the Golden Age
of the Dutch Republic—a period spanning roughly the years from
1568, when seven mainly Protestant provinces of the Catholic Span-
ish Netherlands declared themselves an independent republic and

initiated a rebellion against Philip II of Spain, until the end of the seventeenth century. (Some scholars more simply define the Golden Age as encompassing the seventeenth century.) Though war raged between the "United Provinces" of the Netherlands and Spain for eighty years of this Golden Age—excepting the official Twelve-Year Truce, between 1609 and 1621—until the Treaty of Münster finally ended the struggle in 1648, the Dutch managed to become one of the most advanced nations in the world in trade, military might, science, technology, and art.

Indeed, for a brief span of time, this small, soggy patch of land sixteen thousand square miles, with its one and a half million inhabitants, was a major world power. Up until the 1640s the Dutch possessed a vast and profitable colonial empire, ranging from Brazil (New Holland), the Amazon estuary to the mouth of the São Francisco River; to Africa, where the Dutch Republic was the strongest European power; to the Guyanas and nearby islands of Antilles; to New Netherland, on the east coast of North America with its capital New Amsterdam (today's Manhattan). Its ships roamed the world's seas, bringing back sugar from Brazil, furs from New Amsterdam and Fort Orange in North America, and, from Africa, men, women, and children bound for the slave market. Later, the Dutch acquired colonies in Indonesia, South and North India, Ceylon, Siam, and Japan; in 1657 the Dutch East India Company, the VOC, had 160 ships in Asian waters. The VOC would become the largest employer in the Dutch Republic. From South India the ships would pick up cotton textiles to take to Indonesia to trade for spices, which were shipped to India and Persia in exchange for Indian textiles and Persian raw silk, meant for the European market; Chinese raw silk traveled from Taiwan to Japan, in exchange for Japanese silver destined to be sold in Europe. Along the way ship captains would pick up exotic "rarities"—flora, fauna, fossils, shells, and minerals—for the delight of naturalists and collectors, specimens to be classified, studied, and added to their "cabinets of curiosity." Some of these collectors would one day proudly bring prized specimens to Leeuwenhoek for him to study with his microscope, such as the merchant who bestowed upon him the rare "cockchafer" (more prosaically known as the West Indies cockroach).

Industry, especially in areas related to the global trade, thrived as well; in order to send goods around the globe, ships were needed, so the Dutch became master shipbuilders; dry goods were transported in baskets, so basket weaving advanced; wet goods required pots, so pottery kilns proliferated; the growing tapestry and cloth industry required—and stimulated—new thread-spinning and weaving technologies. This global trade created a wealthy class of merchants with disposable income to spend on decorating their homes, so painting, glassblowing, faience making, and other artistic crafts thrived in the Dutch Republic. Dealers and artisans offered wealthy buyers silver vessels, jewelry, cameos, medals, finely decorated majolica, Chinese porcelain, and sculptures in alabaster, wood, and bronze. Even workers spent money on the decorative arts. Throughout the Dutch Republic people craved items considered luxuries in other countries: pottery, pictures, furniture, bedding, fine clothing. Refugees from the south brought with them a legacy of refined artistic skill; Antwerp, Bruges, and Ghent had been the foremost artistic centers of the whole of Europe. Painting became a considerable industry, with many pictures produced for export, especially to places such as Germany that had a Protestant civic culture sharing the same tastes as Dutch society. Between five and ten *million* paintings were produced in the Dutch Republic in the seventeenth century. Of course, these were of varying quality and cost—only a small proportion were the masterworks we know today.

The seemingly endless decades of war with Spain, and skirmishes with England, France, and other powers, honed the Dutch Republic's skill at building and maintaining garrisons; rallying, training, and deploying troops; and developing ever more powerful weapons. The Netherlands was considered the "principal school of warfare" in Europe at the time. Even apart from the increasingly technological nature of warfare, gaining technological expertise was literally a life-or-death necessity for the Dutch: because much of the country is at or below sea level, keeping flood waters at bay required engineering and scientific skill, and so these were nourished among its young people, who had to invent or improve, and then build and maintain, a series of dikes, locks, sluices, and other devices, such as "mud mills"

to dredge the mud and silt from harbor floors; these mud mills were sought out by the Venetians, who were having their own trouble with the silting up of their canals and harbors.

The topography required innovations in agricultural techniques as well, such as better drainage, soil replenishment methods, and the use of fodder crops; these innovations were later borrowed by the English, who used them to revolutionize their own agricultural system in the eighteenth century. Dutch drainage experts were commissioned for projects in Bordeaux, Tuscany, and the Papal States. The Dutch also improved harbor cranes, timber saws, tactile looms, windmills, and clocks. Amsterdam would soon be the first city in Europe to have an efficient system of street lighting, designed and implemented by the artist-inventor Jan van der Heyden.

The Dutch were known throughout the world for their work ethic. Labor was highly respected, even among the very wealthy. As the painter Karel van Mander put it in his *Schilderboek* (*Book on Painting*) in 1604, "In my opinion a better custom prevails among us Netherlanders than any other people, namely that parents, however rich they may be, have their children taught some craft, art, or trade while they are still young." Workers in the Dutch Republic enjoyed a better life than workers elsewhere; the republic has justly been called "an island of plenty in an ocean of want" during this period. Throughout the Golden Age, Dutch workers had higher real incomes, better diets, and safer livelihoods than did workers elsewhere in Europe. Even in the eighteenth century, the French philosopher Denis Diderot was shocked enough to comment on the fact that workers in the towns and cities ate fresh and cured meat and fish, fresh vegetables and fruits, butter, eggs, and cheeses. Employers in the Dutch Republic complained that they had to pay their workers more than twice what their counterparts in England, in Germany, or in the Southern Netherlands had to pay, and they were correct. Workers in glass manufactures in Holland earned eighteen to twenty-four stuivers a day (about fifteen dollars a day in today's money),* while their coun-

---

* It is notoriously difficult to estimate current value from Dutch currency of the seventeenth century. At that time there was no central mint, and each of the

terparts in Liège received less than half that amount. The British writer and fellow of the Royal Society of London William Aglionby surely exaggerated when he supposed that it was "not very rare to meet with peasants here worth ten thousand pounds," but his comment highlights the impression made by the Dutch working classes upon members of higher classes from elsewhere. Certainly, in the Dutch Republic, most citizens were not in want, and those who were benefited from numerous civic organizations set up by the state to provide what they needed.

Citizens of the republic were taxed at a higher rate in order to help the needy. The English ambassador William Temple would later remark that the Dutch "pay the taxes willingly and take as much pleasure and vanity in the public works as in other countries people do in their possessions." Voluntary contributions were also common, sometimes in the form of coins dropped into a "poor-man's box" to seal the deal whenever terms were reached in a business transaction. Visitors were suitably impressed by the breadth and effectiveness of the Dutch welfare system. The Dutch Republic took care of its poor, its elderly, and its mentally ill with as much dignity—and order—as possible. The Amsterdam madhouse, for example, featured separate cubicles for each inmate, as well as an interior garden with trees and flowers; an English tourist was prompted to exclaim, "The very Bedlam is so stately that one would take it to be the house of some Lord." Of course, the orderliness was a form of social control; the mad were kept off the streets, and the poor were pressed into low-cost labor for the quickly growing manufacturers.

To the rest of the world, the Dutch Republic seemed an industrious and successful little nation, powerful far beyond what its small size and modest people could ever have led an observer to predict. This could not help but excite the envy and, perhaps inevitably, the

---

provinces produced its own coins and also accepted coins from Spain, Italy, and elsewhere. For the most part, the value of coins was determined by their silver or gold weights. As a very rough guide I am converting the value of the Dutch guilder during various years of the seventeenth century into today's purchasing power by using the website of the International Institute of Social History's "Value of Guilder to Euro" converter, http://www.iisg.nl/hpw/calculate.php.

disdain of men from other, more established global powers: in 1651 the British poet and politician Andrew Marvell would scoff,

> *Holland, that scarce deserve the name of land,*
> *As but th'off-scouring of British sand. . . .*
> *This indigested vomit of the sea*
> *fell to the Dutch by just propriety.*

(Napoleon Bonaparte would later claim for France the dubious honor of having provided the "sand" that created the Netherlands, dismissing the nation as so much "alluvium deposited by some of the principal rivers of my empire.") And yet, British and French visitors flocked to the Dutch Republic, hoping to pick up goods—and ideas—to bring back home.

-2-

Delft, located in the province of Holland, about halfway between Rotterdam to the southeast and The Hague to the northwest, was then a lovely town of twenty-one thousand inhabitants, crisscrossed with the canals for which it is named (the Dutch word *delf* means "canal" or "ditch"; *delven* means "to dig"). After visiting the city, Samuel Pepys described Delft in 1660 as "a most sweet town, with bridges and a river in every street." The topography of Delft is moorlike; most of the city lies below sea level, the water being held back by dikes and by a system of sluices draining the costal fens; much of the marshy ground is covered in peat. For centuries inhabitants and visitors had noted mysterious glimmering lights over the former fenlands; these visions were sometimes interpreted as having a mystical or religious origin, an interpretation that led to the building of St. Ursula's Church (afterward renamed the Nieuwe Kerk) in the fourteenth century. Much later it was realized that this phenomenon was not a kind of ghostly visitation but simply the combustion of moor gasses. The abundant peat would soon be harvested and used to burn fires for the brewing of ale; like the Scottish highlands, the Dutch

lowlands would become renowned for the use of peat in producing their fermented beverages.

Medieval ramparts surrounded the town; with their turrets and moats these walls helped protect Delft during the Eighty Years' War with Spain. When the war finally ended in 1648, citizens were able to walk along the ramparts and take in the panoramic views. Along the western part of the wall the pedestrian would come upon one of the largest and most imposing city gates in all of the Northern Netherlands: the Sint Jorispoort (St. George's Gate). The massive towers of this gate also served as prison cells. Behind the Sint Jorispoort lay the city's "lumber gardens," where timber shipped from the Baltics was stored and cut. Two other grand city gates, the Schiedam and the Rotterdam, were connected by a bridge, under which low boats often passed into the city. The only gate remaining today, the Oostpoort (East Gate), was near the Oostmolen (East Mill), one of nine grain mills in Delft in the sixteenth century. By the end of the seventeenth, only four mills remained, due to the decline of the brewing industry.

Many buildings along the canals were constructed in the Middle Ages; a number of these, no longer modern enough for private residences, had been given community roles: the Orphanage (with the Foundling Home and the Madhouse), the Hospital, the Charity House (in two parts, the Poor House and the Leper House), the Workhouse, and the Old Women's and Old Men's House on the Voldersgracht, which would soon be used as the cloth-testing hall and then, later, be knocked down so that the new building of the St. Luke's Guild, the professional organization of the artisans and artists, could take its place.

The town's business and social life was dominated by the rectangular Market Square. Given how central the square was to the life of Delft's citizens, it is surprisingly small; once you are standing in its midst, it is all but impossible to imagine Johannes Vermeer and Antoni Leeuwenhoek going about their daily lives without passing each other frequently. The square is anchored at one end by the Nieuwe Kerk, where both boys were baptized. At the other end of the square is the Stadhuis, the Town Hall, a building designed by the sculptor and architect Hendrik de Keyser (who also designed

the stately monument to William the Silent that drew visitors to the Nieuwe Kerk). It was built between 1618 and 1621, constructed around a medieval tower. Here is where the city government met, and where Antoni would one day perform his duties as warden of the Sheriff's Chamber. Behind the Town Hall and to its right is the Oude Kerk (Old Church), built in the thirteenth century, where both men were buried; the house Antoni would buy when he married lies close by the church, not far from the Town Hall and across the canal from the *vismarkt* (fish market) and the *vleeshal* (meat market), where he would sometimes obtain his specimens. On the left side behind the Stadhuis is the Waag, the weighing house, where he would one day serve as the *wijnroeier*, or wine gauger. Johannes's father owned an inn, called Mechelen, on one side of the square, across from the Voldersgracht, the street where Johannes was born, and where the new building for the St. Luke's Guild would later be erected. The opposite side of the square is bounded by the Oude Langendijck, where Johannes would later live with his wife and her mother.

Throughout the seventeenth century Delft was a "town full of life and business," as recounted by the Delft chronicler Dirck van Bley-swijck in 1667; it had prospered during the Twelve-Year Truce with Spain between 1609 and 1621, and would remain strong for some decades more. The Dutch East India Company, formed to direct trade between the Dutch Republic and the Far East, had one of its five offices in Delft. From Delfshaven, the nearby port on the Maas River, East India Company ships sailed to all corners of the world. In Delft, the renowned producers of pottery, beer, and woven cloth both created demand throughout the nation and then strove to satisfy it.

In a country celebrated around the world for its cleanliness, Delft was reputed to be the cleanest town. Throughout the Dutch Republic preachers exhorted their flocks to keep their souls as clean as their houses. Household manuals of the time prescribed different tasks for each day of the week: according to one such pamphlet, every week-day morning the steps, the path leading to the house, and the front hall were to be cleaned; on Mondays and Tuesdays the bedrooms and reception rooms were to be dusted and swept; Wednesdays the entire house was gone over, in a search to eradicate dirt; Thursdays were

days for scrubbing and scouring, for which finely ground sand was used; Fridays the kitchen and cellar were cleaned. Visitors were given slippers at the front door to wear in the house so that they would not bring any dirt in from outside.

In Delft, however, cleanliness was not only next to godliness, it was next to affluence. The beer industry—with around one hundred breweries in Delft at the beginning of the seventeenth century—required clean water. Since the Middle Ages, local ordinances had prohibited the throwing of rubbish and feces into the canals, explicitly to keep the water pure for the breweries. Because of this, beer was the drink most recommended for both adults and children—it was the least likely to cause intestinal upset or illness (no one yet knew quite why that was; only after the discovery of microorganisms in the water could this question be answered). That was quite different from the situation in London, for example, where vast quantities of human and horse excrement were dumped daily into the Thames, which functioned not only as the city's sewer but also as its source of drinking water. The streets of Delft were also kept meticulously clean; an English traveler to the Dutch Republic marveled, "The beauty and cleanliness of the streets are so extraordinary that Persons of all ranks do not scruple, but even seem to take pleasure in walking them." This was in stark contrast to streets in London and the other cities in Europe, where fine ladies dared not walk, lest their gowns and delicate shoes be ruined by the stew of excrement, rotting food, phlegm, vomit, and dishwater overflowing the cobblestones in even the "best" neighborhoods.

An influx of immigrants from the Southern Netherlands in the 1590s had brought new industries to the north. Tapestry weaving had been established in Delft at the end of the sixteenth century, when weavers from Antwerp—the birthplace of the business—emigrated to Delft. François Spiering was lured to Delft in 1582 by the offer of the old St. Agnes Convent near the East Gate of the city, where he built his factory; another tapestry-weaving concern was located in the St. Anne Convent on the other side of town, near the Hague Gate. With the advent of Protestantism, the former convents and abbeys found new life as factories like these and—with one case that

turned calamitous—as munitions depots. Designs for the tapestries were often provided by painters such as Karel van Mander the younger and Hendrik Cornelisz. Vroom.

Pottery works had also centered in Antwerp until the 1590s, but then moved north to Delft, where they flourished. At first, these factories concentrated on producing square tiles, used for edging the walls of rooms so that the frequent cleaning of the floors would not ruin the whitewash of the walls. Tile makers imitated the multicolored style of the Italian majolica, also known as faience, and the tiles were expensive: about 75–100 guilders ($1,500–$2,000) for one thousand. Soon, trade with China had created demand for the delicate blue-and-white porcelain formed, painted, and fired there. These pieces were quite costly, however, and out of reach of most consumers. Delft pottery works shrewdly began to create decorated porcelain pieces in the blue and white colors and the patterns of the China style; as Bleyswijck rhapsodized, "Dutch Porcelain is nowhere wrought more subtly or delicately than in this town, in which they seem to copy the Chinese to perfection." The temporary interruption of the flow of porcelain from China between 1650 and 1680 helped fuel the growth of the Delftware industry—so much so that when Chinese porcelain was once again available it had hardly any ill effects on the Delft industry. Consumers were happy to continue buying the Delftware imitations instead of the Chinese originals.

Once the manufacturers turned to producing the "Delft Blue" style, the price of tiles dropped dramatically, to about twenty-five guilders (three hundred dollars) for one thousand; now it became possible for even workers to cover the walls of their kitchen pantries completely in the tiles for about three weeks' worth of wages. As the demand for tiles and other pieces of porcelain exploded, the factories multiplied. By 1670 one-quarter of the city's population depended on the industry. As brewing in Delft slowly declined during the seventeenth century, a number of breweries were turned by their owners into the more lucrative china manufactures, which explains why many of the factories were endowed with names better suited to an inn or a pub: The China Bottle, The Fortune, The Greek A, The

Three Bells, The Jug, The Young (and Old) Moor's Head, The Two
Wee Ships, The White Star, The Rose.

## -3-

Johannes's family was well established in Delft; his father had been
born there while his mother had come to Delft from Amsterdam
before they married in 1615. However, there had been rough times.
Not long after their marriage, Johannes's father, Reynier, found
himself inadvertently embroiled in a perilous plot involving his new
father-in-law. Sometime around 1620 his wife's father, Balthasar, and
her grandfather Claes Gerritsz. were imprisoned for playing key roles
in a counterfeiting scheme; because the counterfeiting of currency
was a capital offense in the Dutch Republic, this was an extremely
dire situation. Although the full story is still cloaked in mystery, it
seems indisputable that Johannes's great-grandfather Claes Gerritsz.,
assisted by his son, Balthasar, had used his skills at metalworking
(gained in his training as a clockmaker) to make dies for pressing
three-stuiver coins. The two masterminds of the counterfeiting ring
were discovered and convicted of having ordered Balthasar to make
the dies and then stamping two hundred fake coins. The ringlead-
ers, both members of the aristocracy in the Dutch Republic, were
sentenced to execution and were decapitated by sword on August 8,
1620. Balthasar and Claes were briefly imprisoned, but then released
without being formally charged.

By the end of the matter, all members of Johannes's mother's
immediate family—not only her father and grandfather but also her
stepmother, brother, stepbrother, husband, and mother-in-law—had
become embroiled in some way: in being questioned, in trying to
cover up the involvement of the two men, in signing affidavits about
the affair, or in seeking the release of the men from prison. This must
have been especially trying for Johannes's mother, who was pregnant
with Johannes's older sister, Gertruy, during much of the affair (Ger-
truy was born in March of 1620). We cannot know whether this epi-

sode became part of family lore and was still being discussed when Johannes was a young boy, or whether it was never mentioned again.

Johannes's father, Reynier, supported his family at first by his trade as a *caffa-werker*, someone who produced and sold the heavy satin material known as caffa, originally made in Flanders, a type of damask used for upholstery, curtains, and some clothing—including the gleaming, luxurious skirts that would later feature in Vermeer's paintings. Reynier had served his mandatory four-year apprenticeship in Amsterdam, where he worked from 6 a.m. in the summer and sunrise in the winter until 8 p.m.; in exchange, he received ten stuivers a week plus food and lodging. He most likely met his future wife during his apprenticeship in Amsterdam. Reynier was still referred to as a caffa worker in the records of the Delft city government in 1635, as a witness to a brawl on the ice; he was one of a group that tried to break up a knife fight with their *kolven*, curved sticks with which the Dutch played a game similar to ice hockey. By this time, however, Reynier was also working as an art dealer. On October 13, 1631, a year before Johannes was born, he registered in the artists' guild, the Guild of St. Luke, as was required for members of that profession.

In the guild's entry book he is recorded as "Reynier Voss or Reynier van den Minne," two names he had begun to call himself when surnames were becoming more typical (variability in last names was common during this transition period). When he later leased an inn on the north side of the Voldersgracht (thus embarking on a third career as an innkeeper), Reynier named it De Vliegende Vos (The Flying Fox). Most likely he named the inn after himself, and not—as some have claimed—the other way around, since he was already using "Vos" before he leased the inn. Indeed, Reynier Vos was a common combination of names. "Reynier" sounds, in Dutch, like *renard*, the French word for "fox," and the compilation of fables the French call "Le Roman de Renard" was famous in Holland as "Reynaerd de Vos." Perhaps to distinguish himself from all the other Reynier Voses, Johannes's father had settled on the name "Vermeer" by 1640. It is not known why Reynier chose this last name, though since the word *vermee*r in Dutch means "to increase," it was perhaps wishful thinking about his own fortune that suggested the name.

More prosaically, Vermeer is a contraction of Van der Meer (from the lake), and was a common surname. One of Reynier's brothers had already adopted this surname around 1624.

It is not surprising that Reynier Vermeer would embark on the two careers—art dealing and inn keeping—at once. These often went together. Artists and their prospective customers tended to gather in inns, which were frequently places of business transaction as well as conviviality. Adam Pick, the owner of The Big Vat, also traded in paintings. Pick himself was a still-life painter who had studied with Evert van Aelst.

In 1641, when Johannes was nine years old, his father lost the lease on The Flying Fox, which was several steps away from the building that would later house the St. Luke's Guild; however, in a move up the ladder of economic and social status, he bought another inn nearby called Mechelen, which was right on the Market Square and therefore in the path of much foot traffic. This was one of the most imposing private buildings on the square, with seven meters of frontage, as opposed to the more usual four to six meters; inside were a lavish six hearths. Reynier purchased it for a hefty 2,700 guilders (the equivalent of $42,000 today), paying 200 down and taking out two loans for the remainder; even so, the yearly repayment was 125 guilders, less than he had been paying for renting The Flying Fox. Above the inn was a building large enough to house Reynier's family, small as it was with only two children, as well as his growing collection of paintings, most of which were given to him to sell by artists in Delft.

The Dutch were great consumers of art. They spent much of their earnings on household goods, in part because the prevalent taste—dictated by the country's Calvinism—was for internal, rather than external, displays of wealth. Citizens were discouraged by their ministers from wearing jewels or building houses that shouted extravagance from the outside. The Calvinist clergy went so far as to exclude bankers from communion by an ordinance of 1581; their wives and children could join communion, but only after a public profession of repugnance at the vocation of their paterfamilias. Many people covered their walls in paintings; even middle-class homes displayed paintings, to the surprise of visitors from other countries. John Eve-

lyn remarked, "Pictures are very common here, there being scarce an ordinary tradesman whose house is not decorated with them." Aglionby mused, "The Dutch in the midst of their *Boggs* and ill *Air*, have their *Houses* full of *Pictures*, from the *Highest* to the *Lowest!*" Of course, the wealthy took this to greater lengths: in the grandest home in Amsterdam, the Bartolotti house, one bedroom contained twelve paintings—even the room of one of the maids had seven. Closer to home, we know that Delft middle-class workers also sometimes owned numerous paintings. Eight years before Reynier Vermeer began working as an art dealer, when he was merely a thirty-two-year-old caffa worker, an inventory of his household goods shows that he owned nineteen paintings: two portraits of himself and his wife, four pictures of the stadtholder and his family, five paintings on alabaster, one flower still life, one dish of grapes, one landscape, one "story of Lot," one "sacrifice of Abraham," one brothel scene, one night scene, and one Italian piper. A study of probate inventories shows that there were about fifty thousand pictures in Delft households in the middle of the seventeenth century, when the population numbered under twenty thousand.

Because so many Dutch citizens desired to purchase paintings, a lively art market arose. Reynier Vermeer recognized this as an excellent business opportunity early on, and was one of the first professional art dealers in Delft (the other was Abraham de Cooge, who registered with the guild a year after Vermeer).

At this time, the guilds played a dominant role in the economic life of Dutch towns. There were guilds of butchers, bakers, candlestick makers (as the eighteenth-century nursery rhyme has it), as well as fishmongers, grocers, shoemakers, tailors, bargemen, porters, and artisans. These guilds were something like today's unions—they restricted participation in the regulated profession to citizens of the towns who possessed certain qualifications (in some cases, such as the brewers' guild in Ghent in the sixteenth century, membership was limited to sons of existing members). The guilds also regulated the work practices and quality control of the activity, so they not only provided security against competition for its members but also protected consumers from shoddy or unsafe goods. The guilds collected

dues from their members, which they used for contributions to local charitable institutions, especially those set up for sick, incapacitated, or elderly guild members and their families or widows and orphans.

The guilds were also thriving social organizations. Before the Reformation they played a large role in religious festivals and processions. Afterward the guilds transferred their energies to the civic festivals; these were numerous, because the new republic celebrated its existence as often as possible. The guilds all had their own insignia, collections of ceremonial objects such as drinking horns, salt cellars, basins, and goblets, all engraved with the insignia of the guild and their town—which would be brought out at the large feasts sponsored by the guilds—and their own buildings, often the most imposing structures in the towns hosting them.

Inscription in the St. Luke's Guild in Delft was required, according to the 1611 rules, for "all those earning their living here with the art of painting . . . in oil or watercolors, glassmakers, glass-sellers, faienciers, tapestry-makers, embroiderers, engravers, sculptors . . . , scabbard-makers, art-printers, booksellers, and sellers of prints and paintings, of whatever kind they may be." The St. Luke's Guild protected local artists by forbidding the auction of any paintings by artists who were not members of the Delft guild. The only exception to this rule was during the annual fair. (Dealers did get around this rule by holding "raffles" and "lotteries" rather than auctions for pictures by nonlocal artists.) The artists' guilds in the Dutch Republic imparted a "corporate spirit" to artistic activity. Even more, they played a major role in the lives of artists, especially in Delft. The St. Luke's Guild would come to play an important role in the life of Johannes Vermeer.

-*4*-

From the time he was nine, young Johannes lived above a bustling and successful inn, where his father served the public while entertaining artists and potential buyers for their paintings. He was learning how to read and write, probably at a neighborhood school, and

may have studied some drawing and mathematics at the little academy run by one of his neighbors on the Voldersgracht, the painter Cornelis Rietwijck. Between this period and his marriage thirteen years later, we know nothing with certainty about his life.

But we can draw some inferences—here is where the detective work of history comes into play. Johannes registered with the St. Luke's Guild at the very end of 1653 as a painter; in order to do so, he must have served a six-year apprenticeship with a master painter who was registered in an artisans' guild in either Delft or another city (sometimes, young artists would divide this period between two master painters). This was a requirement of the guild.

With whom could Vermeer have studied from the late 1640s? Johannes may have studied for one or two years with Evert van Aelst, a Delft still-life painter who had left a painting on commission with Reynier Vermeer in 1643. We know Van Aelst owed Reynier money when Johannes was eleven years old, only a few years before the boy would have begun his apprenticeship. Providing free lessons to Johannes could have been how Van Aelst paid off his debt, and how his father, despite some money troubles around this time, could have afforded to send Johannes to a teacher. (The cost of a local teacher would have been worth about 50 guilders a year, or roughly $787 today; the cost would have risen to twice that, plus room and board, for a teacher in Amsterdam or Utrecht; Rembrandt, for example, charged his pupils 100 guilders for lessons alone.) Van Aelst's brilliance in depicting the gleam of light on reflective metals could have been a formative part of Johannes's artistic upbringing. And although Vermeer never painted a still life as such, it is clear that he was influenced by still-life painting in Delft. This is seen in the wicker basket of *Christ in the House of Mary and Martha*, the bowl of fruit in *A Maid Asleep*, and the sensuous fruit falling out of the tilted charger in *The Letter Reader*.

The painter's nephew Willem van Aelst had apprenticed with him when he was very young, a few years before Johannes's apprenticeship would have begun. Willem was later known for his effusive use of the ultramarine pigment, a habit that Johannes also developed. The painter and biographer Arnold Houbraken would later say

of Willem that "he knew how to imitate life so naturally, that the work of his brush seemed to be no painting but life itself"—which is almost exactly how Constantijn Huygens described the way the camera obscura could be deployed by painters. One wonders whether Willem and his uncle were using the camera obscura at the time Vermeer was studying, and whether Evert was the one who introduced the young Johannes to that technology.

Most likely, even if Johannes did study for a time with Van Aelst, he apprenticed with another painter for part of his six-year period. Vermeer probably went to Amsterdam—the center of fine arts at the time, where his father had apprenticed and where his mother's family probably still lived. He may have studied with either of two painters: Erasmus Quillenus II (who was based in Antwerp, but spent time in Amsterdam in the 1650s) or Jacob van Loo. Both Quillenus and Van Loo painted canvases in the early 1650s that are reminiscent of Johannes's first-known paintings: *Christ in the House of Mary and Martha* and *Diana and Her Companions.** Johannes's trajectory as a painter resembled Van Loo's as well: both began by painting large canvases with mythological and religious scenes and later switched to smaller genre studies.

-5-

We may never know for certain with whom Johannes apprenticed. But we do know what he would have learned from his master. First, the young painter in training would have been instructed in drawing from plaster casts (such as the plaster face seen on the table in Vermeer's *The Art of Painting*); then he would have progressed to depicting models from life. He would have learned at least the rudiments of perspective theory, which would have taught him how to depict three-dimensional objects on a two-dimensional plane. Understanding perspective required some knowledge of geometrical relations;

---

* There is some variability in the names given to Vermeer's paintings. I use those from Walter Liedtke's complete catalog.

this is why the painter Rietwijck, Johannes's neighbor on the Voldersgracht, was known for teaching both mathematics and drawing.*

The painter's apprentice needed to learn how to prepare the canvas to receive the paint. The use of canvas was fairly new in the Northern Netherlands. Up to the first quarter of the seventeenth century, painters there used mainly wooden panels, not canvas. The panels—made of oak, mostly from the Eastern Baltic states, and often cut at the Delft lumberyards—were prepared with a mixture of chalk and glue, thinly laid on; this was to seal the openings in the wood grain and assure a smooth surface. Then this mixture was scraped with a knife, and covered with a thin layer of lead white and umber. This provided a yellowish ocher-colored surface that could function as an intermediary tint among the dark and light colors of the painting itself. Even after canvas came into widespread use, panels were still sometimes used; Johannes would use them for his *Girl with a Flute* and *Girl with a Red Hat*, so he learned how to prepare the wooden panels at some point. He may also have painted on panels more than the body of his surviving works might suggest; the inventory taken after his death found six unpainted panels, along with ten unpainted canvases.

Canvas offered many advantages over panels, especially its greater ease of transport and the ability to paint larger pictures that would not be unworkably heavy. Canvas could be any kind of woven material but was usually made of linen. The fineness of a canvas was given by its thread count, just like the quality of any other fabric. It is believed that, by Vermeer's time, some artists bought canvas that was already prepared from specialists who sold preprimed canvas; a Rotterdam shop is known to have dealt exclusively in painters' supplies, including both primed and unprimed canvas. Even if Vermeer at some point bought ready-prepared canvases, he had most likely learned how to prepare them himself. To prepare canvas, the apprentice would learn that he must first remove the protruding threads and other irregularities of the weave. He would next brush the surface with animal glue, applying one or two coats to fill any remaining

---

* For more on perspective theory, see part 3.

irregularities and provide a smooth surface, while also protecting the linen from penetration by the binding medium in the ground.

The ground was then applied, usually by the artist himself, even if he had bought the canvas already primed. The ground was generally a mixture of chalk, glue, and linseed oil, as well as various pigments.* Most often, in Holland in this period, the ground was a reddish brown ocher followed by a gray or flesh-toned layer containing mostly lead white. Johannes would later use this method in *The Love Letter*. Sometimes the pigment of the ground was a mixture of lead white and a bit of umber, resulting in a light buff or warm grayish color, as Johannes would use in *A View of Delft*. Or the ground would be painted completely in lead white, as he did for *Girl with a Pearl Earring* (adding just a touch of ocher and carbon black to make a cool gray), *Young Woman with a Wineglass*, and *Woman with a Pearl Necklace*. He would learn that the first stage in painting was to apply the dead color, or monochrome underpainting, which at the time referred to local development of the composition to indicate light and dark areas. Johannes would go on to use this very subtly to determine the required tone. For instance, in *A View of Delft* he would underpaint the sky with a layer of lead white on the brown ground, which provided the cool tone of the blue sky. In *Girl with a Pearl Earring*, he would lay black paint under the jacket and the turban to provide dark shadows in their blue colors. In *Woman with a Pearl Necklace*, he used different kinds of black in his underpainting: bone black, which has some brown in it (and is a warm tone), and carbon black, which tends toward blue (and is a cool tone). For shadows on the face, he laid on red and brown underpainting. The skin has underpainting in warm, creamy tones. Johannes would eventually develop an economical technique that used the underlying layer of paint—sometimes the ground, sometimes the underpaint—as part of the final composition. In *The Art of Painting*, for example, he used the ground as parts of the stalks of the model's laurel wreath. Next, the final layers of paint

---

* That Vermeer applied his own ground is suggested by the fact that the canvases found at his death inventory were listed as "unpainted" and also that he seemed to alter the ground depending upon his conception of the painting.

were applied, sometimes thickly, sometimes more thinly, and even transparently for the final glazes.

Johannes would have also learned how to prepare and store the paints. Synthetic colors, such as cobalt and Prussian blue, came on the market only around 1750. Premade paints sold in little tubes were not available until the nineteenth century. There is some evidence that already in the seventeenth century, in certain cities in the Netherlands, there were "colormen" who sold premixed paints. In the early part of the century the painter Gerard ter Brugghen suggested that artists not waste their time in mixing their own colors, because the colors that could be purchased already mixed were far superior. Half a century later, Van Hoogstraten would also advise his readers to have their pigments made by a meticulous amateur. In some cities, vermilion (a red color), smalt (a cheap blue pigment), lead white, and "mountain green" were produced on a large scale and sold to artists. However, it is unclear how widespread the availability of such premixed paints was, and many painters mixed their own paints from raw materials that could be obtained from the local apothecary.

Some of these materials were hard and had to be crushed in a mortar, and then ground fine on a grindstone; the newest apprentices or the painter's servants were usually delegated this task. Other materials, such as those prepared from plants, had to be dissolved, boiled, and filtered. The earth-based paints or ochers needed no grinding, for they were already soft and crumbly. All the powdered substances were turned into oil paints by combining them with linseed oil, a process requiring that the powder be worked into the oil on a hard smooth surface, like a marble block, with a flat-ended stone called a muller (in Dutch, a *loper*). Johannes would have been taught that the consistency of the finished paint should be fairly thick, able to stand up in tiny peaks like whipped cream. He would have learned through trial and error that different colors are more difficult to blend, requiring more elbow grease; vermilion, the red-colored paint most preferred by painters of the day, was quite hard to get right.*

---

* I learned this from Donnée Festen, a painter in Amsterdam who still mixes her own paints the old-fashioned way.

A painter's apprentice would often go to bed with aching shoulders, with the putty-like smell of the linseed oil lingering on his clothing and in his nostrils.

Each type of paint had its own special method of preparation, and the recipes were passed down over the years from master to apprentice. The painter had to be a kind of alchemist, capable of memorizing and reproducing recipes like this one, for making the red color vermilion (which was also called cinnabar):

> Take two parts Quicksilver [liquid metallic mercury] and a third part Sulphur, put it in a pot, melt the Sulphur and the Quicksilver under a weight, when cold grind well together. Then put it in a Glass, which is already completely covered a finger-breadth thick with hairy Loam [a combination of sand and cow's hair]. Previously prepare an Oven of the width of your Glass or Retort. Set this Glass on the Oven. Or put it on an iron Tripod, or in another little distiller's oven, make a little Tin lid over the Basket of the Retort, and a little hole in the middle of the lid, seal it well with the prescribed Loam, push an iron in through this hole that you may stir all with it. First make a small fire under it of dry wood and gradually increase it. And take great note of the Glass too, for out of it you may see smoke, and steam also from out the Glass, but take no heed of it, but mind that you keep a steady fire under it without ceasing until you see that the smoke is as red as blood, then it suffices. Then let it get cold and so you have good cinnabar.

Over time, an apprentice watching over this toxic stew could suffer from pink cheeks and nose, and possibly even loss of hair and teeth, muscle weakness, and sensitivity to light—all signs of mercury vapor poisoning in children.

Other, less deadly red paints were "Indian red, brown-red, and red lead." There was also "Florence lake, Haarlem lake, ball-lake and distilled red lead; Bresille-red, dragon's blood, carmine, crimson madder." Crimson madder came from the juice of the root of the madder plant; dragon's blood derived from the sap of the Indian palm

called Dracano Drago. Florence Lake, also known as carnelian, was obtained from the crushed remains of the cochineal beetle, a kind of cactus louse. This dye was so precious that its price was often quoted on the Amsterdam stock exchange; because of its value, Mexico, its principal exporter at the time, kept the animal origins of the dye a secret—anyone caught trying to smuggle out the beetles was put to death—and so no one knew that the color was made from animals until Leeuwenhoek examined some of the dried dye with his microscope in 1687 and saw tiny insect parts. (Leeuwenhoek says that he examined the cochineal twice, the second time finding "some shells of little animals that were black, each having a reddish spot in the center." He does not mention from whom he got the cochineal sample—it could have been from one of his artist relatives or acquaintances.) The paint color was sometimes obtained by means of steeping wool that had been dyed with the cochineal beetle, rather than using the crushed beetle itself. This beetle-based dye is still used today to color some cosmetics and foods because it is a "natural" additive. Johannes would use it in *The Love Letter* and *The Procuress*.

Johannes was most struck by the blue and yellow paints, which he would deploy with such bravura later on. For the color blue, Van Hoogstraten related that painters had at their disposal "English, German, and Haarlem ashes, smalt, blue lac, indigo, and the invaluable aquamarine." Smalt was made of crushed blue glass rubbed in linseed oil. It was hard to work with; the color was best when the glass particles were larger, but then it was hard to smooth on the canvas and had a tendency to drip off. Johannes stayed away from smalt after deploying it in his painting *Christ in the House of Mary and Martha* and other early works. As Van Hoogstraten noted, the ashes were unstable, often fading to a gray color over time. Johannes was drawn to the "invaluable aquamarine," which he would later use more than other Dutch painters—even to his own economic ruin. It was the most sumptuously stunning paint, made from the colored part of the relatively rare semiprecious stone lapis lazuli. Not only was the lapis itself expensive, but the process of dividing the splendid blue coloring from the other components of the stone, such as the lime-

stone, was time-consuming and tedious. By repeatedly crushing and then washing off the sludge, one could remove the limestone from the compound, but each time the limestone took something of the blue with it. The remaining concoction, known as aquamarine ash, was not always the same color, ranging from blue-gray to light gray-blue. However, if a painter could afford to obtain some pure ultramarine, he would have an intense blue color. In Johannes's time the prepared ultramarine, already in powdered form, could be purchased from an apothecary, but it cost a small fortune, selling at 60 guilders ($790) per quarter pound. In 1649 the inventory of the painter Jacob Marrell records half an ounce of ultramarine as being worth even more: 10 guilders, or 80 guilders per quarter pound—(about $1,050 today). Paintings produced with such expensive paints tended to have more time and care lavished on them. The concept of "fine painters," or *fijnschilders*, who would use expensive materials to create highly polished and luminously colored art that was sold to connoisseurs, developed in the Dutch Republic around the late 1620s, led at first by Rembrandt, then his student Gerrit Dou.

Yellows were easier to obtain. They could come from the ochers, clays of different shades of brown or yellow; or they could be made of massicot, white lead that has been heated to 300 degrees Celsius, yielding a pure, almost lemon-yellow; or from *schietgeel*, "fade-yellow," made of a decoction of yellow flower petals, which Johannes would use later on. Lead white by itself was one of the most commonly used paints, because it was so durable and covered well. Johannes would later exploit the bright white color for the *pointillés*, or highlights, found in many of his paintings. However, lead white was one of the most toxic paints, as well as one of the least pleasant to produce, requiring a process that employed vinegar and horse manure. Most of the black paints were produced by the burning of organic substances: ivory, bone, vine tendrils. The most intense black, called lampblack, involved collecting the soot of a burning flame and mixing it with the oil. Johannes would have learned that each of the blacks had its own color qualities: bone black has some brown in it and is a warm black, carbon black is as flat a black as charcoal, and lampblack tends

more toward a bluish, cold black. Painters could exploit these different blacks to great effect; Van Gogh would later say admiringly of Frans Hals that he "must have had twenty-seven blacks."

Green paints always gave painters trouble; "Spanish green" was harsh, as well as being poisonous, made from copper filings steeped in the juice of vine tendrils; *terra verde*, a form of ocher, was not a strong green; and "green ash" was unstable, turning gray over time. Consequently, the painter would often just mix blue and yellow on his palette to produce his own green. This had its own problems; in several of Johannes's paintings, foliage is seen as blue, which is probably due to his having mixed ultramarine with fade yellow, but as the yellow faded over time, only the blue was left behind.

Johannes, like other apprentices, was also taught how to keep the paints. Those that were easiest to prepare and used most often, the brown and yellow ochers, were usually made in larger quantities and kept in little earthenware pots, covered with parchment to keep them from drying out. The more valuable colors, such as ultramarine blue, were prepared in small amounts, and kept in pig's bladders tied up with a string—arrayed on a shelf, the bladders looked like a row of large figs. When needed, a small hole was pricked in the bladder with a short nail; the paint was squeezed out, as from today's tubes of paint. When the painter was finished using the color, the little hole in the bladder was closed up again with the nail. A pig's bladder could be used for about ten years before getting too dried out and hard.

In the middle stages of his apprenticeship, after he learned how to lay on the paint on canvas in careful layers, Johannes would have completed parts of his master's paintings, especially the solid colored backgrounds and areas of dense foliage or other simple patterns. Later, toward the end of his time with his master, he would have progressed to helping with the more difficult parts of the painting, such as drapery or the folds of a dress or blanket. When the apprentice was deemed ready to execute his own paintings, he would sign them with his master's name; all work completed during the apprenticeship "belonged" to the master, with the exception of work executed during vacations—three weeks in summer and two weeks in winter. This is why the studios of those painters who attracted large numbers

of students, such as Rembrandt, turned out great quantities of paintings, all in the same style, and some at one time or another attributed to Rembrandt—but eventually recognized as being the work of his "school" or workshop. A painter could sign and sell his own works only after joining a guild in his own right. At that point, he or she (there were some women guild members) could also sell the works of other painters, and many of the artists of the time earned extra money as art dealers.

-*6*-

After completing his apprenticeship, Johannes returned to Delft. We are not sure when he arrived in Delft, but we know that by the beginning of April 1653 he was in residence there, hoping to get married to a young woman named Catharina Bolnes. On the evening of April 4, the well-known Delft painter and former head of the St. Luke's Guild, Leonaert Bramer, and a sea captain named Bartholomeus Melling called on the imposing Maria Thins, a woman living on the Oude Langendijck. They were accompanied by Johannes Ranck, a Delft lawyer. This party had come on Johannes's behalf to convince Maria that the young up-and-coming artist was a good match for her daughter Catharina and should be allowed to marry her. The visitors asked Maria to sign a document permitting the marriage banns, or vows, to be published. Maria refused to sign such an act of consent. However, after some discussion she did agree that she would not oppose the publication of the vows—she would not block the marriage.

The next morning, Ranck drew up an official document attesting to what had occurred the night before. This was witnessed by Bramer, Melling, and two other men: Gerrit van Oosten and the Delft notary Willem de Langue, a prominent art collector who owned an important art collection, including works by Bramer and Rembrandt, and who had frequent dealings with many artists, as well as with Vermeer's family. The Delft city archives contain a document written by De Langue and dated April 5, 1653, stating that the two witnesses,

Bramer and Melling, had heard Catharina Bolnes's mother, Maria Thins, say that she did not intend to sign the act of consent for the registration of the marriage banns of her daughter Catharina with Johannes Vermeer, but that she was willing to "tolerate" the banns to be published. With this document the marriage could be performed.

Catharina's mother had reasons to be displeased with her intended son-in-law. She had come from a well-to-do family, but Johannes was a painter with no apparent source of income, from a family of counterfeiters and innkeepers. Even more upsetting to Maria Thins, Johannes and his family were Protestant, while she and her daughter were Catholic—Maria's sister had even become a nun in Louvain. It was most likely a condition of Maria Thins's "toleration" of the banns that Johannes would undergo conversion to Catholicism, because the Council of Trent (1545–63) had declared marriages between a Catholic and a non-Catholic null and void.

Marriage between a Protestant and a Catholic was not unheard of in the Dutch Republic at this time, but still it was a fraught enterprise. Since the break from Catholic Spain, the official religion of the Dutch Republic was Protestantism. At the Union of Utrecht, which formed the "United Provinces" of the Dutch Republic, the Reformed Church was proclaimed the "public church"; members of other faiths were granted freedom of conscience, but not freedom of worship. Restrictions on the practice of Catholicism waxed and waned over the next decades; most of the time, Catholics were allowed to worship as Catholics in private, and sometimes the public practice of the Catholic religion was tolerated as well. At other times, though, Catholics had been persecuted. In the minds of many patriotic citizens, Spanish oppression was linked to Spanish Catholicism, and even the burgomasters of the towns could not always hold back their citizens. One of the first things some citizens did after the formation of the republic was go out and pillage Catholic churches, convents, and monasteries, smashing stained glass windows and statues. Antipathy toward Catholics intensified in 1584, when the first leader of the United Provinces, Prince William I, was assassinated in Delft by Balthasar Gerard, a Catholic supporter of King Philip II of Spain.

Delft had a fairly large Catholic population, which had grown

from about zero in 1616 to 5,500, or 26 percent of the population, in 1656. Catholics were prominent in business and industry, and so the magistrates found it difficult to carry out anti-Catholic edicts. Delft officials complained, for example, in 1643, "[The Catholics] have increased in boldness and not only continue their gatherings but also in great numbers come to other people [i.e., proselytize] . . . and have bought house after house, which they have made their own for this purpose, which have entrances in the dividing walls such that they cannot be disrupted successfully." Catholics also paid "protection money," bribing officials to allow them to hold their services undisturbed.

For a brief period in the early days after the Union of Utrecht (before the murder of William I), Catholics had been allowed to worship openly in the Oude Kerk, while the Protestants used the Nieuwe Kerk. This arrangement lasted only a few months, however, and soon Delft's Catholics were forbidden to worship publicly. They began to create "secret churches," or *schuilkerken*, hidden in the homes of Catholic families. They also formed hidden Catholic schools. A Catholic revival throughout the Dutch Republic in the 1620s brought a new backlash, along with further restrictions, upon Catholics in Delft. Not only were the Catholics forbidden to hold their Masses, but one of their priests, the Jesuit Lodewijk Makeblijde, was harrassed. Hostility toward Catholics in Delft reached its peak in the 1640s and continued into the 1650s, when the Reformed consistory of Delft took up the attack, petitioning the town's burgomasters to demonstrate their "Christian zeal" by cracking down on these semi-clandestine Catholic practices such as the secret Masses and hidden Catholic schools. Although the local government resisted such calls, the situation grew so heated that in January 1645 the papal nuncio in Cologne, Fabio Chigi (the future Pope Alexander VII), had reported to Cardinal Barberini in Rome that the Catholics in Delft had suffered so much "insolence" on the part of "the heretics" that they had petitioned the city authorities for help. In 1649 the consistory formally asked the government to close the secret churches and schools; the authorities told the consistory that they would "keep an eye" on the priests, but refused to close down the churches. By the middle

of the 1650s, the tension in Delft had abated somewhat, but Catholics still mainly segregated themselves, choosing to live together in areas like the Paepenhoek, or Papists' Corner area, a collection of about fifteen buildings housing families as well as a hidden church and a Catholic school, located in the shadow of the Nieuwe Kerk.

-7-

Vermeer's intended bride, Catharina, had been born in Gouda, a city known for its large Catholic population. Secret Catholic Masses were sometimes held in Maria Thins's house in Gouda when Catharina was a child. Maria had moved to Delft with her two daughters after obtaining a legal separation from her husband, Reynier Bolnes, who frequently beat her—once when she was nine months pregnant with Catharina—and squandered Maria's dowry by drinking and gambling. Their son, Willem, remained with Reynier, and turned out, not surprisingly, to be quite a troublemaker himself, once even pulling down his trousers in public to "moon" his mother. Maria was able to obtain a legal separation because, in the Dutch Republic, husbands were not allowed to tyrannize their wives. As the poet-moralist Jacob Cats put it, "In our Netherlands, God be praised, there are no yokes for the wife, nor slaves' shackles or fetters on her legs."

Other factors also allowed Maria to leave her husband with her finances intact—at least, what was left of her dowry after Reynier's spending spree—so that she could support herself and her daughters. (This was important, as her husband refused to pay the support she had been awarded by the court.) Women had legal rights in the Dutch Republic that they lacked elsewhere at the time: they could inherit and bequeath property, and on a husband's death the widow would generally recover her marriage portion as well as the possessions she had acquired during the marriage. Women also had recourse to legal action: paternity suits, actions to reclaim her marriage portion if her husband was squandering it, and suits for divorce in cases of abandonment or adultery (or, as in the case of Johannes's

mother-in-law, extreme cruelty, though Maria's Catholicism kept her from going as far as divorce). Women could make commercial contracts and notarized documents and thus were able to have business dealings in their own name. Because of these rights women could have independent careers so they could support themselves and not rely on fathers, brothers, or husbands for their sustenance.

After she moved to Delft with her two daughters, Catharina and Cornelia, Maria purchased a house in the Paepenhoek, on the Oude Langendijck across from the Nieuwe Kerk and next door to the secret Catholic church founded by the Jesuits in 1616. Sometime before April 1653, Johannes and Catharina became acquainted and developed the "tender sentiments" regarded as indispensable for a successful marriage in the Dutch Republic. Johannes may have encountered Catharina at the home of his first teacher, Cornelis Rietwijck, who was Catholic. Or if, as some believe, Johannes's painting master was the Utrecht painter Abraham Bloemaert, who was a distant relative of Maria Thins's, Bloemaert may have introduced him to Catharina. Johannes may have met her at Mechelen—young women were not discouraged from taking a glass of beer in a respectable inn—or even on the Market Square. It was easy for men and women to meet on the street, as it were, because young, unmarried women could come and go, unaccompanied and unchaperoned, to market, to work, and to engage in conversation just like men. Thanks to this freedom, unheard of in most other countries at the time, unmarried Dutch women were sometimes assumed by foreign visitors to have "loose morals"; John Ray noted that "the women are said not much to regard chastity while unmarried, but once married none more chaste and true to their husbands." There may in fact be some truth to this; while few babies were born out of wedlock, many were born "early," that is, seven months—or less—after marriage.

Since Maria Thins was initially opposed to the marriage, Johannes and Catharina may have dispensed with the traditional method of courtship of the time, in which after an initial encounter a potential suitor would seek permission to visit the girl at home—under the watchful eye of a chaperone. After some weeks of such visits, the cou-

ple could "go public" by taking walks and attending church together. This would be followed by a formal "betrothal act," a notarized agreement, sometimes signed in the blood of the young couple.

The marriage of Johannes and Catharina was evidently a love match, not only because Catharina's mother was against the connection, but also because in the Dutch Republic at this time most marriages were initiated by the young man and the woman themselves, and not by their parents, as was then more common in other parts of Europe (at least in the middle and upper classes). Marriage in the Dutch Republic was seen as being for more than just producing a family, it was also for companionship; young men and women were expected to enjoy the company of their future spouses. And they were exhorted to enjoy their spouses once married, with frequent "fleshly conversation." One marriage manual from 1687 felt the need to warn new couples that husbands should not overdo it: four or five ejaculations per night were the maximum without risking his health and fertility. Visitors from other countries were often shocked by the public displays of affection between husband and wife, and remarked on the contrast between such displays and the extremely modest clothing dictated for women by social custom. (One disgruntled French officer complained of the women that one "can see nothing of their bosoms since they cover them up so carefully.")

At the same time, Johannes may not have been unmindful of the advice often given to young artists then, as now: marry well. Fabritius, for example, had married the sister of a successful cloth merchant, who owned several grand houses in Amsterdam and helped support his brother-in-law. Van Hoogstraten would later codify this rule in his book on painting, reminding young artists that affluence was essential for their "peace of mind," especially if they were to strive for "highly refined effects" (such as, one cannot help but think, the effusive use of the expensive ultramarine). Over the years to come, Maria Thins would offer invaluable aid to the couple: shelter, money, and connections.

The couple wed on April 20, 1653, at the secret Catholic church in Schipluy (today's Schipluiden), a small town an hour's walk southwest of Delft that was known as a Catholic enclave. They moved

into rented rooms on the Market Square. At the end of that year, on December 29, when he was twenty-one years old, Johannes registered as a member of the Guild of St. Luke. He was unable to pay in full the entrance fee of six guilders (about seventy-eight dollars today); instead, he gave one and a half guilders as a down payment. Thus, inauspiciously, Johannes Vermeer launched his career as a painter. In a time when paintings were sometimes referred to as *conterfeytsel*, Vermeer would himself become a kind of counterfeiter, like his grandfather: a counterfeiter of nature, copying his vision of the visible world.

PART TWO

# From the Lion's Corner

⸻⸻⸻⸻⸻⸻⸻⸻⸻⸻⸻⸻⸻⸻⸻⸻⸻⸻⸻⸻⸻⸻⸻⸻⸻⸻

𝒪N NOVEMBER 4, 1632, four days after Johannes Vermeer was bap-
tized in the Nieuwe Kerk, another infant boy was brought there for
the same ceremony. The baby and his parents, Philips Thonisz. and
Grietge Jacobs., were accompanied by the boy's paternal grandfather,
Thonis Philipsz. Leeuwenhoek, his uncle Huijch Thonisz. Leeu-
wenhoek, aunt Magdalena Jacobs. van den Berch, and aunt Catharina
Jacobs. van den Berch. The boy was given the name Thonis Philipsz.,
after his grandfather. The family lived in a brick house with a tile roof
on a corner of Leeuwenpoort Street, and will later take a surname
from their address: Leeuwenhoek, meaning "from the Lion's cor-
ner" (it is pronounced, roughly, "Lay-ven-hook").* Nearly fifty years
later, when he is renowned throughout the world for his microscop-
ical observations, Thonis, who will always sign his name "Antoni,"
will add a dignified "van" to the family's name, becoming Antoni van
Leewenhoek.

In the baptismal records in the Delft archives, the entry for Anto-
ni's baptism is recorded several lines under the record for Joannis
Vermeer. For the next forty-three years, the lines tracing the tra-

⸻⸻⸻⸻⸻

* Until about 1680, Antoni spelled his surname a number of ways, including
"Leeuwenhoeck" and "Leewenhoeck." I will use the later version that he pre-
ferred from 1680 until his death.

45

jectory of their lives will frequently veer close, even, perhaps, inter-
secting on occasion, until 1676, when their names again appear on
the same page in the Delft archives—in an entry recording Anto-
ni's appointment as executor of the estate of the recently deceased
painter.

-*1*-

Antoni's father was a basket maker from a family of basket makers;
theirs was a lucrative trade in Delft, as the thriving export business
required large numbers of well-made baskets for packing and trans-
porting merchandise. His mother's family, which had already begun
using the surname van der Berch, van den Berch or sometimes van
den Burch, was in the brewery business in Delft—an even more prof-
itable trade. Many brewers were members of the local government,
and the name van der Burch shows up many times in the lists of the
"council of 40," the most important political organization of Delft.
Philips and Grietge (short for Magriete) had married ten years ear-
lier, in 1622. Before her marriage, Grietge lived on the Oude Lan-
gendijck, only a few doors down from the house later purchased by
Vermeer's future mother-in-law.* It is possible that a young Antoni
visited his grandparents on the Oude Langendijck, where he might
have met the two Bolnes sisters, Catharina and Cornelia, and joined
them in their games.

Antoni would have enjoyed a happy early childhood; children in
the Dutch Republic were prized, cosseted, and encouraged to spend
their time playing games—many of which were depicted on the
blue-and-white tiles produced by the potteries. A writer on educa-
tion urged parents to allow children to exercise their childishness.

---

* Grietge is listed on the marriage license as living at the Oude Langendijck,
though it does not give a number of the house. But as the street is not very long,
only the length of the Market Square, and Maria Thins's house was right in the
middle of it, so wherever Grietge's parents' house was on that street it would
have been only a few doors away from Maria Thins's house.

"Let them freely play and let school use play for their maturing . . . otherwise they will be against learning before they know what learning is." Foreign visitors were sometimes surprised by the tenderness and overt affection shown to children by their parents; they were cuddled, hugged, and—to the discomfort of the sterner Calvinists— routinely kissed good-night at bedtime. Aglionby complained of the Dutch that "they are a little too indulgent to their Children," but noted with some satisfaction that they "are punished for it; for many of them rebel against their parents, and at last go away to the *Indies*." He was peeved, though, by the parents' response to his criticism: *"Does anyone spoil their own Face, or cut off their own Nose?"* Such anecdotal evidence for the cherishing of Dutch children is confirmed by statistics showing that the Dutch had very low rates of abandonment and infanticide in this period compared with the French and the English.

As a child, Antoni would have amused himself by raising silkworms; this was a common pastime in Delft, since the worm of the domesticated silk moth *Bombyx mori* eats only the leaves of mulberry trees, such as those lining the Delft canals. Young boys and girls would buy silkworms and feed them mulberry leaves, observe them as they spun their chrysalises, and then sell the cocoons to the silk spinners, who would boil them, killing the moth forming inside, and unravel the silken threads. Many years later Antoni would describe the breeding of silkworms by the children of Delft, grieving that since a disease had recently killed all the mulberry trees, youths were no longer able to enjoy this wholesome and lucrative occupation.

However, before Antoni's sixth birthday, in 1638, tragedy struck the family: two of his siblings died, followed quickly by his father. His mother was left with five children, including an infant daughter. Grietge did not remarry right away, suggesting either that Antoni's father had left enough money for the family to survive on or that Grietge's family and the basket weavers' guild had helped out with her expenses. Two years later she wed Jacob Jansz. Molijn, also known as Jacob du Molyn, a painter and a member of the St. Luke's Guild. Jacob Molijn, then in his sixties, had been widowed twice; he had five children from his first marriage and three from his second,

including two sons, Jan and Gerrit, both around twenty and both painters and guild members. This branch of the Molijn family was probably related to another part, which produced the famous landscape painter Pieter de Molijn, born in London of Flemish parents in 1595 and living in Delft—where he married a second time after his first wife died—between at least 1616 and 1629. Both the father, Jacob Molijn, and his son Jan were official "town painters" in Delft, and carried out important commissions for the city government, for which they were well compensated. Gerrit worked with his father on at least one project: painting and repairing the house of the painter Michiel van Miereveld.

Antoni's new stepfather, Jacob Molijn, was a versatile painter, though not a creator of works on canvas; he usually painted walls, statues, and "armories" (that is, heraldic coats of arms), but could also paint figures. In 1608 he was commissioned to paint a man's and a woman's face in order "to distinguish the privies where the men and the women go." Antoni's stepbrother Jan was most often called upon to paint armories and do other types of painting work for the Hoogheemraadschap, the Water Board, which was the government agency chartered with monitoring the elaborate system of dikes and locks as well as water cleanliness. In 1643 Antoni's older sister Margriete (born nine years before him, in 1623) married Jan. He would later prove to be a link to both the art world and the civic government for the young Antoni.

Around the time of her remarriage, Grietge sent Antoni, then about eight, to school at Warmond, a small town nineteen miles north of Delft. She may have felt that her new husband preferred not to have too many young children underfoot. The fact that Grietge sent her son to Warmond, so far away, at such a young age, is interesting, for it raises the question of whether the Leeuwenhoek family was secretly Catholic. Warmond was known in the seventeenth century for having Catholic schoolmasters and teachers placed furtively in the village schools by the Catholic noble families there; by the early eighteenth century the population of the village was overwhelmingly Catholic. Antoni's mother may have wished him to attend a state-run school that was essentially a Catholic school, without the possible

sanctions that would accrue if she were caught sending him to a "hidden," non-state-run Catholic school in Delft. (Some Catholics in the Dutch Republic refused to send their children to the state schools, administered by the Reformed Church; because of that, Catholics had a lower literacy rate than did Protestants.) The headmaster of the school in Warmond also taught Latin, so Leeuwenhoek would have studied at least some elementary Latin there.

The suggestion that the Leeuwenhoek family was Catholic is more compelling when it is considered that Antoni's parents had had seven children in their relatively short marriage. In the Dutch Republic during this period, most Protestant families had two or, sometimes, three children, while Catholic families were much larger. (As a point of comparison, Johannes's parents had only two children, whereas Johannes himself, when he converted to Catholicism and married a Catholic girl, would have eleven children.) Also telling is the fact that the Leeuwenhoek family home—after which they took their surname—was right next to the Bagijnhof, the courtyard area near the Oude Delft around which the group of devout Catholic women— lay nuns of the Roman Catholic Church—called beguines had lived since the thirteenth century. Attached to the Bagijnhof was a "secular" Catholic church, that is, one not attached to any particular religious order, hidden in a private home. After Antoni's marriage, he bought a house near this area, as if he wanted to continue living close to a Catholic enclave. (Sadly, his childhood home no longer stands; in its place is a concrete playground in the midst of a middle-class housing estate.) Since Catholics in Delft tended to socialize as well as worship together, this could have provided another avenue of acquaintance for Antoni and Johannes.

-2-

It is unclear how long Antoni remained at Warmond. Some years afterward, probably by 1646, he was sent to Benthuizen, nine miles northeast of Delft, where he lived with his uncle Cornelis Jacobsz. van den Berch, the sheriff and bailiff of the village. The sheriff's

role was something like that of a judge today. Sheriff Van den Berch apparently intended to teach Antoni the principles of the law and its enforcement. When it began to emerge that his interests were more practical and business-oriented, Antoni's mother sent him in 1648, at the age of sixteen, to Amsterdam to learn a trade.

Many members of the Van den Berch family were successful merchants. Grietge's grandfather Sebastiaen Cornelisz. van den Berch and her uncle Johan Sebastiaensz. van den Berch were in the cloth trade, as was her brother-in-law Pieter Mauritz. Douchy. Douchy lived in Amsterdam, where he was an influential wool merchant. He agreed to accept Antoni into his home and promised to find a position for him at a firm of good standing.

Antoni's uncle kept his promise. He found a place for the young man at the establishment of William Davidson, an Amsterdam cloth merchant who had been born in Dundee, Scotland, in 1616 and had been living in the Dutch Republic since 1640, eight years before Antoni came to work for him. Davidson would go on to have a colorful life. He was knighted in 1661 for services he had earlier rendered to Mary, widow of Prince William II of Orange; the dowager princess had stayed with Davidson while in Amsterdam to plead with the States General—the central organ of the united Dutch Republic—to appoint her young son stadtholder, or leader of the republic, even though they had suspended that office in a kind of republican fervor. (In the end Mary prevailed, and her son eventually became both the stadtholder of the Dutch Republic and king of England, as William III.) Later, during the English-Dutch wars, Davidson suffered a downturn in his fortunes when he was suspected of spying and being a traitor to his adopted home.

The Scots had long been well represented among the merchant classes in the Netherlands. By the late seventeenth century some eight hundred Scots were living in Rotterdam alone. The Dutch Republic—especially the major port cities of Rotterdam and Amsterdam—was a popular choice for Scots going abroad. In 1642 the Scottish clergyman Thomas Fuller exhorted his country folk, "If thou wilt see much in a little, travel the Low countreys. Holland is all Europe in an Amsterdam-print, for Minerva, Mars, and Mercurie, Learning,

Warre and Traffick." Many Scottish soldiers, brought over as merce-
naries on the Dutch side during wars against Spain and France, had
stayed on, and so did some of the young men who had come to attend
the universities in the Dutch Republic. Because the Dutch Repub-
lic had the most robust economy in Europe in those days, it was an
attractive place for Scottish merchants, who traded in Dutch ports.

Most Scottish merchants who came to live in the Dutch Repub-
lic learned Dutch quickly. Probably, by the time Antoni came to
work for Davidson, the Scottish cloth merchant was already speaking
Dutch with his servants and his business associates, as well as with
his wife, a Dutch woman named Geertruyt Schuyringh (he would
later be widowed twice, ultimately marrying three Dutch women
successively). Still, although Antoni later denied knowing any lan-
guages other than Dutch, it seems probable that the young apprentice
would have heard, and picked up, some English during his six-year
apprenticeship. Davidson would most likely have spoken in English
to his Scottish and English visitors during these years, as well as
to English-speaking business associates. By 1653, when Antoni was
granted proxy power for Davidson—that is, the right to answer let-
ters and sign documents for his master when he was away—Antoni
would have needed at least some reading knowledge of English in
case an absent Davidson received any important letters, orders, or
bills in that language.

A young man like Antoni would have marveled at the hustle and
bustle of Amsterdam, then the largest city in the Dutch Repub-
lic with 140,000 inhabitants, almost seven times the population of
Delft. Amsterdam had grown exponentially, its population doubling
between 1567 and 1610, and then again between 1610 and 1620. In
1607, the ruling families of Amsterdam approved the Plan of the
Three Canals, a major urban expansion project increasing the size
of the city from 450 to 1,800 acres and establishing the topography
of the city that remains today. The plan called for the digging of
three great semicircular canals, links between them and existing
canals with radial canals, the erection of buildings on pilings, san-
itary arrangements for each house, a complex network of drains and
sewers, and, near the Amstel River, the construction of warehouses

and merchants' houses with storage facilities on the upper floors. Each canal was seventy-five feet across, which provided space for two-way traffic as well as a lane for moored boats. The canals were bordered by a line of elm trees. Next to the canals were quays for loading and unloading merchandise; these were prescribed at thirty-three feet wide. Even the size of the housing plots was ordained by the plan: each plot could be only twenty-six feet wide fronting on the canals (wealthy merchants could buy two plots, and thus build wider houses for their families).

Most of the increase in population was due to immigration: Jews from the Iberian Peninsula, Huguenots from France, prosperous merchants and printers from Flanders, and economic and religious refugees from the Spanish-controlled parts of the Low Countries. They flocked to Amsterdam, a city already known for its religious and political toleration. When Descartes arrived there, he would exclaim that there was no other country "où l'on puisse jouir d'une liberté si entière [where you can enjoy complete freedom]." Immigrants from all over the world were welcomed, as long as they held up their end of the bargain and worked productively; vagrants or vagabonds were considered "outsiders" and not tolerated—they could be thrown out of the city—even if they were Dutch-born.

The peculiar guild structure of Amsterdam made it easier there than elsewhere for newcomers to prosper. There were only thirty-seven guilds with a total of eleven thousand members, a relatively small percentage of the working population compared with that of other Dutch cities, where the guilds were much more pervasive. That left many trades and craft professions open to those who would not have been welcomed by the guilds, especially Jews, who gravitated to industries not covered by guilds, such as tobacco spinning and the diamond industry. (Other "open" industries in Amsterdam at the time included cane sugar refining, brewing, soapmaking, and calico printing.) The influx of Flemish printers, as well as the reputation for tolerance, made Amsterdam a center for the European free press, attracting men—like Descartes—who wished to publish without the threat of censorship from either the Catholic Church or a royal government.

Amsterdam was known as the "marketplace of Europe," because of its bourse, or stock exchange, the first in the world. The city became the hub of the European art market; buyers purchased art from all over on behalf of clients in England, France, Germany, and Scandinavia. Amsterdam was also the industrial capital of the Dutch Republic: it imported raw materials and turned them into valuable exports such as finished silk, leather, wool, and tobacco products. It imported wool from Sweden, which was finished into fine cloth in Leiden and sent to Italy (where it was made into clothing) in exchange for olive oil made locally, and spices imported from the Middle East. Sometimes, Amsterdam took this strategy too far, as when it was accused by English merchants of importing Wiltshire and Gloucestershire woolens, "finishing" them in Holland (usually just by adding a label), and passing them off as "Dutch goods."

As Descartes exclaimed in delight after moving to Amsterdam, "Where else on earth could you find . . . all the conveniences of life and all the curiosities you could hope to see?" On the Nieuwe Brug, Antoni could find bookshops, stationers, and nautical goods purveyors selling charts, maps, sextants, and other instruments for navigation; ironmonger shops, dye shops, and apothecaries. On the Singel Canal was a large farmer's market; in the Nes, pastry shops and bakers; in the Kalverstraat, print shops and haberdashers; in the Halsteeg, cobblers and boot makers. Drapers like Davidson—many of them on the Warmoesstraat—displayed shimmering Lyons silk, crisp Spanish taffeta, lustrous caffa, and Haarlem linen bleached in the sun in "linen yards" to dazzling whiteness.

There were many pleasures to be had for a young man in Amsterdam. Inns were to be found on every corner, serving not only beer but also spirits—including the juniper-infused genever, later called gin when it made its way to England—many of which were being distilled near the port of Amsterdam, where ships would come in laden with spices and herbs used in the distilling process. Music was played on the street by itinerant musicians entertaining folks with instruments whose very names sound musical to us today: not only fiddles and bagpipes but also the hurdy-gurdy, the shawm, the dulcian, the rommelpot, the crumhorn, the hommel, the midwinter

horn. Delft, in the grip of its severe Calvinism, had outlawed such displays, so they would have seemed particularly exotic to Antoni. There were less-wholesome pleasures as well. Although the dominance of the Reformed Church had led to the suppression of prostitution throughout the Dutch Republic, Amsterdam was still known for its brothels and "bawds," as it had been since the Middle Ages. At the time that Antoni was in Amsterdam, there were about one thousand prostitutes and hundreds of brothel keepers; Amsterdam's police force of only thirty men could not hope to prosecute all of them. Some of the women worked out of whorehouses (*hoerhutzen*), others were employed as waitresses at disreputable inns; most of these types of establishments were located in the poorer neighborhoods near the harbor, where immigrants and passing sailors tended to live—and where Amsterdam's red-light district remains today.

-3-

During his apprenticeship, however, Antoni would not have had much time to enjoy the pleasures of Amsterdam. The responsibility of a master to his apprentice was to prepare the boy for both the world of trade and the wider world outside. It was not thought that one could achieve these ends without hard work—and long hours—six days a week. The apprentice was expected, during these years, to respect and obey his master, as much as he would his own father. Usually the boy lived with his master's family, who would be responsible for feeding and clothing him, but since it appears that Antoni lived with his uncle, this would have been his uncle's responsibility.

Davidson had a great deal to teach Antoni. An apprentice to a draper would learn about the technologies involved in making the different kinds of cloth—combing, spinning, weaving, bleaching—in order to better negotiate with the cloth makers and with his customers. Those in the cloth trade had much to keep up with; unlike cloth industries in other countries, and unlike some other industries in the Dutch Republic, the Dutch cloth industries eagerly adopted new technologies as soon as they were developed, such as the filling mill,

the twining mill, hot presses, and the ribbon frame. For instance, the "Dutch loom," invented in 1604, was put into use in Holland almost immediately, but—though it was known in London in 1614—was not adopted by Lancashire weavers until the beginning of the eighteenth century. The draper's apprentice would learn about the market for the different types of cloth not only in Amsterdam but around the world as well; he would need to understand the global aspects of the cloth trade. He also had to acquire the basics about running his own shop: deciding how much of what stock to order, details about pricing, bookkeeping, taxes, and, if he was hoping to one day become a master in the guild himself, taking on and training apprentices. When he was advanced in his apprenticeship—around the time he was given the proxy power for Davidson—Antoni may have been brought to the Drapers' Guild House on the Staalstraat to observe a meeting of the cloth-weaving inspectors, such as that which would be later depicted in Rembrandt's *Syndics of the Amsterdam Drapers' Guild* (1662). Antoni could aspire, one day, to be appointed a syndic of the drapers' guild in Delft.

There was another skill Davidson had to teach his young apprentice, one that would not only alter Antoni's life but transform science: examining objects through a convex lens. A magnifying glass was a crucial instrument for cloth merchants. It provided the only way to distinguish the thread count—and thus the quality—of fabrics. This was most likely the first time Antoni had ever used a lens—the first time he would have marveled at the fact that a piece of glass could allow him to see what could not be seen with the naked eye.

-*4*-

Although a young man like Antoni would not have had much call to use lenses before his work in the cloth trade, they were not rare in the Dutch Republic and elsewhere in Europe at this time. Magnifying lenses, also known as burning glasses—because they concentrate the sun's rays enough to cause combustion—already had a long history. These lenses were convex, that is, bulging out at the center,

and thinner at the ends, like a lentil. The oldest known convex lens is the "Nimrud lens," which dates back to ancient Assyria three thousand years ago and was unearthed in the nineteenth century. When it was found, the Scottish physicist David Brewster proposed that it might have been used either as a magnifying glass, perhaps to help artisans with their engravings, or as a burning glass to start fires. Aristophanes, in his play *The Clouds* (fifth century BCE), mentions a burning glass used for the latter purpose. Precious stones ground into lenslike shapes may have been used occasionally in ancient times as magnifiers or even as visual aids to help a person with defective sight see better; Nero was said to have observed gladiator games through an emerald. "Reading stones" came into use sometime between the eleventh and the thirteenth centuries; made by cutting a glass sphere in half, they were laid directly on the paper to enlarge the words and images. Such stones were probably used by monks to help them create their illuminated manuscripts.

But it was not until the last few decades of the thirteenth century that convex lenses were fitted into metal frames specifically to assist people with defective vision. The first convex spectacles were used to help older people read more easily. As one ages, the eyes suffer from presbyopia, the progressive loss of power of the eye to focus on nearby objects. The normal human eye is able to see distant objects sharply in its relaxed state. However, for clearly viewing objects nearer than about twenty meters away, the refractive power of the optical system of the eye must be increased; this occurs by the contraction of tiny muscles (called cilia) around the lens of the eye. By increasing the curvature of the lens, the contraction of the cilia results in greater refractive power. At ten years old, the normal eye can adjust or "accommodate" itself to see objects as near as three inches from the eye in sharp focus. This ability decreases with age; by the middle forties the eye can only accommodate itself to see clearly about ten inches removed from the eye. When the abilty to accommodate decreases to about twenty inches away, reading becomes impossible without optical aids. (A person born without this ability in the first place has defective vision that must be corrected sooner, which is why some of us need reading glasses before middle age.)

Up until the nineteenth century, purchasing spectacles for correcting presbyopia was simply a matter of going to a spectacle shop; there were rules of thumb relating the strength of reading glasses to a person's age, and by trial and error you would find the strength correct for you. The weakest ones generally had focal lengths (that is, the distance over which rays are brought to converge on a single point) about thirty to fifty centimeters (twelve to twenty inches). A shorter focal length has greater optical power. The strength of a lens, expressed in diopters, is the inverse of the focal length in meters; so the strength of these lenses was two to three diopters. Stronger spectacles were available for older people or those who had had cataract surgery (an early version of cataract surgery was already being performed around 800 BCE). Weaker lenses were not common. At the time there was no real demand for weaker glasses—people needing less correction can still read without spectacles, but may suffer eyestrain over time—and weaker lenses were more difficult to grind.

It was only later that lenses could be consistently ground to correct another vision deficit, myopia, or nearsightedness, a problem with seeing distant objects clearly. Correcting myopia requires concave lenses, those that are thickest at the ends and thinner in the middle; they are more difficult to grind than convex lenses. Concave lenses were available for sale in Florence by 1451, and soon spread to other cities in Europe. By the mid-fifteenth century, spectacles were widely prevalent among the elites, not only as aids to vision but as appropriate gifts of courtly patronage, even as status symbols.*

Once both convex and concave lenses were commonly available, it was only a matter of time before an optical device like the telescope would be invented. Already by Aristotle's time in the fourth century BCE it was known that a tube could help one view distant objects. In his book *On the Generation of Animals*, Aristotle explained that "the man who shades his eye with his hand or looks through a tube will not distinguish any more or any less the differences in colors, but he will see further." In the sixteenth century, the Danish astronomer

---

* One wonders whether some upper-class men wore spectacles without needing them, as a sign of their intelligence, like Brooklyn hipsters today.

Tycho Brahe observed the heavens using a long tube; even without lenses, this device enabled Brahe to make the impressively accurate observations of Mars's orbit that enabled Kepler to discover that the planetary orbits are elliptical, not circular.

By about 1600, the strongest concave lenses in a spectacle maker's shop had focal lengths of about twenty to thirty centimeters (eight to twelve inches); so the strength of these lenses ranged from three to five diopters. By putting together at two ends of a tube the weakest convex lens with the strongest concave lens then readily available, a telescope approaching useful magnification (about 2 or 2.5 times) could have been created. Only by about 1600, then, was it possible to construct a weak telescope from lenses that were easy to find.

So both the idea behind a tubelike optical device, and the technology to make one with lenses, were in the air around Europe by 1600. But it is not clear who the first person was to put together a tube with lenses to create a working device. It is probable that one of three men from the Dutch Republic was the original inventor of a usable telescope. Isaac Beeckman, a rector of the Latin School in Dordrecht and a friend of Descartes's, took lens-grinding lessons in the 1630s in Middelburg with Johannes Sachariassen, the son of a spectacle maker named Sacharias Janssen. Sachariassen told Beeckman that the first telescope in the Netherlands had been made by his father in 1604, after a model made by an Italian in 1590. His son's story is plausible, because at that time Middelburg was the site of a major glass factory established in 1581; it employed a number of Italians, who had deserted from the Spanish army, in which they had fought as mercenaries. Around the time Janssen supposedly made his first telescope, the Middelburg glass factory was run by an Italian named Antonio Miotto. It could well be that an Italian prototype of a telescope made its way to Middelburg, and then to Janssen, who improved it.

Beyond that, the historical record is murky. We know that on September 25, 1608, a "spectacle maker from Middleburg" applied to the States General for a patent on his invention of a new instrument to see objects far away, and requested the opportunity to demonstrate the device to the stadtholder, Prince Maurits, at The Hague. The record of this event does not reveal the name of the spectacle

maker. Whoever he was, we know that he showed the prince a device made from two glass lenses, one convex and one concave, enclosed in a tube twelve to fourteen inches long; the concave lens was used for the eyepiece, and the convex for the objective (the lens farthest from the eye). From the tower of the prince's home in The Hague, the men were able to see the clock on the Town Hall in Delft, almost six miles away! On this day the prince was entertaining Ambrogio Spinola, the commander of the Spanish troops in the Netherlands, who was at The Hague negotiating for peace. Seeing no reason to dismiss his onetime foe, Maurits allowed Spinola to remain and observe the demonstration. Spinola is said to have remarked to Maurits's son, Prince Frederik Hendrik, "From now on I can no longer be safe, for you will see me from afar." Prince Frederik Hendrik jokingly assured Spinola that he would not allow his men to fire upon him, even though they would see him before he would see them.

Who was this "spectacle maker from Middelburg"? It might have been Janssen, though it is odd that he waited four years from when he supposedly improved the Italian prototype to request permission to demonstrate it to Prince Maurits. It may have been another spectacle maker from Middelburg, Hans Lippershey. A week after the demonstration to Prince Maurits, Lippershey submitted a patent application for a different kind of telescope altogether: one that had two viewing lenses, like binoculars, and with lenses made of quartz, rather than glass. Before two more weeks had passed, a third Dutchman, Jacob Metius of Alkmaar, petitioned the authorities for an exclusive patent for an optical device for seeing faraway objects; in his application he acknowledged the efforts of "a spectacle maker of Middelburg" who had preceded him in applying for a patent, but claimed he had been working for two years on his invention and was privy to "secret knowledge" about glass.

Wisely, the States General declined to give anyone a patent for the device, claiming that it was not really new—after all, how innovative could the device be if three supposed inventors had all applied for patents at the same time? Indeed, by this time a Dutch peddler had been reportedly hawking a telescope at the Frankfurt fair. The States General instead awarded Lippershey nine hundred guilders

for making three binocular instruments in five months, and Metius was granted some money to improve his prototype. Janssen seems not to have received anything. One wonders whether that is why he later became involved in two counterfeiting schemes, one in 1608, and one in 1620, around the time that Johannes Vermeer's family was implicated in a similar plot. In order to avoid execution for the second offense, Janssen had to leave Middelburg—in fact, he completely vanished from the historical record at that time.

-5-

Once introduced in the Dutch Republic, the new optical instrument spread quickly throughout Europe. Not surprisingly, after Spinola had witnessed the demonstration of the new device with Prince Maurits, he obtained a telescope of his own in short order and showed it to the ruler of the Spanish Netherlands, Archduke Albert of Austria—who had acquired two for himself by the spring of 1609. The papal nuncio Guido Bentivoglio, a former student of Galileo's, saw the Archduke's instruments and described them in a letter to Cardinal Scipione Borghese, a nephew of Pope Paul V. In mid-April 1609 the English ambassador to the Spanish Netherlands suddenly took up astronomy with enthusiasm while at the archduke's castle, suggesting that he, too, was using the new device. By then the instruments were commercially available at a shop on the Pont Neuf in Paris, by May they could be purchased in Milan, and by summer in Bavaria, London, Rome, Naples, Venice, and Padua. In 1617 Galileo's intimate friend Giovanfrancesco Sagredo was disappointed to discover that his correspondents in distant India already had plenty of telescopes and were therefore not impressed by the ones he sent them.

Sometime during this period, a device fell into the hands of Galileo. He was not, as is often claimed, the telescope's inventor. Nor was he the first to turn the instrument to the heavens; others—such as Thomas Harriot and William Lower in England—used telescopes to view the moon a few months before Galileo. However, Galileo was one of the first to improve the device so that it could be fruitfully

applied to astronomy. He swiftly understood that, with lenses pur-
chased in shops, it was only possible to create devices with a magni-
fication of three times. He realized that greater magnification would
require lenses with increased differentiation in power between the
convex objective and the concave eyepiece. This meant he would need
to grind and polish his own lenses. He began to do so and, in August
of 1609, presented a device that magnified nine times to the Vene-
tian senate, which was impressed enough that it doubled his salary
at Padua and gave him a permanent appointment there. But Galileo
continued working on his grinding and polishing techniques, and by
the beginning of 1610 he had made telescopes that magnified twenty
and even thirty times. More importantly, he adapted the device for
astronomical use by adding aperture stops to his objective lenses. In
this way Galileo limited the amount of light entering the lens, reduc-
ing the interference caused by the brightness of celestial bodies; this
made it possible to accurately observe stars and other bright bodies.

Nor was Galileo the first to use the word "telescope," as some
believe, though he was present at the term's birth. Galileo had been
calling his device a *perspicillum* (the English were calling it a "per-
spective cylinder"). On April 14, 1611, he attended a dinner held
at the Accademia dei Lincei, the scientific organization founded by
Federico Cesi in Rome in 1603. Cesi had been inspired to form the
scientific society by Giambattista Della Porta's description of the
natural philosopher as an investigator "examining with lynx-like eyes
those things which manifest themselves." After a lavish banquet, the
party repaired outside to use one of Galileo's telescopes to observe
Jupiter's moons and Saturn's "companions" (not yet recognized as
rings). At the dinner the Greek poet and theologian John Demisiani
had baptized the instrument *telescopio*, from the Greek for "to see at
a distance."

Once the telescope was in use, it was not long before another,
related device was invented: the microscope. Galileo may have been
the first to use a telescope to view objects close up, thus setting the
stage for the invention of the new instrument. A student of his
reported that in 1610 Galileo had used an inverted telescope to
observe "a certain insect in which each eye is covered with a rather

thick membrane, which is perforated with seven holes like the visor of a warrior to allow it sight." Five years later Giovanni du Pont described how Galileo had used the device to discover that flies could walk upside down on glass because they were "inserting the points of their nails in the pores of the glass." By sometime between 1620 and 1624 Galileo was constructing a special kind of microscope that he called an *occhialino*, or little eye, for the purpose of, as he put it, "observing minute objects closely."

Around the same time Galileo made his first microscopes, the eccentric Dutch inventor, instrument maker, and engineer Cornelis Drebbel—then living in London—was also constructing and selling his own microscopes. Drebbel, another artist–natural philosopher, had studied engraving with the famed engraver Hendrick Goltzius in Haarlem; he later married Goltzius's sister Sophia and moved to England. He was a light-haired, somewhat coarse-looking man with good manners and a brilliant intellect. Constantijn Huygens, who spent much time with him while on his diplomatic mission with the Prince of Orange in London, recalled that "in appearance he is a Dutch farmer, but his learned talk is reminiscent of the sages of Samos and Sicily." Their relationship was warm; Constantijn remarked to his parents that he had "possessed Drebbel for a whole year, and he possessed me too, his possessor, and a not unfavorable one, unless I mistake me; this he proved to me during many lessons, being more affectionate to me than to any of his friends." (His parents promptly warned Constantijn not to spend too much time with this "magician.")

Constantijn had sought out Drebbel at first because of his renown as an inventor of remarkable objects: a *perpetuum mobile*, a perpetual motion machine, in which the constant motion of water inside a series of glass tubes seems to have been caused by changes in the temperature and pressure of the surrounding air (it was a kind of air thermometer/barometer); a regulated oven, in which the temperature could be controlled; an incubator, which Drebbel used to hatch ducklings and chicks by himself even in the coldest winters; and, most spectacularly, a kind of submarine or diving bell, which he demonstrated with great fanfare in the Thames River one afternoon.

In his autobiography, Huygens described what he had observed on that day. Drebbel and a few trusting souls had dived under the water in a "little ship" with a leather-covered frame. On hand were King James I of England and several thousand Londoners. They waited for the ship to resurface . . . and waited . . . and waited longer, until everyone was quite sure the funny little inventor and his crew had been swept away by the tides and drowned. Many in the crowd went home. Some curious onlookers remained, along with the king, who refused to give up hope. Finally, Huygens remarks, after three long hours, Drebbel

> suddenly rose to the surface a considerable distance from where he had dived down, bringing with him the several companions of his dangerous adventure to witness to the fact that they had experienced no trouble or fear under the water, . . . yea, even that they had done in the belly of that whale all the things people are used to do in the air, and this without any trouble.

Although King James did not take up Drebbel's suggestion that this ship could be useful in warfare, he was still impressed enough to take the plunge with Drebbel on a later trip—or so a possibly apocryphal story has it. Decades later, fellows of the Royal Society of London, including Robert Boyle and Robert Hooke, would marvel at how Drebbel had managed to replenish the breathable air underwater for such a long time; even the philosophers Gottfried Leibniz and Baruch Spinoza would wonder about this. To this day, no one knows Drebbel's secret for certain, though Boyle thought that Drebbel had likely generated oxygen by heating *nitre* (potassium nitrate or sodium nitrate) in a metal pan to make it emit oxygen. That would also turn the nitrate into sodium or potassium oxide or hydroxide, which would tend to absorb the carbon dioxide being exhaled by those inside the ship. In 1662 Boyle wrote that he had spoken with *"an excellent mathematician,"* who was still alive and had been on the submarine, who said that Drebbel had a *"chymical liquor* that would replace that *quintessence of air* that was able to *cherish the vital flame residing in the heart."*

But Huygens, who was beginning to take an interest in lenses and optical instruments, was most interested in the fact that Drebbel was not only grinding his own lenses, but had created a new type of device with those lenses. Some believe that it was actually Drebbel who made the first instruments designed specifically for viewing very small objects. He was certainly the one to devise a crucial innovation. Each of Drebbel's devices consisted of a three-piece extensible brass tube. The tube was fitted with a small plano-convex lens as the objective (that is, the lens was convex on one side but flat on the other), with the convex side turned to the object being examined. The ocular end of the tube held a larger, double-convex lens (both sides were convex), which was not right at the end but about five centimeters from its mouth. The tube was encased in a brass ring, fitted with three legs fastened to a small, flat round surface. The object to be studied was placed in the middle of this surface. The lens was focused by sliding the tube up and down within its tripod stand. Magnification was increased by extending the tube out to different lengths. The use of two convex lenses rather than the concave/convex combination of the Galilean telescope was ingenious, because it allowed for a shorter tube and a broader field of vision. After looking through one of Drebbel's microscopes, Constantijn Huygens enthusiastically wrote of the "new theater of nature," indeed "another world," visible through it.

By the early 1620s, several microscopes of this type made by Drebbel were fast circulating throughout Europe; one was presented to Marie de Médicis, queen of France, in 1622, by a brother of Drebbel's son-in-law. Nicolas-Claude Fabri de Peiresc, a French natural philosopher and collector, saw the Drebbel microscope when he was attending the court of Marie de Médicis and insisted on acquiring several copies for his own use. Some of these made their way to Roman notables by 1623. Peiresc wrote excitedly to Girolamo Aleandro describing this device: it was a

> periscope or occhiale, a new invention different from that of Galileo, which shows a flea as large as a cricket . . . [and] the minute animals generated in cheese, called mites, so tiny that they are like

dust-grains, but when seen with this instrument become as large as fleas but without wings.

Galileo came across one in 1624 and proceeded to use the concave/convex system to create his own new microscopes. He presented examples of these to Cesi at the Accademia dei Lincei. Cesi would later employ one to produce the first published microscopic study, a close examination of the bee, in 1625. Another of the Linceans, Johannes Faber, after seeing the instruments presented to Cesi by Galileo, wrote in a letter to Cesi, "I should also mention that I am calling the new *occhiale* for looking at minute things a *microscope*."

The microscope had entered the scientific toolkit. It was clear from the start that this new device would revolutionize science no less than the telescope had already done. However, while the microscope captured the imagination of natural philosophers, it did not immediately lead to new scientific discoveries—unlike the telescope, through which Galileo had seen never-before imagined celestial objects and attributes (the satellites of Jupiter, the mountainous surface of the moon) almost immediately. For the next forty years, the role of microscopes was limited mostly to the demonstration of wonders and curiosities of nature, as natural philosophers and the public delighted to see the known world magnified. Insects, in particular, were examined, and examined again, as everyone marveled at the intricacy and beauty of the smallest and lowliest of God's creatures—or, what were believed to be the smallest of his creatures. Athanasius Kircher gaped at the unexpectedly complex construction of even the smallest insect. Who would have thought that God would spend such care in forming the lowly mite or louse? Pierre Borel, who published the first book devoted exclusively to microscopic observations, gazed in awe at the wondrousness of the minute body of a mite, remarking especially on its eye—in which he could sometimes perceive a mischievous glint. Gioanbatista Odierna conducted a more detailed study of the eye of the fly, making observations both before and after a dexterous dissection of the tiny organ. Francesco Fontana delicately pressed the transparent eggs out of the abdomen of a flea and observed the nits emerging prematurely from the damaged ova,

charting a future role for the microscope in the controversy about spontaneous generation, as tiny pests were, at this time, still generally assumed to arise from mud or decay.

These observations set the stage for a new revolution in science and in the understanding of how we see. But it would not be until forty years after its invention—when the new device began to be used less for evoking curious delight and more for the purposeful study of organic structure—that the true age of the microscope was born. Only then would the invisible world be made visible. This transformative moment had to await the flowering of genius in a draper's apprentice, Antoni Leeuwenhoek.

PART THREE

# Fire and Light

‖‖‖‖‖‖‖‖‖‖‖‖‖‖‖‖‖‖‖‖‖‖‖‖‖‖‖‖‖‖‖‖‖‖‖‖‖‖‖‖‖‖‖‖‖‖‖‖‖‖‖‖‖‖‖‖‖‖‖‖‖‖‖‖‖‖‖‖‖‖‖‖‖‖‖‖‖‖‖‖‖‖‖‖‖‖‖‖‖‖‖‖‖‖‖‖‖‖‖‖

ON MONDAY, OCTOBER 12, 1654, around ten thirty in the morning, the painter Carel Fabritius—considered one of the finest students of Rembrandt's—sat in front of his easel on the ground floor of his small house on the Doelenstraat, a narrow street in the northeast part of Delft. Fabritius's house was close to the headquarters of the city militia and near the former convent of the Poor Clares, which had been repurposed after the founding of the Protestant republic as a store for army munitions. The subject of his portrait—Simon Decker, the former sexton of the Oude Kerk—posed patiently, and Fabritius's student Mathias Spoor stood nearby, ready to bring his master a fresh brush when needed.

As Fabritius painted, a clerk for the States General approached the former convent, which lay nestled among the trees behind the Doelen, on a mission: to remove a two-pound sample of gunpowder. Although the Treaty of Münster had ended the fighting with Spain in 1648, security continued to be of major concern for the Dutch. Conflict with England had led to an Anglo-Dutch war in 1652 that had only ended five months earlier. Tensions still simmered between the two seagoing powers; they clashed frequently over who had the right to the vast schools of herring passing by England's east coast, and who would dominate the Iberian spice trade. The Dutch militia

67

remained on a state of semi-alert, and on this day a routine test of the quality of the gunpowder stores was to take place.

The clerk lit a lantern and entered the gunpowder store, a tower partly submerged in the ground of the convent garden holding about ninety thousand pounds of gunpowder. Moments passed. Then, suddenly, a roar, which Fabritius heard—indeed, it was heard as far as the island of Texel in the North Sea—followed by five immense explosions. An immense cloud of smoke rose over Delft, a dark shroud filled with rubble, chalk, stones, and wooden beams, mixed with human and animal body parts. It was, as one eyewitness recorded, "as if the pools of hell had opened their throats to spew out their poisonous breath over the whole world."

-1-

The munitions depot explosion destroyed much of Delft. In the large area bounded by the Geerweg on the north, by the Verwersdijck on the west, the Singel canal on the east, and Fabritius's street, the Doelenstraat, on the south, every house was razed to the ground—at least two hundred buildings. Many buildings beyond this area—over three hundred—were completely wrecked, and it was said that not one house in Delft escaped damage. Furniture was splintered, china was smashed, clothing left torn and dirty. Even the stained glass windows of the Nieuwe Kerk—which had been spared by Protestant iconoclasts destroying the trappings of Catholicism in 1566 and later—were shattered by the explosion's force. All the windowpanes in the Town Hall were blown out. One eyewitness said it looked as if houses were belching out their very innards. Hundreds of lives were lost; to this day no one knows exactly how many people died. All that was left at the site of the gunpowder magazine was a hole about fifteen feet deep, filled with water. For seventeen years the ground would remain open, as a kind of sacred ground, used only periodically as the town's horse market (*paardenmarkt*).

In the chaos immediately following the explosion, as horses screamed in their stables and people huddled under tables hoping

to save themselves from falling roofs and shattered glass, some-
one pulled Fabritius from the rubble of his house. He was, mirac-
ulously, still alive. Carried to Delft's hospital, along with hundreds
of other wounded citizens, Fabritius died an hour later. Most of
his paintings—still stacked in his studio, waiting to be sold—were
destroyed in the blast. Fabritius was also known to have painted
murals directly on walls for some patrons; many of these murals were
destroyed in the blast as well. Yet at least one was spared: in 1660 the
widowed owner of a Dutch brewery called The World Upside Down
made it a condition of the building's sale that she be allowed to rip
out the part of the wall that Fabritius had painted, so that she could
take it with her. Only about a dozen of his paintings are known to
us today, including the glorious study *The Goldfinch*, which features
the kind of lush backlighting that could have inspired Vermeer's
later work.

Fabritius would be memorialized in 1667 by the Delft chronicler
Dirck van Bleyswijck, who described him as "a very fine and outstand-
ing painter, who in matters of perspective and natural coloring . . .
was so skillful and powerful that (according to the judgment of many
connoisseurs) [he] has never had his equal." In a later edition of the
work, Bleyswijck would add a reference to Vermeer as the "phoenix"
who arose out of Fabritius's ashes.

Soon after the explosion, Fabritius's neighbor Egbert van der Poel
memorialized the event by painting the destroyed town. Though
Van der Poel and his wife had survived the blast, two days later they
buried a daughter, who probably perished in the explosion. Van der
Poel, haunted by the tragedy, produced no fewer than twenty views of
Delft as it looked immediately following the disaster. In one, *A View
of Delft after the Explosion* (1654), the devastated landscape is filled
with the rubble of collapsed buildings; the only structures remaining
intact are the Old and the New Churches, whose spires can be seen
looming over burned trees and piles of rubble. Groups of people help
the wounded, comfort each other, and try to salvage some belong-
ings. After depicting the obliterated landscape so many times, Van
der Poel, as if unable to bear living in the ruined city depicted in his
pictures, left his native Delft forever, and settled in Rotterdam.

Six years later, Johannes Vermeer would paint his own *View of Delft*. His picture shows the town, which had been rebuilt remarkably quickly, in its full glory. Delft citizens had had to rebuild before— after the great fire of 1536 had destroyed the western quarters of the city. Like before, Delft had risen from the ashes. Vermeer exhibits Delft from the south, depicting from across the harbor its city walls, the Schiedam Gate with its clock tower and the Rotterdam Gate with its twinned turrets. The interior of the city is bathed in strong sunlight, in which the reddish tile roofs of the buildings lining the canals seem to glow with their own benign flame.

-2-

In the 1650s, Delft was home to some of the most brilliant artistic talent in the world. Fabritius lived and worked in Delft from the summer of 1650 until his tragic death; his few remaining paintings are enough to secure his position as a true master. Jan Steen, a Catholic whose lively genre paintings, filled with light and color, depicted chaotic and even lustful moments in family life (so much so that messy and unordered Dutch households began to be called Jan Steen households, *een huishuden van Jan Steen*), was on the scene from 1654 to 1656. And Pieter de Hooch, sometimes spelled Hoogh, who had worked in Haarlem as an assistant to a linen merchant, moved to Delft, married a local woman named Jannetge van der Burch, or Berch (who may have been a relative of Leeuwenhoek's mother, Grietge van der Berch), and began painting his decorous interiors featuring merry figures, often viewed through doors and corridors.* De Hooch remained in Delft until moving to Amsterdam in 1661; he died in Amsterdam's *dolhuis*, or madhouse, though when exactly he died, and why he became mad, no one knows. Delft also hosted a brief flourishing of architectural

---

* Jannetge was the daughter of the candlemaker Rochers van der Burch and the sister or stepsister of the painter Hendrick van der Burch. In 1650 there were six residents of Delft with the painter's name, at least one of whom does seem to have been related to Leeuwenhoek's mother.

painting—especially by Hendrik van Vilet, Gerard Houckgeest, and Emanuel de Witte—spurred on by the vogue among patriotic buyers for views of the city's New Church, and its mausoleum of William the Silent, father of the United Netherlands.

When he joined this thriving art scene, Vermeer was newly married. Babies began arriving almost immediately—his daughter Maria was born in 1654. If the young man featured in Vermeer's painting *The Procuress* is a self-portrait, as many believe, then Vermeer was a jolly-looking man with long, curly dark hair (probably a wig, as the style dictated), a pale face, a wide nose, and a large grin. Vermeer and his wife, Catharina, may have been renting rooms for a short time, probably on the Market Square; by the time they buried a child, in December 1660, the couple are listed in the city's records as residing in the Oude Langendijck, where they lived with Catharina's mother. Once they began to have a family, Vermeer and his wife would have needed the space that could be provided by sharing the large house owned by Maria Thins.

Vermeer's father, Reynier, had died in 1652. His widow was left with Mechelen, and with its remaining mortgage. When Vermeer returned to Delft after his apprenticeship, he must have helped his mother run the inn. It was a great deal of work for an older woman left alone (by the time of the Delft explosion his mother would have been around sixty). Food, beer, and spirits needed to be ordered, a serving girl, barmaid, and cook hired, the daily cleaning and weekly accounts done. Vermeer also inherited the art-dealing business of his father, and for the rest of his life a good part of Vermeer's income would come from selling the works of other painters. Perhaps Vermeer inherited something else from his father: a convex lens, left over from Reynier's days as a cloth merchant.

Once he was established in the Delft artists' guild, Vermeer commenced painting works that he could sign with his own name and sell. He began with large-scale works based on biblical or mythological traditions. His first-known paintings are *Christ in the House of Mary and Martha* and *Diana and Her Companions*. Two other early history paintings, *Jupiter, Venus, and Mercury* and *Visit to the Tomb*, are known to have existed at one point but have not survived. The

latter was listed and attributed to Vermeer in the 1657 inventory of the estate of an Amsterdam art dealer.

In his *Diana and Her Companions*, Vermeer depicted the goddess gathered with four of her attendants at the edge of a forest. The scene is more chaste in Vermeer's painting than in its portrayal by other artists, who tended to envision it as a kind of female bacchanal, with Diana and her nymphs cavorting nakedly in the woods. Here, Diana and her companions are fully clothed. Diana wears a golden dress cinched at the waist with an animal skin. She perches on a boulder while one of her nymphs bends down to bathe her left foot, which is held out slightly. The subject, its innocent depiction, and some aspects of the arrangement of figures are similar to Van Loo's *Diana and Her Nymphs*, from around 1650, and this is one reason that some experts think Vermeer studied with Van Loo in Amsterdam. Yet Vermeer's painting is quite reminiscent of Rembrandt's *Bathsheba at Her Bath* (ca. 1654). In Rembrandt's picture the main figure is nude, facing toward the viewer's left, and has only one attendant, while in Vermeer's *Diana* the goddess is clothed, is facing the viewer's right, and is surrounded by her four nymphs. But in both pictures, the central figure is turned to one side, holding out her foot for another to wash it. There is a similar use of brushwork, especially in the thickly laid-on layers of paint, known as impastos, and the visible brushstrokes that follow the contours of the folds of flesh. And there is something about the fleshiness of the bodies of two women, contrasted with their quiet, reflective countenances, and the way the light is centered on them against darkened backgrounds, that suggests a connection between the two paintings. Diana's mood and her pose, as well as that of her kneeling attendant, so resemble Rembrandt's *Bathsheba* in content and feeling that it seems likely Vermeer knew this work firsthand—another reason to think he studied in Amsterdam. If Vermeer did serve his apprenticeship in Amsterdam, he could have seen the *Bathsheba* itself, while Rembrandt was still working on it. Indeed, the similarities between Vermeer's *Diana* and Rembrandt's *Bathsheba* could almost convince one that Vermeer *must* have been in Amsterdam to see the *Bathsheba* at some point before painting his *Diana*.

Another very early work, *Christ in the House of Mary and Martha*

(ca. 1654–55), is based on a text from the New Testament. Both Luke and John describe Mary and Martha as friends of Jesus. Luke's story about the two sisters, though brief, has been debated for centuries, because of the different ways it is interpreted by Catholics and Protestants. According to the story, Christ arrives in Bethany, a town not far from Jerusalem beyond the Mount of Olives. Martha welcomes him into her home. Her sister Mary sits at Christ's feet and listens to his teachings, leaving Martha to take care of all the household tasks. Martha comes to Christ and asks, "Lord, do you not care that my sister has left me to do all the work by myself? Tell her then to help me." But Christ answers her, "Martha, Martha, you are worried and distracted by many things; there is need of only one thing. Mary has chosen the better part, which will not be taken away from her" (Luke 10:38–42). In the Dutch Republic of Vermeer's day, the story was seen as drawing a contrast between Catholics and Protestants: the latter sought salvation in action, like Martha's work, while the former placed greater value on the contemplative life, like Mary's study at Christ's feet.

Vermeer's choice of subject may have been motivated by his recent conversion to Catholicism, or the picture may have been a commission from a local collector. The seated Christ is the focus of the scene; Mary sits at his feet gazing up at him, her head resting on her fist, and Martha stands over both of them, bowing down to speak to Christ, holding a basket of freshly baked bread in her hands. Most art historians believe that Vermeer's composition was influenced by a painting of the same scene by Erasmus Quellinus—one of Rubens's most successful followers—from 1645, which is one reason why it is thought that Vermeer may have studied with him during the short period Quellinus was in Amsterdam. However, a number of Dutch painters of the day depicted this moment—including, notably, Jan Miense Molenaer of Haarlem, whose more earthy version captures the aggrieved Martha still holding by its legs a goose she has just killed for dinner when she complains to Christ (1635). Vermeer's composition is similar to Molenaer's (minus the goose) except that Vermeer closes in on the figures so that they fill up most of the canvas in a more classical way.

In his next painting, Vermeer radically shifted his subject matter away from the historical and religious. Painters at the time generally specialized; the unprecedented numbers of buyers for art in the seventeenth century created a market for variety, so painters would focus on one type of picture: religious or historical scenes, still lifes, landscapes, portraits, or other kinds. Vermeer's next picture was one of these types: it was a so-called *bordeeltje*, or brothel scene, like those that popular Dutch painters were selling to wealthy merchants around the country. In Delft, Christiaen van Couwenbergh—who was also Delft's leading history painter—had been profiting from such pictures for decades already. Gerrit van Honthorst and Dirck van Baburen in Haarlem did numerous brothel scenes in the 1620s, intended less to titillate than to dramatize the dangers of the seductive prostitute and venal brothel keeper. *The Procuress* is the only picture before 1658 that was dated by Vermeer himself, so we know it was painted in 1656, when he was twenty-four years old. He may have been inspired to paint it by the presence in Maria Thins's house of Van Baburen's *Procuress*, which Vermeer later included in the composition of two of his works, *The Concert* and *Young Woman Seated at a Virginal*. He may, too, have wanted to try his hand at a more "marketable" painting.

Like many of these *bordeeltjes*, Vermeer's painting depicted the moment at which a prostitute is accepting money from a client; as was often the case, the brothel keeper—generally depicted as an avaricious elderly woman—is shown hovering about, keeping an eye on the transaction (the brothel "madams" were usually retired prostitutes who had saved their earnings and entered into the more profitable part of the trade when their looks faded). In his composition, Vermeer includes another onlooker, a man (who is thought to be a self-portrait) genially eyeing the viewer as if to confirm that he or she is taking note of what is happening. What stands out is Vermeer's sensitive rendering of the prostitute, who looks sweet and contemplative, and is dressed as a proper young married woman would be; only her heightened redness suggest an overly zealous use of rouge and the effects of too much wine. A number of the Dutch genre painters played with ambiguity in depicting young women, enticing viewers

to try to guess whether a subject was innocent or carnal. This ambiguity can also be seen, for example, in Ter Borch's *Soldier Offering a Young Woman Coins* (1662–63).

Although Vermeer's *Procuress* is one of his earlier efforts, the young painter's interest in experimentation and his knowledge of the scientific principles of painting are already on display. We see him experimenting with unusual paints, in particular for the lush oriental carpet covering the balustrade in front of the prostitute and her procuress. The blue parts of the carpets are now a dull, grayish color. Chemical analysis has shown that Vermeer used a rare pigment, a mineral iron phosphate, most likely vivianite, which is known to darken under the influence of light. Those grayish areas of the carpet would originally have been a clear, bright blue. Vivianite was used only infrequently by painters of the day, and Vermeer's choice to try it illustrates his willingness to experiment with unusual colors. Vermeer had also begun to engage in other kinds of experiments— namely, optical experiments.

-3-

*The Procuress* demonstrates Vermeer's early attempts—partly successful, partly not—to deploy the perspective theory he would have studied during his apprenticeship. Perspective is a method for approximating on paper an image seen by the eye. In this way, perspective is related to optics, the science of light, which explains how objects are seen by the eye in the first place. Indeed, in Medieval Latin texts, the term *perspectiva* was used to denote the science of optics. It is a common misperception that no artists depicted perspective prior to the fifteenth century; artists before, such as Giotto, had developed their own empirical strategies for evoking space and depicting solid forms by around 1325, including the use of light and dark parts to mimic the way three-dimensional objects are illuminated by a light source, known as chiaroscuro. But the first systematic attempts to explain perspective theory, and the first explicit efforts to exemplify it in painting, did arise during that period. That perspective theory

was born in the fifteenth century has partly to do with the status and content of theories of vision at that time.

Many ancient writers believed in the "active eye"—they thought the eye sees by sending rays out from within itself to the object being viewed. The eye, as the ancient Greek philosopher Theophrastus wrote, sends out its "fire within." Plato had a more complex idea of seeing, in which the eye sends out rays from its inner fire, which meet and coalesce with the rays coming from the sun, forming "a single homogenous body in a direct line with the eyes . . . and thus causes the sensation we call seeing." Later, Aristotle rejected the notion that there is an emanation from the eyes, arguing instead that the eye receives rays from an object or the air. Constantijn Huygens contrasted the two competing views of vision in verse:

> *Here our eyes are [seen as] bows,*
> *And shoot out rays: there it's [deemed] a gross lie,*
> *There it's naught but mirror glass that takes things in.*

In the third century BCE the Greek mathematician Euclid connected theories of vision to mathematics. In his *Optica*, he defined the visual process in a purely geometrical way: rays proceed in straight lines from the eye, radiating outward to objects in the shape of a cone. This cone, with its apex at the eye and its base at the object viewed, became known in the eleventh century as "the pyramid of vision." In this way, optical problems of how we see the size and position of objects were transformed into geometrical problems. For example, a visible object's size is determined by the angular separation between the visual rays that encounter its extremes; large objects subtend large angles of vision, small objects subtend small angles. A visible object's position in space is determined by the location within the visual cone of the rays by which it is perceived; Euclid noted that rays from the eyes to the right see objects on the right, and rays to the left see objects to the left. Although Euclid accepted the so-called extramission theory, believing that sight is achieved by the process of rays sent by the eye to the seen object, his main concern was with the geometrical relations, which could be used, he believed, to explain

various visual phenomena. He completely ignored questions about vision that could not be determined geometrically, questions such as how the eye perceives color or the relation between touch and vision.

In the second century CE the Roman physician-philosopher Galen extensively studied the eye as a physical organ. Benefiting from the work of the Alexandrian anatomists who performed dissections, Galen described many fundamental features of the anatomy of the eye, including the retina, cornea, iris, uvea, tear ducts, and eyelids. He postulated that the most important organ of sight is the crystalline humor, a lentil-shaped organ at the center of the eye. Visual impressions received on the surface of this organ were transferred to the brain through hollow optic nerves by an optical pneuma, or "visual spirit." Galen adopted a bidirectional sequence of extramission-intromission (from the eye and to the eye): rays issue from the eyes to somehow transform the "medium" between the eye and the object seen, and this medium, the air, returns visual impressions to the eye.

During the medieval period Islamic medical writers and natural philosophers wrote scores of books on vision. Most of these Islamic writers accepted either Galen's bidirectional approach or a straightforward extramission theory of vision. One exception to this was the early eleventh-century writer Abu Ali al-Hasan ibn al-Haytham (known in the West as Alhazen). Alhazen's was the first fully integrated theory of vision, bringing together anatomical studies of the eye, like the ones Galen used, and mathematical approaches to sight, like Euclid's. Alhazen used insights from both areas to make the first strong case for an intromission theory of vision. Each point of an illuminated object emits rays of light; these travel in straight lines to the eye. The surface of the crystalline humor receives each of these rays of light separately; there is a point-to-point correspondence between the object and the image as it appears on the surface of the organ of sight.

Alhazen insightfully proposed that vision was a type of pain sensation; he noted that, because strong light hurts the eye, it made more sense to assume that light enters the eye during vision than otherwise. He also claimed that only perpendicular rays traveling from

the object to the eye are responsible for sight. By such rays, the form of light and color is transmitted to the eye from the visible object; this form endows the "glacial humor" (that is, the organ of sight at the center of the eye) with the qualities of the object, including its color. Vision is transmitted not by particles or corpuscles flying from the object into the eye, as others had argued, but by a "quality" of bodies that can be propagated in straight lines through a transparent medium, the air, to produce visual sensation. This quality is then transmitted to the brain through the optic nerve in order to be interpreted as a visual perception. Alhazen's comprehensive view of vision would go on to be enormously influential, providing the basic conceptual framework of Kepler's theory of vision in the seventeenth century. It also supplied the basis for the science of perspective that first arose in the fifteenth century.

Alhazen believed that rays issue in every direction from every point of a visible object and reach all points on the surface of the eye. Another way of putting this, from the viewpoint of the observer, is that "each point on the surface of the eye is the point of a pyramid of radiation emanating from the visible object." There is, in this way, a "visual pyramid" whose base is a series of points on the visible object and whose apex is at the center of the "glacial humor."

This notion of the "pyramid of vision" made possible the one-point perspective system, devised by the Florentine painter and architect Filippo Brunelleschi around 1413. According to his disciple Antonio Manetti, Brunelleschi's theory of perspective "consists of setting down properly and rationally the reductions and enlargements of near and distant objects as perceived by the eye of man: buildings, plains, mountains, places of every sort and location, with figures and objects in correct proportion to the distance in which they are shown."

Brunelleschi had famously painted a panel depicting the baptistry in the Piazza del Duomo in Florence; it was perforated with a small peephole in the center. The viewer was instructed to point the painting at a mirror held at arm's length, and view it through the peephole to see the picture reflected in the mirror. This forced the viewer to observe the painting from the single point corresponding to that

viewpoint from which it had been painted. Viewed this way, the painting appeared so true to life that, as Manetti put it, "the spectator felt he saw the actual scene" and not just a painting of it.

Brunelleschi's system was translated into a practical system and set down in a formal treatise by his friend Leon Battista Alberti, in his book *Della pittura* (*On Painting*), first published in 1435. Alberti refused to take a position on whether the intromission or the extramission system was correct, but he used the notion of a visual pyramid and the straight-line radiation of sight to explain how the artist can truly imitate nature. Thinking, perhaps, of Brunelleschi's neat trick with the baptistry panel, Alberti explained that a painting is to be imagined as a flat piece of glass, or an open window, intercepting the visual pyramid extending from the artist's eye to his subject. The vanishing point—at which all sight lines in the painting converge—marks the point at which the central ray of the pyramid of vision intersects that flat plane.

More technically, one-point perspective exists when the picture plane is parallel to two axes of a rectilinear scene—a scene composed entirely of linear elements that intersect only at right angles. If one axis is parallel to the picture plane, then all elements are either parallel to the picture plane (either horizontally or vertically) or perpendicular to it. All elements that are parallel to the picture plane are drawn as parallel lines. All elements that are perpendicular to the picture plane converge at the vanishing point.

The introduction of perspective theory dramatically changed the way paintings were perceived. Previously, a painting was thought of as an opaque two-dimensional surface covered with lines and colors meant to be seen as symbols of three-dimensional objects. After the enunciation of the principles of perspective, a painting was to be considered, in Alberti's words, as a "window through which we look out onto a section of the visible world."

This innovation was possible in the fifteenth century partly because of the development of optics and theories of visions that had occurred from the time of Euclid to the medieval period. But there is another reason as well for the appearance of a formal theory of perspective at this time, one that can be understood in the

context of ongoing debates about the value of painting as one of the "liberal arts." Centuries earlier, Plato had disparaged painting for not being based on any mathematical knowledge, but being instead dependent upon the senses, and thus subject to the imperfections and contingencies of the physical world. Renaissance theorists wanting to elevate painting to what they viewed as its proper place among the liberal arts had two choices: either show that painting was based on mathematical principles and was therefore as "scientific" as arithmetic, geometry, astronomy, and music (as it was thought at the time), or prove that the visual arts were as worthy as the practical literary arts of grammar, dialectic, and rhetoric. By devising laws of perspective on a geometrical basis, art theorists such as Alberti sought to justify the scientific validity of painting. (Ironically, given this scientific motivation for developing the geometrical principles of perspective, the topic was, for a time, regarded as a kind of natural magic, a "visual alchemy" that could transform the base methods of painting into a kind of visionary gold. It was regarded this way by the German painter and inventor Albrecht Dürer, who told a correspondent, "I shall ride to Bologna, where someone is willing to teach me the *secrets* of perspective.") Once painting was thus elevated to the status of the liberal arts, artists could commence arguing about whether painting or sculpture was the superior art. Galileo weighed in on this controversy, agreeing with an earlier writer who had praised painters for representing the world in two dimensions when God himself had needed three to produce it.

-*4*-

Two characteristic elements are seen in paintings deploying perspective. First, objects are smaller as their distance to the viewing increases—so objects that are farther away from the viewer will be smaller, objects closer will be larger. Second, objects are "foreshortened"—the size of an object's dimensions are shorter *along* the line of sight relative to its dimensions *across* the line of sight. Foreshortening mimics the distorted appearance of a form when it is not perpendic-

ular to the line of sight; for instance, a hand held out directly toward the viewer will look shorter, and larger, than a hand hanging straight down by a figure's side.

Both of these elements help artists depict depth on a two-dimensional canvas. In both cases, the use of perspective requires the artist to paint what the eye actually sees, not what we expect to see. We know that two people are the same size, even if one is farther away, and that two hands are the same size, even if one is held out toward the viewer and the other is hanging down at the figure's side. Prior to the development of perspective theory, artists would tend to paint figures the way we know them to be. But what we see is something different—that the person farther away looks smaller and that the hand held out toward the viewer looks larger. The painter now had to try to depict figures this way.

Vermeer's most evocative use of foreshortening in his entire oeuvre is visible in *The Procuress*. We see the prostitute's hand open, palm up, to receive the gold coin her client is about to toss into it. Her four fingers are, as one writer has put it, "so intensely foreshortened that only the genius of Vermeer makes her gesture appear so absolutely natural." The thumb of her client's hand holding the gold coin is so foreshortened as to become almost invisible, "and yet we almost sense its built-up energy ready to cause the coins to fall." This mastery of one aspect of perspective is in contrast to what we find in Vermeer's earlier picture *Diana and Her Companions*, in which it appears that the golden plate at Diana's feet has been placed on an incline and is about to slip from the frame of the picture. Although the use of foreshortening in *The Procuress* is adroit, the figures still appear to exist in a split space, with the group of three figures existing in a separate plane from that of the laughing man. Vermeer would continue to struggle with the problem of representing a logically consistent space in his paintings, a problem that he would seem to solve only after 1657.

How did Vermeer achieve the remarkable effect of the foreshortened thumb? He most likely used a mirror. Painters had been using mirrors to help them portray foreshortening from the time that Alberti published *On Painting* in the fifteenth century. The Floren-

tine sculptor and architect Antonio di Pietro Averlino, known as Filarete, had advised painters in the 1460s,

> If you should desire to portray something in an easier way, take a mirror and hold it in front of the thing you want to do. Look in it and you will see the outlines of the thing more easily. Whatever is closer or farther will appear foreshortened to you.

Filarete was describing a characteristic of mirrors of the time. In an imperfect mirror—like the flat glass mirrors that had just begun to be available in Venice—the reflection of an object will appear flattened because of how the light reflects off the surface and slightly merges before reaching the two eyes of the observer. Because of this effect, in the mirror image the artist could see more clearly how to depict the object onto his or her flat canvas in order to correctly represent the perspective and foreshortening of that object from the frontal viewpoint.*

Leonardo da Vinci pointed to two additional reasons for painters to use mirrors. By looking at a mirror image of the subject, a painter is forced to attend to aspects of his visual perception that he would otherwise not typically notice. Within a mirror's frame (for they were mostly framed in those days), the scene is brought to the viewer's focused attention. Like the tube Aristotle suggested for seeing "farther," and the lensless telescope used by Tycho Brahe, a mirror could be used to concentrate attention on a small scene by blocking out what is around it. When we look at a scene directly, for example, we do not notice that it appears in perspective, that is, with the lines converging to a point in the horizon. But when we view that same scene in a mirror we tend to notice its perspective more. This is partly because of the mirror's flattening effect, but also because the use of an optical device disrupts our visual habits and forces us to look at the scene in a new way. "Since you can see that the mirror," Leonardo explained,

---

* Even with today's more perfect mirrors, artists continue to use them to learn more about their subjects, by seeing them in new ways: reversed, inverted, and from different angles.

"by means of outlines, shadow, and lights, makes objects appear in relief, you, who have in your colours far stronger lights and shades than those in a mirror, can certainly . . . make your picture look like a natural scene reflected in a large mirror." The mirror cast nature into a new light for artists, by showing nature reversed, framed, and with its visual characteristics intensified.

Leonardo also noted that by comparing a picture to a mirror image of the same subject, the artist could judge whether he had successfully painted the subject. "When you want to see if your painting corresponds throughout with the objects you have drawn from nature," he advised, "take a mirror and look in that at the reflection of the real things, and compare the reflected image with your picture." Earlier, Alberti had called the mirror the *iudex optimus*, the optimal judge, of paintings, because it intensifies the picture's properties. By the seventeenth century, a mirror was a common part of the painter's toolkit.

The supposition that Vermeer used a mirror to depict foreshortening is strengthened by the realization that the figure to the left—Vermeer himself, we think—looks like nothing so much as an imperfect mirror reflection, with its forms flattened, and its outlines slightly blurred. If Vermeer was using the common method of painting a self-portrait from a mirror reflection, it would have been a simple matter to turn the mirror to the model of the prostitute and see how the fingers of the outstretched hand were reflected there as well. He could have learned this technique from Fabritius, whose self-portrait of 1648–50 also vividly resembles a mirror reflection—in its subject, pose, and glance as well as the way light is depicted. The use of a mirror is evidence of Vermeer's increasing preoccupation with the way things actually appear to our vision, shown in this picture by his depiction of the green glass and the ceramic jug, the ribbon and feather on the customer's hat, the texture of the lace on the white scarf.

Besides the mirror, Vermeer also availed himself of another instrument in painting this picture. At the far right of the painting (in danger of being toppled over by the prostitute's left hand) is an elaborately painted white-and-blue wine jug. It is clear that Vermeer used a pair of compasses—such as those used by surveyors—in order to achieve

the incredible accuracy of the vessel's contours and decorations; the point at which the compass pierced the canvas, and the scratches made to define the contours and designs on the jug, can still be seen in the paint layers. Even at this early stage of his career, Vermeer was showing a willingness to use devices—mirrors, compasses—that could help him achieve the effects he sought.

In this willingness to deploy aids in his painting process, Vermeer was taking part in an artistic tradition of long standing. From about the time that perspective theory was devised by Brunelleschi, various instruments were contrived to help artists instantiate these geometrical principles in their paintings and drawings.

-5-

The person who had first laid out the laws of perspective, Alberti, had invented a simple device called an intersection—also known as an Alberti veil—in order to help painters depict three-dimensional objects on two-dimensional paper or canvas. The Alberti veil was a sheer piece of fabric, loosely woven of fine thread, divided by thicker threads into parallel squares, stretched on a wooden frame. The artist looking at his scene through the sheer veil could transcribe the arrangement of forms onto a drawing or painting surface that had been divided into corresponding squares. Alberti described this *velo* in his discussion of perspective in *Della pittura*: "Nothing can be found, so I think, which is more useful than that veil which among my friends I call an intersection. . . . This veil I place between the eye and the thing seen, so the visual pyramid penetrates through the thinness of the veil."

In his widely translated and distributed treatise *Instructions for Measuring* (1525), Albrecht Dürer described a version of the Alberti veil that could be stretched over a glass pane placed perpendicular to a table; the artist would sit at the table, look through the glass at the object being painted, and draw the image onto a sheet of paper before him. Numerous depictions and descriptions of the Alberti veil would later appear in works by Italian writers on perspective theory, as well

as in writings by the seventeenth-century Dutch mathematician and engineer Samuel Marolois, whose book on perspective, originally published in 1614, was probably the most widely read volume on perspective theory by a Dutch writer.

A related method was soon developed as well: by inserting a pin, with an attached string, through the canvas at the desired horizon point, the artist could use the string to show him where the orthogonals—the straight lines that meet in the vanishing point—should go. The painter could sketch the lines in chalk (which would dissolve under the oil paint) or could even chalk up the strings, pull them tight, and let go so that the chalk would be transferred onto the canvas. This method was commonly employed in the seventeenth century in Delft by the architectural painters Houckgeest and De Witte, as well as by Fabritius, Vermeer, and others. Tiny pinholes at the vantage points have been found, on x-ray analysis, in some paintings, including a number of Vermeer's canvases.

More elaborate devices were also described in books on perspective during the sixteenth and seventeenth centuries. Undoubtedly some of these were fantastical in their conception and were never built, intended more as demonstrations of the author's imaginative prowess than as useful tools for artists. Some inventions were basically mechanized versions of the Alberti veil, such as one described by the architect Jacopo Barozzi da Vignola in his *Le due regole della prospettiva pratica* (Two rules for practical perspective) of 1583. This large-scale machine used a rope-and-pulley system to move an eyepiece up and down and side to side along a vertical and horizontal ruler, so that the artist could first measure, then transcribe, an image bit by bit onto a gridded surface, perhaps with the help of an assistant to whom he would dictate instructions.

Not long after Vignola's book was published, an innovation was introduced by the painter and natural philosopher Lodovico Cigoli. Cigoli was a friend of Galileo's and such a supporter that, even before the ink had fully dried on the pages of Galileo's *Sidereus nuncius*, Cigoli had painted a ceiling in the church of Santa Maria Maggiore in Rome showing Mary standing on a pockmarked Galilean moon rather than the conventional smooth Aristotelian crescent. At the

same time that he painted the church's ceiling, Cigoli was conducting his own study of sunspots from the church's roof. His perspective machine mechanized both the viewing of a scene and the recording of it.

Using this device required some coordination and effort, however. With his left hand, the draftsman would twist a pulley clockwise or counterclockwise to make a vertical pole move left or right over a flat base covered by paper. With his right hand, he would move a pencil connected to a sighting bead. With the motion of the pencil, the bead is moved up and down the shaft of the vertical pole as the pole is moved back and forth by the twisting motion of the left hand. The sighting bead can in this way trace the outlines of the object. At the same time the pencil is recording the resulting configuration directly onto the paper.

Unlike Vignola's device, which would have been the height of a person and nearly as wide, Cigoli's was a tabletop model and fairly portable. We know that Cigoli's machine was produced in his time. One was in the collection of Louis Hesselin, a counselor to Louis XIV of France. The device was still being produced in the mid-nineteenth century. But its use seems to have been mainly as a kind of "perspectival robotics" that demonstrated how perspective drawings could copy reality, rather than a practical instrument used by working artists.

Another natural philosopher, the astronomer Christoph Scheiner, invented the "pantograph," which was designed for copying designs or maps, or for enlarging or reducing drawings. Four rods hinged together to form a parallelogram connected two pens in such a way that the movement of one pen, drawing or tracing an image, produced an identical motion in a second pen. These instruments were, essentially, copying machines. But mounted vertically, half on a canvas or paper-covered board and half on an open frame, a pantograph could be used as a device to draw an object in proper perspective. Looking at the object through the frame, the artist would hold the pen end and move it so that the stylus attached to the hinged rod would "trace" the outline of what he sees. This was difficult to do because, in effect, he would need to "predict" the path of the trac-

ing stylus as he drew. A complex version of the pantograph, using a system of pulleys and counterweights, was devised in 1669 by Christopher Wren, the English natural philosopher and architect. When Wren demonstrated his device to the Royal Society, he introduced it as an "instrument for drawing in perspective."

Artists had various instruments available to help them depict perspective properly. But at the same time, new studies of vision began to expose cracks in the edifice of classical perspective theory. And artists—especially in Delft—were paying attention to this development. Eventually, these fissures would lead Delft's artists to experiment with different kinds of devices—optical instruments—to help them achieve the effects they sought.

## -6-

Johannes Kepler, the mathematician, astronomer, and astrologer (those last two being noncontradictory in his time), had shown in his *Ad Vitellionem paralipomena* (1604) and in his *Dioptrice* (1611) that the actual character of the physiological nature of vision was not reconcilable with the geometrical assumptions about optics made by Euclid or with the anatomical claims made by Galen and his followers. Kepler, following discoveries described by the anatomist Felix Platter in his *De corporis humani structura et usu* (1583), claimed that the crystalline substance of the eye was not the seat of vision but was, rather, a lens that magnified images before they passed to the retina. Platter had shown that the crystalline humor is not connected to the optic nerve, as would be necessary on the view that it was the humor that transmitted its perceptions of an object through the nerves running to the brain. Instead, it was the retina that was connected to the optic nerve (more precisely, as we know today, the optic nerve begins in the cerebrum and culminates in the retina). Kepler also disagreed with the earlier writers on vision, who claimed that the crystalline humor had a flat posterior surface; this hypothesis was necessary in order to ensure that the rays from the visible object would not intersect at the center of the eye, which would result in an inverted visual

image—something these thinkers wished to avoid, because it seemed so counter to our experience (we do not see everything upside down). Kepler, however, fearlessly pointed out that the posterior surface of the crystalline humor is rounded—and that the image projected on the retina is, contrary to common sense, inverted.

Kepler also showed that the geometrical assumptions of the earlier theorists were flawed. On the view of the medieval writers, since every point within the eye receives rays emanating from every point in the visual field, there will be pure visual confusion unless some of these rays are ignored. (Seeing everything equally, the eye would see nothing.) This confusion was avoided by the claim that only the rays that are not refracted—that is, the perpendicular rays—are responsible for vision. Kepler pointed out the absurdity in claiming that only perpendicular rays are responsible for vision. What about rays that are only slightly oblique? While it could make sense to say that rays that are nearly perpendicular do not act on sight as strongly as perpendicular rays, it is absurd to say that the nearly perpendicular rays cannot stimulate the visual power at all. Kepler was then faced with the problem of explaining how an infinite number of rays from each point in the visual field could be drawn into a coherent, point-to-point correspondence in the eye. Against the medieval tradition, Kepler argued that the crystalline lens refocused intromitted rays upon the retina, where vision was thus made possible. Significantly, Kepler called this retinal image a *pictura*. In this way he drew a distinction between visual pictures (projected onto the retina, or onto walls or screens) and visual images (produced *by* the mind, and *in* the mind, out of the information received through the nerves from the senses).

One consequence of Kepler's new theory of vision was that the single "pyramid of vision" of the medievalists, and of classical perspective theory, was split into numerous cones or pyramids being refracted onto the retina from various points of the visual field; he used the term *pencilli*, or "pencils," for these rays—a word that was used by artists of the time to refer to their brushes. It became unclear how the actual way we see could be made consistent with

how the classical theories of perspective said artists should depict what we see. No perspective theorist of the time really attempted to come to grips with Kepler's optical theory. Indeed, even several years after Kepler published his new theory of vision, the Dutch theorist Samuel Marolois explicitly *abandoned* efforts to accommodate perspective theory to the up-to-date optics, reverting to older optical theories in his perspective treatise of 1614. Marolois emphasized that understanding the nature of vision was irrelevant to his concerns, and he exhorted artists to follow established laws of perspective—and explicitly told them they should *not* paint according to their visual impressions. However, this clashed with the sensibility of mid-seventeenth-century Dutch painters, who were resolved to record exactly these visual impressions. A kind of uneasy uncertainty about the relation between vision and perspective theory led Dutch painters of the time to feel that they were free to experiment with perspective rules.

-7-

This more casual attitude toward perspective theory is indicated by the topic's relegation to only a few pages in Van Hoogstraten's *Inleyding tot de hooge schoole der schilderkonst* (Introduction to the academy of painting), whereas a full third of Alberti's book on painting is devoted to perspective. This was not only because for Alberti perspective was a new and exciting discovery, while by Van Hoogstraten's day it was mundane, but also because for Van Hoogstraten and his compatriots perspective was merely one tool of many in the artist's toolkit, and far from the most important tool at that. In 1678 Van Hoogstraten could still say that it is the eye, not the object, that emits visual rays, signaling his casual attitude about vision and how it relates to perspective. Van Hoogstraten had studied with Rembrandt, and his paintings show that he was, like his master, skilled in perspective; like Rembrandt's, however, Van Hoogstraten's sense of space was intuitive, not depending on the rational, geometric laws

governing perspective theory. That may be another reason he was willing to dispense with classical perspective theory in his treatise for painters.

This willingness to stray from classical perspective theory was especially true of the Delft school of painters starting from around 1650. Vermeer's neighbors and colleagues Fabritius (who was a friend of Van Hoogstraten's), Gerard Houckgeest, and Pieter de Hooch, along with Vermeer himself, began to explore new possibilities of spatial representation. Like the natural philosophers–inventors of the Dutch Republic, Dutch artists were eminently practical, more than theoretical. Rather than thinking of their representations of space in an idealized, geometrical way, they began to depict more realistically. They realized that an accurate sense of light and air is necessary for creating a convincing three-dimensional space. Accordingly, their interests became more purely optical than geometrical, and their paintings more concerned with the play of light and color than with the strict portrayal of proper perspective as a way of representing three-dimensional forms on a flat surface. Most artists would know, of course, that the "orthogonals," or sight lines, needed to converge to a point on the horizon, but not necessarily the more technical details that so engaged the Italian painters. (There were exceptions to this: Pieter Saenredam, whose masterful architectural paintings of churches have a lively infusion of light, did leave a number of perspective drawings showing the extent to which he worked out geometrical perspective before beginning to paint; but besides these, few perspective drawings by the Dutch artists from this period have been found.)

In order to explore optical effects and depict them on canvas, Dutch artists began using optical devices. Concave lenses and convex mirrors were discussed as possible aids to painters, especially for depicting perspective, as early as the sixteenth century. We have already seen prescriptions by Leonardo da Vinci and Filarete for the use of mirrors by painters. A manuscript at the British Library on the construction of mirrors and lenses "necessary for perspective" by William Bourne dates from the mid-sixteenth century. Della Porta described a role for the concave lens in painting in his *Magia naturalis* (1589): "With the concave lens placed up, it draws into a very small

circumference objects which are in a very large plane. The painter who looks at such things [through the lens] with a small amount of effort and skill, paints all things accurately in proportion." The benefit of using either a convex mirror or a concave lens is that it reduces the size of a large building or wide landscape to a small scale easily transferable to canvas or panel; in doing so, the optical aid heightens the intensity of color. Disadvantages include the curved and distorted edges of wide-angle images, and the reversed images created by a mirror, but such problems can be corrected by the painter. There is evidence that convex mirrors were part of artists' workshops and studios going back to the late fifteenth and sixteenth centuries. How widely they were used by artists during this period is in dispute.

In recent years the artist David Hockney and the physicist Charles Falco have argued that artists going back to 1430 were extensively using mirrors, lenses, and other optical instruments. They claim that painters such as Van Eyck *must* have used optical devices by tracing images seen in them; otherwise, they argue, it would be impossible to account for the levels of accuracy and realism those artists attained. It is unlikely, however, that any such large-scale deployment of optical devices goes back as far as they maintain, mainly because in the fifteenth and early sixteenth centuries mirrors and lenses were not of a high enough quality to be used in the way the Hockney-Falco thesis suggests.

But by the seventeenth century it is indisputable that some painters used lenses and mirrors extensively. Pieter van Laer, a Haarlem painter known in Rome as Il Bamboccio (ca.1592–1642), owned and used a black convex mirror, later referred to as a Claude glass. This was a tinted, curved piece of glass, usually in a small leather case, which reflected the scene in harmonious, subtly gradated tones reminiscent of those found in the work of the great seventeenth-century landscape painter Claude Lorraine (although Lorraine is not thought to have used this optical tool). A painter would use a Claude glass by turning his back to the scene and viewing its reflection in the glass. The painter could then consult that glass while painting, capturing the gradations of light and tone in his picture by the judicious application of paint. Velázquez, whose pictures—such as *Las Meninas* and

*Venus at Her Mirror*—feature reflections prominently, was known to have used both mirrors and lenses extensively when he painted, so much so that it is said that by 1625 he began to "look at the world like a lens sees it" and could paint a lenslike spectacle without even using one. An inventory taken after his death in 1660 noted, in addition to "a little bronze instrument for producing lines" and two compasses, "a thick round glass placed in a box"—possibly a camera obscura.

Gerrit Dou, one of Rembrandt's most accomplished students, used magnifying or concave lenses to achieve the incredible fineness and detail of his paintings—Houbraken would later criticize Dou for relying on such lenses too much. Dou placed a concave lens in the center of a screen between him and the object to be painted, using the device as a compositional aid as well as a means to explore the heightened colors and the perspective of objects within their environments. With this device Dou was so aware of every minuscule detail before him that he would sit at his easel and wait for the dust to settle before he began painting. This technique would account for the "preciousness" of his interiors, with the intensity of color and the intrinsic sense of belonging that the forms seem to have to their environments, as well as the disproportionately large foreground objects in a number of his works.

Jan van der Heyden and Fabritius are also thought to have used concave lenses in order to achieve the wide field of vision of their cityscapes. Fabritius almost certainly used a double-concave lens (a lens concave on both sides) in painting his *View in Delft*, and for this reason it is considered one of Fabritius's "experiments" in perspective and optics. The use of such a lens is almost required in order to explain the distortions that appear at the edges of this work. Houbraken praised Van der Heyden for his ability to paint "every stone in the building," both in the foreground and in the distance, and noted that "one believes that he has invented a special instrument, because to everyone who knows the brush it seems impossible to achieve this [effect] in the usual way of painting."

Van der Heyden's painting *The Dam in Amsterdam* was set up as a kind of peep show, by the attachment of an iron eyepiece to the frame through which the viewer was instructed to observe the painting from the ideal vantage point; from other angles, the cupola on the

City Hall looks distorted. Van der Heyden had trained with a glass painter, and worked in the mirror store of his older brother Goris, so he would have been well acquainted with glass lenses and mirrors. He was also interested in optics, including its practical applications: in 1670, Van der Heyden was appointed the director of street lighting, and under his guidance Amsterdam became one of the earliest cities to install streetlights.

It was in this experimental milieu that Vermeer began his own explorations of painting, perspective, optics, and optical instruments —first mirrors, and now lenses.

-8-

Vermeer abandoned the brothel-scene subject almost as soon as he had taken it up. As he became more enmeshed in the artists' community in Delft, he would have seen that most of the successful— the most financially solvent—painters of the day were creating and selling "genre pictures," that is, scenes of everyday life, depicting moments captured at the market, in taverns and homes, as well as on the street. Often such genre scenes employed witty metaphors, sometimes to illustrate well-known proverbs.

Frans Hals, then working in Haarlem, was a master of this type of painting. Like Vermeer a son of a cloth merchant, Hals was painting scenes of dissolution in drinking establishments, such as that depicted in *Young Man and Woman in an Inn*, in which the viewer seems to have just thrown open the door in time to see a happy couple about to fall over the threshold, and *Merrymakers at Shrovetide*, in which a riotous scene of Carnival revelers is revealed to be a witty—and obscene—commentary on the amorous potential of the featured old man. Many of these genre paintings played around with the obscuring of moral boundaries, using intentional ambiguity: is it a home or a brothel? Is this a scene of innocent love or of prostitution? Sexual symbols abound: opened oysters, wet and pink, wine glasses offered to the viewer, liquids pouring out of gaping jugs.

Another talented painter of genre scenes in Haarlem in the 1630s

was Judith Leyster, one of the few women members of the artists' guilds. Leyster painted some outstanding pictures—including a wonderfully frank self-portrait, now at the National Gallery in Washington—before her marriage to Jan Miense Molenaer, another artist, and the birth of five children led her to give up her own work. Her husband would later depict a woman beating her husband with a hairbrush to symbolize the "Sense of Touch," which (one hopes) was a good-natured commentary on their marriage. Several of Leyster's works were later incorrectly attributed to Hals, who is sometimes thought to have been her teacher because of similarities in style, in particular the way they both place the figures in a shallow space, without conveying any sense of depth. (At one point, Leyster sued Hals for "stealing" one of her apprentices, a main source of income for artists.) Unlike Hals, Leyster often depicted quiet, intimate scenes of women at home. Some of her paintings evoke Vermeer's domestic canvases; in her *Young Woman with a Lute*, for instance, the woman is bathed in a radiant light; her presence—almost glowing against the dark background—arouses both a sense of intimate stillness and a sense of mystery.

By the time Vermeer began his career, many other artists were painting domestic scenes. Gerard ter Borch—with whom, we have seen, Vermeer was acquainted—had become quite renowned for such pictures. His paintings depicting domestic activities are prized for his skillful rendition of textures. Ter Borch's interiors tend to be dark, and, while Vermeer would soon begin to bathe his private spaces in a radiant light, his first domestic interior, *A Maid Asleep*, shares the darker aspect of Ter Borch's pictures, especially on the left side of the painting, where the maid sits. Later paintings by Vermeer would feature a subject also favored by Ter Borch, the solitary woman reading or writing a letter—one of which, *Mistress and Maid*, has a dark background. Dou, Van Mieris, and Gabriel Metsu were also painting exquisite pictures that could have been a point of departure for Vermeer. Closer to home, Pieter de Hooch was the leading genre painter of this period, in whose quiet domestic spaces only a few figures fit comfortably—quite unlike the raucous and crowded genre paintings of Hals. De Hooch was a master of using perspective to create an interior or courtyard scene infused with light.

Although no documents link Vermeer and De Hooch, it is highly probable that the two artists were in close contact during this period, since they were both living in Delft, and since the subject matter and style of their paintings during those years were very similar. This becomes most obvious, of course, with Vermeer's *The Little Street* (ca. 1657–58): like De Hooch's courtyard scenes, it portrays a world of domestic tranquility, where women and children go about their daily lives within the reassuring setting of their courtyards. But we see this similarity of subject and style as well in the quiet domestic scenes of the two men. De Hooch and Vermeer both began to refine a type of picture already known, but infusing it with more realistic qualities of light and atmosphere. In their works, visual experience was being incorporated into existing patterns of painting.

-*9*-

Besides the milieu in which Vermeer was working, there were also practical reasons for his shift in subject and style. The ability to sell his paintings at a good price began to matter to Vermeer more and more, as his family grew in size, numbering eventually eleven living children. Although his mother-in-law, Maria Thins, helped support this growing brood, it could not have escaped Vermeer's notice that she would be happier if he were bringing in more money.

Vermeer's move to more domestic interiors in the mid-1650s may also have been influenced by a new development in his career: the presence in his life of a patron. Pieter van Ruijven was one of Delft's wealthiest citizens, who had made shrewd investments with his inheritance from his family's brewing business. Van Ruijven was a distant cousin of Pieter Jansz. van Ruijven, the history and portrait painter. He is thought to have been Vermeer's patron because in 1696 twenty-one of Vermeer's thirty-four known paintings were listed in the estate sale of Van Ruijven's son-in-law Jacob Dissius, the owner of a printing press on the Market Square; most likely Dissius had inherited them from his father-in-law. Van Ruijven may have kept Vermeer on a kind of retainer, paying him in advance for paintings or the right of first refusal on paintings. This would have been sim-

ilar to the arrangement Gerrit Dou had with Pieter Spiering, who paid the painter 500 guilders a year for the right of first refusal on all his new works and for the guarantee of one painting a year. Spiering and Van Ruijven were related by marriage, so they knew each other, and could have discussed their strategies in collecting art. In 1657 Van Ruijven lent Vermeer 200 guilders at an extremely low interest rate for the time, 4.5 percent; perhaps it was a partial advance on a group of future paintings. (He did eventually own five works from the late 1650s.) In another indication of the closeness of relationship between the two men, Van Ruijven and his wife included Vermeer in their will, signed in 1665, leaving him a bequest (should he outlive both of them) of 500 guilders. Vermeer did not outlive the couple. But Van Ruijven's association with Vermeer lasted until the end of the painter's life; among the paintings his son-in-law inherited from him was one of Vermeer's final works, *Young Woman Seated at a Virginal.*

It was not uncommon for patrons and painters to consult on the subjects of pictures. Van Ruijven, admiring the domestic interiors of Dou collected by his relative Spiering, may have requested a similar subject. Vermeer's first intimate domestic interior, known as *A Maid Asleep*, was later owned by Van Ruijven. When it was first sold at auction it was given the title "A Drunken, Sleeping Maid." This was a familiar theme in Dutch genre paintings around the middle of the seventeenth century. Maidservants were frequently depicted in the genre paintings of the day, in part because they were ubiquitous in Dutch society: around 20 percent of all Dutch households in the middle and late seventeenth century had at least one maidservant. Maids were integrated closely into the family circle; a German observer in 1694 noted that the servant girls in Holland behaved and dressed so much like their mistresses that it was hard to tell which was which. Literature of the time is full of maidservants speaking their minds; and in paintings they are shown in anything but obsequious positions: smirking in the background as their mistresses undergo various trials, frolicking and flirting with fiddlers and soldiers, eavesdropping in the shadows. Maidservants were seen as dangerous women: unmarried but young and away from their parents' protection, essen-

tial to the running of the home but ultimately untrustworthy. And this was not merely a literary and pictorial fantasy—maids were well represented in the court records of petty thieves in Amsterdam. Nevertheless, maidservants were well treated in the Netherlands; it was not acceptable even to slap them, as was common in other nations. Household manuals advised the mistress of a home to speak politely (but without intimacy) to her maids, to pay them modestly (but not stingily, and with a bonus at the end of the year if merited), and to feed them decently (but to avoid coffee and tea, which were thought to breed bad habits in working women).

Vermeer's picture fits well into the typical ambivalent view of housemaids. The maid is overly dressed up, as if she had prepared herself for a suitor, and has glued a large, black beauty mark right next to her left eye—fashion of the day run amok in her unsophisticated hands. She has been drinking, and not alone: the overturned *roemer*, or goblet, in the foreground signals a visitor. X-ray analysis reveals that Vermeer had, in fact, originally painted a man leaving the room, but later edited that figure out. The maid now dozes drunkenly, a quite serious dereliction of duty. Worse, she has left her keys in the door, almost a cardinal sin for a housemaid. It is an image of innocence on the edge of experience, perhaps on the edge of danger. It would have been an inviting picture for the male viewer—Van Ruijven, for instance—who might feel guilty about desiring the mistress of the household, but not the family's young maid.

In composing this painting, Vermeer may have used either a convex mirror or, more likely, a double-concave lens. Looking at a seated woman through such a lens, perhaps mounted in a frame like Dou's device, Vermeer would have seen spatial distortions such as those depicted in his picture. The seated girl would have been small in comparison with the objects in the foreground. Although no one is seated opposite her, the viewer imagines that a man sitting there would be disproportionately large. Through the lens, Vermeer would have seen the tabletop at a tilted angle, again because of the distortions caused by the curved shape of the edge of the lens. Indeed, having painted the tabletop in this tilted way, Vermeer found himself having trouble setting his still life convincingly on top of it; x-ray

analysis shows he repainted this bowl of fruit a number of times. As in *The Procuress*, he was forced to obscure the way the objects sat on the table with the folds of drapery and carpet. Although he had experimented with mirrors while painting *The Procuress*, this is probably the first time Vermeer used a lens in composing a picture.

Evidence suggests that he may have used a lens in this way while composing two other pictures from this period in the late 1650s: *Cavalier and Young Woman* and *The Letter Reader*. The latter shares a number of motifs with *A Maid Asleep*, in particular the carpet-covered table and the askew fruit bowl. In each of these later paintings, the scene resembles a wide-angle image seen in a concave lens, in that the subjects in the foreground are disproportionately large compared with those in the background. But in *Cavalier and Young Woman* we see the way that Vermeer modified the optical images to suit his artistic choices for the painting. The enormous bulk of the soldier, closest to us, dominates the rather small girl on the other side of the table, even more than would be expected with a wide-angle lens. Rather than compensating for the disproportion, Vermeer increased it, strengthening his final design. The man looks big, solid, and important as he sizes up his petite conquest.

In this manner Vermeer set the pattern for how he would use optical instruments throughout his career. Looking through lenses, he saw the world in a new way, one that he wanted to capture on his canvas. But he also felt free to alter the images he saw with those optical instruments, relying on his artistic instincts to make different choices when they improved the final design. In a time—and place—of burgeoning interest in optics, and excitement about the possibilities offered to the artist by lenses and mirrors, it is no surprise that a young artist trying to make his name would want to be seen as au courant with the latest technology. One cannot help but notice that Vermeer's interest in looking through lenses arose right at the very moment the same interest awakened in his neighbor Antoni Leeuwenhoek.

PART FOUR

# Learning to See

‖‖‖‖‖‖‖‖‖‖‖‖‖‖‖‖‖‖‖‖‖‖‖‖‖‖‖‖‖‖‖‖‖‖‖‖‖‖‖‖‖‖‖‖‖‖‖‖‖‖‖‖‖‖‖‖‖‖‖‖‖‖‖‖‖‖‖‖‖‖‖‖‖‖‖‖‖‖‖‖‖‖‖‖‖‖‖‖‖‖‖‖‖‖‖‖‖‖‖‖‖‖‖‖‖‖‖‖‖‖‖‖‖‖‖‖‖‖

*I*N HIS SHOP on the ground floor of his house on the Hippoly-tusbuurt, Antoni Leeuwenhoek carefully wrote out a bill for Pieter Heijnsbroeck, a builder from Rotterdam who had just purchased "4½ ells [about 4.5 meters] red kersey . . . 2½ dozen buttons and button-loops . . . 1 ell white bombazine . . . [and the same of] raw silk." He dated the bill December 19, 1659. Heijnsbroeck owed six guilders, eleven stuivers, and eight pennings.* Leeuwenhoek's wife, Barbara de Meij,† may have been present there, quickly and neatly wrapping the purchases in brown paper and handing them to the customer. Later that week, Heijnsbroeck, who has relatives in Delft, will return— the Rotterdam-to-Delft journey takes only part of an afternoon and costs a mere five stuivers for a ferry—and purchase two ells of a wide ribbon for six stuivers, which Leeuwenhoek will add onto the same bill. The builder's debt would be paid off only on June 15, 1660, as Leeuwenhoek will fastidiously record at the bottom of the receipt.

---

* The ell was a measure based on the distance from armpit to fingertips, and it differed slightly from place to place. A Delft ell was 68.2 centimeters, about 2.25 feet. 16 pennings = 1 stuiver, 20 stuivers = 1 guilder, 28 stuivers =1 florin.
† Her family name sometimes appears in the archives as de Mey.

*-1-*

Leeuwenhoek had married Barbara de Meij on July 19, 1654, soon after he returned to Delft at the end of his apprenticeship in Amsterdam. Barbara was the daughter of Elias de Meij and Maria Virlin.* Elias was a cloth weaver of Dutch origin who had been living in Norwich, England. He and his wife were in Delft by December of 1629, when Barbara was baptized—making Barbara a few years older than Antoni. It is likely that Barbara's father had been born in England. The records of the Dutch Church in London show that an Elias de Mey (as the name was known in England) was an officer of the church from 1581 until his death in 1583; this may have been Barbara's paternal grandfather. He had married a woman named Tanneken Simons in 1572 (probably this was a second marriage for him). A Deborah de Meij listed in the marriage register as "a young lady from Norwich" married in Delft in 1617; Deborah was probably the sister of Barbara's father, suggesting that some of the De Meij clan emigrated to Delft around that time.

Barbara's father and aunt, then, would have spoken English as a native language; although Barbara was born in Delft, she must have heard English spoken in the home at least some of the time. When Antoni Leeuwenhoek, a young man just starting in the cloth business, returned to Delft, the fact that he spoke English he had learned during his apprenticeship with the Scots Davidson may have helped win over Barbara and her mother (her father was dead by this time, having been buried in May of 1646). It was not unusual for a young man to marry the daughter of someone in his own profession; Barbara would have been familiar with the cloth trade from her father's activities. She may even have helped out in his shop as a girl, learning how to wrap up packages for customers and perhaps even how to write out receipts. Unlike girls in the rest of Europe, girls in the Dutch Republic had levels of literacy and writing ability that approached the levels

---

* Maria Virlin also appears in the archives as Maria Virulij.

attained by boys. When the French religious scholar J. J. Scaliger arrived in the Netherlands in 1593, he was scandalized to find that girls—even maidservants!—could read.

Around the time of their marriage, Leeuwenhoek purchased the home that he would inhabit for the rest of his life, a house called The Golden Head in the Hippolytusbuurt, a street running parallel to the Oude Delft (the main canal and thoroughfare of the town), near the Town Hall and the fish and meat markets. The house and the interest on the loan Leeuwenhoek needed in order to buy it cost him an astonishing 5,000 guilders (about $76,200 today); Leeuwenhoek had to borrow much of that amount, and agreed to pay it off with a combination of cash and goods. The young couple must have felt extremely fortunate that they were safe, and their house still standing, after the munitions explosion a few months after their marriage. Indeed, it was a particularly good time to have begun plying the cloth trade in Delft: after the devastating event, Leeuwenhoek was probably busier than ever, selling cloth to Delft citizens who had lost all their clothes in the explosion and fires that followed. This would have made the period especially lucrative for the town's clothiers— compared with other household items, such as kitchen furnishings, personal clothing was at the high end of cost per item. For example, a pewter bowl might cost a few stuivers, while a women's blouse would cost almost 1 florin (28 stuivers, or about $20), and a full dress for a special occasion could be worth up to 67 florins (roughly $1,400 today). Although clothing was expensive, even middle-class families generally owned a large number of clothing items. For families whose total household goods—including furniture, kitchenware, paintings, and the tools of the husband's trade—were inventoried at between 700 and 1,400 florins, about one-third of the value would be the family's clothes. It was not unusual, for example, for a middle-class Dutch housewife to own thirteen different bonnets.

Leeuwenhoek may also have had an additional source of business: selling veils to the members of the thriving local art scene. The artists' guildhall was not far from his house and shop, and Leeuwenhoek knew a number of artists through his stepbrothers Jan and Gerrit Molijn, who were members of the guild. Artists who used the per-

spective devices known as the Alberti veils—pieces of sheer fabric with threads running through it in a grid pattern—would need to buy the material from a clothier like Leeuwenhoek. (Unfortunately, only two receipts in Leeuwenhoek's hand remain extant, and they both record items sold to Heijnsbroeck, so we cannot verify that artists shopped at Leeuwenhoek's business.)

Leeuwenhoek was a large-framed, well-built man, who probably stood five feet five or six inches (on the tall side for men of his time in the Netherlands) and weighed 160 pounds, as he would for his entire adult life—or so he bragged to a correspondent decades later. From paintings in which he appears, we can see that he had dark eyes and a long straight nose, flared out a little at the nostrils, and wore a light brown wig, long and curled—wigs such as this had come into fashion ever since a vain and early-balding King Louis XIV in France had begun to sport one around 1655 (when he was only seventeen years old). Leeuwenhoek is shown smiling (faintly) only in one image, the last known, an engraving made of him in 1686 by Johannes Verkolje. By that time he had gained weight, and his face is fatter.

He and Barbara would go on to have five children, three boys and two girls; all died in childhood except one daughter, Maria, who—like Vermeer's daughter Maria—was named after her maternal grandmother. Maria survived to old age and took care of her father until his death at the age of ninety, in 1723. By the time Leeuwenhoek wrote out the receipt to Heijnsbroeck in 1659, his life, it seemed, had settled into a typical course: a successful cloth merchant, a responsible member of civic society, and a husband and father. There was no indication, yet, that he would soon emerge as a leading natural philosopher of the day. But around this time Leeuwenhoek, for reasons no one knows, began to experiment with making his own lenses out of glass.

-2-

This interest in lenses did not come completely out of the blue; after all, Leeuwenhoek had already mastered the use of magnifying lenses

to determine the thread counts of fabrics. Lenses were all around Leeuwenhoek, both in Amsterdam during his apprenticeship and in Delft when he returned home. Spectacles were sold not only in shops but also by salesmen in the market squares of the Dutch Republic, sometimes even by sellers going from door to door, as in Rembrandt's *The Spectacles Seller* (1623–24). In this painting, which represents "sight" in a series painted by Rembrandt to exemplify the five senses, we see a spectacles seller with a box strapped to his chest, holding it open in front of an elderly couple, the woman seemingly blind, or nearly so. There was already a fad for purchasing magnifying glasses, called flea glasses, which were used eagerly by men and women to examine the small mites crawling from their bread and cheese. The Anglo-Irish satirist Jonathan Swift would later parody this interest in mites:

> *So, Naturalists observe, a Flea*
> *Hath smaller Fleas that on him prey,*
> *And these have smaller Fleas to bit 'em,*
> *And so proceed ad infinitum.*

In 1637, after he arrived in the Dutch Republic, Descartes remarked on "these small flea glasses [*lunettes à puces*] made of a single lens, whose use is now quite common everywhere."

In the 1650s, Delft was already known for the quality of its lenses, in part because of the excellence of the glass produced by the local glassworks. (Notably, in the early 1660s Christiaan and Constantijn Huygens the younger, sons of Constantijn Huygens the elder, both obsessed with optics and renowned for their skill in making their own lenses, ordered lenses from Johan de Wyck, a Delft lens manufacturer.) Whenever Leeuwenhoek crossed the Market Square, he would have passed displays of lenses glittering in the sun like diamonds.

The fascination with lenses pervaded society. Many inhabitants of the Dutch Republic and elsewhere wished to produce their own; some became "almost fanatical in their devotion" to this undertaking, as a biographer of Descartes described his subject's good friend

Claude Mydorge. Mydorge, a mathematician, spent so much time studying optics and making lenses as well as mirrors that he completely neglected his family. Descartes himself was not only writing about optics while he was living in the Dutch Republic; he was grinding lenses and even trying to invent a lens-grinding machine. Over in England, enough people were grinding and using lenses that, even by 1658, the political thinker James Harrington could assert that Oxford scholars were "good at two things, at diminishing a Commonwealth and at Multiplying a Louse!"

Not much had changed in the method of making lenses since the sixteenth century. The new group of artisans that arose to take advantage of the desire for optical devices—instrument makers— were using the same techniques used by spectacle makers since the 1590s. Almost always, glass blanks (flat, round pieces cut from sheets of glass) made by the glass manufacturers were shaped by hand in metal forms, usually made of iron, sometimes of brass, and occasionally of a hard, nonporous wood. The metal forms, or "laps," were at first simply pounded out and shaped by hammers, but later began to be molded on lathes similar to those used by clockmakers or jewelers. The lap would have the shape of the curvature desired for the finished lens; the precision of the curve would be tested, both when the lap was first made and then periodically afterward, by pressing a gauge with the correct curvature to the lap and holding both up to the window to see whether a sliver of light showed between them (in which case the curvature of the lap needed adjusting, by further carving or pounding out or by the addition of some material). The glass blank would be shaped, or "ground," to fit the lap by the use of successively finer types of abrasive powders: tripoli, a dustlike silica; emery, a grayish black mixture of corundum and magnetite; and plain old sand, such as that used by the Dutch housewife to scour her floors. The final stage would usually involve the use of felt—a thick disk of felt would be glued to the lap, and the finest polishing agent would be applied to the lens while it rested on top of the felt. Alternatively, this combination of lap, felt, lens, and polish could be turned on a jeweler's polishing wheel, once these instruments were modified for the lens-making craft.

However, although the techniques for grinding lenses did not change over the century, and were essentially the same for anyone grinding lenses, the quality of lenses produced by various lens makers varied greatly. Starting from an excellent glass blank was essential; indeed, the main difficulty in making good lenses out of ground glass at the time was that there were many imperfections in seventeenth- and eighteenth-century glass; it tended to be colored with greenish tints and marred by tiny bubbles, spots, and streaks. The best glass was found in Holland and England, and also sometimes in Italy, while Parisian glass was considered to be terrible, filled with bubbles and even visible black particles. Slight imperfections did not greatly affect lenses used for spectacles, but for instruments such as telescopes and, especially, microscopes, they could be ruinous. Tiny particles, bubbles, spots, and streaks could confuse the observer, leading him to see structures or shapes that were not really there, but were only artifacts of the imperfections in the glass. The polishing stages could add numerous minuscule irregularities on the surface of the lens, each of which could cause disturbing refractions and reflections. As little as a single large grain of abrasive could ruin everything: if it ended up in the mix being used in one of the later phases of grinding, it could scar the surface of the glass—and then excessive polishing to fix such scratches would distort the shape of the lens. The lens maker would check his lens for flaws by holding it up to strong sunlight in such a way that light reflected off the surface; nicks or breaks in the reflection would indicate imperfections in the lens. Sometimes the lens maker would find a rippled effect as the light passed through the polished lens, a result of a lack of homogeneity in the glass he had used. In 1616 Galileo's student Giovanfrancesco Sagredo, charged with procuring lenses for Galileo's telescopes, noted that he had examined three hundred lenses made by one of the best artisans in Venice; he deemed only twenty-two of them worthy of further testing, a mere three of them passed those tests, and none was perfect.

Two other methods for making lenses were used in the seventeenth century, each with its own problems. In his *Magia naturalis* (1589) Della Porta had informed his readers, "In Germany there are made glass-balls, whose diameter is a Rhineland foot long [31.39 cen-

timeters or 1.3 feet]. The ball is marked with an emerald-stone round and so is cut into many small circles." Glass was blown into a sphere, and sections of that sphere were cut into the shape of a circle; each circle would already be curved, and would require merely finishing in the lap. (Early watch crystals were made in this way, too, but did not require as much finishing.) This method was plagued by the same problems facing the ground lenses, especially those imperfections introduced at the polishing stage.*

Another possible technique for creating microscope lenses was making glass beads, or "spherules," by drawing out a very thin thread of glass over a flame and cutting off the end when it had become a tiny bubble; sometimes the ends were just held over the flame until the glass melted into droplets, which fell onto a flat surface, where they would cool and harden. These glass beads could then be ground in the lap to form small, powerful lenses with very short focal lengths but high magnification. Although the beads suffered sooty stains from the flames and a greater susceptibility to bubbling, they magnified to such a degree that Kircher's disciple Gaspar Schott would enthuse that in the smallest visible things, the smallest invisible things could be seen. Such glass beads were used in microscopes from at least the 1640s. In 1644 Odierna described using a crystal globule not larger than a chickpea. The same year, Galileo's former student Evangelista Torricelli (who had recently invented the barometer) was reportedly making and using glass spherules as well. Soon afterward one of Torricelli's patrons, Cardinal Gian Carlo de' Medici, presented Kircher with glass globules no larger than the smallest pearls. Kircher used a small tube with one of these tiny beads at the end to examine the leg of a flea and was astonished by what he saw.

---

* It is interesting that the glass sphere hanging over the scene of Vermeer's *Allegory of the Catholic Faith* (representing heaven) and glass spheres appearing in some still-life paintings of the time (such as by Claesz and Kalf) are similar to the glass balls used for making lenses. Since such spheres were not common in homes at the time, one wonders whether the Dutch painters had seen glass-blowers preparing these balls for lens makers.

-3-

Leeuwenhoek later claimed that he was making bead lenses as early as 1659—two or three years before anyone else in the Netherlands is known to have been using them. In some ways it is not surprising that Leeuwenhoek, once he decided to make lenses, would have begun with bead lenses, since they were the simplest to make: nothing was required but very thin glass rods and a candle flame. The flames of wax candles are surprisingly hot: their temperature can reach 2,600 degrees Fahrenheit, while typical glass melts at around 1,500 degrees. However, in order to create usable bead lenses, one would need great patience, and the time to make large numbers of them, as so many would be useless for observations because they were too sooty or bubble filled. Later, the Dutch natural philosopher Jan Swammerdam would say he could make forty bead lenses in an hour, but that they varied greatly in quality. Other makers of the bead lenses said that only one in a hundred was perfect. In Leiden, Johan van Musschenbroek sold the bead lenses at the rate of forty for one guilder (about twelve dollars, roughly a day's wages for a skilled laborer in the Dutch Republic). Natural philosophers would buy them by the scoopful, test each one, and discard all but the very best.

It is unclear from whom Leeuwenhoek would have learned the technique for making bead lenses, since he did not know Latin well, according to all accounts, and the books reporting the method for producing them before 1659 were exclusively in that language. The earliest written documentation of the use of bead lenses in the Dutch language was not published until the early 1660s. Leeuwenhoek may have discovered the method for making the lenses spontaneously, while toying with a thread of glass in a candle flame, much as the natural philosopher Nicolaas Hartsoeker would later claim to have done in 1674. Or Leeuwenhoek may have learned about bead lenses from one of his compatriots. Johan Hudde, the Amsterdam mathematician (and future burgomaster) had begun making such beads by around 1660; Christiaan Huygens said Hudde's excellent bead lenses were

the size of small peas. Leeuwenhoek may also have heard of these lenses from his friend and neighbor, the Delft city anatomist Cornelis 's Gravesande. Another possible source of the method of producing bead lenses may have come to Leeuwenhoek from Constantijn Huygens the elder. Although we do not have evidence that the two men were acquainted by 1659, they may well have met through Leeuwenhoek's position as an employee of the Delft city government. Huygens was quite familiar with lens making by the 1650s; he was friendly with Descartes, and had encouraged him to publish his book on optics, the *Dioptrics* (1637)—a work that contained illustrations of two different kinds of single-lens microscopes, one of which Leeuwenhoek either adopted or independently invented. At around the same time that Leeuwenhoek probably began making his beadlenses, Hooke was developing his own method for making them in England, although he disclosed this to the world only in 1665, with the publication of his book *Micrographia*.

-*4*-

However it came to be that Leeuwenhoek started to make lenses, he would later claim to have made "hundreds and hundreds" of microscopes with them. Although he began with bead lenses, he would soon move on to the other methods for making lenses: grinding and blowing glass. Some estimates have put his production at 566 microscopes by the time of his death. Only nine specimens remain today; one of them is missing its lens, so only eight complete Leeuwenhoek microscopes remain extant—or, more accurately, are known to remain extant, because who knows how many might remain in boxes and drawers of old metal objects, thought to have no historical importance? One single-lens microscope of historical importance turned up not long ago in a Dorset garage sale!

Leeuwenhoek's microscopes shared a basic structure, being constructed of a single bead or tiny lens of glass set into a flat metal holder. These holders were rectangles about one inch wide and one and a half inches long, made of thin sheets of brass or silver that Leeu-

wenhoek said he had produced entirely by himself—he even claimed to have made the metal by melting the ore he took from the rocks. (This seems overly exacting, because metal sheets were already being manufactured in Delft at the time and could easily have been purchased by Leeuwenhoek and then cut to the size he required.) Each plate had a concavity rounded outward, which had been punched or ground out into its center. A minute hole was pricked into the center of this socket; the hole was slightly smaller on the object side than on the viewing side. The lens was fitted into the sockets, between the plates, and then clamped into place with four homemade screws. To focus on the object being observed, the lens itself was not moved; rather, the object was fastened to a specimen pin with a screw-cut thread in front of the lens. By the use of screws the user could bring the object into focus by moving the specimen pin up and down and back and forth. As Leeuwenhoek himself put it, "You then hold the microscope towards the open sky, within doors, and out of the sunshine, as though you had a telescope and were trying to look at the stars in the sky through it." The best way to make observations with the Leeuwenhoek microscopes was to put the microscope very close to the eye, and face upward to a narrow beam of sunlight coming in from the window; by adjusting the shutters, one could get this kind of beam and aim it toward the microscope. In certain cases, though, Leeuwenhoek found it best to observe by relying on the light of a candle, sometimes using a mirror to amplify its brightness.

In recent years the eight remaining Leeuwenhoek lenses have been examined closely. The examination was conducted by constructing a special microscope with which to view the lenses in situ, without removing the lenses from their metal holders—the devices are far too important as historical artifacts to risk damage by taking them apart. The tube of the testing microscope was fitted with a crossbar, to which were attached four tiny incandescent lamps. When a curved lens is viewed with the microscope, the lamps are reflected in its upper surface, and the distance between their reflections can be measured. These distances can be used to calculate the radius of curvature of the lens. By repeating the measurement on the other side of the lens, the lower surface curvature can also be calculated.

From these two figures both the thickness of the lens and its refractive index (the precise way that light travels through the lens) can be computed. The focal length of the lens can also be determined, and from the focal length the magnification of the lens can be gauged.

The analysis of the eight remaining lenses showed that the magnification ranged from 69 times, for the weakest lens, to 266 times, for the strongest. It was also determined that all the lenses, with the exception of the strongest, were ground and polished; the strongest lens was blown. (None of the eight seem to have been bead lenses.) This is known because all but the one lens exhibited a characteristic property of lenses that are ground and polished: an "orange peel texture" on the surface, meaning that when lit in a certain way, one can see shallow pits with rounded edges—a result of polishing glass on a soft, resilient material like felt. But since the pits in these lenses are quite small, relative to those in other lenses from the seventeenth century, it means that Leeuwenhoek polished only for a short time, which would result in a good shape to the surface of the lens. He most likely began by taking a tiny shard of glass, quite possibly from a mirror, and ground and polished it with sand that he had first crushed to a fine, smooth powder. By the late seventeenth century, the grinding technique for large, flat mirrors had improved greatly, and so mirrors would have provided excellent glass that was easy to obtain. Leeuwenhoek was also an accomplished polisher. It was found during the examination of his microscopes that the most skillfully polished surfaces of the surviving lenses are very nearly acceptable even on modern standards of microscopy; and even the least successfully polished lenses are markedly better than two remaining telescope lenses made by the Huygens brothers—considered among the finest lens makers of their time—in 1655 and 1686.

The eighth lens, the one in the "Utrecht microscope" (named for its current location, in the museum of the University of Utrecht), does not exhibit the orange peel texture, and it contains numerous minute bubbles, leading to the conclusion that Leeuwenhoek made this lens by blowing it. The lens is also aspherical, the radii of curvature increasing to the margin of the lens. It is nearly impossible

to make such a lens by grinding, but this is the shape that would be expected for a blown lens. The magnification of this lens, at 266 times, is such that a bluebottle fly viewed with it would appear one meter in length. And a bacterium would be clearly visible as a dot the size of the period at the end of this sentence. This may not even have been the highest magnification achieved by Leeuwenhoek; in his letters there is evidence that he had used lenses that magnified up to 480 times, and contemporaries believed that he had instruments capable of 500 times. As a point of comparison, the telescope with which Galileo made his most famous discoveries in 1609 had a magnification of only 20 times.

Leeuwenhoek probably began grinding his lenses by hand, but later he began using a lathe, of a type similar to that used by jewelers. He described the setup of the lathe in his study:

My Study stands toward the North east, in my Antichamber, and is very close joyned together with Wainscot, having no other opening than one hole of an inch and a half broad, and 8 inches long, through which the wooden spring of my lathe passes towards the street furnisht with 4 windows, of which the two lowermost open inwards, and by night are closed with two wooden Shut[ter]s. . . .

This type of "pole-lathe" would have had a cord fixed to a wooden spring, fastened to his ceiling; the other end was attached to a pedal moved by one foot. The cord was wrapped two or three times around the spindle, which, when the pedal was worked, would have a to-and-fro rotation. The spring was fitted outside the room and put through a horizontal slit, and therefore could work only in a horizontal plane, which suggests that the spindle itself was vertical. This would not be practical for turning wood or metal—and so this layout would not be used by woodworkers or metalworkers—but is the best positioning for grinding lenses. A rotating lathe would speed up the grinding process. But since the outer parts of the tool have a greater velocity than the inner, the resulting lens would be worn more at the cen-

ter, and thus have a flatter curvature; this corresponds to the results of the examination of the surviving lenses, strongly suggesting that Leeuwenhoek did use the lathe in grinding the lenses, as he reported.

Leeuwenhoek's use of the lathe may have been similar to the manner a lathe was employed by Baruch Spinoza, the philosopher expelled from the Jewish community in Amsterdam. Born a few weeks after Leeuwenhoek and Vermeer, Spinoza began making lenses as a way of earning a living when he was thrown out of his family's importing business after his excommunication. Spinoza had an elementary lathe with which he ground his lenses; he then polished the lenses by hand. Like Leeuwenhoek, Spinoza made very small lenses, which he fitted into single-lens microscopes. Leeuwenhoek did not mention when he first acquired the lathe, but it is notable that in the summer of 1665 he and Spinoza were living only four miles apart, both were friends of members of the Huygens family, both had similar backgrounds, as coming from families of merchants, both were practical opticians rather than highly mathematical ones. And, whether or not Leeuwenhoek was Catholic, both men were citizens of the republic who were not formally affiliated with the Dutch Reformed Church. It is not at all unlikely that by the mid-1660s they were acquainted, and that Spinoza may have inspired Leeuwenhoek to purchase the lathe. This is another historical possibility that must remain tantalizingly speculative.

-5-

Lens making may have begun as a part-time occupation for Leeuwenhoek, but it soon became an obsession, upon which he was able to concentrate by 1660. He probably ceased work as a clothier around that year, because at that time he was appointed to a post in civic government. He was made chamberlain (*camerbewaarder*) to the sheriffs of Delft, a position he held for thirty-nine years; he continued, even after that period, to draw a salary from the position until his death. It would seem that Leeuwenhoek's early training by his uncle Cornelis

Jacobsz. van den Berch, the sheriff in Benthuizen, qualified him for this position. At first he was paid 314 florins per year (about $5,600 today); eventually this rose to 450 florins ($9,827). The average, well-paid Dutch glassworker would have received around 270 florins a year, so 314 was a good income, 450 a quite good one.* In the town records we find his appointment, and the work he was expected to perform:

> Their Worships the Burgomasters and Magistrates of the Town of Delft have appointed and do hereby charge Antony Leeuwenhoek to look after the Chamber wherein the Chief Judge the Sheriffs and the Law Officers of this Town do assemble: to open and to shut the foresaid Chamber at both ordinary and extraordinary assemblies of the foresaid Gentlemen . . . to show towards these Gentlemen all respect honour and reverence and diligently to perform and faithfully to execute all charges which may be laid upon him and to keep to himself whatever he may over hear in the Chamber: to clean the foresaid Chamber properly and to keep it neat and tidy: to lay the fire at such times as it may be required and at his own convenience and carefully to preserve for his own profit what coals may remain unconsumed and to see to it that no mischance befall thereby nor from the light of the candles. . . .

The room of the sheriffs was on the north side of the second story of the Town Hall, a quick walk from Leeuwenhoek's house on the Hippolytusbuurt. It may have been expected that the chamberlain would hire a servant girl to perform the more menial tasks involved, paying her from his salary. It is noteworthy that part of his remuneration included the leftover coals—he would have brought these home for Barbara to burn in their own fireplaces. Since coal burns hotter

---

*As we saw earlier, the glassworkers in the Dutch Republic were paid about 24 stuivers a day, which would be 144 per week (assuming a six-day workweek) and about 7,488 per year (assuming pay over fifty-two weeks). A florin was 28 stuivers, so that yearly income would be 267 florins.

than wax or an oil lamp, Leeuwenhoek could have used the coal to burn in a furnace that would be hot enough to melt large quantities of glass in order to obtain molten glass for blowing.

Since Leeuwenhoek was explicitly charged to keep silent about matters discussed by the council, he must have been present during their conversations. Leeuwenhoek would, then, have been privy to council discussions of issues pertaining to the civic government, such as the elections that took place every October 18 (St. Luke's Day) for the head of the St. Luke's Guild—a position to which Vermeer would be elected for the first time two years after Leeuwenhoek's appointment as chamberlain. Most likely, once he was appointed to this civic position, Leeuwenhoek began to devote himself to making lenses in earnest, employing all of the time he was not employed by his work for the government.

Once he made his first devices, Leeuwenhoek began to peer at whatever he could find around him. He first trained his new instruments on the little creatures he found crawling and flying around his study and in his small garden, entranced by flies, mites, worms, and moths, just like the other natural philosophers, the artists, and ordinary people with their flea glasses. Leeuwenhoek was irresistibly drawn to the eyes of the insects, more than to other parts of their tiny bodies. Indeed, for most of the new microscopists, eyes were a continual source of fascination—as if they were using this new optical instrument to understand sight itself, and the way that the instrument worked, by examining natural optical systems. Federico Cesi, in the first published microscopic examination in the 1620s, had turned the new instrument on the eye of the bee, Borel had paid especial attention to the eye of the mite, Odierna had carefully studied the compound eye of the fly, concluding that the insect eye both receives and perceives the "multitudinous images of the outside world"—that visual perception in insects occurs outside the brain. Over the next sixty years Leeuwenhoek would return again and again to eyes: the eye of the bee, described in his very first letter to the Royal Society of London; the eye of a cow—obtained from a helpful butcher at the *vleeshal*—its "aqueous humor" in the anterior chamber of the eye, its optic nerve, which was springy and filled with filaments that seemed

to come from the brain, its iris, cornea, and retina; and the eye of a whale, pickled in brandy, brought to him by the captain of a whaling ship. In one notable frenzy of dissection and examination, the eyes of pigs, sheep, dogs, cats, rabbits, hares, fishes, and birds were all discussed in a single lengthy letter to the Royal Society.

It would be another decade before Leeuwenhoek realized that he had begun to see objects that could not be seen at all with the naked eye. But from the end of the 1650s until the 1660s—the period of his microscopic apprenticeship, as it were—he began to hone his technique for using his devices to see more than anyone else had before him, even in macroscopic structures like the eye of a bee. He was, in a sense, learning to see.

-6-

The idea that one must "learn to see" was, perhaps inevitably, part of the revolution in the new way of seeing that came about in the seventeenth century. Kepler's claim that the retinal image was inverted introduced a new element into discussions about vision and the relation between object, light, sensation, and perception. If the image from a viewed object that is projected onto the retina is inverted, what explains the fact that we see it as upright? Something happens in the process that makes the figure appear to us that way. Is that process an innate mechanism, or must we learn to see this way? Kepler had admitted the existence of this problem but demurred to answer it, claiming that how the image is formed is an optical problem but that how it is perceived by the mind is not, and was therefore not his concern. "All this," Kepler said, "I leave to be disputed by [others]. For the armament of opticians does not take them beyond this first opaque wall encountered within the eye."

Others took up this problem with gusto. A robust debate arose about whether vision was something "native," or innate, or whether it had to be learned through experience. In 1688 John Molyneux, an Irish fellow of the Royal Society, expressed the question at issue in a letter to the English philosopher John Locke, by formulating what is

now known as Molyneux's problem. Suppose a man born blind has learned to distinguish a sphere and a cube by his sense of touch. If sight is suddenly restored to him, will he recognize the sphere and the cube solely by sight? Or would he need to touch the two shapes in order to know which is which—in order to match his new visual perception with his accustomed tactile sensations?

Molyneux's wife had become blind after an illness in their first year of marriage, which is one reason he had become interested in such questions. Molyneux concluded that the man would *not* recognize the shapes by sight alone; he would need to use his sense of touch to learn by experience which visual sensations corresponded to the familiar tactile sensations of roundness or squareness. Locke agreed with Molyneux's answer to the problem, arguing in his *Essay Concerning Human Understanding* (1690) that perception was a matter of acquired custom and the accumulation of knowledge. Without past experience, we would be unable to make sense of the flat patches of color on our retina; we need a means to "translate" these patches into three-dimensional pictures of the world (much as the artist needs to make us see patches of color on a flat canvas in the same way). In 1709 George Berkeley concurred, proposing in his book *A New Theory of Vision* that a blind man who was suddenly given sight would not be able to discern by his eyes alone what was "high or low, erect or inverted." There was no necessary connection between the world of sight and the world of touch; experience is needed to establish a link between them.

The idea that we must learn to see gained empirical support in 1728. The English surgeon William Cheselden had invented a new way of safely removing cataracts, which in some cases were so thick that they caused blindness or near blindness. Cheselden operated on a thirteen-year-old boy who had been born blind. After the surgery, the boy was able to see for the first time. Cheselden reported that the boy, who was quite intelligent, found even the simplest visual perceptions difficult. Cheselden recorded that, "when he first saw, he was so far from making any judgements about distances, that he thought all objects whatever touched his eyes . . . he knew not the shape of anything, nor any one thing from another, however different in shape

or magnitude." The boy had to learn how to make sense of the multiplicity of impressions he received through his newly functioning eyes. The experience he required involved touching the objects he was able to see for the first time, "feeling" their visual characteristics so that he could match them with their tactile properties.

The boy had a particularly difficult time understanding that paintings represented objects in three-dimensional space. As Cheselden related, the boy thought that paintings were only surfaces painted with random shapes and colors. Once the boy realized that the colored surfaces were paintings, he touched them and was further confused by their use of perspective. "Expecting the pictures would feel like the things they represented [he] was amazed when he found those parts, which by their light and shadow appeared now round and uneven, felt flat like the rest and asked, which was the lying sense, feeling or seeing?" After his experience treating the boy, Cheselden came to believe that we learn to see by interacting with the world around us. From 1728 on, his case study was frequently cited in discussions of the Molyneux problem.

If we need to learn how to see the world around us with our eyes, how much more must there be to learn when we use a telescope or, especially, a microscope, to see! The modern-day philosopher Ian Hacking has argued that we do not see *through* a microscope, but *with* one, just as we don't see through our eyes, exactly, but with them. Learning to see with a device like a microscope requires interaction with the microscopic world, not only by repeated viewing with a microscope but by dissecting and manipulating the specimens being observed with it. We know we are seeing the microscopic structures of an insect's body because we can dissect them, move them around, change their color with the use of dye, and make other interventions. Hacking's claim is reminiscent of Molyneux's that we learn shapes by touching them. Interestingly, three years before setting out this problem in the letter to Locke, John Molyneux had visited Leeuwenhoek in Delft with his brother Thomas, in order to examine his microscopes. It is likely that the episode—which caused Molyneux to realize how much training and experience were required to see with the device—sparked his thoughts about how hard it is to see with a

different kind of optical instrument: our eyes. After all, the new optical instruments were often compared to the human eye, suggesting that the eye itself was an optical device.

-7-

Even before the philosophers began debating the difficulty of learning to see, natural philosophers grappled with it every time they looked through their instruments. It is not surprising that the debate over whether we must learn to see with our eyes arose at the very time that natural philosophers were struggling to see with their new optical devices. The difficulty with using microscopes and telescopes forced people to realize that sight does not just happen—that it is something we must learn.

Galileo, for example, had to admit to the public that seeing through a telescope was complicated. Those trying to repeat his observations were often flummoxed—sometimes even when Galileo himself set up his own telescope and pointed it in the right direction for them. The physical act of using a telescope itself introduced problems, as Galileo cautioned an eager would-be observer:

> The instrument must be held firm, and hence it is good, in order to escape the shaking of the hand that arises from the motion of the arteries and from respiration itself, to fix the tube in some stable place. The glasses should be kept very clear and clean by means of a cloth, or else they become fogged by the breath, humid or foggy air, or by the vapor itself which evaporates from the eye, especially when it is warm.

Even if the viewer could somehow avoid the shaking of his hand holding the telescope caused by the circulation of his own blood, and keep the outside humidity from fogging up the lens, he would still have to contend with the very vapors coming off his eyeball! Leeuwenhoek's microscopes, with their single lenses held up to the sky "like a telescope," suffered the same problems—though it was even

more difficult for Leeuwenhoek, as he had to contend with keeping the specimen in the right spot for viewing, whereas for Galileo the slow-moving celestial bodies took care of that for him. The double lens tripod-style microscope, known to many of us from our high school science classes, came to dominate in the nineteenth century mainly because of its stability and ease of keeping a specimen in proper place for being observed with the lens (as well as the ease of taking notes while viewing, without having to put the whole contraption down first).

Learning to see with a microscope also involved navigating the range of optical defects plaguing the images viewed through lenses. The true appearance of structures often remained elusive. Robert Hooke would complain that "of these kinds of Objects [that is, those seen with a microscope] there is much more difficulty to discover the true shape, than of those visible to the naked eye, the same Object seeming quite differing, in one position to the Light, from what it really is, and may be discovered in another." He had observed this himself, while studying the compound eye of the fly: "In one kind of light [the eyes] appear almost like a Lattice, drilled through with abundance of small bodies. . . . In the sunshine they look like a Surface cover'd with golden Nails; in another posture, like a surface covered with pyramids, in another, with Cones."

Such defects in optical instruments were caused by the optical problems inherent to the lenses available at the time. Because of the spherical shape of lenses, straight lines at the margins of the field of light appear curved when viewed through a lens; a spherical surface does not focus precisely over its whole surface resulting in an image of uneven sharpness and distorted shapes near the edges. This distorts the apparent shape of the object being viewed, a result called spherical aberration. Spherical aberration occurs because the refraction of light at the edge of the lens is greater than in the center, which causes a blurring of the image. In the seventeenth century many philosophers and lens makers thought they could solve this problem by designing machines to grind lenses that were "hyperbolic": they would have a surface that would exactly focus an image to a point behind the lens so that no blurring would occur. Descartes

spent years trying in vain to invent such a machine. By the end of the eighteenth century, the problem was solved by using a combination of lenses to correct for the spherical aberration, allowing the entire image to be in focus at one time.

Another difficulty in looking through lenses resulted from the fact that the surface of a lens, just like a prism, disperses the colors composing white light and produces colored fringes in the image, especially under strong light, an effect called chromatic aberration. Chromatic aberration was not really understood until Isaac Newton's early optical studies were published in 1672. Newton explained the phenomenon, but concluded, too pessimistically, that all transparent lenses must inevitably suffer from this problem, and so optical devices would always be slightly imperfect. It was only in the late eighteenth century that it was realized that achromatic objectives for microscopes could be created by combining lenses of different kinds of glass. But until then chromatic aberration remained an impediment to seeing with microscopes. The obstacle was compounded for double-lens microscopes, which suffered from the composite aberration of two lenses, rather than only one.

Learning to see through a microscope not only involved learning to cope with optical defects; it also had to do with understanding the way that our underlying beliefs influence what we see—an idea that emerged during this period. Because of the difficulty of seeing with the devices, and the newness of the images seen with them, it was easier for a viewer's beliefs and expectations to influence how he or she interpreted what was seen through a telescope or microscope. It wasn't only Galileo's training in perspective theory that allowed him to see the moon's splotches as craters and shadows; it was also his acceptance of the Copernican theory. If one accepted Copernicus's theory there was no conceptual barrier to imagining that the moon's surface resembled that of Earth, because both bodies were the same kind of thing: celestial bodies orbiting the Sun. But on the old Aristotelian view, Earth resided in a special terrestrial realm at the center of the universe, and everything going around Earth was made up of a perfect celestial "ether" that was "luminiferous," or shining. An observer who believed with all his might that the moon's

surface must be perfectly smooth and shining just *could not see* the craters and mountains—that observer was not pretending not to see, he was really not seeing, because his expectations were coloring his sight. Instead, he saw blotchy clouds over the moon's shining, perfectly smooth surface, or he blamed defects of the telescope for causing the mottled appearance of the moon viewed with it. Later, when studying sperm, Leeuwenhoek's own beliefs influenced his observations, causing him to spend hour upon hour seeking the homunculus or "little man" within; he sometimes thought he caught a glimpse of him. In the nineteenth century William James coined the phrase "will to believe," noting that sometimes we convince ourselves to believe what we chose to believe, even without rational evidence; so too, it can be said, we sometimes will ourselves to see what we want to see, or what we are accustomed to seeing.

But the natural philosopher of the seventeenth century sought to see the natural world as it was, not how he was accustomed to believe it was on the basis of a favorite theory or other beliefs. It was necessary to train the mind, as it were, to allow it to see what was there, even if it was hard to see with the new optical instruments, and even if what was seen went against strongly held beliefs. Galileo recognized this problem when he said of one of his critics that he should use "not just the eyes in his head, but those of his mind as well." It was necessary to realize that expectations, beliefs, even desires can cause us to see something other than what is present to our eyes. Like the painters using mirrors to focus their attention and disrupt their visual habits, natural philosophers, too, needed to take pains to suspend their expectations while viewing nature through optical instruments. Only once they succeeded could the Scientific Revolution take place; only then could the ancient texts and theories be overthrown. And so Leeuwenhoek, and all the men and women using the new optical instruments, needed to learn how to discern what was really there and what was not, what was merely an artifact of the device itself, what was an artifact of the mind's expectations or desires, and what was being revealed by the lens.

Learning to see with the microscope was more difficult than learning to see with a telescope in one crucial way. Telescopes revealed

that the heavens were remarkably similar to the known, familiar world. Indeed, what was so controversial about the new discoveries made with the telescope was the forced recognition that there was no distinct, Aristotelian celestial realm, where heavenly bodies were made of the luminiferous ether and were completely unlike Earth. Instead, the telescope showed us that the moon was just like Earth—pockmarked, with mountains and craters—and so was Jupiter, which had its own moons circling about it, just as Earth has a moon cycling around us. Telescopes showed us that there were even more stars than we had imagined; but these were not strange new things, just more of the same. In this way, the new awareness of the vastness of the universe—which made the world stranger than it seemed to be—was balanced by the idea that this vast universe was familiar, that the parts of it we cannot see with the naked eye are similar to the parts we can see.

Microscopes, by contrast, revealed a new and strange world to viewers, a "color-charged, glistening world," as one writer has put it, in which new textures, hues, forms, and light effects were revealed for the very first time. Learning to see through a microscope required coming to accept that the world was, after all, very different from the way it had always seemed. Huygens had remarked on this when he described people looking at a specimen with Drebbel's microscopes for the first time. They at first complained that they could see nothing. Then they cried out with surprise at the sight of unbelievable, marvelous things. "For in fact," Huygens explained, "this concerns a new theater of nature, another world." In the early part of his self-imposed microscopic apprenticeship, Leeuwenhoek began to train himself to see the "color-charged, glistening world," a world newly revealed to be unfamiliar and strange.

# Ut pictura, ita visio

||||||||||||||||||||||||||||||||||||||||||||||||||||||||||||||||||||||||||||||||||||||||||||||||||||||||||||||||||||||||||||||||||||||||||||||||||||||||||||||||||||||||||||||

$\mathcal{O}$N A FINE summer day in 1623, Constantijn Huygens hosted a group of acquaintances and friends at his father's house in The Hague. Huygens had just returned home after his second trip to England as the diplomatic secretary of the Dutch delegation. He was eager to demonstrate some newly invented devices he had brought home with him. Several painters were in attendance, including Huygens's neighbors, the Jacob de Gheyns—both the father (Jacob II), a painter, and the son (Jacob III), a painter and engraver who had accompanied Huygens to London—and Johannes Symonsz. van der Beeck, known as Johannes Torrentius (the Latin equivalent of his Dutch surname, which means brook or torrent).

During the afternoon, Huygens showed his guests an instrument he had purchased in England from a close friend, the inventor Cornelis Drebbel. Huygens explained to his guests that this "machine" was "a kind of viewing device, by [means of] which likenesses of things presented to it from outside are directed on to a white [or bright] plate within its enclosed space." Huygens had set up a wooden box on the windowsill of his dining room. The box had a brass extendable tube—like the kind Drebell made for his microscopes—facing outdoors. The tube held a glass lens, which projected an image of the people outside onto a bright white plate inside the box. Huygens

informed his friends that he had been using the device for making paintings, with great "delight" at the results.

As Huygens later recalled, his guests crowded around the box excitedly, watching the moving image on the white screen inside the box. Torrentius, however, acted strangely, asking, "Are the little people that are seen on the plate . . . [the ones] observed going about outside the dining room?" Huygens felt certain that the painter had feigned ignorance about the camera obscura, which, Huygens knew, "now-a-days is familiar to every one" in its whole-room or tented configurations—though the box type was still new. Huygens suspected that "this cunning fox" used a camera obscura when painting—that must be how he was able to depict objects made of glass, tin, earthenware, and iron with such exquisite realism, showing the different textures and sheens of each—but was trying to keep his use of the device a secret so that "the simple, uncritical public in this way would ascribe [his skill] to bursts of *Divine Inspiration*." Torrentius's still-life paintings, Huygens and his friend De Gheyn agreed, resembled nothing so much as projections of objects in a camera obsura. Although he continued to admire Torrentius's work, Huygens concluded that afternoon that the artist was a "holy quack" for pretending to create his pictures without the instrument.*

*-1-*

Already by 1623 Huygens could assume that all painters—indeed, most educated people—had heard about the camera obscura. Nevertheless, today the history of the camera obscura is not as clear and

---

* Huygens was not the only one who viewed Torrentius with suspicion—the painter was later condemned by the Dutch Reformed Church for his libertine ways. He was tortured on the *painbench* (the "rack"), condemned to life imprisonment, and his paintings were burned. After serving two years Torrentius was released at the urging of King Charles I of England, who wanted Torrentius as his royal painter. Today, only one of his paintings is extant, the stunning *Emblematic Still Life with Flagon, Glass, Jug and Bridle* (1614), which hangs in the Rijksmuseum in Amsterdam.

sharp as the images it can project. In part that is because the optical concept of a "camera obscura" existed even before there were any actual physical camera obscuras, and because actual camera obscuras existed even before they were called camera obscuras.

The concept of the camera obscura was useful in the early days of optical science because it illustrates a basic principle of optics, namely that rays of light, which move in straight lines, will, when passing through a small aperture, cross and reemerge on the other side in a divergent configuration; if a flat screen is placed in such a way as to intercept the path of the light rays after passing through the aperture, an image of what is on the other side of the hole will be formed on the screen. This image, though, will be reversed (as in a mirror) and inverted (upside down). In order for the image to be adequately visible, the screen must be placed in a room or box in which the level of light is lower than the light around the object.

As far back as the fifth century BCE, the Chinese writer Mo Ti recorded the creation of an inverted image when light passed through a pinhole in a screen. He referred to the place the inverted image occurred as a "collecting place" or a "locked treasure room." Later, sometime after the third century BCE, Greek writers observed a natural occurrence of the camera obscura effect. During a solar eclipse, they noted, if the light falls through small holes in leaves, the image of the sun's crescent is visible on the ground. This passage identified the basic theoretical concept of the camera obscura: the formation of an image through an aperture, in this case small holes found in nature. The ninth-century Chinese writer Tuan Cheng-shih discussed an inverted image of a pagoda being formed through a small hole he had made in a screen, but incorrectly explained the inversion, attributing it to reflections from the nearby sea. Another writer, Shen Kua, correctly explained the inversion by comparing the light rays to an oar in its oarlock: when the handle is up, the blade of the oar is down, and vice versa. In the tenth century Yu Chao-Lung constructed models of pagodas and projected their inverted image through an aperture onto a screen.

The eleventh-century Arab writer on optics Alhazen described his experiments with image formation through pinhole apertures

in his book *Perpectiva*, using the term *locum obscurum* (dark place). He arranged three candles in a row and set up a screen with a small hole between them and the wall. He observed that the candle to the right of the hole made an image on the left of the wall, and vice versa. He did not mention that the images were inverted. He noted that images were formed only when there was a very small hole in the screen; when he tried larger holes, all that was produced on the wall was a round patch of light. In a discussion on "the shape of the eclipse," Alhazen argued that a partially eclipsed sun will project a crescent-shaped image on a screen if its light passes through a round aperture.

New uses for the camera obscura were devised in the thirteenth century. Arnaud de Villeneuve arranged for players to enact a violent scene in an area of bright sunshine outside a darkened room. A small hole was made in the shutter facing the scene, which was projected onto a white sheet hanging opposite the hole. He hired other actors to stand just outside the window loudly imitating the sounds of men fighting and dying. A later writer described such spectacles, noting with satisfaction, "The spectators that see not the sheet, will see the image hanging in the middle of the air, very clear, not without fear and terror." This was the medieval version of a movie theater.

Also in the thirteenth century, Roger Bacon followed up on Alhazen's discussion by explicitly recommending the use of the camera obscura for making astronomical observations of the sun. This was an important development in astronomy, because natural philosophers could become blind temporarily—sometimes even permanently—after staring directly at the sun to observe solar eclipses or sunspots. John Greaves, professor of astronomy at Oxford in the sixteenth century, made a common complaint after measuring the sun's diameter: "For some days after, to that eye with which I had observed, there appeared, as it were, a company of crows flying together in the air at a good distance." For safer observations of the sun, one could make a small hole in a closed shutter, through which light from the sun outside would pass. On the wall opposite the hole, an inverted image of the eclipsing sun would be projected and could be watched safely.

In 1292 Guillaume de Saint-Cloud described how he had used a setup like this one to observe the solar eclipse of 1285. But it is not until the sixteenth century that we find a published illustration of a room-type camera obscura being used for observing a solar eclipse. This was also the first published illustration of an actual camera obscura setup, as opposed to a merely theoretical drawing of the camera obscura principle showing rays intersecting after passing through a hole and then ending up on a flat surface.

The solar eclipse of January 1544 was observed by the Dutch mathematician and physician Reincrus Gemma Frisius (also known simply as Gemma Frisius), whose book *De radio astronomico et geometrico* (1545) contains the image of a solar eclipse projected onto the wall of a room by a pinhole in the shutter. The drawing shows the inverted and reversed image of the sun projected on the wall opposite the small hole in a window shutter. Later Copernicus, Tycho Brahe, Johannes Kepler, and others used this kind of room-type camera obscura. To observe sunspots, Galileo used a telescope as a compound lens to project the image of the sun on the wall of a darkened room.

-2-

In order for the camera obscura to be useful to artists, however, another innovation was required: the use of a lens in place of the small aperture. The first to suggest this in print was the sixteenth-century Venetian architect Daniele Barbaro. In his *La pratica della perspettiva* (The practice of perspective, 1569), a book written specifically for artists, Barbaro published a detailed description of the camera obscura, calling it "a most beautiful experiment concerning perspective." He instructed his readers to "make a hole of the size of a spectacle lens in the window shutter of a window of a room from which you wish to observe. Then take a lens from spectacles used by old men [i.e., a convex lens] and fix this lens in the hole you made." Next, he advised, close up all the windows and doors of the room so that the only light entering the chamber comes through the lens. Then

"take a sheet of paper and hold it behind the lens. . . . By moving the sheet of paper towards or away from the lens you will find the most suitable position."

Given his suggestion of moving a sheet of paper closer to and farther from the lens in order to find the optimal focus, it is likely that Barbaro was not just imagining a new way to construct a camera obscura but had actually built one like this. He also proposed the addition of a diaphragm, a small aperture placed behind the lens to decrease the light passing through it, and in this way increase the brightness of the image. Actually, it was sharper, not brighter—the diaphragm prevented spherical aberration by blocking all the light except that passing through the center of the lens. But this would make the image seem brighter. The fact that Barbaro takes no credit for these two innovations, the lens and the diaphragm—introducing them in the book as if everyone knew about them—may mean that they were already known when he wrote. Convex lenses, as we saw, had been being used in spectacles since the end of the thirteenth century, so in some ways it is surprising that it took over two centuries before anyone thought of adding a lens to the camera obscura. But it was probably not until around Barbaro's time that the lenses being produced were capable of projecting an image.

Once a lens and a diaphragm were introduced into the camera obscura, the image became clearer and brighter, and numerous writers began to mention the usefulness of the device to artists. Barbaro himself suggested that the camera obscura could be employed for making exact copies of maps by projecting and tracing the images. (The discussion of the camera obscura appears in a section of his book on mechanical drawing devices.) Others had proposed the artistic use of a camera obscura before this—for instance, in 1521 Cesare Cesariano had noted that the camera obscura would be excellent for "painters, astronomers, and opticians [those who study optics]." And astronomers were already tracing the solar image projected by a camera obscura, so it was not a stretch for this use to be taken up by artists as well. Reinerus Gemma Frisius mentioned marking with a pencil the diameter of the sun as projected by the camera obscura. Christoph Scheiner claimed to have observed, and sketched, sun-

spots in 1612 by projecting the image through a telescope onto a tablet below. He included drawings made with the device in his *Rosa ursina*, published in 1630.*

Soon another improvement in the design of the camera obscura was introduced: the use of a mirror to correct the reversal and inversion of the image. If a mirror was placed at a 45-degree angle to the light before it was projected onto the wall, it would correct the inversion and reversion of the image. The use of a mirror was suggested in a manuscript by the Venetian Ettore Ausonio (1520–70), and later in a book by Giovanni Battista Benedetti published in 1585. Around this time English mathematicians were also talking about the combination of a lens and a mirror for projecting images in a camera obscura; John Dee, Thomas Diggs, and William Bourne all mention this setup and its application for making the drawings used to create maps.

Although the additions of a lens and a mirror to the camera obscura setup had been mentioned earlier, they were widely publicized by the discussion of camera obscuras in the twenty-volume second edition of Della Porta's *Magia naturalis* (1589). Della Porta was a showman, natural philosopher, and wizard, whose dabbling in magic led to his investigation by the Inquisition. He founded a secret society in his hometown in Naples, called I Segreti, whose members were instructed to "discover a secret unknown to the rest of mankind." These secrets, collected in his book, included methods for removing warts, curing baldness, and countering armpit odor. Della Porta, who wrote sixteen other books, became so renowned that it was said the two greatest tourist attractions in the Naples of his day were the baths of Pozzuoli and Giovanbattista Della Porta.

Like earlier writers, Della Porta highlighted the value of the camera obscura to painters, especially when a lens was added to the device to make the image clearer. He exhorted, "One that is skilled in painting, must lay on color where they [the colors] are on the table, and

---

* In 1639 Jeremiah Horrocks used a telescopic camera obscura to observe the transit of Venus across the sun. My son and I used a similar device to observe the Venus transit in 2011.

shall describe the manner of the countenance, so the image being removed, the picture will remain on the table." He believed that the camera obscura, besides being useful for painters, was a model for studying optics and a way of exploiting natural phenomena to astonish and entertain, like Villaneuve's theaters. Della Porta's book was published in a Dutch edition (as well as Latin, Italian, and French editions) in the sixteenth century, so with the publication of his book knowledge of the camera obscura using a lens and a mirror became widespread.

The first to propose a smaller, portable camera obscura seems to have been the German mathematician Friedrich Risner, who held the first chair of mathematics at the Collège Royale de France. In his edition of the works of Alhazen and Witelo, published in 1572, Risner proposed a lightweight wooden hut that could be carried on two rails—like a litter used to transport royalty—to any desired location for the purpose of creating topographical drawings. This large box would be fitted with lenses on each of the four sides, with a cube of paper placed in the middle. A man would go inside the box and trace the images being projected through each of the four lenses onto the sides of the cube.

Johannes Kepler would soon invent another version of this portable hut: a tentlike camera obscura, which could be set up anywhere one wished outdoors and which projected an image of the outside scene onto a sheet of paper inside the tent. Kepler himself had coined the term "camera obscura," employing it for the first time in his 1611 book *Dioptrice*. Kepler used the term while describing the solution to the problem of "paint[ing] visible objects on a white wall with a convex lens."

Kepler had learned how to use the camera obscura for astronomical purposes from Michael Mastlin at the University of Tübingen. In July of 1590, Mastlin had taken his students—including Kepler— onto the roof of the town's cathedral to teach them how to observe and record a solar eclipse. Through a small aperture in the roof, the image of the sun fell onto a white tablet below; Mastlin had his students safely observe the progress of the eclipse and calculate the diameters of the sun and the moon. Kepler remembered this experi-

ence and later used it to invent a camera obscura that could be used out "in the field" for making drawings for maps or topological studies.

The English diplomat Sir Henry Wotton, who met Kepler in Linz in 1620, excitedly wrote to Francis Bacon, the natural philosopher and politician, to tell him about this new invention. Wotton had learned about it after complimenting Kepler on a drawing in Kepler's house. Kepler admitted that he had done it himself, adding with a sly smile, "*non tanquam pictor, sed tanquam mathematicus*" (not as a painter, but as a mathematician). This answer, Wotton said, "set me on fire," and he pressed Kepler until he told him his secret. As Wotton revealed to Bacon, Kepler had devised a small black tent that was completely closed off except for a small hole, to which he attached a telescope. The image of the landscape outside the tent was projected onto a piece of paper inside the tent. To sketch a 360-degree panorama, Kepler rotated the tent on its stand by degrees, till he had painted the whole aspect of the field—a "true portrait" of an entire territory, as Wotton put it. Wotton told Bacon that in his opinion, the device would be most useful for "chorography" (mapping and surveying). While he acknowledged that it could be used by artists, he felt that their reliance on the device would be "illiberal," though he admitted that no artist drawing without the device could do so as "precisely." Wotton, who had lived in The Hague when he was the English ambassador, would surely have shared the news of this innovation with his friend and former neighbor Constantijn Huygens.

-*3*-

At this point in the history of the camera obscura, things get hazy. By 1572 the room-type camera obscura had already been shrunk down to a small, portable room, which can be thought of, after all, as a very large box. However, when pinpointing the first appearance of box-type camera obscuras—devices in which the lens, the mirror, and the screen on which the image was projected were put inside a small wooden box—most writers date it to around the mid-seventeenth century, nearly a hundred years later. Gaspar Schott described a

small, portable camera obscura in his *Magia universalis* in 1657, and in 1669 the British natural philosopher Robert Boyle depicted a box-type camera he claimed to have constructed "severall years ago." Boyle wrote to the Royal Society of London,

> I need not perhaps tell you, that if a pretty large Box be con-
> trived, that there may be towards the one end of it a fine sheet of
> Paper stretch'd like the Leather of a Drum-head at a convenient
> distance from the remoter end; where there is to be left an hole
> covered with a Lenticular Glasse fitted for the purpose, you may
> at a little hole, left at the upper part of the Box, see upon the
> Paper such a lively representation; not only of the Motions but
> shapes and Colours of outward Objects, as did not a little delight
> me, when I first caused this portable darkened Roome, if I may so
> call it, to be made.

Johann Zahn illustrated several types of small box-type camera obscuras in a book published in 1685, and Hooke is thought to have devised a portable one around the same time.

I believe, however, that the type of camera obscura Huygens purchased from Drebbel in London and brought back with him to The Hague was a box-type device, which means that the existence of box-type camera obscuras dates back at least to 1622. Huygens had mentioned to his parents in a letter from England, "I have at home Drebbel's other instrument, which certainly makes admirable effects in painting." In his autobiography, written in the late 1620s (only a few years after the events he related there), Huygens tells us that he brought back a camera obscura from Drebbel, that it was a "con-structed instrument" with the ability to focus the image by "the plac-ing of the movement, the pushing of it forwards and backwards and the easy turning to all sides," that he had been using it to paint, and that he demonstrated it to his guests at his father's house. So there must have been something physical that he brought back with him, not just, say, the technique for putting a hole in his window shutter to form a room-type camera obscura. In his report of the demonstra-tion, Huygens described the device as something that has a bright

plate or panel in an enclosed space, which the Latin makes clear is the enclosed space "of the plate," which means a box surrounding the plate, not an enclosed space of a room. The "pushing" forward and backward sounds very much like the focusing of the tube holding the lens, as in the microscopes that Drebbel was constructing around the same time. Huygens also noted that Drebbel had a way to correct the inversion of the image in the camera obscura, so he presumably had invented a box-type reflex camera obscura, one with a mirror placed to revert the image.

And Drebbel was, let us remember, the foremost inventor of the day. He was probably the first to invent the microscope. He devised numerous clever and original instruments—even a working under-water ship or diving bell. Once lenses of a good enough quality were available, all the theoretical knowledge and practical requirements were ready for putting the camera obscura setup inside a box. In a sense, the only thing new was the wooden structure; conceptually, this was not a far leap from Risner's hut, or even from the description of the camera obscura in Della Porta's widely read *Magia naturalis.* The optics of the box-type camera obscura were the same as those of the room-type camera; it would be a simple matter of shrinking the room down to a small chamber and constructing it in wood.

Lenses of the correct size and quality for such a use certainly existed by the 1620s. The lens for a camera obscura does not need to be as high in quality as a telescope lens, though it must be higher in quality than a spectacle lens. In the case of spectacles, the eye makes use of only a small part of the surface of the lens, and the eye's power of accommodation (or adjusting) ensures that the object being viewed stays in focus even when the eye is seeing it from another direction, through a part of the lens with relative asphericity. With the lens of a camera obscura, however, every part of the lens is used to produce an image. So the quality of the glass and its polishing matters more than in spectacles: asphericity, inhomogeneity, bubbles, and other flaws will all reduce the quality of the projected images. However, since the camera obscura was not intended to greatly magnify the image, lenses as fine as those used in telescopes were not necessary. What was needed, basically, was a lens that would project the image

of a relatively close object on a projection surface—either a wall, a canvas, or a plate inside a box-type camera—and to make the projection as large and bright as possible. The lens must have a fairly large diameter and a large aperture ratio to generate a large, bright projection. For a life-size projection the lens should have a diameter of about a foot. By 1604 Kepler had reported seeing a room-type camera obscura with a lens a foot in diameter in Dresden, but it is unknown how clear the image was; it is thought that lenses so large at the time had many irregularities, and would not have cast an exceptional image. Box-type camera obscuras, which projected a smaller image, would require smaller lenses, even as small as an inch or two in diameter, and these existed, at a high enough quality, by the early 1600s. There is no reason, then, to doubt that box-type camera obscuras existed by 1622.

-4-

By the mid-seventeenth century, the concept of the camera obscura, and room-type camera obscuras, had been known for centuries, tent-like camera obscuras were being used already for artistic purposes, especially in surveying and mapmaking, and box-type camera obscuras were available. Various authors were recommending the use of the camera obscura to artists. Writers on the camera obscura from Barbaro to Huygens, and later Van Hoogstraten, all expressed the view that the camera obscura displayed *more* than what could be seen with the naked eye; the camera also revealed something about nature and how it operated. In particular, it revealed optical laws, the way light works. As Huygens would declare, the camera was "one of the best optical experiments." The camera obscura allowed the viewer to perceive truths of nature that were otherwise unseen.

This ability of the camera obscura to observe more than what appeared to the naked eye was of special interest at the time. It was an empirical age, in which there was a nearly universal interest in making careful and numerous observations of natural phenomena in order to learn something about the underlying laws organizing them.

Science had seen an increasing emphasis on observing phenomena carefully and using that data to infer laws of nature, as opposed to drawing conclusions about laws from what was written in ancient texts. Laws of nature, being universal, are inherently unobservable—we cannot observe all instances of a universal—and often involve unobservable causes. The new astronomers, like Galileo and Kepler, made and employed careful observations of heavenly bodies to conclude that the cosmos was not at all like Aristotle's depiction of it. Francis Bacon was urging all natural philosophers to conduct experiments before drawing their conclusions. "Dig a pit upon the seashore," he exhorted in the first line of his *Sylva sylvarum*, in order to study the percolation of water through sand. That book contained 1,000 suggested experiments, divided into 10 "centuries," or groupings of 100, giving the natural philosopher much to do.

But it wasn't only the astronomers and other scientific men who were taking an empirical outlook—this philosophy permeated Dutch society. Wealthy traders and ordinary citizens created enormous cabinets of curiosity filled with specimens from all over the globe, testifying to their belief in the power of observing instances. Shells, stones, insects, antiquities, skeletons, even human body parts—collections like these graced the homes of many middle-class Dutch families. Swammerdam, who would later make groundbreaking observations with a microscope, was reputed to have the most splendid cabinet in all the land; the duke of Tuscany offered him 12,000 guilders (about $97,500 today)—a king's ransom—but the offer stipulated that Swammerdam accompany the collection to Tuscany and remain to oversee it, so even though he was in desperate need of money, Swammerdam had to refuse. His father also had an enormous cabinet; it filled an entire floor of his home in Amsterdam and contained more than three thousand specimens, including the eggs of unusual species, aborted fetuses in jars, fossils, the skin of a seventeen-foot snake, as well as artifacts like Chinese porcelain and ancient Roman coins. Leeuwenhoek, too, would eventually compile a cabinet of curiosity of sorts, comprising samples taken from his own body, as well as specimens of canal water and rainwater, parts of animals and plants, and the bodily fluids and discarded hair and nails of his family members, friends,

and neighbors. (Each sample was preserved with a particular microscope, the one most suited to observing it.) Medical doctors began performing public dissections in huge anatomical theaters, discovering—and demonstrating to crowds of citizens—the inner workings of the human and animal body. Mapmakers used the observations of men exploring the globe to produce ever-improved charts of the sea and land. Surveyors measured and mapped the land, often with the help of camera obscuras, just as astronomers were mapping the skies with the use of telescopes. Alchemists were using known principles of chemistry and trial and error to try to discover substances that could turn base metals into gold and silver.

Artists also believed that their endeavors were founded on empirical processes. Especially starting in the 1650s, younger artists in the Dutch Republic held that painting must begin with direct observation of the world. This was a shift from earlier views of art, in which even landscapes were painted with more imagination than visual evidence. Landscape and seascape painters in the Dutch Republic began to go outside to paint directly from nature or from sketches made of observed aspects of a landscape. Still-life painters examined flowers, fruits, even insects carefully with magnifying lenses. Painters of genre scenes and portraits, too, were observing their models and their settings more closely.

One of the main motivations for Dutch painting in the seventeenth century was a curiosity about the natural world, as it was accessible through the sense of sight. Indeed, one can say the subject of painting became sight itself. Whether a seascape, a landscape, a still life or a genre scene, a painting proclaimed, "This is what is seen." That declaration had an associated value judgment: "And that is good, and it is enough." No longer did a picture need to tell a story, as it had in the Italian narrative tradition. It was enough to describe what was observed.

As Van Hoogstraten, writing in the 1660s, would remind painters, their object was to create "a truly natural painting." Nature as it appeared to them—not an idealized or sentimental conception of nature—was to be the guide. Galileo had noted earlier that he preferred painting to sculpture, on the grounds that sculptors "imitate

things as they are, and painters as they appear." Such thinking led to the seventeenth-century expressive naturalism seen in Fabritius's *The Sentry*, where the viewer seems to be standing right over the corner of space inhabited by the sleeping guard, and in De Hooch's views of courtyards in Delft. The viewer of De Hooch's courtyards feels as if he or she had just left Emanuel de Witte's church on the way home, and turned into a little street off the Market Square. Van Hoogstraten cautioned that to create a natural painting, it was not enough to observe casually: the artist must be an investigator of the visible world. Like the natural philosophers—who turned to telescopes and microscopes—painters, especially in Delft, were eager to avail themselves of optical aids to help them understand and represent nature as it appears.

And yet, as Van Hoogstraten explained further, "a painter, whose work is to fool the sense of sight, also must have so much understanding of the nature of things that he thoroughly understands the means by which the eye is deceived." Nature as it appears was understood to be different from nature as it really exists. Dutch Golden Age painting is often associated with a heightened realism, but in some ways it was a kind of *illusionism*, in which the painter's knowledge of how nature looks to us was deployed to fool the eye in various ways. In 1604 Karel van Mander praised Hans Holbein's portrait of Henry VIII as being so thoroughly alive (*"soo gheheel levendigh"*) that its head and body appeared to move, frightening those who saw it. A century later Arnold Houbraken remarked of a Rembrandt portrait that the head seemed to come out of the frame to speak to you. Art is a mirror of nature, Van Hoogstraten would say, a mirror for "making things that are *not* appear to *be*, and deceiving in a permissible, diverting and commendable way."

A picture shows us something that is not, in fact, before us; in that sense it intrinsically makes things that are *not* there appear to *be* there. In his own pictures Van Hoogstraten had used the pictorial device of the feigned frame in order to bring the viewer's attention to the illusionism inherent in realist painting, the way that the painter simultaneously simulates and dissimulates. Some of the Delft church painters incorporated into their pictures a curtain on a rod,

pulled over to one side, to draw attention to the fact that these were pictures—because paintings sometimes were hung on walls behind a curtain, to protect them from dust and sunlight. (Vermeer would use this device as well, for instance, in his *The Reader* [*The Letter Reader*].) The artist was encouraged to create deceptions of the eye (*bedriegertjes*) to fool the viewer into thinking that he is looking at visible nature, when he is really viewing a flat canvas. Like the drops of "dew" on the Verelst painting owned by Pepys, or the shadows of nails in the wall placed in the upper left corner of Vermeer's *Milkmaid*, or the missing chip of paint on the wall behind the bird in Fabritius's *Goldfinch*, the Dutch painter fooled the eye into thinking that what was made of paint on a flat surface was really a natural, three-dimensional thing. Dutch theorists and artists used the term *houding* as a blanket term for the many strategies that could be combined to create a compelling mimetic or imitative picture. The use of such strategies could "transform a painter's imagination into a make-believe space" that looked, in the words of one of Van Hoogstraten's fellow Dutch art theorists, "as if it were accessible with one's feet." Van Hoogstraten had seen a camera obscura at the Jesuit College in Vienna, where he viewed "countless people strolling and turning about on a piece of paper in a small room," and one of his clients was Emperor Ferdinand III, who was known to take a special interest in the optical device. Van Hoogstraten had also observed a camera obscura in London, where he "saw hundreds of little barges with passengers and the whole river, landscape, and sky on a wall, and everything that was capable of moving was moving!" He most likely used the instrument in painting at least one of his works, *View of the Hofburg in Vienna* (1652). By the time he wrote the *Inleyding*, he had come to believe that the camera obscura could help the young artist more closely observe nature, and to learn more fully how it appears to us. "I am certain," Van Hoogstraten confidently wrote, "that vision from these reflections in the dark can give no small light to the sight of the young artists; because besides gaining knowledge of nature, so one sees here what main or general [characteristics] should belong to a truly natural painting."

## -5-

At this moment the time was ripe for the use by Dutch artists not only of mirrors and lenses but also of camera obscuras. However, there was a long tradition of disparaging the painter's use of optical and mechanical devices. In the early sixteenth century Leonardo da Vinci had scoffed at the pervasiveness of Alberti's veils. "There are some who look at the things produced by nature through glass, or other surfaces or transparent veils," he said. "They trace outlines on the surface of the transparent medium. . . . But such an invention is to be condemned in those who do not know how to portray things without it, nor how to reason about nature with their minds." Although Leonardo had devised his own method similar to the Alberti veil to help students learn to draw the poses of models, he believed that after such training painters should be able to produce their pictures without them.

The Paduan humanist Pomponius Gauricus, in his 1504 treatise on sculpture, told a "well-known story," illustrating the same point, about a young acolyte who wished to see the "abacus" of Donatello— the device by which the sculptor was able to control the mathematical proportions of his works. Donatello is said to have replied, "I have no other calculator than that which I always carry without fail amongst my belongings." He urged the young man to bring him a piece of paper, promising to demonstrate this calculator to him. When the student supplied the paper, Donatello simply sketched nude and clothed figures. As Michelangelo would say later in the sixteenth century, the painter should have compasses in his eyes, not in his hands. The science of art, he believed, should be so incorporated into the painter's very being that he or she can deploy it without explicit thought.

In the seventeenth century, however, especially in the Dutch Republic, the idea of what it *meant* to have instruments in the eye had changed. Empirical studies of the structure of the eye had overturned the old theories of vision. First, it was shown that the organ

of vision was not, as it had previously been assumed to be, a lenticular organ filled with viscous fluid in the center of the eye, known as the "crystalline" or "glacial humor." It was, rather, a lens located in the front part of the eye, one that would, like all lenses, invert the image it projected onto the retina at the back of the eye. To better understand the eye, Kepler had used the camera obscura as a model, arguing that the eye functioned like the optical device: with a lens receiving light rays from outside, focusing and projecting these rays onto the retina, which functioned as a "screen" for an inverted image. The eye, then, was a picture-making optical instrument. It is no accident that, discussing the way that all rays from one point formed an image on the retina, Kepler used the term *pencilli*, which referred to the artist's brushes. To Kepler, the image on the retina was painted by a brush, just as was the artist's picture. As he put it, "the retina is painted with the colored rays of visible things."

Earlier, Leonardo had been fascinated by the notion of the eye as an instrument and was the first to propose the camera obscura—not the version with a lens, but the one with a pinhole—as its model. Galileo's friend Cigoli had compared the eye to a camera obscura with a lens in his *Prospettiva pratica*. Indeed, the eye had been compared to an optical device as early as the eleventh century, when the Persian polymath Avicenna compared it to a mirror: "The eye is like a mirror, and the visible object is like the thing reflected in the mirror." The comparison of the eye to a camera obscura, which soon became widespread, was in step with the mechanistic anatomy of the day: William Harvey was using hydraulic machines as models of blood circulation, and Descartes modeled muscle contraction on pneumatic systems. Why not model the eye on yet another device?

Knowing that people would be skeptical about the idea of an inverted image on the retina—after all, we do not see things upside down—Kepler and, later, Descartes described an experiment with a dissected eye that would show the retinal image to be inverted. By peeling off the outer membranes of the eye and replacing them with an artificial screen, the retinal images formed at the back of the eye could be observed. Descartes rather gruesomely suggested that the experimenter "take the eye of a newly deceased man or, failing that, an

ox or some other large animal; carefully cut away the three enveloping membranes at the back, so as to expose a large part of the humour without shedding any; then cover the hole with some white body, thin enough to let daylight through, for example a piece of paper or eggshell." This deconstructed eye should be put in the opening of a window so that the front of it faced objects outside lit by the sun, and the back (with the eggshell or paper) faced the dark room. The only light entering the room would be through the eye. "If you now look at the white [paper or eggshell]," Descartes instructed, "you will see, I dare say with surprise and pleasure, a picture representing in natural perspective all the objects outside."

In 1625 the astronomer Christoph Scheiner described how, in Rome, he had carefully removed the backs of the eyes of freshly dead oxen in order to observe the image formation on the retina. By 1663 Robert Boyle could gleefully report having demonstrated the inverted retinal image in human eyes: "Something of this kind we have also shown our friends with eyes of dead Men, carefully sever'd from their heads."

Leeuwenhoek would later perform a similar experiment on the tiny eye of the dragonfly. He separated the cornea and found that it was made up of six-sided parts, each forming a segment of a sphere. He viewed a lit candle through the cornea and was able to see through it the steeple of the Nieuwe Kerk, multiplied by the number of parts of the cornea, each tiny image inverted. Performing the same experiment with the eye of a "small fish," he was able to see the inverted image of the street, and could even distinguish the colors of the clothing worn by passersby. Such experiments showed that the eye was indeed like a camera obscura.

The camera obscura not only opened up new views of the visible world, to artists and natural philosophers alike, but was instrumental in overthrowing old and faulty ideas of vision. In this sense the camera obscura was no less significant than the telescope and microscope in ushering in a new approach to seeing the world.

-6-

This new view of vision also changed the perception among some artists about the use of optical aids like the camera obscura. If the eye was itself a kind of camera obscura, then how could the use of an additional camera, let alone basic mirrors or lenses, be a form of "cheating"? More particularly for the seventeenth-century Dutch painters, concerned as they were with a type of natural depiction of the physical world, since the eye is an optical instrument there is no artifice in using another optical instrument, the camera obscura, to view nature. As Kepler put it, *ut pictura, ita visio*: sight itself is a picture. In 1637 the French mathematician and astronomer Pierre Hérigone similarly wrote, "La vision est la perception de l'image de l'objet, peinte en la retine." Vision, he said, is but the perception of the image of an object, painted on the retina. Images seen through the camera obscura came to be considered "more natural" than those produced by painting alone, because they were created in the same way as images on the retina of the eye.

Although the use of an optical device like the camera obscura would have seemed to artists to be a useful and even legitimate tool for them to employ, we have no direct evidence that seventeenth-century Dutch painters used the camera obscura. This is not surprising; in general artists were secretive about their methods. Huygens pointed to this with his recollection of Torrentius's pretending he did not understand the workings of the camera obscura. Rembrandt, too, notoriously hid his method for making his engravings, even from the artists in his own workshop—to this day engravers are hard-pressed to attain the same quality of prints even with today's technology. (It may be something as mundane as the rag he used to wipe off the excess ink.) In his *Vita* Alberti described visiting painters in their workshops to try to uncover the "exceptional and secret knowledge" regarding their art. Hendrik Hondius, describing how some painters used a tilted glass frame through which they viewed a scene in order

to help them capture the proper perspective, noted that artists held the technique as a "fort secrete, & comme un mystere"—as a deep secret, and like a mystery. As another writer of the time pointed out, "that which ravishes the spirit of men is an admirable effect of which the cause is unknown: otherwise should one discover the trick half the pleasure is lost." The painter could not trick the eye if he revealed his secrets. Even the recipes for mixing paint colors were considered privileged information; books containing these recipes were considered "books of secrets." Not only did painters wish to increase the allure and mystery of their work; they were keeping their methods from competitors, as a protection of their trade secrets. We have little documentary evidence about methods from the artists themselves during this time. So it is no argument against the use of the camera obscura that painters did not discuss it in written documents. We must look to the pictures themselves for our evidence. Of all the artists who may have experimented with looking at the world through the camera obscura, Vermeer presents in his paintings the clearest evidence of such experimenting.

- 7 -

After turning to the quiet, intimate scenes that he began to paint at the end of the 1650s, Vermeer realized he had found his niche, and over the next decade he produced his most exquisite pictures. He had already experimented with mirrors and lenses. But who could have introduced Vermeer to the camera obscura? It might have been his possible teacher Evert van Aelst, or Evert's son Willem. It could have been Huygens, who owned a box-type camera obscura since 1622, and was recommending its use to his artist friends. It might have been Fabritius, a close friend of Van Hoogstraten's—and Van Hoogstraten was at that time exhorting artists to use the device. It could have been any of the other painters who seem to have been familiar with the device. Or, as some writers have casually suggested, it might have been Vermeer's neighbor Antoni Leeuwenhoek, though there

is no direct evidence of this.* However it was that Vermeer came to know the camera obscura, his pictures from about 1660, when he was twenty-eight years old, demonstrate a familiarity with images seen through the device. A likely candidate for his first painting made after experiencing a camera obscura image is his only known cityscape, *A View of Delft*. In that picture, we see Delft across the Schie Canal, with the Schiedam Gate at the left, the twinned-turret Rotterdam Gate at the right, and, in the brightest area of light, the tower of the New Church. To the left is the smaller tower of the Old Church. Although *A View of Delft* depicts a restful scene, the Schie Canal was a bustling waterway. On any given day a constant stream of tugboats, clam runners, and *trekschuits* (horse-drawn canal barges) came up the river Schie from Rotterdam, Schiedam, and Delfshaven, headed to The Hague, Leiden, and ports north. Passengers and goods incessantly streamed on and off along this stretch of the city walls. As Mariët Westermann evocatively writes of this picture, "the scene's varied light effects look so natural—deep shadow and bright patches, pinpoint highlights and watery reflections—that *the eye ignores what the mind knows: that this light is high artifice, that it is a work of painting.*"

Other artists known for using the camera obscura tended to specialize in "chorographical" or panoramic studies such as this. Canaletto, of whom it was said that he "taught the correct way of using the *camera ottica* [camera obscura]," was expert in painting views of Venice by means of the optical device starting around 1719. Even earlier than Canaletto, a painter from the Netherlands was known to rely on a camera obscura to depict Roman cityscapes.

Gaspare Vanvitelli (born in Utrecht as Gaspar van Wittel in 1653) had originally been employed by a Dutch engineer to make topographical drawings of the area around the river Tiber, a task for which the use of a camera obscura was already routine. He later Italianized his name and became a successful painter of panoramic Roman scenes. Vanvitelli would take a portable, box-type camera obscura to a site opposite a view that he wanted to paint. He used a

---

* Unlike these other writers, I believe that Leeuwenhoek may have been using a form of camera obscura himself, as I discuss in part II.

coordinate grid system to map what he saw on the screen of his camera onto his canvas. Then he would take the canvas to his studio and fill in the remaining details of the picture. As Vanvitelli would later do, Vermeer may have taken a box-type camera on-site to explore the optics of the scene before painting *A View of Delft*. He may even have taken his canvas with him. But even if he did so, instead of using a careful and precise coordinate grid system, Vermeer probably just took some visual "notes," either in white chalk on the canvas (which would be dissolved by the later addition of oil paint, and so become invisible to x-rays centuries later) or in the lead white underpainting. There is evidence for a similar kind of "note taking" in the underpainting of several of Vermeer's paintings, including *Girl with a Pearl Earring*. Stereomicroscopic analysis has shown some paint strokes in a light ocher color on the ground at the edge of the girl's face. In the seventeenth century it was not unusual to use light ocher for sketching the composition before beginning to paint.

Looking at the scene of Delft through a camera obscura, Vermeer would have noted the richness of color, the nuances of light and shade, the special nature of the highlights glinting off the canal. He would have seen the different planes of focus, how the foreground looks slightly blurred as the middle ground is sharp. He would have taken in the very "visual feel" of the camera obscura image, which he would file in his mind—as a kind of "visual memory"—for recalling while painting in his studio. One reason it is clear that Vermeer did not merely trace the camera obscura image is that we can see by x-ray analysis that he modified the red roofs to the right of the image, a change that reinforced the essential horizontality of the composition and so seems to have been made for that reason alone—a change, then, that he made for stylistic rather than photographic reasons. We can date Vermeer's discovery of the value of the camera obscura to about this time because, in his earlier works, Vermeer was struggling with the perspective of his scenes, as in *The Procuress*, where there seems to be a "split screen" between the two parts of the painting, the triad of the courtesan, brothel keeper, and customer on the one side and the onlooker on the other. Similarly, the sloping table of *A Maid Asleep* seems to exist in a distinct perspective scheme from the

lady slumbering over it. In his masterworks of the 1660s—*The Milkmaid*, *Woman in Blue Reading a Letter*, and *Woman with a Pearl Necklace*, for example—Vermeer's figures and their spatial environments are, at last, "mutually complementary," with a newfound harmony between them. Suddenly, every element in his pictures finds its place. In *Woman with a Pearl Necklace*, the perspective pattern extends along the window frames, across the floor, to the wall where the girl is "discovered" by the viewer. She is caught in what Lawrence Gowing beautifully described as Vermeer's "mathematical net, made definite at last."

At this time Vermeer's painting style becomes more consistent with the way that perspective was being depicted in the domestic interiors of this period by artists such as De Hooch, and in the church interiors painted by Houckgeest, Van Vliet, and De Witte. These pictures feature black and white marble floors such as those Vermeer began to include in his domestic interiors. In many of those pictures, the floor tiles, tabletops, windows, and figures all recede to a single vanishing point on the horizon. Vermeer takes this to its highest level; in *The Glass of Wine* not only do the floor tiles, tabletop, and window all recede to a single vanishing point, but so does the man's eye and the top of the woman's head. Vermeer in a sense one-ups De Hooch, whose similar painting from the same year, *An Interior with a Woman Drinking with Two Men, and a Maidservant*, does not fully integrate the figures into their setting. The two men, painting similar scenes in Delft in the late 1650s, clearly inspired—and may have been competing with—each other. (It may not be accidental that around the time that Vermeer discovered the camera obscura and began to create his finest paintings, De Hooch also "upped his game," seemingly making a conscious decision to raise his standards and paint pictures addressed to connoisseurs.)

The camera obscura was known by artists to be an extraordinary tool in composing perspective views. Jean-François Niceron wrote in his book on perspective theory that images created in the camera obscura were so vivid that if "the painter imitates all the shapes he sees, and if he applies to them the colors that appear so vividly, he will have a perspective as perfect as one could reasonably desire." As

Leonardo had much earlier recognized with mirrors, it was of great value for the painter to see three-dimensional scenes reflected or projected into a two-dimensional form, since painting with proper perspective required imitating the same result: a flattened rendering of three-dimensional space. The artist is in the challenging position of looking at a three-dimensional scene with his two-dimensional retinas and then generating a two-dimensional picture that appears three-dimensional to viewers looking at it with their two-dimensional eyes. An optical device that projected a two-dimensional image of the scene would be valuable in solving this problem by replicating the image on the retina. Vermeer's sudden facility with perspective may have been related to his discovery of the camera obscura, because seeing the way that three-dimensional perspective is rendered on the two-dimensional screen of a camera obscura would have provided insights for his own depictions of perspective.

-8-

A camera obscura may also have helped Vermeer with his composing of pictures. He doubtless possessed an uncanny sense of how composition could convey a sense of timelessness to fleeting moments of daily life: the milkmaid caught pouring out a pitcher, a woman glimpsed reading, or writing, an emotion-laden letter. His compositions were highly geometrical as well; in *Study of a Young Woman*, the girl's wrist is but a blob of flesh—not at all anatomically correct—but with its shape and position it echoes the head and gives a kind of rhythm to the drape of her garment. By adding just a touch of a white shirt at her collar, Vermeer is picking up the white of her eyes and, of course, the large dimly gleaming pearl earring. In *Young Woman with a Water Pitcher*, the geometry of the composition suggests calmness and concentration, and we sense that we would have the same emotional reaction to this picture even if we viewed it upside down.

Vermeer did not *need* an optical instrument to compose his pictures. But by looking at his compositions with a camera obscura, he could have seen new ways to frame a scene, including complex

arrangements that would have been difficult to translate into two-dimensional space without the camera obscura's flattening effect. We do know that Vermeer took great care in composing his pictures, so much so that many of them have alterations made during the painting process: chairs, maps, framed pictures, musical instruments, men, and even a dog can be seen under x-ray analysis to have been taken out of compositions once Vermeer saw that they did not contribute to the overall compositional or emotional effect he sought. Why would he not, then, have availed himself of a device that would have enabled him to experiment with how certain complex compositions would look on a flat canvas, even before starting to paint?

Vermeer's mastery with color and tone could also have been aided by the use of a camera obscura. Tone is the relative darkness or lightness of a color, and it is not always accurately evaluated by the naked eye. For one thing, the mind's involvement in sight means that we tend to compensate for disparities in tone for the sake of object recognition: when we view a white shirt in the sunlight, and then in shade, we "see" it both times as white, because we know it is the same shirt. However, color perception changes under different levels of illumination, as Vermeer recognized. He realized that if the painter wishes to distinguish different lighting conditions, he or she must represent the white shirt differently in the two cases, by using a pure white pigment in the first case and adding black and/or a bit of umber to the white. Sometimes it is difficult for the painter to do this properly, because he, too, is used to seeing the shirt as having the same tone of white in both lighting conditions. Viewing the shirt through the camera obscura renders the differences in tone under different lighting conditions more noticeable, since the device narrows the range of brightness found in nature to a more limited range—one that is easier to reproduce with the painter's palette. And the camera obscura, unlike the human eye, does not immediately adapt to different amounts of light; the camera obscura allows the painter to see the relative values of tones present in a scene more clearly. In the image produced by a camera obscura, the shirt looks darker—and even a different color—in shadow, and brighter in light. Vermeer's familiarity with the images seen through the camera obscura is apparent

in the way he records tonal value. In *The Concert*, for example, we find the white fur trim on the standing woman's jacket to be a bright white on top, but a darker color at the hem, where it is receiving less of the light from the window.

The camera obscura concentrates colors into a restricted area, so objects seem more intensely pigmented than when seen with the naked eye. The scale of the images is reduced, but not the intensity of the color, resulting in the concentration of color. The effect is the appearance of richer and seemingly purer colors than those seen in nature. Among the most obvious hallmarks of Vermeer's canvases are the bright, jewel-like tones of his colors, his extravagant use of ultramarine and yellow pigments. The richness of color in *A View of Delft* suggests the image in a camera obscura. So does the intensity of yellows and whites, and the saturation of the blues and the browns, in *Mistress and Maid*. But camera obscuras have a particularly noticeable effect on colored objects in deep shadow: even here, the objects are seen with a chromatic intensity missed by the naked eye.* In his *Trattato* Leonardo da Vinci had pointed out that shadows have colors—they are never purely black, or even almost black. For instance, the shadow cast by a haystack on the snow will look bluish, because the haystack is blocking the direct yellow light from the sun, so the snow is lit only by the scattered blue light from the sky. Claude Monet would later use this insight to paint his studies of haystacks, such as *Grainstack in the Morning, Snow Effect* (1891).

Vermeer was one of the first artists to realize this insight in his pictures; his shadows are never uniformly brown or black; time and again we find him reaching for blues—and even yellows—to depict shadows. We see this in the deep blue shadows of the woman's wrap in *The Milkmaid*, the shadows to the right of the chair in *Woman in Blue Reading a Letter*, which are rendered in colors ranging from a soft blue to a deep blue-black, and in *The Music Lesson*, on the lower part of the back wall, where shadows range from blue to yellow. In *The*

---

* While looking through a modern box-type camera obscura pointed out the window from an apartment on a high floor, I have seen dark shadows on buildings outside that I had not noticed with my naked eyes.

*Guitar Player*, the shadow on the girl's neck is almost green. Other painters of Vermeer's time, such as De Hooch and Dou, used the more traditional neutral grays to render deep shadows.

Vermeer would have seen that images viewed with a camera obscura have softer contours; the seventeenth-century lenses, suffering from spherical aberration, did not focus with complete precision through the entire depth of fields, so even a single three-dimensional object would appear blurred in parts. Like camera obscura images, Vermeer's forms, especially in the middle and later paintings, have soft contours made up of areas of light and shade, rather than strict outlines. In *Girl with a Pearl Earring* there are no defining lines of the face; the shape of the head is marked out merely by broad areas of light and dark, separated by softly rounded edges. There is no strong line to speak of between the girl's nose and her right cheek, just a modulation of tone that is enough to signify the division. Similarly, in *Mistress and Maid* the face of the woman of the house is defined only by the slightest of variation in flesh tones, yet still manages to convey her deep concern. Vermeer learned that by applying glazes over impastos he could soften forms and create diffused contours; in *Woman in Blue Reading a Letter*, the woman is outlined with a soft diffused stroke, painted with a blend of the blues of her dress and the white of the wall behind her. In this way Vermeer gives us the impression that the woman is part of the scene, bound tightly to it—and yet, at the same time, standing apart from it. In *The Milkmaid* he achieved a softer "edge" in the contour of the woman's blue skirt against the pale wall by extending the black underpainting beyond the edge of the skirt. The white underpaint of the background wall overlaps this black layer. The blue of the skirt was applied overlapping this white background. The skirt's edge was established just beyond this line with the final background color painted over the white.

A related effect is that the lens produces a differentiation of focus throughout the depth of field, so that when objects in the middle ground are in sharp focus, objects in the foreground and background are blurred. Vermeer captured this effect most noticeably in *The Little Street*, where the façade of the building is painted in detail, while the foreground pavement and background houses are slightly out

of focus. In *The Lacemaker* the white and red threads spilling out of the cushion-shaped box known as a *naaikussen* (sewing pillow) are so abbreviated as to look impressionistic; they are greatly unfocused relative to the forms in the middle of the composition. This effect is also seen in *Girl with a Red Hat*.

Another optical effect peculiar to the seventeenth-century camera obscura was the production of diffused circles of light forming around unfocused specular highlights, resembling those fuzzy spots of light in out-of-focus photographs called "disks of confusion." In camera obscuras of the time, this optical effect was common because of the way instrument makers sought to minimize the spherical aberration. Taking Barbaro's suggestion, they would place a diaphragm with a tiny hole at the center immediately behind the lens. This reduced the effect of spherical aberration by blocking out all the light except for that passing through the center of the lens. However, in order to succeed at that goal the hole had to be so small that it deprived the image of sufficient light, and would sometimes confuse the image with diffraction effects such as small halos of light.

Natural highlights are bright reflections often seen with the naked eye on wet or shiny surfaces, such as glass or polished metal, viewed in bright light. On the screen of a camera obscura, these natural highlights are often surrounded by hazy halos of light, which are not seen with the naked eye. In his later works Vermeer begins an effusive use of *pointillés*, globular touches of thick opaque paint, pure white or slightly yellowish, to indicate these halos or discs of confusion. He scatters these *pointillés* along the water's edge in *A View of Delft*, accentuating the play of light on the different textures of water and wooden boats. In *The Milkmaid* the loaf of bread looks freshly baked in part because of the *pointillés* indicating light reflecting off its surfaces. In *The Lacemaker* thick impasted globules appear on the relatively unfocused foreground objects—the escaping threads and the tablecloth.

Yet, Vermeer did not literally transcribe disks of confusion he saw in the camera obscura. These occur only on shining surfaces in bright sunlight, but he felt free to apply these globules of paint to areas of deep shadow (in *A View of Delft*) and nonreflective, matte

surfaces (bread in *The Milkmaid*, threads in *The Lacemaker*). His use of the specular highlights is not photographic, or even exactly naturalistic, but illusionistic: although matte surfaces would not really have those highlights, his use of them does, somehow, make the surface appear more real to us.

Vermeer looked at nature through the camera obscura to learn about light, shadow, tone, and color, but he did not slavishly imitate what he saw there. He seems to have taken to heart Leonardo's dictum that "the painter who draws merely by practice and by eye, without any reason, is like a mirror which copies everything placed in front of it without knowing about them." Sometimes his optical effects adhere strictly to physical laws of optics, and sometimes they ignore these laws. Vermeer altered the optics of the camera to suit his composition or the emotion he wished to convey.

Indeed, it sometimes looks as though Vermeer is playing up the optical effects of the camera obscura—as though he *wanted* his paintings to look as if painted with one, similar to the way Van Hoogstraten mimicked the camera obscura image in some of his works. For example, in both *Girl with a Pearl Earring* and *Girl with a Red Hat*, the lips show light reflections from moisture that are identical, and the out-of-focus way that Vermeer painted the yellow jacket in the first painting is comparable to the way he paints the lion finials of the chair in the second. As Jørgen Wadum, the former chief conservator of the Royal Cabinet of Paintings, Mauritshuis, asked, "Has this been done because the image was rendered via a camera obscura that would not focus well, or because the artist wanted us to believe that we were looking through such a device when viewing the girls?"

The camera obscura would have supplied new information to Vermeer, information about the way images are seen, and the way they can be manipulated. Just as we pick up an object and turn it around on all sides in order to learn more about it, we can manipulate the image in the camera obscura by moving it closer to and farther from the scene to be projected, by altering the lenses and the angle of the mirror, by focusing it on the foreground, or the background. By playing around with the camera obscura image, Vermeer would have

gained new knowledge about how things appear to us in different conditions of light and space. As one artist has recently described it, "the painter [with] the camera becomes a researcher who, like Van Leeuwenhoek in his microscope, discovers new phenomena in the structures of the familiar environment." That is how Vermeer used his camera obscura.

-9-

Others have argued that Vermeer did imitate the camera obscura image—that he aimed the projection at his canvas and traced directly on it. In 1950, P. T. A. Swillens claimed that Vermeer traced some of his pictures from a camera obscura projection. Two decades later Daniel Fink proposed that Vermeer traced a camera obscura projection in twenty-seven of his paintings, nearly all his works after 1657. Most recently, Philip Steadman suggested that, because of the sudden appearance of perfect perspective composition and the other optical features in Vermeer's pictures around this time, we can be fairly certain that Vermeer traced the images projected onto his canvases by a room-type camera obscura in no fewer than ten pictures. As Steadman's analysis has been influential in discussions of Vermeer since it was published in 2001, it is worth taking a closer look at it.

Steadman concentrated on ten pictures that look as though they were painted in the same room, sharing the same black and white marble tiles (though differing in the pattern of those tiles), and with the same or similar arrangement of casement windows to the viewer's left. By assuming that the marble tiles are the same size in each case, and by assigning them a standard measure of 29.3 cm in length, Steadman claimed we could know the dimensions of the room. He next located the "theoretical perspective viewpoint": that point within the room at which Vermeer would have had to put his eye to see the precise view in question. Everything that can be seen in each picture, Steadman proposed, is contained in a "visual pyramid," whose apex is the viewpoint. If we extend the lines of the pyramid from the apex to meet the room's back wall, we find that those lines define a

rectangle on that wall. In six out of the ten cases, Steadman argued, this rectangle is almost the exact size of Vermeer's painting. This "extraordinary geometrical coincidence" has only one reasonable explanation according to Steadman: "each painting is the same size as its projected image because Vermeer has traced it" from inside a booth-type camera obscura.

Steadman's geometrical analysis was, in many ways, a virtuoso feat. And he has, importantly, drawn the attention of both a broad popular audience and art historians to the fact that Vermeer probably did use a camera obscura in some way. But Steadman was thrown off course by reading too much into the literal translation of the pictures. Pictures, especially of this period, are documents of history but are not to be read literally as exact transcriptions of life in the Dutch Republic. While Vermeer no doubt did paint his pictures in the same room—the attic studio at the home he shared with his mother-in-law—his pictures are not meant to be photographic replicas of that room.

For one thing, it is just about impossible that the attic room had black-and-white marble flooring.* Although many paintings of the day featured black and white marble floor tiles, they were not literal descriptions of the private homes depicted in the scenes. In the seventeenth century such expensive floors were present mainly in public buildings, where impressive public spaces were requisite. One of the few places such tiles actually existed in a domestic setting was in several rooms at the palace of Rijswick, the Prince of Orange's residence. Even in the homes of Delft's wealthy merchants, marble floors were rare, and limited to the *voorhuis*, the vestibule, where guests would enter. The wealthiest Dutch families still preferred wooden floors in their living spaces—they are much more comfortable underfoot in damp and cold climates.

Like Turkish carpets and brass chandeliers, marble floors appear

---

* Steadman believes that Vermeer's studio was on the ground floor, but its location on the top floor of the house is clearly stated in the probate inventory taken after Vermeer's death; and, of course, the light would have been better on the top floor, so it makes sense that Vermeer would have made his studio there.

as decorative elements in the genre paintings of the day to connote the status and taste of prospective buyers, rather than the way these buyers actually lived. These pictures are less like photographs of actual spaces than like the imaginary tiled loggia through which Daniël Vosmaer represented Delft in his *View of Delft through an Imaginary Loggia* (1663). Indeed, there was a tradition in Delft painting of "imaginary architecture," which combined realism and illusionism by depicting made-up spaces in an incredibly realistic way, with effects of light and shadow that made viewers feel they were transported there. Such paintings included Houckgeest's *Imaginary Catholic Church* and Bartholomeus van Bassen's *Imaginary Palace for the Winter King* (1639) and *The Tomb of William the Silent in an Imaginary Church* (1620). Even real spaces were depicted with imaginary elements, as in Johannes Coesermans's *Interior of the Nieuwe Kerk* (1663) and in Louys Aernoutsz Elsevier's *Interior of the Oude Kerk, Delft, Seen through a Stone Doorway* (1653). In these paintings the two Delft churches are depicted with black and white marble tiles, which neither of them had. Indeed, there is no evidence that church interiors ever contained black and white marble tiles, yet they often appear in the church interiors of the time, most likely for their perspective effect. These checkerboard floors even appear in scenes on the Delftware tiles of the day.

This tradition of imaginary tiled floors was continued in the interiors of De Hooch and Vermeer. The appearance of tiled floors in so many of the genre paintings and church interiors of the time is comparable to the imaginary element in the still-life paintings of the same period. Flower paintings, like those of Balthasar van der Ast, depicted flowers that did not bloom at the same time—and which, because of their costliness, would never have been cut, put in a vase, and allowed to wilt quickly. Rather, the flowers (especially the tulips) were kept in gardens designed for displaying prized specimens, much like the cabinets of curiosity of the amateur natural philosophers. These imaginary interiors, both of churches and of private homes, and the depiction of imaginary flower bouquets, all combined the realism and illusionism of seventeenth-century Dutch painting.

There would certainly be no marble flooring in the attic of a house,

especially in a room used by no one but the penurious son-in-law of the home's owner. So it makes no sense to "measure" Vermeer's room from supposed tracings he made of the room's checkerboard marble floor. Further, Steadman's claim that there is only one reasonable explanation for the "extraordinary geometrical coincidence" of the six paintings (the fact that the rectangle formed by the extension of the visual pyramid is the size of the six pictures) is misleading. The six paintings Steadman points to are all just about the same size; five of them differing from each other only by a couple of centimeters in width or height. Another, even simpler explanation for this fact is that Vermeer was using standard-size canvases, and painted pictures of rooms that fit on those canvases.

There is much evidence that canvas sizes in the Northern Netherlands were starting to become standardized at this time, as they were in Britain, Italy, and France. Some support for this is that pictures in a particular genre tended to be painted on canvases with the same ratio. Sea paintings were generally painted on narrow canvases with a height-to-width ratio of about 1:1.60. Landscapes often had a ratio of 1:1.40 and portraits a width-to-height ratio of 1:1.20. Many of Vermeer's paintings have a ratio of 1:1.14, which suggests that he bought portrait-size canvases and cut them down slightly. Of course, it could also be that Vermeer simply chose canvas sizes he liked to work with, or that his clients preferred to purchase, and then fit his scenes onto them. In either case, it stands to reason that Vermeer would compose his pictures to depict a room that could fit into the canvas he was using—that he would choose to paint marble tiles and chairs and windows and ceiling beams that were the right proportions to make the room look like a real three-dimensional space, even if the pictures were not photographic replicas of the room and its contents.

Vermeer did not trace his paintings wholesale from the camera obscura image. But one need not conjecture that Vermeer traced a camera obscura image in order to see a role for it in his toolkit. He used the camera obscura much as the natural philosophers used it: to experiment with light, to investigate and discover its optical properties. His object would have been to learn how to create the

"semblance of reality"—how to attain that sense of *houding*, that make-believe space that feels real. Since the ideal of a painting in the seventeenth century was an image that makes things that do not exist appear to exist, thereby deceiving the viewer in a pleasurable way, Vermeer needed to learn how things appear to exist—how things are seen by us. His success is confirmed by how strongly we feel that we have stumbled upon a private moment, that we are spying upon a woman alone in her thoughts, reading or writing a letter, pouring milk from a pitcher, or measuring silver with a balance.

While using the camera obscura, we may imagine, Vermeer would have felt as though he had entered Kepler's eye itself and was seeing the image "painted" on the retina. He was not merely reproducing nature but evoking the way nature manifested itself to human vision. He was experimentally exploring the concept of sight. Like Leeuwenhoek, and following Leonardo da Vinci's dictum, Vermeer needed to "learn how to see." In the seventeenth century, Dutch painters—Vermeer foremost among them—began to use optical instruments to help them learn how to see—and how to translate sight, itself a picture, into the language of paint on canvas.

# Mathematical Artists

||||||||||||||||||||||||||||||||||||||||||||||||||||||||||||||||||||||||||||||||||||||||||||||||||||||||||||||||||||||||||||||||||||||||||||||||||||||||||||||||||||||||||||||||||||||||||||||

*I*N 1669 VERMEER painted a picture known today as *The Geographer*, but that depicts a surveyor at work, with the tools of his trade: a pair of dividers, used by surveyors to make measurements, a terrestrial globe, and two maps (one unrolled on the table, one hung on the wall behind him). Vermeer's surveyor is a solidly built man in his late thirties, his hair in fashionably cascading dark ringlets. His left hand firmly grasps the table over which he leans, while his right hand holds the dividers. Light streams into the room from a leaded glass window to the left of the man, illuminating his face and the map on the table.*

Vermeer's surveyor is dressed in scholarly robes, blue with red trim, and his hair is pulled behind his ears, testifying to the seriousness of his studies. He shows an energy and active nature absent from Vermeer's quieter, more contemplative pictures of women from this period. Even the brisk furrows of the blue robe give us a sense of the surveyor's intensity. Yet he shares an attitude with Vermeer's women: he is shown absorbed in his own doings, not posing for the viewer.

---

*Although the geographer is looking out the window, toward the light, it is known by x-ray analysis that Vermeer originally painted his head looking down at the table; indeed, the faint outline of the original position of the head is still visible in the picture.

We have come upon him unawares, and are now eavesdropping on him as he works.

Later, when the picture was sold at auction, it was described as depicting a "mathematical artist." Why did Vermeer abandon his studies of women in domestic settings to depict a male natural philosopher actively pursuing his studies? And who was this mathematical artist? Could the model be, as some writers have casually speculated, Vermeer's neighbor Antoni Leeuwenhoek?

-1-

There are some reasons to believe that Vermeer's model for this painting was Leeuwenheok. The man in the picture is about Leeuwenhoek's age—in his late thirties, like Vermeer—and it is possible to see the model as an idealized version of Leeuwenhoek as he could have looked a decade before he appears in another painting, Cornelis de Man's *Anatomy Lesson of Cornelis Isaaks 's Gravesande* (1681).

De Man was commissioned to produce the painting by the surgeons' guild. The group portrait depicted a human dissection by Cornelis Isaaks 's Gravesande, a surgeon who lived near Leeuwenhoek, on the corner of the Nieuwstraat and Hippolytusbuurt. As the city's official anatomist, 's Gravesande performed weekly dissections in the Theatrum Anatomicum, on the Verwersdijk, dissections that Leeuwenhoek would sometimes observe. The painting shows the surgeon examining a cadaver, while other members of the guild (and Leeuwenhoek) look on. According to the report of the Delft historian Boitet, De Man asked Leeuwenhoek, who was not a member of the guild, to sit for the picture "in order to add more luster" to it. Leeuwenhoek is behind the left shoulder of 's Gravesande, with his hand over his heart. His nephew and godson, Antoni de Molijn (1656–1729), son of his sister Margriete and her husband Jan Molijn, is at the top left of the picture. Antoni de Molijn was a surgeon who trained in Paris and had returned to Delft to practice. Another figure represented in the picture is the municipal physician Hendrik d'Acquet. D'Acquet was known for having the most impressive cabinet of

curiosities in Delft and had obtained for Leeuwenhoek from Guelders "a certain sort of insect (unknown, for ought I known, in this part of the country) called cockchafer." (Leeuwenhoek later observed two of these insects copulating in order to examine the male sperm.) Leeuwenhoek was related to De Man; the daughter of his great-aunt Margaretha van den Berch, Cornelia Jans Van Halmael, had married Anthoni Cornelis de Man (1587–1665), the nephew of the painter. In this picture Leeuwenhoek looks older than in the Vermeer pictures, and less romanticized, but with the same brown ringlets, strong nose, large dark eyes, and thin face.

Later still, at the height of his fame, Leeuwenhoek would be painted by Johannes Verkolje, in what was pronounced by Constantijn Huygens to be an "excellent likeness." The man in the 1686 picture is older, and much fleshier, especially around the nose and eyes, than Vermeer's model, but not completely different from him—though it is more difficult to see the resemblance. Notably, however, Verkolje depicts Leeuwenhoek with the very same equipment portrayed in Vermeer's painting: a pair of dividers, a globe, and a map—as if Leeuwenhoek wished to be remembered not only for his scientific discoveries but also for posing for Vermeer.

Not only does the model in *The Geographer* somewhat resemble Leeuwenhoek, but Vermeer has painted a man engaged in science, an activity that Leeuwenhoek was pursuing single-mindedly by this time. Boitet reports that Leeuwenhoek was known by his fellow townsmen to have begun studying navigation, astronomy, mathematics, and natural philosophy around 1665. And the very year that Vermeer depicted a surveyor at work, Leeuwenhoek had passed the exam enabling him to be registered as an official *landmeter*, or surveyor, in Delft. It is suggestive that this is one of the few paintings dated by Vermeer himself, as if the year 1669 was particularly significant. On February 4, 1669, an act admitting Leeuwenhoek to the surveying profession was published in the state archives:

Forasmuch as Antony Leeuwenhoeck [*sic*], burgher and denizen of the town of Delft, hath made petition unto the Court of Holland, saying that he hath for some while heretofore exer-

cised himself in the art of Geometry, and advanced so far that he deems himself capable to fulfil henceforth the office of surveyor, and perform the service and duty thereof, wherefore he humbly intreateth that the Court be pleased to permit him to exercise the office of surveyor. . . .

The entry goes on to note that Leeuwenhoek was examined by "the mathematician Genesius Baen" and has been found competent to perform the office of surveyor. Leeuwenhoek commented on one of the surveying tasks he undertook—measuring the height of the tower of the Nieuwe Kerk using his quadrant. Later, his correspondence will be replete with mathematical calculations of various kinds: atmospheric pressure, air resistance on falling bodies, water pressure on the eye of a swimming whale, and number of minuscule beings in a single drop of water.

Vermeer intended *The Geographer* as a pendant, or a companion picture, to one painted the year before, *The Astronomer*, which featured the same model. In the earlier picture, the natural philosopher is turned toward a celestial globe on the table and an astronomical manual opened on the table before him. The book is Adriaen Metius's* *Institutiones astronomicae & geographicae*, a book on both astronomy and geography, subjects then considered two sides of the same scientific coin; the presence of this book further suggests that the two pictures were meant as pendants. Another clue that Vermeer gives us is that on the wall behind the natural philosopher in *The Astronomer* we can see part of Peter Lely's painting of Moses. In the seventeenth century Moses was often described as the oldest geographer. The pictures were originally the same size, though *The Astronomer* was cut down later. Throughout the eighteenth century they were always offered for sale together, from their first appearances at a Rotterdam auction in 1713—where they were offered as a set for three hundred guilders (about $4,025 today).

As a surveyor, Leeuwenhoek would have used the book portrayed

---

* Adriaen Metius was the brother of Jacob Metius, who had applied unsuccessfully to the States General for a patent for his telecscope in 1608.

in *The Astronomer.* Metius taught surveying at the University of Franeker, and the book discusses how astronomy and geography are related in the tasks required of a surveyor. If Leeuwenhoek owned that book, then he may have lent it to Vermeer—he may even have brought it to his sittings for the painting. We know that Leeuwenhoek probably owned another book by Metius, his *Arithmeticae et geomitrae practica*, because he would later use it to calculate the number of spermatozoa in the milt of a cod.

It is possible, as some have speculated, that Leeuwenhoek commissioned the two paintings to mark his new position as surveyor of Delft. There is no evidence of this. What is more likely is that the paintings are Vermeer's comment on the keen interest in—almost obsession with—science that pervaded Delft and the Dutch Republic. His depictions of the natural philosopher at work are most likely not a paint-for-hire celebration of Leeuwenhoek's new scientific status, and may not even be meant as portraits of him, but they do represent the kind of person Leeuwenhoek was. And they are clearly celebrations of science, in particular sciences that gain knowledge by visual experience.

Surely it is telling that in depicting natural philosophers studying both the heavens and the earth, Vermeer is also showing off two fields in which the new optical instruments were used. (He shows neither in the pictures themselves, although one might—with a little imagination—see a box-type camera obscura in what looks like a little side table with a hinged top in the lower-right corner of *The Geographer.*) Astronomers, of course, used the telescope for their observations of the night sky. Just four years before he painted *The Astronomer*, in 1664, a comet appeared and was visible for six weeks. During this time it was tracked across the sky by astronomers, including Constantijn Huygens's son Christiaan, until March 20, 1665. When this comet disappeared, another—this one with a tail an astonishing thirty astronomical degrees in length—was visible for a week. Several treatises on comets appeared in the following years, and many amateurs were moved to purchase telescopes and begin to study the night skies, seeking the next comet.

Surveyors, too, used optical devices: as we saw, they had been

using a type of camera obscura for cartographical drawing since the sixteenth century. The English mathematicians John Dee, Thomas Diggs, and William Browne had discussed the use of camera obscuras for cartographical drawing in the last quarter of the century, as had the inventor of the first portable camera obscura, Friedrich Risner. Thomas Browne described the use of "perspective glasses," a type of camera obscura, for making topographical surveys; these used a biconvex lens a foot or more in diameter, placed in a wooden frame. A large concave mirror was placed slightly beyond the point of the inversion of light rays; the mirror would show an enlarged image of the landscape being surveyed, which could be copied by the surveyor. (Although the production of the right-side-up image was similar to that of the camera obscura in that it used a lens and mirror, the image was not projected onto a screen or paper, as in the standard camera obscura setup.) Thomas Harriot used perspective glasses in his cartographical surveys of the lands of Virginia in 1588; he later employed a similar device to project and draw the moon's surface. In depicting the astronomer and the surveyor at work, Vermeer has painted two natural philosophers who, much like Vermeer himself, rely on optical devices to gain their knowledge of the physical world.

-2-

By this time—whether or not Leeuwenhoek modeled for Vermeer, and whether or not they knew each other—the two men were moving in very close geographical, social, and professional circles. They both lived and worked within a small area in and near the Market Square; the distance between their homes could be walked at a leisurely pace in three minutes. In a town whose population then numbered less than twenty thousand, these exact contemporaries had both attained positions of social and political standing. Leeuwenhoek was already recognized by his fellow citizens as someone engaged in scientific pursuits, while Vermeer was known as a painter of note even outside of Delft; the 1664 inventory of the painter Johan Larson, who lived in The Hague, listed a *tronie*, or picture of a head, by

Vermeer. Both men had connections to the city government. Leeuwenhoek was the chamberlain of the Sheriff's Chamber, and, in 1661 and 1662, Vermeer was appointed headman of the Guild of St. Luke. (He served a later term in 1672.) These two positions intersected in various ways. In 1661 the artists of Delft had built themselves a new guildhall, which stood on the site of city property, the Old Men's House Chapel. The guildhall was on the Voldersgracht, right behind the Market Square—close to Vermeer's birth home, his family's tavern, and Leeuwenhoek's workplace in the Town Hall.

The board of the guild, called the "headmen," was chosen every year on October 18 (St. Luke's Day). It consisted of six board members; the custom was that two members would be painters, two glassmakers, and two "china potters," or faience makers. The board met every four weeks in the guild chamber at five in the afternoon; anyone who missed a meeting was fined twenty-four stuivers. The board was responsible for enforcing the rules of the guild and setting fines for offenders; for example, if a master did not properly register his apprentices, he was fined thirty stuivers (one and a half guilders, or twenty-two dollars) per day.

Each year the guild would supply a list of names, two for each vacant post, to the Town Hall, and the burgomasters and aldermen would choose the administrators of the guilds from the list. As someone privy to the deliberations of the burgomasters, for whom he worked, Leeuwenhoek would have known that Vermeer had been appointed headman of the St. Luke's Guild even before the painter did.

Leeuwenhoek was well acquainted with a number of men who were members of the St. Luke's Guild at the same time as Vermeer. His stepfather and stepbrothers had been members; though his stepfather had died in 1646, his brother-in-law Jan Molijn was still a guild member, as was Jan's brother Gerrit. Leeuwenhoek may also have been related to two other Delft painters, both members of the guild: Mateus de Bergh (also called Mateus van den Berch) and his brother Gillis. Mateus and Gillis were sons of the sailmaker Daniel de Bergh, who sold Vermeer an iceboat—popular with children for gliding over the frozen canals—for eighty guilders in the winter of 1660. (Unfor

tunately for Vermeer's children, the canals failed to freeze for the next two winters.) Leeuwenhoek's mother's family was called Van den Berch or Van der Bergh, and it could be that she met her second husband through her artist relatives. And we have seen that Leeuwenhoek was related by marriage to Cornelis de Man. So Leeuwenhoek would have had many opportunities to socialize with artists.

Through his artist relatives, or through his connections at the Town Hall, Leeuwenhoek would surely have been invited to some of the large feasts often held at the St. Luke's Guildhall. The guilds, which had previously taken part in Catholic festivals, had transferred their former religious rituals to secular celebrations; after the Reformation the guild feasts became known for their intricate rites and customs, in which members and their guests would be bestowed honors of wine pouring, toast making, and meat carving. Indeed, carving became so elaborate an art that books were published to detail the proper way to carve on formal occasions. Visitors may be forgiven for suspecting that all the ceremony was just a way of formalizing an opportunity to get as drunk as possible: Théophile de Viau complained that "all these gentlemen of the Netherlands have so many rules and ceremonies for getting drunk, that I am repelled as much by them as by the sheer excess." A visitor to the annual feast of the *schutters* (militia shooters) in Dordrecht reported, "I do not believe scarce a sober man to be found amongst them, nor was it safe for a sober man to trust himself amongst them, they did shout so and sing, roar, skip and leap."

Leeuwenhoek and Vermeer shared other acquaintances. Both men were on friendly terms with Jan Boogert, a lawyer and notary public in Delft. In 1677 he signed an attestation as a witness to Leeuwenhoek's observations. His father, François, another notary public, was also known to both Leeuwenhoek and Vermeer; he had drafted a legal document for Leeuwenhoek in 1656 and had attended the wedding of Vermeer and Catharina Bolnes. And both Vermeer and Leeuwenhoek knew the diplomat, natural philosopher, art enthusiast, and camera obscura–user Constantijn Huygens, whose life exemplifies the close-knit relation between artists and natural philosophers in seventeenth-century Holland.

-3-

In the decades since demonstrating his camera obscura to his artist friends, Constantijn Huygens had continued his ascent in political power and prestige, and had become even more immersed in the art world. In 1625 he had been appointed secretary to the stadtholder, Prince Frederik Hendrik of Orange. In 1630 Huygens gained the additional position of the *reekenmeester*, a financial administrator to the house of Orange, the ruling family of the Dutch Republic, for which he received a generous income of 1,000 florins (about $18,260 today) a year. To underscore his newly exalted social and financial status he purchased the estate and title of Zuilichem, in the province of Gelderland, becoming "Lord of Zuilichem." Huygens, who had already been knighted by King James I of England, received the same honor from Louis XIII of France in 1632. When Frederik Hendrik died in 1647, Huygens continued in his capacity of confidential secretary to the new stadtholder, Frederik Hendrik's son William II. On his behalf Huygens attended the final negotiations in Brussels in 1648 leading to the Peace of Westphalia that ended the Eighty Years' War by officially granting the Dutch Republic independence from Spain.

Huygens was also called upon for the almost constant negotiations between the Dutch Republic and England, especially once William II married Mary Henrietta Stuart, the eldest daughter of Charles I of England. William II died in 1650, instituting what was later known as the first stadtholderless period. Although Huygens worked hard to maneuver for the Orange family, he was unsuccessful in stopping the drive for a more republican form of government.

One faction of the Dutch regents, the de facto patrician class of the Dutch Republic, led by Grand Pensionary Johan de Witt and his brother Cornelis, tried to prevent the elevation of the son of William II, who had been born only eight days before the death of his father, to the office of stadtholder in the province of Holland. In 1654 they enacted the Act of Seclusion, which prevented any member of the

house of Orange from being appointed to the office. This act was revoked in 1660, after the restoration of William's uncle Charles II of England. After Charles regained the throne, there was increasing agitation by the Orangist adherents of the prince to give him a high office of some kind.

In July 1667, just before the Treaty of Breda ended the Second Anglo-Dutch War, De Witt presented a political compromise to the States of Holland. He proposed that William be appointed captain-general of the republic and assigned a seat in the Raad van State, the Council of State, which functioned as the executive committee of the republic. However, William would be excluded from the office of stadtholder. Three prominent Amsterdam regents added an addendum to abolish that position forever. The new law, entitled Perpetual Edict for the Preserving of Freedom, was enacted on August 5, 1667, transferring the political power and functions of the stadtholderate to the provincial states. This political situation would change only in 1672, a year of intense domestic unrest and war with England and France.

During this period Huygens was kept busy with the political machinations of the house of Orange. He also had a growing family. His marriage in 1627 to Suzanna van Baerle was a happy one—producing four sons and a daughter—until Suzanna's death shortly after delivering her daughter in 1637. They had a companionate partnership, and in verse Huygens celebrated her as being his intellectual equal, "two minds joined in a single mind." This was not only Huygens's assessment; Descartes also praised Suzanna's intelligence, above the usual polite flattery of an acquaintance's wife, telling Huygens—after sending him proof sheets of his *Dioptrique*—"If Madame de Zulichem [sic] would like also to add her own corrections, I would consider that an inestimable favor on her part. I would value her judgment, which is naturally excellent, far higher than that of many of the Philosophers, whose judgment art [formal training] has rendered extremely defective."

Huygens was part of the literary and musical circle known as the Muiderkring, or Muiden circle, after the Amsterdam residence of Pieter Cornelis Hooft, one of the leading Dutch literary figures of

the day. Huygens himself would publish over 75,000 lines of original verse in seven languages, and translate some of the works of the English metaphysical poet John Donne into Dutch. Other participants in the Muiden circle included Joost van den Vondel, the most prominent Dutch poet and playwright, and Anna Roemers Visscher and her sister Maria Tesselschade, daughters of a wealthy merchant and both talented poets. Another member of this cosmopolitan circle was Francisca Duarte, a noted singer who was the sister of Huygens's friend Gaspar Duarte, a Jewish diamond merchant (who also dealt in paintings) born in Antwerp, the son of Jewish refugees who had fled Lisbon in 1591. Huygens regularly did business with Duarte, for example to acquire jewelry given by William III to his cousin and bride Princess Mary of England as a wedding gift. Later, Gaspar's son Diego Duarte, a wealthy jeweler in Amsterdam with strong musical interests, whose art collection listed more than two hundred works by Holbein, Raphael, Titian, Rubens, and others, would purchase one of Vermeer's paintings. The picture, described in his inventory of artworks as "a small painting with a lady playing the clavecin [i.e., the virginal], with accessories," was valued at 150 guilders (roughly $1,477 today) in 1682. It was probably one of Vermeer's last two paintings, either *Young Woman Standing at a Virginal* or, more likely, *Young Woman Seated at a Virginal*. Huygens was probably involved in the sale of this painting, acting as an intermediary between his friend's son and Vermeer.

Huygens enjoyed the company of this lively Muiderkring, especially, no doubt, the women who were part of it. Huygens always did have a weakness for attractive, intelligent women. During his visit to London in 1622, he had enjoyed the hospitality of Sir Robert Killigrew, an English politician who served as the ambassador to the United Provinces. It was through Killigrew that Huygens met Cornelis Drebbel, the natural philosopher and diplomat Sir Francis Bacon (whom Huygens praised extravagantly in his autobiography), the poet John Donne, and possibly the playwright Ben Jonson. It has been suggested that during this visit, Huygens developed a serious flirtation, if not more, with Lady Mary Killigrew (the former Mary Woodhouse), who was also the niece of Bacon. This romance, if it was

that, was not unique. Huygens had intellectual—sometimes highly flirtatious—friendships with Visscher and Tesselschade, the artist Anna Maria van Schurman, and the English poet and natural philosopher Margaret Cavendish, Duchess of Newcastle upon Tyne, who was living in Antwerp during the English Commonwealth period.

Before her marriage to a British nobleman, Cavendish had served as an attendant of Queen Henrietta Maria, the wife of King Charles I, and fled into exile with her queen when the monarchy was abolished. Cavendish went on to write perhaps the first book of science fiction, *The Blazing World*, and to publish extensively in natural philosophy, eventually becoming the first woman to attend a meeting of the Royal Society of London, in 1667. Virginia Woolf would later criticize Cavendish as a "crazy Duchess" who "shut herself up at Welbeck [the Newcastle estate] alone," where she "frittered her time away scribbling nonsense." Many men of Cavendish's day no doubt shared this view of a woman interested in scientific pursuits. Huygens, however, did not consider Cavendish's scientific avocation a "disease"; rather, he found her intellectual interests stimulating. They carried on a spirited correspondence on the topic of Prince Rupert's drops, a mysterious phenomenon of interest to many natural philosophers at the time: these were glass teardrops formed by dripping molten glass in cold water, which hardened the glass. The head runs on into a crooked tail, and the drops have a peculiar combination of fragility and strength. The head can resist even the blow of a hammer. But once a piece of the tail is broken off, the drop explodes and is reduced to powder. Puzzling over Prince Rupert's drops exercised the fellows of the Royal Society of London for years, taking up many pages of their *Philosophical Transactions*. Even today an explanation for this phenomenon is hard to find. The correspondence between Huygens and Cavendish shows Huygens treating Cavendish—whom he teasingly described as "ruining many a white petticoat" by her experiments—as an intellectual at his level.

In his autobiography Huygens made clear his passion not only for intelligent women but also for science, especially the observational sciences of the day. He told Henry Oldenburg of the Royal Society of London that he always carried a small microscope in his pocket

to be at the ready for any observations he could make of the tiniest parts of nature. He took a close interest in the education of his sons, emphasizing natural philosophy. His son Christiaan became one of the most important astronomers of his day, the first to describe accurately the rings of Saturn and to see one of its moons. Christiaan Huygens ground and polished his own lenses, patented the first pendulum clock, which greatly improved accuracy in timekeeping, and derived the law of centrifugal motion, and from this an inverse square law of gravitation (however, he would later reject Newton's inverse square law of universal gravitation, ridiculing its claim that two distant masses could attract each other across empty space).

Constantijn Huygens was a major player in the newly developing art market, acting as a go-between arranging commissions for artists with the stadtholder Frederik Hendrik—who hoped to put together an art collection of international renown—and other members of his family. In 1625 Amalia van Solms, Frederik Hendrik's wife, sought to purchase a painting by Peter Paul Rubens, the famous Flemish artist; she wanted his *Alexander Crowning Roxane*, a large-scale work depicting the marriage of Alexander the Great and his wife, who had not been born into royalty. Van Solms hoped to own the work as a tribute to her new husband, who had similarly raised her to the equivalent of Dutch royalty by their marriage. Huygens negotiated with Rubens on behalf of his royal patron for the painting, which finally hung in her private quarters in 1632.

Huygens had a keen eye, and he recognized, earlier than most men of his time, the potential of the young Rembrandt van Rijn. He had visited the shared studio of Rembrandt and Jan Lievens in Leiden in 1628. In his autobiography, written the following year, Huygens commented on the state of contemporary Dutch art. He praised the school of Dutch landscape painters, especially Cornelis van Poelenburg, Moses van Uyttenbroeck, Jan van Goyen, Jan Wildens, Paul Bril, and Esias van de Velde, as being able to paint truly "natural pictures," which could show "the warmth of the sun and the movement caused by cool breezes." He approved of the history painters, chief among them Rubens, but also Gerard van Honthorst, Hendrik ter Brugghen, Antony van Dyck, and Abraham Janssens. Yet the future

of Dutch fine art, he predicted, would lie with the two young stars he had just met: Lievens and Rembrandt. Lievens is better at depicting "that which is magnificent and lofty," Huygens noted, while Rembrandt "loves to devote himself to a small painting and present an effect of concentration." Rembrandt, he believed, was possessed of a finer hand and could communicate emotions more strongly in his pictures. In 1629—when the painter was only twenty-three—Huygens brought Rembrandt to the attention of the stadtholder, arranging a commission for Rembrandt: a series of depictions of Christ's passion. In 1633 Rembrandt painted two large religious canvases for the stadtholder, the *Raising of the Cross* and *Descent from the Cross*. After delivering these, Rembrandt was commissioned to paint three more religious canvases. He also painted a portrait of Amalia van Solms. History has preserved the close tie between the two men: only seven letters written by Rembrandt are extant, and all of them are letters to Huygens.

Huygens's interest in the art of his day was inextricably tied to his enthusiasm for the new optical technologies, the new ways of seeing and gaining knowledge. In his *Daghwerck* (Day's work), his verse tribute (with prose commentary) to life with Suzanna, Huygens deployed the notion of the camera obscura as a metaphor of knowledge acquisition: "I have agreeable tidings which I shall bring you inside the house. Just as in a darkened room one can see by the action of the sun through a glass everything (though inverted) which goes on outside." Elsewhere in this work, he praised the knowledge gained with the new optical devices—telescopes and microscopes. "From little Flowers, Midges, Ants, and Mites shall I draw my lessons. With the aid of the microscope, parts of these smallest of Creatures till now invisible have at this time become known." Celebrating the fact that much that was previously unseen was now visible, Huygens remarked, "And discerning everything with our eyes as if we were touching it with our hands; we wander through a world of tiny creatures till now unknown, as if it were a newly discovered continent of our globe." Throughout the piece, Huygens expressed the idea that knowledge is pictorial and optical; all knowledge is like the image projected in the camera obscura, or the drawings of little beings seen through

microscopes. Huygens explicitly compared Dutch art to the empirical outlook of the science of the day. Images were linked inextricably to the advancement of learning. Recalling his experience of looking through Drebbel's microscope, Huygens mourned his recently deceased friend Jacob de Gheyn II, wishing he were around to record the tiny denizens of the "new world" seen under the lenses.

-*4*-

As a man steeped so deeply in the worlds of art and science, Huygens was well placed to know both Leeuwenhoek and Vermeer. We know that Huygens and Leeuwenhoek were friends. Huygens's interest in microscopy, dating back to the 1620s, certainly led him to Leeuwenhoek by the 1660s, when the former cloth salesman was becoming known in Delft (only about six miles from The Hague) for his scientific pursuits. Huygens later recommended his fellow countryman to the Royal Society of London. By the early 1670s the two were corresponding and visiting frequently, with Huygens eventually signing his letters your "*bysondere goede*" (specially good) friend. The trip between The Hague and Delft could be traveled by coach in as little as thirty or forty minutes, or by *trekschuit* in one to one and a half hours (barges ran twice hourly in both directions). While Leeuwenhoek was in The Hague on business related to Vermeer's estate, as well as at other times, he visited Huygens; when Huygens was in Delft on business for the republic, he called on Leeuwenhoek. In the correspondence between the two men, we can see Huygens exhorting Leeuwenhoek to persevere and assuring him of the importance and uniqueness of his efforts. When Verkolje painted Leeuwenhoek's portrait, Huygens wrote a celebratory verse that was published with the mezzotint:

> *To the picture of Ant. Leeuwenhoeck.*
> *There lives a charming Man, a skilful Man and smart,*
> *Who bringth forth miracles, and presseth Nature hard,*
> *Espieth her secrets all, her ev'ry lock he's opening:*

*His little Keys of Glass t'escape there is no hoping,*
*Nor can there be. This ain't that fearless Man, but there:*
*If seeking him, look sharp, 'tis like him as tho' 't were.*

In an expression of the close relation between art and science, Huygens remarks upon the painting's success at "fooling the eye" into thinking that the natural philosopher was really present.

Huygens's connection to Vermeer is not as well documented, but he almost certainly knew him. We know that Huygens sought out and maintained contact with Rembrandt, Lievens, Van Dyck, and Rubens; it seems beyond question that he would have wanted to meet Vermeer, an artist with a growing reputation in nearby Delft and elsewhere. Indeed, Huygens appears to have visited Vermeer in the company of a young regent named Pieter Teding van Berckhout, whose sister would later marry Huygens's son Lodwijk. On May 14, 1669, Van Berckhout recorded in his diary that he went to Delft from The Hague to visit Vermeer. Van Berckhout was met at the city gate by Ewert van der Horst (a member of the parliament), Willem Nieuwport (Dutch ambassador to London), and Huygens. Most likely, they all went together to Vermeer's studio, Huygens providing the introduction of the others to the painter.

Van Berckhout returned for another visit to Vermeer's studio less than a month later, recording his assessment that in the painter's work "the most extraordinary and most curious aspect consists in the perspective." These visits to artists' studios were typical of men of a certain class, who had been brought up to believe that an understanding and appreciation of the visual arts was a sign of a gentleman's taste and stature. Such men would read manuals such as Pierre Le Brun's "Essays on the Wonders of Painting" (1635), which taught them that in order "to discourse on this noble profession, you must have frequented the studio and disputed with the masters, have seen the magic effects of the brush, and the unerring judgment with which the details are worked out."

Huygens may also have arranged another visit to Vermeer's studio. The French diplomat Balthasar de Monconys (1611–65), a native of Lyon who had studied mathematics and physics, made a number

of tours throughout Europe and the Ottoman Empire, eventually visiting Portugal, Italy, Egypt, Syria, Turkey, England, Germany, Spain, and the Netherlands. During his travels he routinely called on both artists and natural philosophers; when he was in Florence, for instance, Monconys sought out Evangelista Torricelli, successor to Galileo as professor of mathematics at the University of Pisa and inventor of the barometer. While in London in 1663, Monconys visited the Royal Society, introduced to the group by Sir Robert Moray; he attended several meetings that summer, and described experiments he had witnessed there. On that visit Monconys also went to see a "M. Rives"—Richard Reeves, an instrument maker known for his microscopes and telescopes. Monconys kept a journal during his travels, recounting his attendance at experiments by Boyle and his conversations and correspondence with Thomas Hobbes, Henry Oldenburg, Christopher Wren, and others. He was also in contact with Pierre Gassendi, Blaise Pascal, and Kircher. The first volume of his *Voyages* testifies to his special interest in optics, including letters and discussions dealing with the construction of spectacles, microscopes, and telescopes.

Monconys traveled to Delft in the summer of 1663. He visited the Huygens family in The Hague, comparing their telescopes with his own, admiring the sharpness and brightness of their lenses. He went to see Isaac Vossius in The Hague and Johan Hudde in Amsterdam to examine their microscopes, which were mainly single-lens types. On his way to Amsterdam he called at Van Mieris's studio.

While he was visiting with Huygens, Monconys admired his extensive art collection. He admitted that he had not seen Vermeer when he was in Delft. Huygens must have been surprised that a visitor so interested in art had not visited Vermeer and encouraged Monconys to do so, because not long afterward, on August 11, 1663, Monconys did meet with the Delft painter. In his published account of his travels, Monconys reported on his visit to Vermeer:

In Delft I saw the painter Verme[e]r who did not have any of his works: but we did see one at a baker's, for which six hundred livres [600 guilders] had been paid, although it contained but a

single figure, for which six pistoles [50 guilders] would have been too high a price.

Monconys seemed to believe that the painting he saw was worth less than a tenth of what had been paid for it. The baker was most likely Hendrick van Buyten, headman of the bakers' guild and a prominent Delft citizen who owned four paintings by Vermeer at one time or another—including, later, two paintings given to him by Catharina after Vermeer's death to settle the bill for three years' worth of bread. The price Monconys was quoted was considerable: six hundred guilders (over $7,846 today) was the annual salary of a skilled craftsman, and the price of a small house.

Monconys, less of a connoisseur than Huygens, appeared to judge a painting by the number of subjects appearing in it. He balked two days after his visit to Vermeer when Gerrit Dou asked Monconys for the same price for his painting of a *Woman at a Window* (also a work with only one figure). Apparently, even at this fairly early stage in Vermeer's career, his paintings had the same market price as those by Gerrit Dou, who had already been invited by Charles II of England to become his court painter.

It seems likely that Monconys would also have visited Leeuwenhoek on one of his trips to Delft, either because of Leeuwenhoek's growing reputation, in Delft at least, as a natural philosopher interested in lenses, or because he was told of Leeuwenhoek—perhaps by Huygens. But Monconys does not record any such visit in his journal.

-5-

By the time Vermeer painted *The Geographer*, when he was thirty-seven, he and Catharina had been living with her mother, Maria Thins, in her spacious house on the Oude Langendijck for some years, at least since 1660, when that residence was listed on the burial notice of one of their infants. In this house, which no longer stands, the "great hall" held portraits of Vermeer's father and mother, as well as Vermeer's coat of arms in a black frame, in addition to religious

paintings, two *tronien* by Fabritius, and other pictures. The hall was furnished with a "cabinet of joinery work and inlaid ebony," a table with a green tablecloth, nine red-leather chairs, a mirror with an ebony frame, and an ebony crucifix. A pair of green silk curtains with a valance in front of the bedstead marked out a built-in bed where Johannes and Catharina slept. A small room adjoining the great hall held a simple bed, an oak table, a child's bed, and two chairs for small children. The *voorhuis* (front room) held a less ornate cabinet, four green chairs, a bench, and an oak chest, and a number of paintings.

At the back of the house were four rooms called kitchens, only one of which was actually used for cooking; the others held beds and chairs. The cooking kitchen also contained a bed and basic furniture, as well as a cupboard, a wooden rack, twenty-one shell-shaped dishes, and pewter and tin vessels. Downstairs there was a cellar room and a "washing kitchen." There were two rooms upstairs, a front one where Maria Thins slept, and a back room, facing north, where Vermeer painted, and which contained two easels, three palettes, canvases and wood panels, bundles of prints, a desk and two chairs, a stone table on which to grind colors, a muller and a maulstick—a cane-like stick used to steady the hand of the painter (one can be seen in use in Vermeer's *The Art of Painting*). On the top floor there was also a room referred to in documents after Vermeer's death as a "place"—the privies, perhaps—a little room where clothing and the laundry was hung, and an attic. There was probably another room or two reserved for the use of Maria Thins and containing her furniture and belongings.

Leeuwenhoek and his wife Barbara de Meij continued to live at The Golden Head, on the Hippolytusbuurt, the street right behind the Town Hall, "not more than one hundred feet from our Vleeshall," where an obliging butcher would sell Leeuwenhoek cows' eyes, the testicles of hares, and other required specimens. This house was about 150 yards away from Vermeer's residence, diagonally across the Market Square. Like the Thins house, The Golden Head no longer stands. In front of the house was a courtyard containing a well surrounded by a wall so high that the sun barely reached the well and did not warm the water. In the back of the house was a garden; Leeu-

wenhoek would speak of studying the aphids found on cherry trees, apple trees, and currant bushes from his own orchard. We know that his study was on the ground floor, probably in the space he had formerly used as his haberdashery shop. The room where Leeuwenhoek and his wife slept was also on the ground floor. The Golden Head was not as large as Maria Thins's house, but it was more than adequate for Leeuwenhoek's small family.

Both Vermeer and Leeuwenhoek were raising families, and both had, by 1669, suffered the loss of children. Vermeer and his wife had eleven living children, seven girls (Maria, Elizabeth, Cornelia, Aleydis, Beatrix, Gertruyd, and Catharina), three boys (Johannes, Franciscus, and Ignatius), and one other child, whose sex and name are not known. They lost four children in infancy or early childhood. Leeuwenhoek and his wife Barbara also lost four children; they had had five children, all of whom died in infancy except one, Maria. It has become almost a commonplace to say that in those days parents were so inured to the loss of children that they treated their deaths with resigned stoicism or callousness as a coping strategy. But this is one of those historical truisms that are, in fact, false. Parents— both mothers and fathers—mourned their deceased children with as much pain as they do today. Their outpourings of grief were not only expressed privately in letters to family and friends, but also publicly; family group portraits, such as those by Nicolaes Maes (1634–93) and Johannes Mytens (1614–70), often included lost babies as angels hovering above, watching over their parents and siblings. Sometimes children were painted on their deathbeds; Ferdinand Bol depicted a young boy, Jodocus van den Bempden, already dead, lying in bed with a crown of flowers and holding a wilted rose still in bud, while an extinguished torch and a setting sun further attest to his early death. The fear of losing a child was very real, and it hung over parents throughout their child-raising years. Heijman Jacobi exemplified this parental nightmare in a book published the year that Leeuwenhoek and Vermeer were born, *Schat der Armen* (The treasury of the poor): a woodcut illustration shows the skeletal figure of death plucking a newborn baby from his crib while his mother slumbers nearby.

The flip side of the omnipresent fear of infant death in the Dutch

Republic was the exuberant celebrations greeting the birth of a new child. Almost twenty times combined, Leeuwenhoek and Vermeer would have donned the "paternity bonnet" of new fathers, hosted a festive meal, and posted on the door a *kraam kloppertje* made of paper and lace indicating the sex of the newborn and muffling the sound of the door knocker. When a piece of white cloth was placed behind the open lacework, the family was announcing the birth of a girl; when the red door knocker showed through the lace, a boy had been born. This door "beater" was removed after six to eight weeks, at the time the mother first resumed attending church services. Only then would the tax collector and debtors be allowed to come knocking— during the period immediately after a child was born, the father's household would be exempt from some taxes and duties. Still, having as many living children as Vermeer and Catharina had put a great strain on finances, and the young painter struggled to make ends meet, even with the help of his mother-in-law and his patron Van Ruijven. Leeuwenhoek, with his fixed income from the city government and smaller family, was more at ease financially. During these years, Vermeer and Leeuwenhoek were raising—and losing— children, and carrying on with their work, within a three-minute walk from each other.

A skein of thread ties together Leeuwenhoek and Vermeer, catching them both in something like the "mathematical net" of Vermeer's best paintings. But the speculation that they knew each other must remain only that: a speculation.

# A Treasure-House of Nature

⟡N THE CHALK cliffs near Gravesend, a market town twenty-six miles from London on the southern bank of the Thames, Leeuwenhoek made his first-known microscopical examinations. He traveled to England in 1668 or 1669, when he was around thirty-six years old. His wife Barbara had died in 1666, after twelve years of marriage. Of their five children, only Maria, then ten years old, had lived past infancy, while a daughter and three sons—each named Philips, in a series of heartbreaking attempts to name a child after Leeuwenhoek's father—had died. Two years or so later Leeuwenhoek had departed Delft to travel across the North Sea to England. He may have left Maria with his sister Margriete in Delft or with his sister Catharina and her husband in Rotterdam. Or he may have taken Maria with him, especially if the reason for the journey—never disclosed by Leeuwenhoek—was to visit relatives of his wife's still living in Norfolk.

We know from his later report that Leeuwenhoek brought at least one of his microscopes with him on the trip. While walking along the chalk cliffs, he must have taken a pinchful of the chalk, placed it in a stoppered vial, and brought it back to his room. He would have placed a tiny grain of the sample on the point of the specimen pin behind the lens. Keeping his hands perfectly steady, he would have lifted the device upward, aiming it toward a window slightly cracked

open, if he examined it during the day, or in the direction of a burning candle, if he examined it at night. He would have gazed through the tiny lens intently, adjusting the specimen pin this way and that, until he could see clearly. What he saw were very small, transparent "globules," which he realized were minuscule round constituents of the chalk. At first Leeuwenhoek was confused—as the chalk was white, he would have expected its parts to be white too. But then he noticed that the globules overlapped each other, and concluded that this was why the chalk looked white.

-1-

To get to England, Leeuwenhoek would have traveled to Rotterdam, where his sister Catharina and her family lived, to catch one of the many ships that left the port bound for Harwich, England, every week. In those days the trip to London from Amsterdam was not considered difficult; on the contrary, it was easier—and cheaper—for a Londoner to travel to Amsterdam than to Lincolnshire, and the "Narrow Seas" between the two nations were more like a highway than a barrier. The travel between the Dutch Republic and England was constant, moving in both directions, as successive waves of religious and political exiles—Calvinists, royalists, republicans, and Whigs—took refuge in the more tolerant United Provinces, while Dutch inventors, scholars, merchants, craftsmen, and artists poured into England to make a good living.

Nevertheless, political tensions between the Dutch Republic and England had remained acute since the end of the First Anglo-Dutch War in 1654. A surge of patriotism after the restoration of King Charles II in 1660 led to the country's being "mad for war," in the words of Samuel Pepys. Hostilities broke out in 1664, with the official declaration of war in March of 1665—by which time some two hundred Dutch ships had already been captured and several Dutch colonies had been overtaken by the British, including New Netherland in the Americas, with its capital, New Amsterdam, promptly renamed New York. But the Dutch, unlike the English, had enough money, munitions, and matériel to keep fighting. In 1666 the English

war effort was undermined by two tragedies: the Great Fire of London, which devastated the city, and the Great Plague, which carried off over 100,000 people, about 15 percent of the population of London. Dutch victories at sea proved decisive, and the war ended in 1667 with the Dutch at the zenith of their military and trade power. Peace was signed at Breda in July of 1667.

Once the war ended, it was possible again to travel to England from the Dutch Republic, and soon afterward Leeuwenhoek took advantage of the opportunity. We know that he went from Harwich to London, along the way examining the yellowish "English earth" imported into the Dutch Republic and used by the Delft potters to make "Porcelanware." He compared how that English earth looked when viewed with his microscope to the "Black earth" around Delft; he saw that the globules in the Delft earth were even smaller than those composing the English earth and, he believed, not as heavy. The Delft earth—really a sand—is a dark gray color, and better suited for being turned into glass than into porcelain—which explains why Delft produced glass among the finest in all of Europe, but had to import the earth used for its famous Delftware. In describing his examination of the chalk and earth in England, Leeuwenhoek made his first reference to using his microscopes to examine the microscopic structure of substances. At the same time, he showed his detailed knowledge of the practice of artisans in Delft—he even knew the recipe the Delftware producers employed. The Dutch earth alone, when it is "baked, 'tis red, and therefore not fit for Porcelan, but 'tis blended with the English and Flamish Earth, to give a strong and good sound to our Porcelan." Leeuwenhoek's combined interests in science and artistic processes coincided with the same fascinations of a recently founded English organization: the Royal Society of London.

-2-

The origins of the Royal Society lie in a so-called invisible college of natural philosophers who began meeting in the mid-1640s for discussions of the new methods of seeking knowledge of the natural world

through observation and experiment. On November 28, 1660, twelve men met at Gresham College after a lecture by Christopher Wren, then the Gresham Professor of Astronomy, and decided to found "a Colledge for the Promoting of Physico-Mathematicall Experimentall Learning." The gathering included Wren, Robert Boyle, John Wilkins, Sir Robert Moray, and William, Viscount Brouncker. One of the first acts of Charles II when he was restored to the throne was to bestow a charter on the group, from then known as The Royal Society of London for Improving Natural Knowledge. The society planned to meet weekly, on Wednesdays "after the lecture of the Astronomy Professor," to witness experiments and discuss scientific topics.

The earliest meetings of the Royal Society demonstrated the wide-ranging nature of its members' interests. The men discussed the petrification of wood, properties of the lodestone (natural magnet), parts of the anatomy of various creatures, the transfusion of blood of one animal into another, the ebb and flow of the sea, the kinds and feeding of oysters, the "wonders and curiosities" observable in the deepest mines. They sent emissaries to try to answer questions about a strange poison believed to be in the possession of the king of Macasser, about whether master craftsmen in Peru used a method to intensify the color of their native rubies, and whether the bones of a certain fish were able to stop the flow of blood from a wound (only this last question was answered definitively, with samples of the fish sent to England on Dutch ships).

Early meetings of the Royal Society were devoted to the methods and processes of artists. On April 10, 1660, the society appointed a committee "to consider about all sorts of tooles and instruments for glasses for [making] perspectives." On January 16, 1660/61, the fellows heard Dr. Goddard read a paper titled "A Brief Experimental Account of the production of some colours by mixtures of several liquors, either having little or no colour, or being of different colours from those produced." At the same meeting Mr. Eveleyn was asked to "bring in a history of engraving and etching." In April of 1666 the fellows heard about a method of making a nonglossy paint glaze by the addition to the paint of either an egg or the sap of the fig tree. No

less a member than Sir Robert Moray, one of the society's founders, went along with Hooke to see the method in action at the artist's studio; afterward it was reported that Moray himself had "broken eggs into two little vessels." (Around this time Van Hoogstraten complained that the glossiness of paintings was one reason why they could never fully deceive the eye into believing it was viewing anything other than a picture.) The following year, Thomas Povey produced a letter by an artist, Alex Marshall, reporting his methods for producing different colors of paint. Povey tried to get the Royal Society's support for a large-scale "History of the Art of Painting," which he would facilitate by bringing together Royal Society fellows and the "best masters of that art living in London," including Peter Lely. Sounding much like Van Hoogstraten's call to artists, published a few years later, Povey described painting as "this almost divine art, which not only imitates but approacheth very deceivably, even to the giving of life itself."

The Royal Society fellows had a particular interest in devices to aid the artist, befitting its original charter "to improve the knowledge of natural things, and all useful Arts Manufactures, Mechanic practices, Engines and Inventions, by Experiments." In 1668 Hooke demonstrated to the group Della Porta's method of projecting with a mirror and lens a scene from another room—without mentioning Della Porta's description in his book, which had been translated into English ten years earlier. In Della Porta's discussion, the experiment had appeared as "how in a Chamber you may see Hunting, Battles of Enemies, and other delusions," while at the Royal Society the demonstration received a more mundanely descriptive title: "A contrivance to make the picture of anything appear on a wall, cupboard, or within a picture frame, etc. in the midst of a light room in the daytime, or in the night time in any room which is enlightened with a considerable number of candles." Boyle had demonstrated his box-type camera obscura sometime before this, and Wren showed his "machine for drawing in perspective" to the fellows in 1669.

What tied together all these different areas of inquiry was the importance placed upon experimentation. It was not enough to read reports of travelers extolling the Macasser king's poison or the

blood-clotting fish; the fellows wanted to see for themselves. They did not just read a paper on the egg-glaze method for making paintings appear with less of a glare in the noontime sun—they went and saw (and mixed in the egg) for themselves. As the first historian of the Royal Society, Thomas Sprat, put it in 1667, they believed the "Seat of Learning" should be in "Laboratories" not "Schools." This emphasis was codified in the society's motto, a saying from Horace: "*Nullius in verba*," roughly translated as "Take no one's word for it," expressing the determination of the fellows to reject the domination of authority of past texts and experts and instead to verify all statements by an appeal to experiment. The Royal Society endeavored, in Sprat's words, "to separate the knowledge of *Nature*, from the colours of *Rhetorick*, the devices of *Fancy*, or the delightful deceit of *Fables*."

-3-

This demand for experimental verification was explicitly linked to the new philosophy proposed by Francis Bacon. Bacon had called for a fresh start to knowledge of the physical world; the natural philosopher must "vex" nature, as he vividly put it, learning her secrets by observation and rigorous experimentation. This was a requirement that resonated with the natural philosophers of the time, who had already begun to practice what Bacon was preaching.

Bacon's inductive method was explicitly opposed to that of the Aristotelians. Bacon respected Aristotle himself, but disdained the views of many medieval followers of Aristotle, who slavishly believed whatever their master had said so many centuries before. Bacon knew that Aristotle himself would have changed his mind on some of his conclusions had he had access to modern knowledge and ways of investigating nature. In the year that Leeuwenhoek and Vermeer were born, Galileo had expressed Bacon's point with a sly story he recounted in a book promoting the Copernican view against the old Aristotelian astronomy. He told of a man attending a dissection at the home of a famous anatomist. Aristotelians believed that all the nerves originated in the heart, while their opponents held they began

in the brain. "The anatomist showed that the great trunk of nerves leaving the brain and passing through the nape, extended down the spine and then branched out through the whole body, and that only a single strand as fine as a thread arrived at the heart," Galileo wrote. The anatomist then turned to an observer who was an Aristotelian and asked whether he was now convinced that the nerves originate in the brain and not the heart. "The philosopher, considering for awhile, answered: You have made me see this matter so plainly and palpably that *if Aristotle's text were not contrary to it, stating clearly that the nerves originate in the heart, I should be forced to admit it to be true.*"

Kepler, too, criticized the slavish allegiance to ancient wisdom, referring to it as nothing but a "world on paper." William Harvey, who discovered the circulation of blood by the pumping of the heart, claimed, "I profess both to learn and to teach anatomy, not from books but from dissections, not from the positions of philosophers but from the fabric of nature." Leeuwenhoek would later similarly chide those who drew conclusions about salt particles in the body without ever having seen them.

Bacon rejected as well the claims of those who thought that all knowledge, even knowledge of the physical world, came primarily through human reason and not the senses. He considered these philosophies to be like the method of the spider, which spins a web entirely out of its own body, not using anything outside of itself. In Leeuwenhoek's time the most prominent "spider" was René Descartes, who had lived in Amsterdam for twenty years until leaving for Sweden to tutor Queen Christina in 1649 (there he died, partly from the cold climate, soon afterward). Descartes espoused an epistemology, or method of knowledge acquisition, that expressed mistrust in the senses, and placed primary value on reasoning from ideas found in the mind rather than from observations of nature.

For example, in determining his three laws of motion, Descartes began from a "clear and distinct" idea found in his mind: the idea of God. His idea of God included, by definition, that God is omnipotent, immutable, and eternal (that is what we mean by "God," Descartes believed). From this "first principle" Descartes derived his three laws of physics, what we would call his laws of motion, as well

as a general law, the law of conservation of motion—that the total amount of motion in the world remains constant. Descartes's proof of this law is logical, rather than empirical, following necessarily from God's properties. When God created the universe, he endowed its material bodies with a finite quantity of motion. At each moment subsequently, God acts to preserve this same amount of motion.

> It is obvious that when God first created the world, He not only moved its parts in various ways, but also simultaneously caused some of the parts to push others and to transfer their motion to these others. So in now maintaining the world by the same action and with the same laws with which He created it, He conserves motion; not always contained in the same parts of matter, but transferred from some parts to others depending on the ways in which they come in contact.

In his treatise on scientific method, Descartes employed the same logic to prove all sorts of laws of nature. By the end of the book he concluded—optimistically and erroneously—"no phenomena of nature have been omitted. . . . There is nothing visible or perceptible in this world that I have not explained."

As the Royal Society's historian Sprat put it, "I confess the excellent *Monsieur des Cartes* recommends to us another way in his *Philosophical Method*. . . . He at once rejected all the *Impressions*, which he had before receiv'd . . . and wholly gave himself over to a reflexion on the naked *Ideas* of his own mind." Sprat allows that this might be appropriate for the "*Contemplation*" of a gentleman, but emphatically not for a philosopher's "*Inquiry*" into the natural world. In Amsterdam, the microscopist Swammerdam criticized Descartes's scientific method on similar grounds, noting that many a natural philosopher had made egregious errors by relying on reasoning while neglecting to observe the phenomena for himself.

Not only did Descartes invent his theories solely from his mind; he also erred, according to the method of the new philosophy, by not carefully testing and retesting his theories. For Bacon, experimentation was required in order to make a proper induction to a scien-

tific law in the first place. Most of his seventeenth-century followers required additional experimental confirmation of a scientific law. While Descartes did claim to have conducted experiments to confirm his conservation law, many writers today agree with Sprat, who pointed out that his so-called experiments were merely "grosse trials" based on "conjecture." Descartes envisioned experiments based on the assumption that the law was correct, and in this way "proved" what he already "knew" to be true—not only true, but self-evidently true, obvious just by definition. Indeed, echoing Galileo's Aristotelian anatomist, Descartes insisted that "the demonstrations are so certain that, even if experience seemed to show us the contrary, we would nevertheless be obliged to place more faith in our reason than in our senses."

As one would expect from a philosopher emphasizing the use of the senses, Bacon praised microscopes for extending the reach of the sense of sight. (Descartes, too, had praised the invention, as a means to rectify some of the infirmities of the senses, but he still emphasized that the mind had precedence over the senses in science.) The microscope, "lately invented," said Bacon, enables us to "perceive objects not naturally seen." These instruments "exhibit the latent and invisible minutiae of substances, and their hidden formation and motion." With the assistance of a microscope "we behold with astonishment the accurate form and outline of a flea, moss, and animalculae [little animals], as well as their previously invisible color and motion." Indeed, microscopes and telescopes satisfied the "true and lawful goal of the sciences": to ensure that "human life be endowed with new discoveries and powers." These new instruments gave natural philosophers the power to make thrilling discoveries.

Instruments themselves cannot transform science, Bacon was careful to add—experimentation was necessary in conjunction with aids to the senses. Merely looking at the world, even with a microscope, is not enough. But Bacon believed that science fundamentally involved the investigation of "hidden schematisms" and unobservable structures, and the "true textures" of physical bodies; and this was where the microscope would later prove invaluable. One of the problems with the followers of the Scholastics, according to Bacon, had

been their readiness to rely on the naked senses; he criticized them for ending their investigations "where sight ceases." The new investigators of nature would have to go beyond naked sight itself.

-4-

Even before his reputation grew in his native England, Bacon's works were appreciated in the Dutch Republic. One of his earliest and most prominent Dutch readers was Constantijn Huygens, who became interested in Bacon's writings after meeting him in London in 1622. But Bacon's reputation in the Dutch Republic had preceded him; the year prior to Huygens's trip to London, he had solicited the poet and classics professor Daniel Heinsius's opinion of Bacon's *Instauratio magna*, which had just been published in England. While Huygens did not care for Bacon personally, he admired his writings on scientific method and his efforts to spark a new era in science. Huygens saluted Bacon, along with Drebbel, as his time's leading thinkers, saying, "I have looked up in awe at these two men who have offered in my time the most excellent criticism of the useless ideas, theorems, and axioms which . . . the ancients possessed." Indeed, at times Huygens seemed to revere Bacon as an intellectual saint, admitting that he had a sort of "sacred respect" for him. Huygens agreed with Bacon's view that the natural philosopher must reject ancient learning and start anew to discover knowledge through observations and experiments.

In 1648 Bacon's *Sylva sylvarum* was translated from English into Latin by a Dutchman, Jacob Gruter, allowing the book to become more accessible to Dutch readers accustomed to books written in the scientific language of Latin. Gruter's brother Isaac later published a number of important manuscripts of Bacon's he had inherited from the British diplomat Sir William Boswell. Isaac also put out a second edition of his brother's translation of the *Sylva*, asking Huygens whether any corrections were needed. The botanist and physician Herman Boerhaave, who would be appointed a lecturer in medicine

at Leiden in 1701, expressed a view widespread among his country-men when he called Bacon "the father of Experimental Philosophy."

The philosophical outlook of Bacon particularly appealed to the Dutch, with their emphasis on practical innovation and invention, as much as to the English. Indeed the English natural philosophers, who favored the Baconian approach to that of Descartes—partly for patriotic reasons—saw the Dutch as their compatriots in Baconianism. In his defense of the Baconian philosophy against the attack of the Cambridge Platonist Henry More, William Petty (one of the founders of the Royal Society) contrasted the useful activity of the Dutch inventor Cornelis Drebbel with the worthless endeavors of the speculative philosophers such as the Frenchman Descartes. Philosophical systems, Petty argued, were premature and vacuous, metaphysical speculations unproductive; only practical inventions based on observations, experiments, and trials were worth the natural philosopher's time and energy. The "hub" of Dutch scientific activity was known to be Constantijn Huygens's hometown, The Hague (in large part because Huygens lived there), which Sprat compared to Bacon's ideal of a scientific nation, the "New Atlantis" (described in Bacon's book by that name): "They have one place (I mean the *Hague*) which may be soon made the very Copy of a Town in *New Atlantis*; which for its pleasantness, and for the concourse of men of all conditions to it, may be counted above all others (except *London*) the most advantageously seated for this service."

Another reason Bacon's empirical philosophy appealed to the Dutch was a religious one. While Bacon did not place scientific inquiry squarely upon the shoulders of God, as Descartes had done, he nevertheless expressed a religious, as well as scientific, motivation for studying nature.

> Let no man upon a weak conceit of sobriety or an ill-applied moderation think or maintain, that a man can search too far, or be too well studied in the Book of God's Word, or in the Book of God's Works—Divinity or [Natural] Philosophy. But rather, let men endeavour an endless progress or proficience in both.

This idea that God had created two books—the book of scripture and the book of nature—was perfectly attuned to the Calvinism of the day, in both England and the Dutch Republic. The Apostle Paul had described the universe "which is before our eyes as a most elegant book, wherein all creatures great and small, are so many characters leading us to contemplate the invisible things of God, namely his eternal power and Godhead." Closer to home, the opening lines of the Protestant Confession of Faith as revised during the Synod of Dordrecht (1619), establishing the fundamental principles of Calvinism, had echoed the apostle's words by noting, "We know [God] by two means. Firstly, through the Creation, preservation and government of the entire world. . . . Secondly, He reveals himself yet more clearly and perfectly through his holy and Divine word."

Science was esteemed as a way of learning more about God, by studying his works on earth. As Jacob Cats, the most popular poet of the Dutch Republic in the seventeenth century, put it, the first of God's books taught his will; the second, his power. The religious justification for science that was, in a sense, "built in" to Protestant theology helps explain why England and the Dutch Republic were such bastions of scientific discovery in the early modern period, as opposed to the Catholic countries like Spain and the Papal States in Italy, where the Inquisition persecuted Galileo and spread fear throughout the scientific community. It also explains the dominance of Baconianism in Calvinist countries. In the worldview of the Puritans, according to one historian, Bacon's writings "came to attain almost scriptural authority." The Royal Society co-opted this "natural theology," as it was called in England, highlighting the fact that "the *Power*, *Wisdom*, and *Goodness* of the *Creator*, is display'd in the admirable order, and workman-ship," of his creation.

In one of his works Bacon had quoted from Proverbs, "It is the glory of God to conceal a thing, but the honor of Kings to search out a matter." The microscope accordingly became the means of searching out what God has chosen to conceal from man's naked sight, a way of magnifying the "Wisdome of the great Architect of Nature," in the words of Matthew Wren, a cousin of Christopher Wren's and a political writer and proponent of monarchy. As the microscope

began to expose the surprising complexity of the smallest insects, natural philosophers and theologians alike mused that by studying these creatures we could come to understand God as never before. The Northern Brabant minister Johannes Feylingius exclaimed in a work titled *De wonderen van de kleyne werelt* (The wonders of the small world), "God has deposited his holiness in all things; / He can be read in the tiniest ant and stone." The Englishman Thomas Moffett would go so far as to say that, apart from man, nothing in the universe is more divine than insects. While some wondered why God would have bothered to create structures so small that we could not see them, others were content to assume that God foresaw that man would invent devices with which such intricacy could be observed and admired.

Similar claims had been made about the structure of the heavens —with its faraway stars and moons only now visible to men and women. An admirer of Galileo's, Thomas Seggett, had even noted that by enabling humans to behold what was until then the prerogative of heavenly dwellers, the telescope rendered mortals similar to Gods. Constantijn Huygens similarly rhapsodized, "At last mortals may, so to speak, be like gods / If they can see far and near, here and everywhere." Swammerdam, who would later cease his scientific examinations to devote himself full-time to theology, enthused that the study of the smallest visible things, by allowing us to peruse "the book of Nature," would be a way by which "God's invisibility becomes visible." Leeuwenhoek himself would proclaim that there was "no better way to glorify God than observe in amazement his omniscience and perfection in all living things no matter how small." One of his own draftsmen, while drawing the leg of a flea, would, Leeuwenhoek reported, "often burst out with the words, 'dear God, what wonders there are in such a small creature!'"

Constantijn Huygens ended his autobiography with an account of the emotion that overtook him when he first looked through Drebbel's microscope.

Nothing can compel us to honor more fully the infinite wisdom and power of God the Creator unless, satiated with the wonders

of nature that up till now have been obvious to everyone . . . we are led into this second *treasure-house of nature*, and in the most minute and disdained of creatures meet with the same careful labor of the Great Architect, everywhere an equally indescribable majesty.

For the English and Dutch natural philosophers, nature was God's second book, a treasure-house given to us by our Creator. Microscopes and telescopes were new instruments that would enable us to peer more deeply into this treasure-house than ever before.

-5-

When the Royal Society was founded as an experiment-based organization, the original fellows felt they required a "curator of experiments," a position to which they appointed Robert Hooke. In doing so, the society created a new job description—Hooke was first "curator" in the modern sense. Today the idea of a curator as a person in charge of a museum, a gallery of art, or a library, or a keeper or custodian of a collection, is familiar, and even the newer notion of a "curator of ideas" is becoming more common. However, earlier uses of the term "curator"—which derives from the Latin *curare*, "to care for"—were applied either to religious personnel (the "curates") who were caretakers of the souls of their flock or to government bureaucrats who were in charge of public works such as transportation, sanitation, and policing. This latter usage appears as early as Roman times, during which there were *curatores* in charge of navigation on the river Tiber, others who kept records of public spending, and others responsible for the condition of the roads. This bureaucratic use persisted in the seventeenth century for the person appointed trustee or executor of an estate—so Leeuwenhoek would later be appointed "curateur" of Vermeer's estate.

It was only in the 1660s that the use of the term "curator" in something like the modern sense appeared. The second volume of the *Philosophical Transactions* of the Royal Society, published in 1667,

described "the Curator of the Royal Society" as the person responsible for making "Tryals" or experiments. The first *History of the Royal Society*, published the same year, also refers to the position of the curator, and outlines one of his duties as cataloging the many gifts given to the new society by its fellows and by foreign correspondents: "all the Effects of *Arts*, and the Common, or Monstrous *Works* of *Nature*." Only much later would the term be applied to the keeper of a museum collection—in 1767 it was used to describe the custodians of the British Museum.

In some ways Hooke was the perfect candidate for this newly invented position. He was born on July 18, 1635, two and a half years after Vermeer and Leeuwenhoek. Robert was a sickly boy, and rather than sending him out to study, his parents left him basically alone; he developed an interest in mechanical devices, amusing himself by taking clocks apart and putting them back together. His father, John Hooke, was a curate in Freshwater, near the western tip of the Isle of Wight. Suffering from a variety of ailments—"a Cough, a Palsy, Jaundice and Dropsy"—John Hooke died, possibly by his own hand, when Robert was thirteen.

When a famous painter of miniatures visited the Isle of Wight in the 1640s, Hooke confidently believed he could master the skills of the artist. According to a boyhood friend, "Mr. Hooke observed what he did, and, thought he, why cannot I doe so too? So he getts him chalke, and ruddle [red ocher], and coale, and grinds them, and putts them on a trencher [a wooden platter], gott a pencil [brush], and to work he went, and made a picture." He proceeded to copy all the pictures in his parents' parlor. In October of 1648, after his father's death, Hooke left for London, where he began his apprenticeship with Lely. Though he was quite talented, Hooke had to give up his artistic pretensions when the chemicals involved in making and using the paint exacerbated his own ill health and migraines.

Hooke instead entered Dr. Richard Busby's Westminster School. Busby was as famous for the frequency with which he meted out corporeal punishment as for his scholarship. But his harsh methods produced—or at least did not destroy—some of the most inventive minds of the day. Hooke's fellow pupils included the future poet and

playwright John Dryden and the future philosopher John Locke. (Hooke's future friend and colleague Christopher Wren had left the school by the time Hooke arrived.) At Busby's school, Hooke learned Latin and Greek, studied the first six books of Euclid, and—as he later boasted to a friend—"invented thirty several [different] ways of flying." After he completed his studies there, Hooke enrolled at Christ Church, a college at Oxford with links to the Westminster School. The Oxford botanist and inventor John Wilkins was impressed with Hooke and hired him as his paid laboratory assistant.

Through his association with Wilkins, Hooke soon came to the notice of the chemist Robert Boyle, who hired him and gave him lodging. Hooke worked with Boyle on the famous experiments with an air pump that led to the positing of the law bearing Boyle's name: that at constant temperature the volume of a gas is inversely proportional to the pressure exerted on it. Boyle generously acknowledged that Hooke had been the one to build him the air pump. Although an air pump was a common experimental apparatus at the time, the pump Hooke built for Boyle was exceptional, in that it was able to create and sustain a complete vacuum in an apparatus small enough to be worked by one man.

In the fall of 1662 Hooke was appointed to his position at the Royal Society, one of whose original founders was his Oxford mentor Wilkins. His duties were "to furnish [the group] every day when they met, with three or four considerable Experiments," and to undertake any tasks suggested by the fellows; it was thought, too, that he would be able to design ingenious displays that would entice the king to support the society. Because Hooke was charged each week by the society to furnish them with experiments based on their interests at the moment, he was forced to turn his attention to an incredibly wide array of topics, including carriages, fountains, pendulum clocks, respiration, combustion, magnetism, gravitation, telegraphy, astronomy, and music. He made improvements to diving bells, discovered a star in Orion, and inferred the rotation of Jupiter. He developed a way to apply the conical pendulum to watches and invented a machine for cutting gear wheels.

Hooke was not a pleasant fellow. Thomas Molyneux called him

"the most ill-natured, conceited man in the world, hated and despised by most of the Royal Society, pretending to have [made] all other inventions, when once discovered by their authors to the world." Christiaan Huygens told his father, "I know [Hooke] very well. He understands no geometry at all. He makes himself ridiculous by his boasting." Hooke believed that others were constantly stealing his ideas and inventions. He engaged in vicious disputes with Christiaan Huygens over who invented the conical spring watch mechanism, and with Isaac Newton over, well, most of Newton's discoveries. When Newton published his "Discourse on Colour" in 1675, Hooke complained that this work was based on experimental results he had published ten years earlier; Newton was forced to admit that he had been "inspired" by Hooke's research—famously commenting, "If I have seen further it is by standing on the shoulders of giants." (Since Hooke was a very short man, this was a backhanded insult to him.) Yet later, in 1687, when Newton published his landmark work, the *Principia mathematica*, he included no acknowledgment of the prior work of Hooke. There is some truth to Hooke's feeling that others were being fêted for his discoveries. However, in 1665 he published a book that brought him undeniable international acclaim.

-6-

In 1663 the Royal Society charged Hooke with making detailed observations with a microscope of his own design. From the time of its invention until this point, the microscope had been deployed in several studies of insects, such as those by Cesi, Stelluti, and Fontana, who had joined forces in their groundbreaking study of the bee in 1625, and Odierna's momentous study of the eye of the fly, which appeared in 1644. In 1656 Pierre Borel had published a miscellany of microscopical observations, describing his use of the device to investigate plants, animals, human materials, and minerals. He saw the compound eyes of insects, the beating heart of a spider, the flow of blood in a louse. He observed the texture of the human heart, liver, kidney, and testicles. Borel's somewhat random collection of

observations pointed the way to the potentially limitless possibilities for the deployment of the microscope, including, for the first time, the application of the microscope to studies of the human body. It is not clear to what extent works of Odierna and Borel were read by other natural philosophers of the day; few references are made to their books in the works written in this time. But the publication of Hooke's microscopical studies was about to give new impetus to the use of the device.

On March 25 Hooke was "solicited"—that is, instructed—by the Royal Society to conduct microscopical observations and demonstrate them to the fellows. (He had previously presented to them some microscopical observations of snowflakes and crystals of frozen urine.) A week later he was charged more specifically with bringing in at least one microscopical observation to every one of the weekly meetings. On April 8 he "delighted" the fellows by showing them common moss under the microscope. The following week he brought in thin slices of cork, cut in both transverse and perpendicular slices. The fellows observed that viewed under the microscope the cork was made up of empty spaces surrounded by walls. Hooke later recalled,

> I with . . . [a] sharp Penknife, cut off from the former smooth surface an exceeding thin piece of it, and placing it on a black object Plate, because it was it self a white body, and casting the light on it with a deep *plano-convex Glass*, I could exceeding plainly perceive it to be all perforated and porous, much like a Honey-comb, but that the pores of it were not regular. . . .

He next cut a piece at right angles from the first piece, discovering that the pores "were not very deep, but consisted of a great many little Boxes, separated out of one continued long pore, by certain *Diaphragms*." No one had ever seen these spaces before, or imagined them to exist. Hooke called these box-like pores "cells" because of their resemblance to monks' chambers. By his careful sectioning of the cork, he had discovered and named cells, the building blocks of all life.

Over the following five months, a cornucopia of fascinating sights

met the eyes of the fellows of the Royal Society at their weekly meetings. With his microscope, Hooke gave them entrée into parts of the world not visible to naked sight—parts seemingly chosen at random, whatever took Hooke's fancy and was readily at hand: the small eels in vinegar, the bluish mold on leather, a spider with six eyes, female and male gnats, the head of an ant, the point of a needle, pores in petrified wood, leaves of sage. Fabrics were of special interest to Hooke: taffeta ribbon, fine cotton lawn, silk from Virginia. He showed them the gilt edge of Venetian paper, the edge of a razor, a millipede, honeycomb seaweed, the tail of a snail, the scales of fish. The demonstrations went on until the end of September. In July, Hooke demonstrated the most impressive of these observations to Charles II himself, presenting the royal patron of the society with a handsome keepsake volume. Once the demonstrations were finished, they were compiled into a book for publication. Hooke's *Micrographia* appeared at the start of 1665.

The publication of this work was a scientific and literary event. After seeing it being prepared at his favorite book bindery, Samuel Pepys ordered a copy on the spot. The day he collected it, he stayed up until two in the morning reading, and declared it "the most ingenious book that I ever read in my life." Pepys was right to be excited. *Micrographia* was the first full-length monograph devoted (almost) entirely to observations made with a microscope. Of the sixty observations detailed in the book, five were of man-made objects (different fabrics, a razor blade), five of minerals (sand, ice crystals), fifteen of vegetable objects (cork, seaweed) and twenty-seven of animal subjects (mainly insects). (Eight of the observations were nonmicroscopic, having to do with light, the stars, and the moon.) The book was only the second to be published with the imprint (and therefore the imprimatur) of the Royal Society. As befits a Royal Society publication, Hooke laid out in his preface the Baconian motivation for his investigations.

The Rules YOU have prescrib'd YOUR selves in YOUR Philosophical Progress do seem the best that have ever yet been practis'd. And particularly that of avoiding *Dogmatizing*, and the

*espousal* of any *Hypothesis* not sufficiently grounded and confirm'd by *Experiments*.

Like Bacon, Hooke wanted to discover the hidden natures and structures of things, and recognized that instruments were needed to see what could not be seen with the naked eye. Hooke explained that one way to correct for the weakness of the senses was by

> a supplying of their infirmities with *Instruments*, and, as it were, the adding of *artificial Organs* to the *natural*. . . . By the means of *Telescope*s, there is nothing so *far distant* but may be represented to our view; and by the help of *Microscopes*, there is nothing so *small*, as to escape our inquiry; hence there is a new visible World discovered to the understanding.

Indeed, one of the reasons for writing the book, Hooke told his audience, was to promote the use of instruments, especially the microscope, in science. By the help of the microscope, he urged, "the subtilty of the composition of Bodies, the structure of their parts, the various texture of their matter, the instruments and manner of their inward motions, and all the other possible appearances of things, may come to be more fully discovered."

The book's impact on both the scientific community and the general literate public was magnified by its numerous illustrations, including a flea so large it required a foldout page to contain it— as big as a cat, even Christiaan Huygens noted admiringly. Hooke's friend Christopher Wren may have assisted him with the engravings, but they were all based on the original drawings made by Hooke himself. In these drawings one can see the talented former student of Lely at work.

In all, there were thirty-eight pages of copperplate engravings, which laid out for all to see the incredible intricacy of even the tiniest parts of things that were visible with the new instrument. This was in marked contrast to the "small and indifferent" illustrations in the earlier books of Odierna and Borel. Anyone paging through Hooke's book could see for himself or herself the delicacy of details opened up

to our vision by this instrument. Pictures demonstrated to everyone, as no verbal description could, the beauty and complexity bestowed by God upon even his smallest and most lowly creatures—and, especially, the way the microscope gave access to this unseen world.

In his book Hooke also showed how natural philosophers could learn about vision by microscopical investigations. *Micrographia*'s figure 8 depicted the compound eye of the drone fly. Hooke explained that he first examined the exterior of the eye, observing that it is composed of some fourteen thousand hemispheres, each perfectly smooth and distributed in a regular fashion over the surface of the eye. Because the hemispheres face all angles, the fly has an incredibly wide field of vision. Hooke next described what he found upon dissecting the eye: an outer, transparent layer, or cornea, filled with a clear liquid and a mucous lining, or retina. He noted that this structure was analogous to the eye of a vertebrate and speculated how the multiple hemispheres could work together to form a precise image of an object and to help the fly determine the position and distance of the object. He concluded his examination by marveling at the mechanism that allowed such a tiny structure to have vision: "How exceeding curious and subtile must the components parts of the *medium* that conveys light be, when we find the instrument made for its reception or refraction to be so exceedingly small?" With his greatly enlarged image of the fly's eye, Hooke brought home to his many readers the intricacy of the tiniest structures devised for sight.

-7-

When Leeuwenhoek was in England, examining the chalky soil around Gravesend, Hooke's book was circulating through the country—a second edition had been printed in 1667—and abroad. During this period books were moving around the continent of Europe, and even across seas, with a speed and efficiency we associate with Internet shopping today. The Royal Society's *Philosophical Transactions*, which would soon become the main publishing outlet for Leeuwenhoek's discoveries, was available on the Continent

almost immediately after it was printed in London. Language was a barrier, but not as much as we might think. Some scientific men complained that *Micrographia* was written in English, rather than the shared scientific language of Latin. Spinoza, for instance, was annoyed by this. But other Dutch speakers were familiar with the book and its contents. Swammerdam seemed to know much about the book—its text as well as its plates—though there is no other evidence that he knew English. Christiaan Huygens translated parts of *Micrographia* into Dutch for the mathematician, natural philosopher, and bureaucrat Johan Hudde, who deeply admired the book; it is possible that other natural philosophers in the Dutch Republic saw this translation as well.

The book was well known in Rotterdam, where English was common among the residents. In the major cities and commercial centers in the Dutch Republic, English was recognized as a valuable, even necessary, second language. The demand for private tutors of English was high. Constantijn Huygens, for example, had learned English as a boy from his Scottish tutor, George Englisham, and had insisted that his sons learn English as well. Many English and Scots travelers to the Dutch Republic could manage to get by without knowing Dutch, because so many of the locals spoke English. A fair number of locals spoke French as well. The French philosopher Pierre Bayle managed to live in Rotterdam for twenty-five years without learning a word of Dutch. Travelers marveled at the linguistic ability of the Dutch; in 1592 Fynes Moryson remarked that "many of them speake the English, Italyan, and other languages."

Leeuwenhoek would later frequently deny that he had any familiarity with Hooke's book when he began his own microscopic examinations. He stressed, time and time again, that he could not have read the book, because he lacked any language but Dutch. However, in this instance it seems that the microscopist doth protest too much. We know his wife Barbara most likely spoke English growing up with her parents, who had, at the time of her birth, recently returned from living in Norwich (where her father had been born). We know that Leeuwenhoek apprenticed for six years to a Scotsman and even had the equivalent of power of attorney for his business activities,

some of which would certainly have been conducted in English. So it is probable that Leeuwenhoek could at least read some English. He would later comment in a letter discussing the eyes of the beetle on the "absurdity" of the "English expression, 'blind as a beetle'"—an indication that he even knew some colloquial English.

Later in his career Leeuwenhoek told his correspondents in the Royal Society that he was reading the issues of the *Philosophical Transactions* with the use of a Dutch-English dictionary. This was probably Henry Hexham's English–Dutch and Dutch–English dictionary, either the 1648 first edition or the 1658 second edition. In both, subjects of English grammar are discussed in the Dutch–English volume, and subjects of Dutch grammar in the other. Leeuwenhoek also revealed that he often sought out people who could translate parts of publications for him. In 1675 he remarked that he had plenty of acquaintances who could translate Latin or French for him, but not English, at least not since the death "of a certain gentleman who was proficient in that language," suggesting that, until then, this gentleman had translated English books and papers for Leeuwenhoek. (He would soon ask for translation help from Alexander Petrie, the pastor of the English congregation in Delft, who wrote an affidavit for the Royal Society attesting to his observations with Leeuwenhoek's microscope.) In one letter Leeuwenhoek quoted passages from a work by the Royal Society member Richard Waller in Dutch—so either Leeuwenhoek himself or someone else had translated them from English. Even if Leeuwenhoek could not read *Micrographia* himself, he could easily have had someone translate it, in whole or in part. He would have heard of the book, in Delft and, especially, when he was visiting England. Surely he would have wanted to see for himself what all the fuss what about.

Leeuwenhoek, who had worked so recently as a haberdasher and cloth salesman, would have been drawn to Hooke's detailed discussion and drawings of what he saw when he observed different fabrics with his microscope. In *Micrographia*, Hooke explained that the microscopist must begin with the simple; and he accordingly started his observations with the point of a sharp needle and the edge of a razor. He turned next to fabrics: "fine Lawn, or Linnen Cloth,"

"fine waled Silk, or Taffety," and "watered Silk, or Stuffs." Hooke described how threads of linen appeared under the microscope:

> A piece of the finest Lawn [linen cloth] I was able to get, so curi-ous that the threads were scarce discernable by the naked eye, and yet through an ordinary *Microscope* you may perceive what a goodly piece of *coarse Matting* it is; what proportionable cords each of its threads are, being not unlike, both in shape and size, the bigger and coarser kind of *single Rope-yarn*, wherewith they usually make *Cables*.

The sight of colored silk ribbon astounded Hooke; he observed reflec-tions so lovely and bright that they seemed to come from a cache of precious stones. Hooke elucidated why the watered silk cloth has the strange, but lovely, effect of an "irregular variety of brighter and darker parts." With a microscope one "may very easily perceive, that it proceeds onely from the variety of the *Reflections* of light, which is caused by the various *Shape of the Particles*, or little protuberant parts of the thread that compose the surface." Hooke described the way the threads of the woof are bent around the threads of the warping. He included an illustration of the weave. Like Leeuwenhoek, Hooke seemed to have a special interest in fabrics. (He may have designed a fabric pattern and attempted to add gold leaf to a shift already printed with a floral design.) Leeuwenhoek would surely have been interested in Hooke's microscopic examination of the very same fabrics he him-self had examined years before with a magnifying lens.

-8-

There is another discussion in Hooke's *Micrographia* that would have excited Leeuwenhoek's interest. In his preface, Hooke treated his methods for constructing microscopes, and explained why he used a double, or compound, microscope—a microscope with two lenses—rather than a single lens—the kind that Leeuwenhoek was employing.

Hooke described how he made the type of microscope he most often employed. First he took a tube of brass in which he placed at one end a "good *plano convex* Object Glass, with the convex side towards the Object." Into the other end he placed a "pretty large plano *Convex* glass, with the *convex* side toward my eye." He would fill the space between the two lenses with water, which helped increase the brightness of the object viewed. He fixed the microscope and the object to a pedestal, allowing for hands-free observing. Although he had made trials with other types of microscopes, he said, he had had more success with this kind of instrument.

But Hooke noted that there was another way to make an even finer microscope: "If you take a very clear piece of a broken *Venice* Glass [mirror]," he instructed, "and in a Lamp draw it out into very small hairs or threads, then holding the ends of these threads in the flame, till they melt and run into a small round Globul, or drop." Next, take these glass beads and grind and polish them. Then, Hooke concluded, "if one of these be fixt with a little soft Wax against a small needle hole, prick'd through a thin Plate of Brass . . . and an Object, plac'd very near, be look'd at through it, it will both magnifie and make some Objects more distinct than any of the great *Microscopes.*"

What Hooke has here described is a type of single-lens microscope identical to that made by Leeuwenhoek, and the method—making and polishing a bead lens —is identical to that used by Leeuwenhoek when he first began constructing microscopes. In this discussion, Hooke noted, correctly, that the single-lens microscope could magnify more than the compound microscopes of the day, and could do so without the distracting chromatic aberration that was more problematic in double microscopes. But Hooke remarked that the single lens microscopes "though exceeding easily made, are yet very troublesome to be us'd. This kind of microscope was much more difficult to employ than the compound microscope on its convenient pedestal stand. Another problem was that the single lens needed to be brought very close to the object being viewed; the object would have to be lit from behind (as there would not be room between the object and the lens). This meant that the object must be transparent or semitransparent. Dissection tools could not be used beneath the

lens, again because of how close to the lens the object would be. And, because of the need for backlighting, there would be diminishing illumination at higher magnification, which often resulted in a "dark and gloomy" image. In the seventeenth century many natural philosophers would make Hooke's choice—Nehemiah Grew in England, and Francesco Redi, Giorgio Baglivi, and Marcello Malpighi in Italy, all used compound microscopes.

However, most of the natural philosophers in the Netherlands were using the single-lens microscope. Hartsoeker declared the single-lens instruments to be the best, and Swammerdam agreed there was nothing better. The main benefit was that the single lens avoided the multiplying of aberrations that occurred when two lenses were used together. Until the nineteenth century the optics of the compound microscope were worse than that of the simple instrument, because the chromatic and optical aberrations were magnified; only when a greater understanding of refraction was gained could scientists construct an array of lenses that could cancel out these effects. Indeed, as late as 1854 the Society of the Arts in London awarded a prize for a design of a new, simple microscope.

Hooke, then, was not the first to recognize the benefit of the single-lens microscope, and Leeuwenhoek need not have read Hooke's discussion of how to make them in order to begin doing so. By the time of his trip to England, Leeuwenhoek was already making his single-lens microscopes, coincidentally using much the same procedure described by Hooke. I believe he saw Hooke's *Micrographia* while he was abroad, and even if he could not read all of its text, he still would have been amazed at the numerous plates of engraved detail showing what Hooke had observed: not only fabrics, but the cells in cork, the mold growing on leather, the eye of a fly—all showing structures invisible to the naked eye. Leeuwenhoek would have returned to Delft filled with excitement about his instruments—inspired all the more to make discoveries that had eluded even Hooke. What Leeuwenhoek could not have imagined, however, was that he would soon see living beings inhabiting an invisible world.

# Year of Catastrophe

$\mathcal{O}$N JUNE 15, 1672, the brilliant mathematician and microscope maker Johan van Waveren Hudde stood overlooking the main sluice holding back the water that constantly threatened to flood Amsterdam, the city of which he had recently been appointed burgomaster, or mayor. Earlier in life Hudde had made contributions to mathematics that influenced both Newton and Leibniz in their simultaneous invention of the infinitesimal calculus. More recently, he had been producing single-lens microscopes with beads of melted glass; during his visit to the Dutch Republic, Monconys had been shown one of Hudde's instruments by Isaac Vossius. A member of the city government since 1663, Hudde still kept up a lively intellectual correspondence, writing to Spinoza about God's uniqueness, to Christiaan Hugyens about the advantages of the single-lens microscope compared with Hooke's double-lens setup, and to Newton and Leibniz on mathematical topics. But now, the Dutch Republic was at war for its very survival. Hudde was forced to take a drastic action in the desperate hope of saving his city and what remained of the Dutch Republic. The States General had decided to flood the land running from Muiden, in front of Amsterdam, on the Zuider Zee, to Gorcum, on the Waal, hoping that this "water line" would keep out the French. Hudde gave a signal to the men at the sluice gate. They pulled on the ropes attached to the gate, opening it.

*-1-*

Two months earlier, on March 23, the English navy, together with the French, had attacked the returning Dutch Levant convoy off the Isle of Wight; guns thundered in the Channel for two full days, awakening the Dutch to the realization that they were in a life-and-death struggle. In May, Louis XIV of France led his large and powerful army across the Spanish Netherlands and into the Dutch Republic, crossing the Maas north of Maastricht. The invading army outnumbered the Dutch forces four to one. The Dutch garrisons in Cleves, on the lower Rhine, fell to the French in under a week.

The States General decided to abandon the lower Rhine provinces, as well as the IJssel, the land to the east of the river IJjssel, and concentrate on defending the states of Holland, Zeeland, and Utrecht. When the French marched into Utrecht, however, its city council decided not to fight, and the French took the city, reinstating the Catholic Mass in the churches (though granting freedom of worship to the members of the Reformed Church). Now the Dutch fought on to save Holland and Zeeland. Though the plan had been met by armed farmers resisting the destruction of their land and livelihoods, the flooding of much of the area surrounding Amsterdam was intended to create a "waterline" to hold back enemy forces. The year that followed would be known throughout Dutch history as the *rampjaar*, the year of catastrophe. It would be the beginning of an exceptionally trying time for Vermeer and his family.

In Delft, able-bodied men were called up for digging a "strong, high rampart of earth" around the city. Many of the men, including Vermeer, also joined the militia; Vermeer signed up as a *schutter*, or marksman, of the first squadron of the third company, called the Orange company, all of whom were recruited from the Papenhoek and nearby. (Leeuwenhoek seems not to have joined the militia, perhaps because he was already serving the town as a government employee.) It was not uncommon for artists to join the ranks of the *schutterij*; earlier, in the conflict against Spain for independence, Frans Hals

had joined the ranks of the Haarlem marksmen. The good eye of the artist would serve him well when aiming a musket, which had a range of seventy-five to a hundred meters. The company met regularly for shooting practice and social events, for parades and patrols of the city gates. Most members of the marksmen company were from the modestly affluent and propertied ranks; the very poor, and daily wage earners, were excluded by the high cost of buying one's uniform and arms and contributing to the cost of food and drink at the elaborate feasts the companies—similar to guilds in many ways—hosted. Vermeer did not quite fit the profile of the other members, but his mother-in-law might have helped with the financial outlay so that he could participate in this prestigious corps. Besides being encouraged to join the militia, citizens of Delft were also exhorted to pray for their town and the republic; town aldermen added twice-weekly special services for this purpose. These weekday services drew crowds large enough to cause the ecclesiastical authorities to consider using the Oude Kerk and the Nieuwe Kerk simultaneously.

Although French armies did not reach the fortified city walls of Delft in 1672, Vermeer and Leeuwenhoek's town saw its share of trouble that year. On June 29, women, workmen, and peasants of Delft, joined by unemployed fishermen from nearby Schiedam and Delfshaven, rioted in the Market Square, overtaking the Town Hall for the greater part of the day. If Leeuwenhoek was performing his duties as chamberlain that day, he would have had to push through the angry crowds to get home or else barricade himself in the rooms with the aldermen until the crowd dispersed.

Riots in Delft and in other towns of the Dutch Republic were sparked by fury at the regents. Citizens blamed them for the republic's lackluster defense against the invading forces. The week before, for example, Schenckenschans was surrendered without a shot being fired, a defeat blamed on the town's having been placed in the charge of an inexperienced, drunken young man, the son of a Nijmegen burgomaster with ties to Grand Pensionary Johan de Witt. Directing their anger at the regent families, the people demanded the repeal of the Perpetual Edict, the reestablishment of the position of stadtholder, and the elevation of William III of Orange to that

position. The regents of the provinces, under siege by both external forces and their own people, were forced to capitulate, and in early July William III took the oath of office.

But riots continued throughout the republic. The situation reached a bloody denouement in The Hague on August 20. The anger of the mob focused on Johan de Witt. His family had played a leading role in republican opposition to the family of Orange and to the position of stadtholderate. On this day Johan and his brother Cornelis were caught by an enraged crowd outside the prison opposite the Binnenhof. Members of the throng, which included men of the local militia, beat the two brothers, stabbed them, and finally shot them to death. They dragged the corpses to the prison's gallows and pulled them up by the feet to be displayed to the crowd. Participants in this mob attack mutilated the hanging bodies, cutting out the hearts, roasting them, and eating them in a cannibalistic convulsion. A phrase was coined to describe current events: "het volk redeloos, de regering radeloos, en het land reddeloos"—the people were irrational, the government distraught, the country irretrievable or past recovery.

The slaughter of the De Witt brothers emboldened the popular movement throughout Holland, and demonstrations led to the purging of many members of the town councils. On September 10, half of the *vroedschap*, the ruling body in Delft, was thrown out and replaced. Since the purged councillors favored not only the Perpetual Edict but also toleration of religious dissenters, times were to become more difficult for Delft's Catholics.

Military defeats for the Dutch Republic continued. By late summer most of the republic was in French or Münsterite hands (Münster having joined the French against the Dutch). Groningen was under siege; the countryside of Gelderland, Overijssel, and Utrecht had been ravaged by enemy soldiers; and the country villas along the river Vecht between Utrecht and Muiden, once known as the "Arcadia" of the Amsterdam elite, had been plundered and lay abandoned. The English continued to disrupt the sea routes for Dutch trade. Under the command of the king's younger brother, James, Duke of York, the English heavily outmatched the Dutch on the seas.

Miraculously, however, the "waterline" around Amsterdam held,

and the French forces were unable to penetrate into Holland. In 1673 the Dutch naval forces won three decisive battles against the English, including the final one, off Texel, in which English and French ships with 5,386 guns faced the 3,667 guns of the Dutch forces; after eleven hours of gunfire—which could be heard throughout the north of Holland—the English and French were forced to retreat. The Dutch had also embarked on a privateering campaign against English merchant ships in waters off England, North America, and Spain and in the Caribbean, forcing Charles to sign a peace treaty in February of 1674 that brought England no gains. Two months later the Münsterite forces were expelled from lands they had taken. By June 1674 Louis had lost all his Dutch conquests except for Grave and Maastricht. The young Prince William was hailed as the savior of the Dutch Republic, and the States General voted that the stadtholderate of Holland be made both "perpetual"—no doubt an ironic riposte to the Perpetual Edict—and hereditary in the male Orange line.

Although the Dutch Republic was eventually victorious in its war with France and England, there were many long-lasting repercussions of the year of catastrophe. The flooding of the countryside around Amsterdam had contributed to the victory against France, but it ruined much of the harvest, leading to food shortages throughout the nation. The high seas had become more dangerous for international trade. Once Dutch merchant ships began to venture out into foreign waters after the peace with England, they were at the mercy of French privateers based in Dunkirk and Saint-Malo, who inflicted great losses on shipping. With the disruptions in overseas commerce the Amsterdam bourse, or stock market, suffered a calamitous decline. Taxes were raised precipitously. Everyone suffered from the economic collapse, but it was worst for those selling luxury goods—like art—that could be dispensed with when necessities were so expensive.

As a result the art market collapsed. No one was buying art; instead, everyone wanted to sell and to convert assets into liquid cash. The "Arcadian" villas had been stripped of any art not taken by their owners, and sold for low prices, further depressing the market. One of Amsterdam's leading art dealers attested in a notarial deed in 1673

that prices of everything, "especially paintings and such rarities have greatly declined and slumped in value, as a result of these disastrous times and the miserable state of our beloved Fatherland."

-2-

Vermeer's situation was even more critical than that of many other artists in Delft. Unlike the typical Calvinist Dutch family of the time, with only two or three children, Vermeer and Catharina had, by 1672, eleven children to support. A large part of Vermeer's income had come from selling the works of other artists, the business he had inherited from his father. Now, these were hard sales to make. He had to offer pictures at a loss. Although he had inherited 148 guilders (about $2,320 today) from his sister's estate the year before, Vermeer was plunged into financial ruin. Unable to pay for the bread to feed his family, he began to rack up an enormous debt to the local baker as well as one to the apothecary Dirck de Cocq.

To make matters worse, Vermeer's production of his own paintings—never rapid to begin with—had also slowed to a crawl. His desire to infuse his pictures with optical effects required a meticulous method, and that took time. These effects become most apparent in his paintings from the mid-1660s onward, during which time Vermeer was fully engaged in his optical method.

Vermeer used a complex technique involving opaque layers, translucent glazes, and diffuse highlights laid over one another in order to depict optical phenomena, including his signature "specular," or mirrorlike, highlights. Contrary to what some writers have suggested, Vermeer was not the only painter of the time to deploy these reflective hightlights; others, such as Willem Kalf, were using them to great effect. Indeed, Vermeer's highlighting of the bread in *The Milkmaid* resembles the skin of a lemon or orange as painted by Kalf. However, Vermeer's method of including highlights as part of his layering technique was unique. In *The Milkmaid*, Vermeer laid down a rich orange-brown mixed with lead white and lead-tin yellow. He then added dabs of white and off-white paint, followed by a glaze of

red lake. Over these layers he added further points of white to the bread and basket to form the specular highlights.

His layering technique was deployed to depict other optical phenomena as well. In *Young Woman with a Water Pitcher*, Vermeer glazed the window with ultramarine in order to suggest subdued light and faint shadows. He left an area free of ultramarine; this is where the fingers can be seen behind the pane as the woman holds the window open. He next bordered the fingers with a whitish blue "halo," creating the illusion that they are being seen through the glass. In other works Vermeer would allow areas of paint to overlap slightly at transition areas along contours. This created a luminous effect, another way of creating a visual halo around his figures. That effect can also be seen around the skirt of the women in *The Milkmaid* and *Young Woman with a Water Pitcher*. Sometimes, as in *Young Woman Seated at a Virginal*, Vermeer achieved this by letting a little of the ground color show between a figure's contour and the background. He was also a master of color, using different layering techniques to achieve diverse tones; in *Woman with a Balance*, he applied a thin blue layer over a reddish brown layer, infusing the generally cool blue tones with an inner warmth.

Vermeer was scrupulous in his depiction of shadows. In *Woman in Blue Reading a Letter*, for instance, on the wall to the right of the chair in the back, the chair's shadow varies from a soft blue tint near the finial to a deep blue-black at its lower extreme. Imparting complexity to the composition, Vermeer added a secondary shadow from another light source not seen in the picture, presumably a window closer to the back wall. This shadow also has a light blue tinge. It falls across the primary shadow, softening its sharp outer edge. Vermeer achieved this by painting a blue-black layer over the ground, which in this case is ocher. He next painted the wall color, a mixture of lead white, light ocher, and light blue; but this color stops right at the edge of the shadow. The secondary shadow and the top part of the primary shadow appear lighter because Vermeer applied a thin blue glaze over the wall color where those shadows appear. In *Woman with a Balance* Vermeer used his monochrome painted sketch not only to define the composition before he began to paint but also to establish the area of

shadow, by darkening this part of the final image, in places where he applied only a thin layer of paint over the underdrawing.

In *Woman in Blue Reading a Letter* Vermeer took much care to create the effect of the highlights on the brass nails in the back of the blue chair on the left. He initially painted each nail at full size in a light color—probably lead-tin yellow. He next added shadows around the nails with a dark thin glaze, applying the glaze more heavily on the right side of each nail. Finally, he added a small dot of the yellow over the glaze to create the accent.

In *A Lady Writing* Vermeer created different visual textures on the brightly lit tabletop by only partially covering his rough under-paint with smooth layers on top. The underpainted layer includes coarse translucent particles of lead-tin yellow paint, which not only represents highlights, but actually catches the light. To suggest the objects on the desk—gray writing paper, a blue tablecloth, and a strand of white pearls—Vermeer simply dragged smooth final paints irregularly over the surface. Elsewhere in the picture a brown mono-chrome underpaint shows through thinly applied final paint layers, evoking an area of dark shadow. In *The Music Lesson*, Vermeer used several layers of paint, including a thin layer of natural ultramarine, in order to depict the sun-drenched carpet covering the table. In the lead bars of the nearest window, he used the ultramarine again, to show their contours diffused with a brilliant light. He distin-guished the differences in tone between direct and reflected light by his depiction of the light falling on the viola da gamba from the window (using a warm brown underpaint) and the glimmer of light reflected in the viola from the woman's skirt (where the underpaint is the same red as the ground underlying the skirt itself). In the viola's red underpainting, which is slightly offset from the folds of the skirt above, Vermeer conveyed not only the color of the light reflected from the skirt, but also the angle of the reflection. In his late painting *Young Woman Seated at a Virginal*, he chose an entirely different way to depict a reflection seen under diverse conditions of light. Here, the woman's skirt and left arm are reflected in the polished surface of a wooden instrument. But there is also another, dim reflection, as if cast by artificial illumination at night. He suggested this with a faint

"scumble" of opaque paint—an area of paint that he rubbed out with a finger to reveal a bit of the layer below—in order to convey the look of a light object reflected on a dark surface.

Vermeer was sensitive, like no other painter, to the variations of color that result from the varying intensities of light. In *A Lady Writing a Letter with Her Maid*, he used different colors to depict the bodice of the letter writer's costume as a way of conveying the different conditions of light in which it appears. In the middle tones of light, he painted the bodice a greenish tan; on her shoulder, where full daylight falls, he used not a lighter version of the same color, but a yellowish white. The conservator Melanie Gifford compares this effect to an overexposed photograph, in which the full range of color is not registered where the light is strongest. "He recorded light effects," she explains, "as the eye perceives them, rather than the rationalized version into which the brain translates this image." The way we see is, once again, the subject of Vermeer's artistry. And Vermeer recognized, ahead of the natural philosophers and "opticians," that the physiology of our color perception is such that when the light is intensified, the hue changes. We may think we see the bodice as uniformly greenish tan, but that is because of the phenomenon of color constancy—the brain compensates for the effect of varied lighting and interprets the dress as a uniform color under different light conditions. What Vermeer was painting was the way the eye actually sees, not the way the mind thinks it sees.

Finding this kind of detail in the layers of paint laid down by Vermeer should, as Walter Liedtke notes, put to rest the idea that Vermeer "sat in a dark closet [a room-type camera obscura] with the projected image of an actual room, and a palette holding colors he could not even see, and simply 'copied' reality." He did not paint his pictures "in a moment," although he did depict the effect of capturing a moment in time. On the contrary, it is not surprising, with all of this carefully crafted detail, that it took Vermeer at least three months to finish a single painting. In his later years it took longer. Not only was Vermeer painstaking in his application of the paint, but there is evidence that there were extended intervals between painting sessions, periods in which a layer of paint dried completely before a

new layer was added; this is seen in a kind of "beading" at the edges of the later paint, an effect that he may have deliberately sought by waiting before adding the later layer. This beading effect is apparent in *A View of Delft* in the edge of a rooftop as well as in the rigging of one of the boats in front of the Schiedam Gate. Vermeer's method may have been like that of Titian, who we know would work for a while on a part of a picture, then turn it around to face the wall, coming back to it again and again over a long period of time.

It is estimated that Vermeer painted only forty-five pictures in total, of which roughly thirty-five are known to us today. This is in contrast to other painters of the time, like Rembrandt and Hals, who produced works in the hundreds, and even to the *fijnschilders* like Dou and Ter Borch, who, similar to Vermeer, used a controlled and refined method, and yet made many more paintings over their careers. Of course, these painters had longer careers—Vermeer painted for only twenty years, while Rembrandt's working life was twice that. In earlier years, when Vermeer was earning perhaps a couple of hundred guilders per painting, and completing several a year, selling the pictures of other artists, and living rent-free with his mother-in-law, his household was comfortable. But later, during the last few years of his life, Vermeer sold no paintings at all, and times were very hard indeed.

-*3*-

Besides his careful rendering of optical effects, another obsession becomes apparent in Vermeer's later works: the depiction of maps and globes. A map is central to his composition in *Cavalier and Young Woman*, from about 1657. In the 1660s and early 1670s, Vermeer returned to this motif no fewer than nine times in all, four times in his final nine pictures. He did seem to have, as a nineteenth-century commentator noted, a "mania for maps."

Wall maps were common elements of home decor in Vermeer's day. Paper maps were often glued onto heavy cloth and hung, tapestry-like, on wooden rods with ball-shaped finials; these finials functioned to hold the map a few inches away from the wall, protecting the map

from the wall's humidity, ubiquitous in the Netherlands. Maps provided a relatively inexpensive way of decorating large swaths of bare walls, with their colorful patterns of land and sea, fleets of sailing ships, ornate emblems and fanciful cartouches—while at the same time exhibiting the owner's national pride in the United Provinces and its domination of world trade. Maps became so common as wall decorations that some map publishers even began reissuing old, out-of-date (but decorative) maps for this purpose. Map production throughout the world had become centered on Amsterdam in the 1590s, in part because Holland's position as a seafaring power required the development of accurate maps, and also because the change from woodcut to copperplate engraving as the method for mapmaking benefited artisans in the Netherlands, who were skilled metalworkers.

Seven of Vermeer's pictures feature maps displayed especially prominently, on the wall behind the figure or figures depicted in the foreground. These maps take on a greater prominence and importance in the final five of these: *Woman in Blue Reading a Letter* (ca. 1663–64), *The Art of Painting* (ca. 1666–68), *The Astronomer* (1668), *The Geographer* (1669), and *Allegory of the Catholic Faith* (1670–72).

The large map behind the *Woman in Blue Reading a Letter* serves as a suggestion of the wider world—one through which her correspondent may be traveling. It also provides a harmonious background for the young woman's face, neck, and hair, which glow with just a hint of light from the window on the left. At the same time the map provides a counterbalance on the top right of the picture, against the weight of the woman's bell-shaped *beddejak* (bed jacket) and the table and chair in the bottom left. Vermeer's concern with getting the compositional balance right is apparent by x-radiograph, which shows that the map had originally extended a few centimeters to the left. By making this adjustment, Vermeer ensured that the woman was closer to the center of the canvas, framed by the map and the two chairs—she becomes the center of our attention.

The map Vermeer depicted has been identified as a map of Holland and West Friesland designed by Balthasar Florisz. van Berkenrode in 1620 and printed by Willem Jansz. Blaeu a few years later. The same

map appears, smaller and with the landmasses colored differently, in *Cavalier and Young Woman* (ca. 1657). The Berkenrode-Blaeu map is oriented with the west, not north, at the top; during this period, designing a map with north at the top was not yet standard cartographic procedure. A mapmaker could choose to depict his subject with north at the left, right, or bottom, if he so pleased.

Only one original of the Berkenrode-Blaeu map remains. A comparison of that map with Vermeer's painting shows that his depiction of the map is extremely realistic, down to the detail of the ships shown sailing on the seas, with the names of the seas as written by the mapmaker: MARE GERMANICVM and DE SVYDER ZEE. By the time Vermeer painted this picture, the map was outdated; it would have been considered out of date even by 1626. The topography of the Dutch provinces was changing quickly in the seventeenth century because of extensive "poldering," by which land was reclaimed from the sea. In his later picture *Young Woman with a Water Pitcher*, we see part of a different map on the wall that is also outdated; it can be identified as a map of the seventeen provinces (with north to the right) by Huyck Allart. When Allart printed this map in the early 1670s, he used plates that had been engraved much earlier. The map shows the Zyp polder, completed in 1597, but not the Beemster polder, completed in 1612.

Although Vermeer's depiction of the Berkenrode-Blaeu map is highly realistic, in *Cavalier and Young Woman* Vermeer chose to color the map oddly, using blue tones for the land and ocher for the sea, an inversion of the usual pigmentation of maps. In *Woman in Blue Reading a Letter*, the map is shown fully in dark, ocher tones, with less attention to the details of content and decoration. Yet Vermeer's depiction in both pictures includes the very same small folds in the surface of the map, suggesting that a copy of the map was actually in Vermeer's possession when he painted both pictures. Although it was not listed in the inventory taken after his death, it may have been a map that he owned as an art dealer, and that he eventually sold.

We have seen that both *The Astronomer* and *The Geographer* prominently feature maps and globes. Maps take on added significance in these paintings because both natural philosophers depicted

by Vermeer are makers, as well as users, of maps: astronomers made celestial maps, while geographers or surveyors made terrestrial ones. These were related endeavors—indeed, at the time astronomy and geography were often studied as interdependent parts of cartography; astronomy was essential not only to navigation but also to mapmaking, for it helped in the determination of latitude on land as well as on the high seas. Holland's greatest mapmaker, Willem Jansz. Blaeu, had studied astronomy with Tycho Brahe, and charted not only the earth but also the heavens, making some important celestial observations. Vermeer underscored this relation between the disciplines—and his two pictures—by having the astronomer consult a book on both astronomy and geography, Adriaen Metius's *Institutiones astronomicae & geographicae*. (Vermeer's depiction is detailed enough that scholars can recognize the second edition of 1621—an edition published by Blaeu.) In that book Metius recommended the globes of his publisher; however, in *The Astronomer* Vermeer depicts a celestial globe by Blaeu's competitor Hondius, dating from 1600. Vermeer meticulously re-creates the constellations appearing on the globe; we can make out the Great Bear on the upper left part of the globe, the Dragon and Hercules in the center, and Lyra to the right. Such globes were often produced in pairs, one depicting the celestial map, one the terrestrial. The terrestrial counterpart to the Hondius celestial globe appears in *The Geographer*, further tying together the two works. These two globes were published and sold together, intended as companions, and were the same size: thirty-four centimeters in diameter. If Vermeer owned a pair of these hand-colored globes, they would have cost him thirty-two guilders (roughly $540 today) in total. The Hondius terrestrial globe of 1618 also appears in the *Allegory of the Catholic Faith*. In *The Geographer* the globe is turned to show the Indian Ocean—called the Orientalis Oceanus—across which the ships of the Dutch East India Company industriously sailed (in *Allegory of the Catholic Faith* the globe is turned so that the decorative cartouches are facing the viewer, highlighting the large central cartouche honoring Prince William of Orange). A map on the wall behind the geographer is a sea chart by Willem Jansz. Blaeu, published in 1600 and intended as a guide for navigating the waters

around Europe. Two unidentified maps lie on the floor, and a large nautical map has been unrolled on the table.

Another picture from this period, Vermeer's *The Art of Painting* (1666–68), prominently features a large map behind the model posing as Clio, the muse of history. Maps frequently adorned artists' studios—perhaps because painting them was a way to show off the artist's technical bravura. They were employed as backdrops in a number of seventeenth-century paintings, including Jan Miense Molenaer's 1631 *The Artist in His Studio*. Incorporating a map in studio paintings was a means of suggesting the importance of the artist in society by placing him right in the center of the world. By depicting maps of the Dutch Republic, the artist was demonstrating his value to the nation.

The map in Vermeer's *The Art of Painting* is recognizably Claes Jansz. Visscher's map of the seventeen provinces, probably a later edition published by his son, Nicolas Claesz. Visscher, after he took over his father's business in 1652. This map was, for centuries, known only via its depiction in paintings, before a copy was found in the Bibliothèque Nationale, in Paris, in 1962. The Visscher map appears in at least two paintings by Nicolaes Maes and as many as four by Jacob Ochtervelt. The map shows the Netherlands at the edge of a ship-filled sea, framed by topographical views of its major cities. It also features several decorative cartouches, explained beneath by a text. The west coast of Holland—rather than the northern border—appears at the top of the map. Vermeer shows the map in its entirety, including decorative elements not seen in other paintings in which the map is depicted. These elements, such as borders with topographical depictions of cities, were generally available by "special order" to purchasers of a particular map, and so they may not have been part of the maps owned or used by Maes and Ochtervelt. Vermeer's mastery at depicting light and substance is evident here, where the map's cracked and varnished surface has a tactile quality—we can almost feel its surface and sense its weight as it hangs from its supports. The map presents to us the strongest sense that Vermeer may have traced an image projected by a camera obscura—we know the instrument

was used extensively for tracing maps in the eighteenth and nineteenth centuries.

On one level of abstraction, the map in *The Art of Painting* represents the past, just as does the artist's outmoded fashion and the appearance of Clio, with her symbolic laurel wreath and trumpet. The seventeen provinces had not been politically united since 1581, before independence was declared from Spanish rule. Could the appearance of this map in this picture suggest a yearning for the days when the Netherlands was united under Catholic Spanish rule? Could the fold that appears in the center of the map, about where the city of Breda would be, mark out a division between the southern and the northern provinces, which by now were split up? Maps showing the seventeen provinces were still being issued long after the Treaty of Westphalia had decisively split the Northern and Southern Netherlands in 1648.

There is another symbolic meaning of the map in *The Art of Painting*, a metaphor that applies to the depiction of maps in Dutch pictures more generally. On the upper border of the map is written "Depictio," reminding us that mapmakers were known as "world describers." The great mapmaker Jacobus Hondius was referred to in 1634 as "the best world-describer of the century." Mapping a place was a common way of depicting it—even memorializing it. Cornelis Drebbel, for instance, mapped his hometown of Alkmaar before he left it; the only map he ever made, it was a kind of homage to his home as well as a way of contributing to knowledge of it. Many of the artists of the day were engaged in mapping. Gaspar van Wittel, later known as Vanvitelli, originally went to Italy as part of a Dutch hydraulics team to map the Tiber as part of a scheme to make it navigable. (That is the job that introduced Vanvitelli to the camera obscura, which he employed to map the Tiber, and which he later used for painting his famous Roman cityscapes.) Claes Visscher was not only a mapmaker but also a draftsman and engraver, and a publisher of not only maps but also landscapes and portraits. Mapmakers were members of the Guild of St. Luke, as were sellers of maps, who were often the same dealers who sold other kinds of prints. Map-

making was considered both an art and a science in the seventeenth century, often symbolized—as in one map—by the addition of a decorative cartouche showing a woman holding a paintbrush and palette, representing the art of drawing and painting, and a man holding a pair of dividers, a yardstick, and a straightedge, representing the science of measuring and surveying.

Vermeer was painting maps at a time when his neighbor Leeuwenhoek was engaged in surveying, geography, and astronomy—endeavors all related to mapmaking. And it was a time when Leeuwenhoek was conducting his early microscopical observations. Although maps looked outward to the wider world, and microscopes looked inward, at the hidden structures of organisms, they shared one characteristic: maps, like Leeuwenhoek's microscope, brought to the eye what could not be seen otherwise, making the invisible visible. "How wonderful a good map is," Van Hoogstraten told artists, "in which one views the world as from another world thanks to the art of drawing." And like a telescope, a map makes distant, unseeable things visible to us. Indeed, maps were often referred to as "glasses" (that is, lenses) to bring objects before the eye. In the introduction to his *Theatrum orbis terrarum* of 1606, Ortelius noted, "Those chartes being placed as it were certaine glasses before our eyes, will the longer be kept in memory and make the deeper impression in us." Placing maps within pictures reinforced the Dutch notion of painting as describing, as opposed to the Italian narrative tradition, in which pictures told stories. Mapping grew out of the impulse to describe nature—an impulse that was shared at the time by surveyors, artists, printers, and the general public in the Netherlands.

-4-

The descriptive impulse was related to the empirical outlook that pervaded Dutch society, and that spurred the collecting of data, specimens, and observations in natural history, anatomy, medicine, and astronomy, and in the cabinets of curiosity compiled by many Dutch citizens. Bacon's writings illustrated and codified this empiri-

cal trend. Natural philosophers were not the only ones reading Bacon during that time—artists were paying attention to his writings as well. Van Hoogstraten, for example, quotes from Bacon's works several times in the *Inleyding*, his treatise instructing artists, and so we know that artists were aware of the English lord chancellor at least after reading that work (if not before).

Van Hoogstraten may have been introduced to Bacon's works during a visit to England in 1662, soon before he began writing his treatise. He had traveled to England as part of his "grand tour" throughout Europe. Reaching London in early August 1662, Van Hoogstraten remained—with just two brief trips elsewhere—until 1667, when he departed for The Hague (where he remained until his death in 1678). While in England, Van Hoogstraten became acquainted with several fellows of the Royal Society of London at a party he attended at the home of Thomas Povey, one of the society's founders. Van Hoogstraten would go on to paint seven pictures while in England, two of which were produced for Povey. Bacon's idea of science was likely one of the topics of discussion at evenings Van Hoogstraten would later spend with Povey and other fellows of the Royal Society. During his stay in London, Van Hoogstraten also attended meetings of the "Tas" association in Vauxhall, which was a meeting place for artisans and engineers; decades earlier Drebbel had been a fixture at the Tas. The group watched experimental demonstrations and discussed technical inventions at the meetings.

Van Hoogstraten's overriding concern in writing his book was to show how the insights artists gained by their scrupulous attention to the visible world were in sync with the knowledge of nature discovered by the natural philosophers of the day. In giving his *Inleyding* the subtitle "The Visible World," Van Hoogstraten was telling his readers that the painter's subject is not the world understood on some metaphysical level, or the supernatural world, but the world as it is visible to us.

But that does not mean that the supernatural has nothing to do with art. Empiricism, as Van Hoogstraten understood it, bestowed a divine justification not only to the role of the natural philosopher but also to the role of the artist. He quoted Bacon's appeal to his readers

that they should study nature as a means "to unroll the volume of Creation." Van Hoogstraten exhorted the painter to depict the visible world in order to concentrate the viewer's mind on the invisible foundation of that world, namely its Creator. This view resonated with the Calvinism of the day; hadn't Calvin himself written that the created world "stands before us as if it were a mirror, in which we can behold God, who himself is invisible"? Bacon, too, had written that God "[has] framed the mind of man as a mirror or glass capable of the image of the universal world." Like Calvin and Bacon, Van Hoogstraten proposed that nature was God's "Second Book," a book that the natural philosopher should learn to read and that the artist should describe on his canvas. As one English writer observed in 1634, "since [painting] is onely the imitation of the surface of Nature, by it as in a book of golden and rarelimned Letters . . . wee reade a continuall Lecture of the Wisedome of the Almightie Creator."

Like the natural philosopher, the artist, in depicting the book of nature, was coming closer to God. In the *Inleyding* Van Hoogstraten quoted Calvin's remark that the art of painting "in the continued mirroring of God's wondrous works, brings its sincere practitioner, through his sublime contemplation, closer to the Creator of all things." Painters should learn about God's book of nature in order to depict it properly; and by doing so, the artist was, in his or her own way, venerating God's work. As Samuel's brother Frans van Hoogstraten wrote in the poem that prefaced the *Inleyding*, "nowadays human sensibility . . . / has begun to sing the praises of the invisible Godhead / through this painting of visible things."

Van Hoogstraten began, but never published, a second volume, entitled *De onzhichtbaere werelt* (The invisible world). The invisible world lying behind the visible world was, for Van Hoogstraten, the spiritual world, the world of God, who created the visible world. But it is tempting to wonder whether he might also have discussed the invisible world soon to be discovered by Leeuwenhoek—the world of beings so small they were invisible to the naked eye.

Van Hoogstraten's self-portrait, reproduced on the frontispiece of the *Inleyding*, makes reference to both the visible and the invisi-

ble worlds, by featuring two spheres behind the painter, a common iconography for the two domains. His teacher Rembrandt had similarly depicted himself in the Kenwood House self-portrait (ca. 1660) with two large circles dominating a background that is, art historians think, unfinished. Rembrandt, like Van Hoogstraten, may be representing himself as a painter standing before the visible and the invisible worlds, *corporalia* and *spiritualia*, the world that God has created and the Creator himself. The two painters have mapped themselves within a dual reality, the visible and the invisible worlds.

-5-

In May of 1672, a month before the riots in Delft against the Perpetual Edict, Vermeer was part of a delegation that traveled to The Hague in order to appraise a collection of disputed Italian paintings to determine whether they were real or copies. Besides Vermeer, serving his second term as headman of the Guild of St. Luke's, the delegation included two other headmen from the guild, and other painters, including Willem van Aelst. One of the artists, Johannes Jordaens, had spent many years in Italy, whereas others, including Vermeer, had never (as far as we know) left the Netherlands.

In 1671 Amsterdam's leading art dealer, Gerrit Uylenburgh, had sold twelve pictures and some sculptures from the famous collection of Gerard Reynit to Friedrich Wilhelm, the Great Elector of Brandenburg. Gerrit was the son of Hendrik Uylenburgh, in whose studio Rembrandt had worked, and whose niece Saskia—Gerrit's cousin— had married Rembrandt.

Friedrich Wilhelm was the grandson of the Brandenburg elector who had been implicated in the counterfeiting scheme undertaken by Vermeer's grandfather and uncle in 1619; one wonders whether Vermeer thought it ironic that he was now being asked to determine whether paintings bought by him were authentic or "counterfeit." These pictures were supposedly the works of sixteenth-century Italian masters, including five by Titian, a Giorgione, a Raphael, and

a Michelangelo. At that time Italian paintings were considered the pinnacle of art; only the wealthiest burghers could afford to collect them. Most Italian paintings in the Dutch Republic were in Amsterdam, and some were in The Hague—only very few were in Delft. (Of course, there was much more trade in Italian paintings in the Southern Netherlands, which, being a colony of Spain, had a closer connection to Catholic Italy. Titian, for instance, had worked for the king of Spain.) Because of the rarity of Italian master paintings in the north, Uylenburgh had asked for a fantastic sum. One picture, supposedly a Venus and Cupid by Michelangelo, was priced at an incredible 875 guilders (about $12,625 today). Another, a portrait of Giorgione by Titian, was assessed at 650 guilders ($9,380).

Uylenburgh's problems began when the still-life painter Hendrik de Fromantiou, acting as the agent for Friedrich Wilhelm, had declared that the collection, with one possible exception, was made up of "bad copies and trash." Affronted, the Great Elector returned the paintings to Amsterdam, but Uylenburgh refused to take them back. Fromantiou began soliciting depositions from painters who claimed the pictures were forgeries, but other artists supported Uylenburgh's claim. Both sides sought painters who had spent time in Italy and would have had more experience viewing Italian pictures than they could have had in the Dutch Republic. The painters Wilhelm Doudijns and Carel Dujardin went through the list of paintings one by one, declaring that most were copies or imitations of the masters to whom they were attributed. Both painters had had extended stays in Italy; Dujardin had studied in Italy, and Doudijns had been a member of the Bentvueghels, a group of Dutch artists in Rome, for twelve years. But then two of Rembrandt's most talented pupils, Gerbrand van den Eeckhout and Philip de Koninck, declared that the paintings did have "merit" and deserved to be hung in a collection of Italian art. Another painter who had studied in Rome, Johan Lingelbach, agreed with them. Fromantiou next induced Abraham van Beyeren, Pieter Codde, and Philips Momper to claim the contrary.

After the Amsterdam art community had weighed in, and Uylenburgh still refused to take the pictures back, they were sent to The

Hague, where the collection was hung on the premises of the Confrerie Pictura, an academic club located in the Boterwaag (the butter-weighing house) on the Prinsengracht. The Pictura had been founded in 1656 by painters unhappy with the administration of the Guild of St. Luke in that city. (One of the founders was the painter Wilhelm Doudijns, who had already declared the paintings to be copies or imitations when he saw them in Amsterdam.) Painters from The Hague and elsewhere viewed the pictures and weighed in on the question of their authenticity. Constantijn Huygens went to see the pictures; he supported Uylenburgh's claim about the value of the pictures, saying that he had examined all of them and found them to be originals, not copies; but he tactfully agreed that "some might be worth more than others." Jordaens and Vermeer gave their opinion before a notary in The Hague on May 23, 1672, declaring that the pictures

> not only were not excellent Italian pictures, but on the contrary did not deserve to bear the name of a good master, let alone the names of such excellent masters as they are supposed to have been made by, and so were not worth by far the tenth part of the afore-mentioned proposed prices.

Uylenburgh was finally compelled to accept the return of the pictures, which catapulted him into financial ruin and bankruptcy proceedings. The Great Elector kept some sculptures from the collection, whose value was equal to the deposit he had paid for the paintings. The rejected paintings were sold at auction in Amsterdam in February of 1673, but there is no record of the prices received for them.

It is hard to know today which side in the controversy was correct. Did Uylenburgh purposely sell fake masterworks? Were they the product of schools or workshops of the masters? Could they have been originals? Only one picture from the collection is extant today: a *Dance of Naked Children* attributed by Uylenburgh to Jacopo Palma; it is probably a sixteenth-century painting by the school of Palma, not by the master himself. Two of Uylenburgh's pictures are known

only by engravings of them. These appear to be not by Giorgione and Paris Bardone as Uylenburgh claimed, but by other painters of the period. Vermeer seems to have been closer to the truth than his acquaintance Huygens. Although Vermeer had never been to Italy, and could not have viewed many Italian originals in Delft, he could see with his own eyes that the pictures at The Hague were not masterpieces.

# The Invisible World

ᴴENRY OLDENBURG, THE secretary of the Royal Society of London, sat at his desk and opened one of the many letters he received each week from correspondents around the world—so many, in fact, that he sometimes asked people to address them to "Mr. Grubendol," using the anagram to try to hide from the postal authorities that he was in contact with so many foreigners. By then, in the spring of 1673, war had raged intermittently for decades: against Spain, against Ireland, and against the Dutch Republic—not to mention England's own civil wars. Spies were everywhere. Even the brother of Francis Bacon had spied for England in France, using, some believe, a cipher devised by the natural philosopher. It was dangerous to be seen as too close to anyone, even a natural philosopher, who lived in a country hostile to England—especially the Dutch Republic. But there was no way Oldenburg could avoid that; his responsibility as secretary of the Royal Society was to be in touch with natural philosophers around the world. Oldenburg must have shuddered to remember the time in the summer of 1667—while the guns of a foreign fleet thundered up the Thames for the first time—when he had been clapped into the Tower of London under suspicion of "carrying on political correspondence with parties abroad, obnoxious to Charles II and the Government."

This time Oldenburg's correspondent was the famous Dutch phy-

sician and Delft resident Reinier de Graaf. England and the Dutch Republic were still officially at war, and De Graaf's letter began with an allusion to that conflict: "That it may be the more evident to you that the humanities and science are not yet banished from among us by the clash of arms, I am writing to tell you that a certain most ingenious person here, named *Leewenhoeck*, has devised microscopes which far surpass those which we have hitherto seen."

Enclosed with the letter from De Graaf was a sheaf of papers addressed to Oldenburg by Leeuwenhoek, dated April 28. Reading Leeuwenhoek's letter, Oldenburg must have been astonished to realize that this natural philosopher—completely unknown to the Royal Society—reported using a microscope to see what even the great Robert Hooke had not observed. Perhaps the Royal Society secretary had an inkling that the history of microscopic studies was about to take a fascinating turn.

-*1*-

The *rampjaar* and its outcome seem not to have impeded Leeuwenhoek's work. Unlike Vermeer's, Leeuwenhoek's income was not tied to the production or sales of any material goods; he was paid by the city government, which needed to operate in times of war and peace alike. His good fortune was furthered by his second marriage. In January of 1671, when he was thirty-nine years old, he married Cornelia Swalmius, the daughter of the Dutch Reformed minister Johannes Swalmius and Grietje Adriaens Uttenbrouck or Uytenbrouck (probably a relation of the painter Moses van Uyttenbroeck). Cornelia was two years younger than Leeuwenhoek and considered a spinster, as she had never married. Her brother was married to a woman named Margrieta van den Burch; the fact that she shared the same name with Leeuwenhoek's mother, and that before her marriage to Adrianus Swalmius she lived on the Hippolytusbuurt, near Leeuwenhoek, suggests that she was a relative of Leeuwenhoek's mother, perhaps a niece, making Margrieta and Leeuwenhoek cousins. It is likely, then, that Leeuwenhoek had met Cornelia through his relative.

Cornelia's family was a distinguished one; the Uttenbroucks were wealthy patricians in the Leiden area, and the Swalmius family contained several well-known scholars and ministers. Rembrandt had painted the portrait of the Reverend Eleazar Swalmius (Cornelia's great uncle), and Eleazar's brother Dr. Henricus Swalmius had sat for Frans Hals.* It is believed that Leeuwenhoek and his wife Cornelia had possession of the Rembrandt and Hals portraits for at least part of their marriage; if so, Leeuwenhoek had pictures by two of the most highly esteemed painters of the day hanging in his house on the Hippolytusbuurt.

Two years after marrying Cornelia, Leeuwenhoek wrote to the Royal Society of London for the first time. He had already been making microscopes and observing with them for some years. But it was De Graaf who finally persuaded Leeuwenhoek to put his observations down on paper and send them to the Royal Society.

De Graaf was younger than Leeuwenhoek; born in Schoonhoven in 1641, he was the son of a wealthy Catholic architect. He studied medicine in Utrecht and Leiden. In Leiden he was friendly with his fellow students Jan Swammerdam, Niels Stensen, and Frederik Ruysch. Their teachers included Franciscus Sylvius and Johannes van Horne. All six men would go on to do groundbreaking work in anatomy, especially regarding the organs of procreation. Ruysch invented new ways to preserve anatomical specimens, and—rather repulsively—created dioramas incorporating human parts (his daughter Rachel, the still-life painter, began her artistic career decorating his vast collection of body parts with flowers, fishes, seashells, and lace for the "delicate areas"). Ruysch proved that the lymphatic system included valves and discovered the central artery of the eye. He would eventually become the director of the botanical gardens in Amsterdam. Stensen, also known as Nicolas Steno, would make important discoveries in both anatomy and geology, including the

---

* The Rembrandt portrait had been thought to be a false attribution until it was cleaned in 2008; it was lent to the Rembrandthuis in Amsterdam until the end of 2015 by its owner, the Royal Museum of Fine Arts, Antwerp. The portrait of Henricus Swalmius is owned by the Detroit Institute of Arts.

discovery of the human tear duct. He gave up science completely when he converted to Catholicism and became a priest (he was beatified by Pope John Paul II and is on his way to canonization in the Catholic Church). Swammerdam, who invented unique methods for preserving and studying dissected corpses and organs, also eventually turned away from science to devote himself to theological writings.

After further study in France, De Graaf settled in Delft, where he met Leeuwenhoek, perhaps through his fellow medical doctor Cornelis Isaaks 's Gravesande, who lived near Leeuwenhoek's home. Leeuwenhoek would later report that he had seen De Graaf transfuse blood from one animal to another; this was something that 's Gravesande would surely also have witnessed. Or De Graaf may initially have met Leeuwenhoek in Catholic circles, if Leeuwenhoek was Catholic. By this time the Catholic community in Delft had diminished, as many Catholics had left Delft for cities in the Southern Netherlands after the purges of the tolerant regents in 1672. By 1700 only 9 percent of the citizens were Catholic, leaving fewer than two thousand adults and children of that faith in Delft. Catholics tended to know each other through the two houses of worship. (This suggests that De Graaf might have known Vermeer too.) De Graaf buried a young son in 1673 and died soon afterward.

De Graaf had been in correspondence with the Royal Society some years before sending his letter introducing Leeuwenhoek. Although the Dutch Republic was leading the way in certain scientific fields, it still had no organized scientific societies; these would arise only in the second half of the eighteenth century. Dutch natural philosophers looked to the Royal Society, as well as the Royal Academy of Sciences in France, as sources of knowledge about developments in the wider scientific community, and as channels for publicizing their own work within it. The Royal Society was a natural outlet for Leeuwenhoek's discoveries.

Leeuwenhoek was, at first, nervous to write to the Royal Society, and his early letters show him deferring to its fellows, showering them with honorifics and praise, yet at the same time firm in his self-confidence about his own observations. In these letters he

addresses the fellows as "Heeren curiuse Lieffhebbers." *Heeren* means "gentlemen," and shows Leeuwenhoek acknowledging the loftier status of these men, many of whom were of noble family or had studied at Oxford or Cambridge. He himself was not of so lofty a social class, and must have been painfully aware of his lack of university training. We find him frequently apologizing to the Royal Society fellows for his lack of ability in Latin and other languages. *Liefhebbers* can be translated as "dabblers," "amateurs," or "cognoscenti" and was sometimes used to denote laymen in a certain area. The term was employed by Van Hoogstraten in his *Inleyding* to refer to art lovers without practical knowledge of artistic technique. At the time natural philosophers did not think of themselves as comprising a profession—the fellows of the Royal Society were wealthy men of leisure, or antiquarians, or other amateurs who were "dabblers" in science. Leeuwenhoek thought of himself that way as well, and was trying to connect to the fellows through this shared designation.

Soon after Leeuwenhoek wrote his first letter to the "Heeren Lieffhebbers" of the Royal Society, Hooke received a note from Constantijn Huygens giving his positive assessment of the former haberdasher from Delft, with whom he had already been in contact.

> He is a person unlearned both in sciences and languages, but of his own nature exceedingly curious and industrious. . . . I trust you will not be unpleased with the confirmations of so diligent a searcher as this man is, though allways modestly submitting his experiences and conceits about them to the censure and correction of the learned. . . .

Here began a fifty-year-long correspondence between Leeuwenhoek and the Royal Society of London, which would end only with Leeuwenhoek's death in his ninety-first year. During these fifty years he would write around three hundred letters, most of them addressed to the Royal Society. Throughout this period, Leeuwenhoek recorded his observations and discoveries in letters only—he never published a book or a scientific paper. Most of his letters were

published in various venues during his lifetime. About half of his letters to the Royal Society were translated into English, in whole or in part, and appeared in the *Philosophical Transactions*.

Reading his letters, one gets the sense of a man in a hurry—rushing to record the exhilarating observations he has made so that he can go back and make some more. Leeuwenhoek certainly cultivated that impression, emphasizing his adherence to the Baconian empiricism of the Royal Society, often claiming that he set down his results just as he obtained then, "unarranged promiscuously as put down during my observations." This could be one reason that Leeuwenhoek never wrote a book, unlike other scientific investigators of the period; he did not wish to take time away from making observations. His lack of academic training may have been another reason he never penned a monograph: he did not have the credentials, the patronage, or the scientific language, Latin, to bolster his writings.

The epistolary form of Leeuwenhoek's writings mirrored what was going on in other areas of literature in his time. The last third of the seventeenth century—just when Leeuwenhoek began writing to the Royal Society—saw the rise of the epistolary novel, in which fictional letters, instead of a third-person narrative, were used to tell a story. James Howell's *Familiar Letters*, published in three volumes starting in 1645, contained fictionalized accounts of his travels abroad as letters written home. The *Letters of a Portuguese Nun*, purporting to tell the tale of forbidden love between a cloistered woman and a French officer, was all the rage in literary circles after it appeared in 1669. And Aphra Behn, whose portrait was painted by Hooke's teacher Peter Lely and was recruited as a spy for the Charles II during the Second Anglo-Dutch War, had great success with her racy *Love Letters between a Nobleman and His Sister*, published in four volumes between 1684 and 1687.

We cannot know whether Leeuwenhoek's ease with this format for publishing his discoveries was related to the literature being read and discussed in educated circles around him (such as the learned members of his new wife's family). But we know that soon, in his letters, truth would become stranger than fiction.

-2-

By the time Leeuwenhoek wrote his first letter to Oldenburg, micro-scopic studies had undergone a metamorphosis since the publication of Hooke's *Micrographia* in 1665, in part because of the popularity of that book. The initial use—marveling at the wonders of tiny creatures—had evolved to the more systematic study of organic beings. Natural philosophers had begun to realize that merely look-ing at an insect with a microscope was not enough. It was exciting for a time to see "flies the size of an elephant," but eventually nat-ural philosophers yearned to know what was *inside* those tiny crea-tures. Soon after *Micrographia* appeared, Huygens's friend Margaret Cavendish—who had used a microscope in the 1640s—dismissed the "art of Micrography" for not doing enough: it described only the out-side of tiny animals, and did not "discover their interior, corporeal, figurative motions, and the obscure actions of Nature, or the causes which make such or such Creatures." She had missed Odierna's ear-lier efforts to meticulously open the eye of the fly to uncover the workings of its vision. But Cavendish was expressing a common dis-enchantment with what seemed to be the limits of the microscope. She was correct that Hooke himself was not particularly interested in looking inside organic beings, and had concentrated on looking at the outside of both organic and inorganic objects. Still, his method-ical study of organic beings—and his careful cross-sectioning of the cork—heralded a new stage in microscopic research. Soon the microscope would be used the way Cavendish had hoped: to look at the "interior" of creatures, to try and discern "the causes which make" them.

At this time Marcello Malpighi, who held the chair of practical medicine at the University of Bologna, was taking the first steps in this direction. He was using a microscope to study the structure and "textures" of various organs in the human and animal body: lungs, skin, brain, liver, and kidney. Malpighi had been influenced by his acquaintance with Giovanni Alfonso Borelli, one of the founding

members of the Accademia del Cimento, a scientific society begun in Florence in 1657 by students of Galileo's. Like the Royal Society in London, the Accademia stressed experimentation and eschewed speculation; its motto was *Provando e riprovando*—Test and retest. Borelli held that the operations of organic structures are caused by the action of the parts of living bodies that are not visible to the naked eye. These parts were often described as familiar machines; as Borelli put it, "The operations of animals are accomplished by mechanical causes, instruments, and procedures, that is, by the scale, the lever, the pulley, the tympanum, the wedge, the screw, and so forth." Borelli's view was in keeping with the time's general mechanistic outlook.

This mechanistic program had been kick-started by Descartes with his first publication, the *Discours de la méthode* in 1637, in which he outlined a plan for explaining all the physical aspects of the human body in terms of machinelike structures. Descartes's championing of the mechanistic philosophy dates back to his meeting Isaac Beeckman in Breda in 1618. Beeckman, a mathematician, physicist, and theologian, known as a man of encyclopedic knowledge, welcomed Descartes when he arrived in Breda and became, in Descartes's words, a "promoter" of his studies (Beeckman would later sniff that he had been more like Descartes's teacher). Like Beeckman, Descartes came to believe that the underlying cause of actions and processes observed in natural bodies were invisible tiny mechanisms throughout nature, specifically small, unobservable "corpuscles" of matter that cause natural phenomena by their contact with one another. Unlike proponents of atomism, such as Boyle, Descartes rejected the idea that there is a smallest, indivisible particle of matter; on his view, God can always divide any particle further. Descartes also rejected the view, held by atomists, that there exists a "void," or vacuum, in which the corpuscles move. His corpuscles somehow move *through* other matter.

Descartes's mechanistic and corpuscular program was wildly influential. A widening circle of university professors and medical doctors held that the workings of the body—and its malfunctions—were to be explained in terms of the shape, arrangement, and move-

ment of particles so small they could not be seen with the naked eye. It became common to use machine metaphors for understanding these mechanistic processes; in his later work *L'Homme*, published in the early 1660s, Descartes had described the human brain as a system of ropes and strings. Earlier, Kepler had said that "the heavenly machine is . . . a kind of clockwork." Boyle claimed more expansively that the entire natural world is "a great piece of clock-work." In his inaugural lecture at the University of Messina in 1662, Malpighi praised the mechanistic philosophy of Descartes as putting anatomy on a firmer footing.

Not only properties of the body but also sense perception was described mechanistically. For instance, taste was described in terms of the contact of particles of different shapes on the tongue, much as the Roman poet Lucretius had argued in the first century BCE. Followers of Descartes, known as Cartesians, speculated about the pointed shapes of the particles making up salt and vinegar, which would hurt the tongue and cause the sharp, acidic tastes of these substances. Later, when Leeuwenhoek examined the infusion of pepper and other spices, he seems to have been looking for the jagged shape of their particles. He subsequently concluded that the pungency of pepper is due to "its sharp parts, [which] leads to stinging or wounding of the tongue." Leeuwenhoek could have known about Cartesian mechanism either by reading the Dutch edition of Descartes's *Principia philosophiae*, published in 1657, or through his conversations with Constantijn Huygens or other of his acquaintances, such as the Utrecht physician Lambert van Velthuysen, who was a staunch Cartesian.

Some writers, however, like Nicolas Steno, complained that proponents of mechanism were not doing enough: you could not just observe a machine from the outside, but had to take it apart, in order to fully understand its workings. This led to a new program of study in human anatomy, called subtle anatomy, which focused on peering inside the body to uncover its tiniest parts, employing the microscope as needed. Steno himself would use subtle anatomy to prove that Descartes was wrong to claim that the pineal gland in the head was unique to humans (and the center of the soul); by numerous care-

ful dissections, Steno found the gland in other animals. Johannes de Raey noted that human bodies are like buildings, in that the façade is surpassed by the skill and beauty within. When studying the human body, one must "descend into the interior, reveal the structure, nexus and spaces of the tiniest parts, observe hidden movements, and fully expose at last the causes and ingenious art of nature." This meant the rejection of Descartes's own scientific method of theorizing from ideas in the mind, and the acceptance of Bacon's method of observation and experimentation. Just four years after his inaugural lecture praising Descartes, Malpighi turned against Cartesianism, denying it any role in anatomy. The only way to "come to know the structure of the kidneys," he explained, is "not by any means" through books or pure reason, but by many dissections, and by "the patient, long-continued and varied use of the microscope."

Like the microscope, the telescope, and the camera obscura, dissections, by opening up human bodies, made visible the invisible. It was inevitable, perhaps, that microscopes would soon be deployed during dissections, or with parts retrieved by dissections, as physicians sought to understand the structures exposed by laying open the body. By the 1680s, microscopical descriptions and illustrations based on microscopic observations were to be found in major anatomical publications by leading Amsterdam physicians. As one writer would declare toward the end of the seventeenth century, never before had there been such a "rummaging through the human body" in search of surprising structures.

To accommodate this new interest in dissection, Padua built the first anatomical theater for human dissection in 1594; three years later Leiden built one, followed by Delft in 1614 and Amsterdam in 1639. These "theaters," as the name suggests, not only allowed physicians and philosophers to perform dissections of human corpses for their own research, but they also hosted public displays. Generally held around Christmas—when the cold weather ensured slower decay of the body—dissections of executed criminals became spectacles, conducted under the watchful eye of the public. Just as the Dutch Republic had put its criminals to work as a way of enabling them to be of use to society, it put the corpses of criminals "to work"

so that they could be of use to anatomical science and to public education. Members of the public, who generally were charged a modest admission fee, would sit in carefully marked-out sections, and were forbidden to take any body parts home with them (these were often passed around the audience for closer inspection, and were highly sought-after trophies for cabinets of curiosity). Public anatomy became a kind of public entertainment. As this fad was described later, "nor was it spurned by gentlewomen, who, clad in sumptuous raiment, attended to the lugubrious exercises of the anatomist during the day, and later went on to gay balls and parties."

In Delft and the other anatomical cities in the Dutch Republic, the theaters played, to some degree, the social role played by the Royal Society in London: as a place where natural philosophers could gather and share their findings. But the theaters were also places for artists to gather. Some would be moved to paint large-scale pictures depicting anatomical lessons in action, like Michiel Jansz. van Mierevelt's *Anatomy Lesson of Dr. Willem van der Meer* (1617), Rembrandt's *Anatomy Lesson of Dr. Nicolaes Tulp* (1631), and De Man's *Anatomy Lesson of Cornelis 's Gravesande* (1681). Artists were drawn to the anatomy theaters not only for the demonstrations of dissections—which gave them insights into human anatomy they could not get elsewhere but also to the collections, or small museums, attached to the theaters. The Leiden theater possessed skins of tigers, leopards, and a sloth; an anteater, the "hand of a mermaid," and paintings, etchings, and gravures, in biblical, historical, and allegorical styles. The Delft theater displayed several skeletons of famous criminals, skeletons of a crocodile, rhinoceros, and shark and collections of plants, eggs, shells, and other curiosities from around the world. The anatomical theaters served as research centers for artists as well as for natural philosophers.

-*3*-

In Bologna's anatomical theater, built in 1637, Malpighi was opening up humans and other creatures to reveal their inner structures,

and examining these structures with his microscope. He applied the techniques of anatomical preparation to these microscopic studies: he injected colored liquids into tiny vessels, cooked, dried, and macerated excised materials, poured colored ink over dissected parts of brains, kidneys, and male genitalia, and blew gases such as carbon dioxide into vessels to expand them for easier examination. By such methods Malpighi was able to see many details in the texture of animal organs not recognized by others, including some later named for him, such as the "Malpighian bodies" of the kidney (the glomeruli, or network of capillaries), the capillaries of the frog lung, and the "Malpighian" (or "reticular") layer in the skin. He was the first to realize that the lungs of animals and men were not merely a homogenous mass of flesh, as had previously been thought, but instead had a complex structure, composed of thin membranes shaped into vesicles that sprouted from the branches of the trachea, like a tree. He was also the first to see capillaries in animals, thus giving an explanation for the connection between veins and arteries that had eluded the English physician William Harvey, when he had published the first correct and mostly complete description of circulation of the blood in 1628. Harvey had used only a magnifying glass, not a more powerful microscope, and his investigation of the blood and its circulation throughout the body was hampered by his lack of a stronger instrument.

Malpighi's work soon became known outside of Bologna. In 1667 Malpighi was contacted by Henry Oldenburg, who challenged him to participate in the scientific program of the Royal Society. Oldenburg specifically suggested a study of the silkworm (such as those that the children raised in Delft). Oldenburg was, perhaps, aware of the importance of the silkworm to the industrial life of Bologna; silk weaving was one of the mainstays of the Bologna economy in the seventeenth century. By the end of the seventeenth century there were 119 silk mills, run by waterwheels powered by the canals running through the city. By the end of the eighteenth century twelve thousand of the city's seventy thousand residents worked in the silk industry.

Malpighi found it easy to acquire silkworms for his examination.

Joris Hoefnagel, *Animalia rationalia et insecta*, ca. 1575. Hoefnagel used a magnifying glass to observe insects and other animals.
*National Gallery of Art, Washington*

Rachel Ruysch, *Still Life with Flowers in a Glass Vase*, ca. 1690. Ruysch, like many of the Dutch flower painters, used a magnifying glass to observe her specimens.
*Rijksmuseum, Amsterdam*

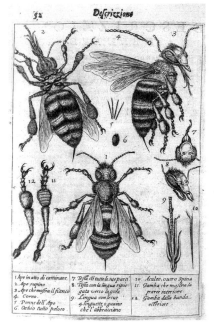

Francesco Stelluti, drawing of a bee and its parts, 1630. This is one of the earliest published drawings made from observations with a microscope.
*Wellcome Library, London*

Leeuwenhoek microscopes.
*Wellcome Library, London*

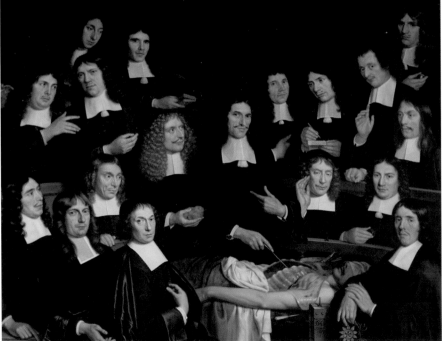

Cornelis de Man, *Anatomy Lesson of Cornelis 's Gravesande*, 1681.
Leeuwenhoek is behind the anatomist's left shoulder,
with his hand over his heart.
*Collection Museum Prinsenhof, Delft, The Netherlands. Photograph: Tom Haartsen*

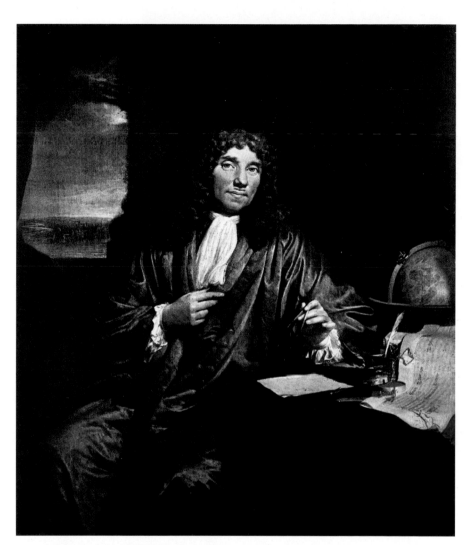

Johannes Verkolje, portrait of Antoni van Leeuwenhoek, ca. 1686.
Leeuwenhoek, at fifty-four, is shown with a pair of dividers, a globe,
and what might be a map—the tools of a surveyor.
*Wellcome Library, London*

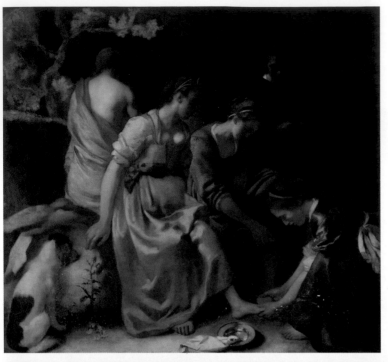

Johannes Vermeer, *Diana and Her Companions*, ca. 1653–54. Vermeer's early painting *Diana and Her Companions* may have been influenced by his seeing Rembrandt's *Bathsheba*. *Mauritshuis, The Hague*

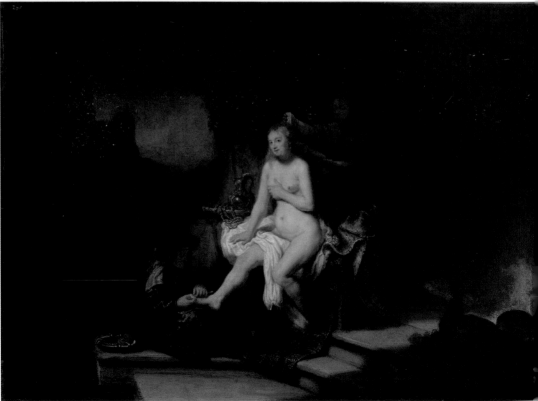

Rembrandt van Rijn, *The Toilet of Bathsheba*, 1643.
*Metropolitan Museum of Art, New York/Bequest of Benjamin Altman, 1913*

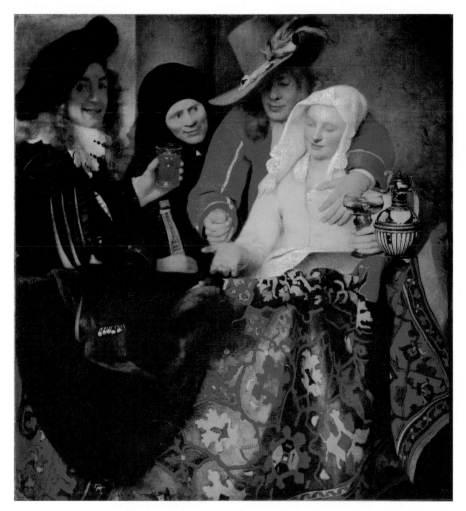

Johannes Vermeer, *The Procuress*, 1656.
It is believed that the man on the left side holding a glass
is a self-portrait of Vermeer.
*Gemaeldegalerie Alte Meister, Staatliche Kunstammlungen, Dresden, Germany*
*Photograph: Erich Lessing/Art Resource, NY*

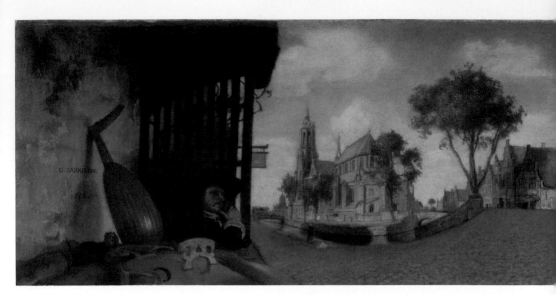

Carel Fabritius, *A View of Delft*, 1652.
Fabritius most likely used a double-concave lens to paint this picture.
*National Gallery, London/Art Resource, NY*

Johannes Torrentius, *Emblematic
Still Life with Flagon, Glass,
Jug and Bridle*, 1614.
Torrentius is believed
to have used a camera
obscura.
*Rijksmuseum,
Amsterdam*

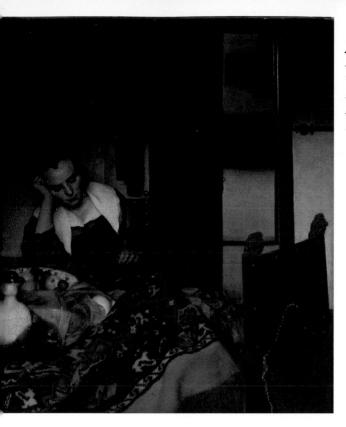

Johannes Vermeer,
*A Maid Asleep*,
ca. 1656–57.
*Metropolitan Museum of
Art, New York/Bequest of
Benjamin Altman, 1913*

Johannes Vermeer,
*Cavalier and Young
Woman*, ca. 1657.
Vermeer most
likely used a
double-concave
lens in composing
these two pictures;
in *Cavalier and
Young Woman*, he
emphasized the
increased size of
the man in the
foreground.
*Frick Collection, New
York/Bridgeman
Images*

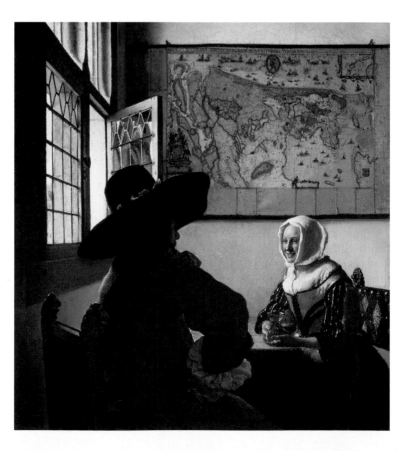

Ludovico Cigoli, drawing machine from
*Prospettiva pratica*, ca. 1610–13.
*Pablo Garcia/DrawingMachines.org*

Giulio Troili, drawing machine from *Paradossi
per pratticare la prospettiva*, 1683.
*Pablo Garcia/DrawingMachines.org*

Daniel Schwenter, camera obscura from *Deliciae physico-mathematicae*, 1636.
*Pablo Garcia/DrawingMachines.org*

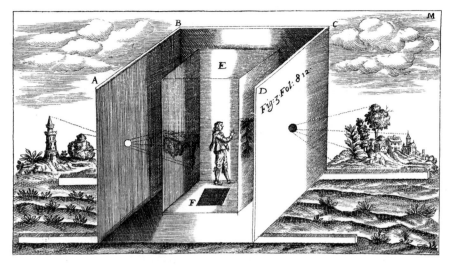

Athanasius Kircher, camera obscura from *Ars magna lucis et umbrae*, 1646.
*Pablo Garcia/DrawingMachines.org*

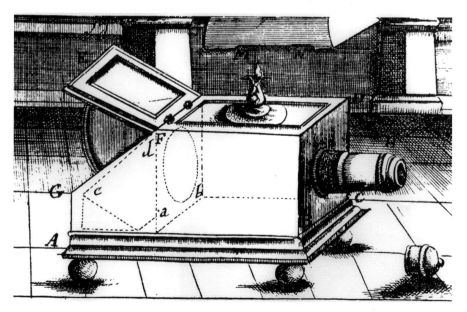

Johann Zahn, reflex box camera obscura from *Oculus
artificialis teledioptricus*, 1685.
*Private Collection/Bridgeman Images*

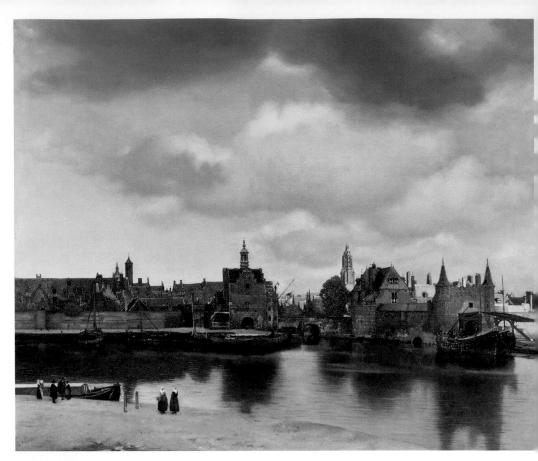

Johannes Vermeer,
*A View of Delft*,
ca. 1660–63.
This may be the
first picture Vermeer
painted using a
camera obscura.
*Mauritshuis, The Hague*

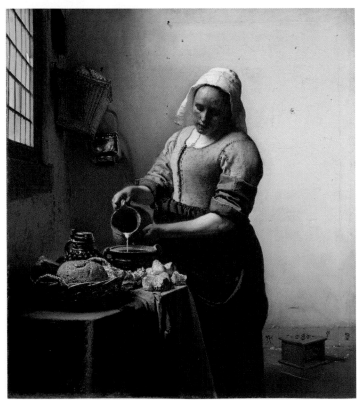

Johannes Vermeer,
*The Milkmaid*, ca. 1660.
*Rijksmuseum, Amsterdam*

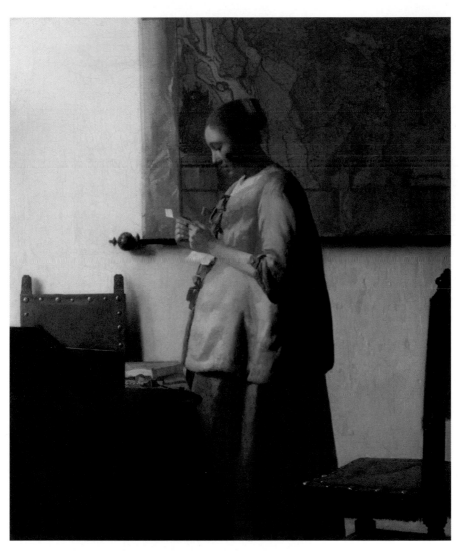

Johannes Vermeer, *Woman in Blue Reading a Letter*, ca. 1665.
*Rijksmuseum, Amsterdam*

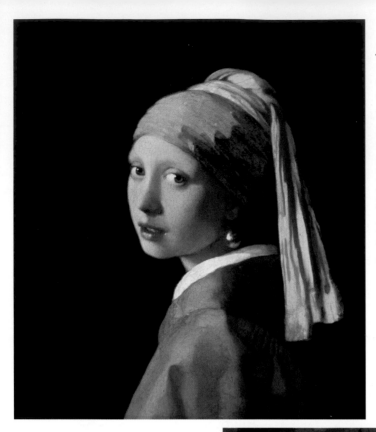

Johannes Vermeer,
*Girl with a Pearl Earring*,
ca. 1665.
On this painting and
the one below, the
girls' lips show light
reflections that are
identical. Vermeer may
have wanted the
pictures to look as
though they were
painted with a camera
obscura.
*Mauritshuis, The Hague*

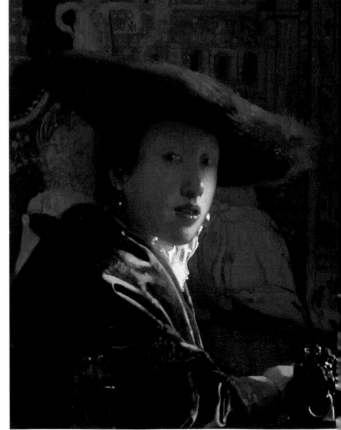

Johannes Vermeer, *Girl
with a Red Hat*,
ca. 1665–66.
*National Gallery of Art,
Washington*

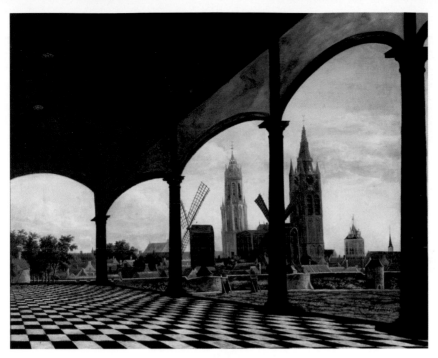

Daniël Vosmaer, *View of Delft through an Imaginary Loggia*, 1663.
*Collection Museum Prinsenhof, Delft, The Netherlands (Loan Cultural
Heritage Agency of the Netherlands) Photograph: Tom Haartsen*

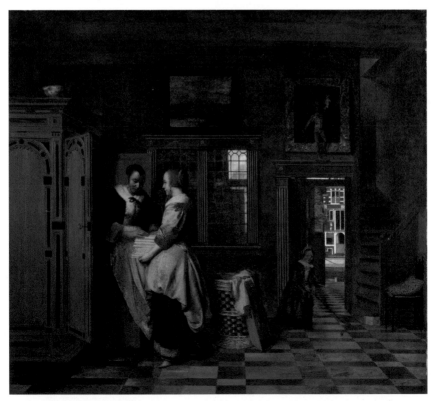

Pieter de Hooch, *Interior with Women beside a Linen Cupboard*, 1663.
Depictions of imaginary tiled floors were common in Delft painting.
*Rijksmuseum, Amsterdam*

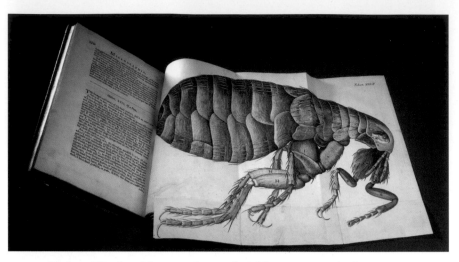

Robert Hooke, *Micrographia*, with foldout image of a flea, 1665.
*Wellcome Library, London*

Robert Hooke, *Micrographia*,
double-lens microscope, 1665.
*Wellcome Library, London*

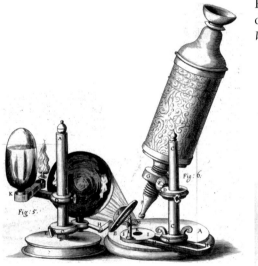

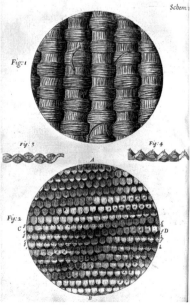

Robert Hooke, *Micrographia*, Silks, 1665.
*Wellcome Library, London*

Antoni van Leeuwenhoek, the sperm of rabbits (1–4)
and dogs (5–8), 1677.
*Wellcome Library, London*

Nicolaas Hartsoeker, homunculus,
*Essai de dioptrique*, 1694.
Leeuwenhoek often sought the "little
man" inside the sperm but never
claimed to have seen one there.
*Wellcome Library, London*

Antoni van Leeuwenhoek, the development of the flea
from egg to adult, 1695.
*Wellcome Library, London*

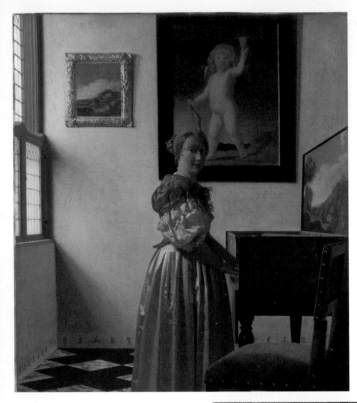

Johannes Vermeer, *Young Woman Standing at a Virginal*, ca. 1670–73. *National Gallery, London/Art Resource, NY*

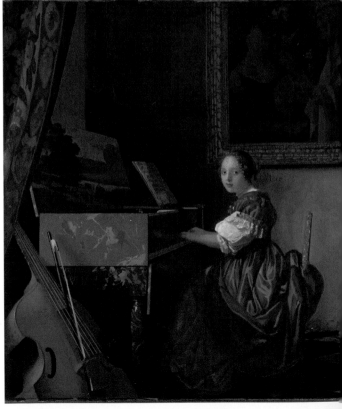

Johannes Vermeer, *Young Woman Seated at a Virginal*, ca. 1670–75. *National Gallery, London/ Art Resource, NY*

He began to breed large numbers of them in his home in order to examine them at every stage in their development. At each phase from chrysalis to moth, Malpighi dissected the insects and observed them both with the naked eye and under the microscope. His observations proved that the silkworm does not use lungs to breathe, but rather the tracheal system, a series of tiny holes in their skin. He also detected the reproductive organs of the moth. In 1669 he published his book on the silkworm, *De bombyce*, which was dedicated to the Royal Society and published under its auspices. The book was lavishly illustrated, in the tradition begun by Hooke, displaying Malpighi's observations in careful detail.

At the time little was understood about the reproduction of silkworms—or of any other animals, for that matter. Margaret Cavendish could publish a verse on the life cycle of the silkworm suggesting that several butterflies were generated from the decay of a single dead caterpillar, not realizing that the caterpillar was turning into a moth. Even more specialized students of insect anatomy and behavior held or had held a similar view about the reproduction of the silkworm, including the naturalist Ulisse Aldrovandi (1522–1605), one of Malpighi's predecessors at the University of Bologna. However, during his study of the silkworm Malpighi saw that the silkworm *becomes* the moth—after the worm becomes a chrysalis, what emerges is the same creature, now transformed into a new form. Malpighi became interested in the origin of the parts of the developing insect, noticing that "the parts belonging to, and destined to be used by the moth," are visible in earlier stages of the creature. This led him to study the development of vertebrates—starting with the embryo of a chick.

As Malpighi knew, centuries earlier Aristotle had conducted a study of chick development by opening up chicken eggs each at a different day after fertilization to examine the changes that occurred in the embryo day by day. Aristotle had correctly noted three stages of chick development: after three days of incubation, the chick heart can be observed; after ten days all parts of the body can be detected; after twenty days the chick is covered in downy feathers and is ready to emerge from the egg; it already makes the "cheep-cheep" sound of the young chick.

Using his anatomical methods, as well as a microscope, and with his mechanistic expectations in place, Malpighi was able to give a description dramatically more accurate than that of Aristotle or later investigators. Malpighi observed and described numerous details of the parts of the developing chick: the neural fold (the precursor to the nervous system), optical vesicles (which develop into the eyes), the cardiac tube (the precursor to the heart), and aortic arches (structures that turn into the major arteries). He studied the chick heart, noting that it was observable to the naked eye as a red, pulsating speck before any of the other parts of the chick became visible. However, when viewed with a microscope, the heart was visible even before the liquid propelled through it turned red; it could be seen solely through its motion, which the microscope revealed. This examination led him to the cautious claim that the entire chick "lies concealed in the egg" right at fertilization, though he admitted that he had not come to a definite conclusion about this.

-4-

During this period natural philosophers were puzzling over how new organic beings were made, especially in the case of viviparous animals, those giving birth to live offspring. Today that knowledge seems obvious: sperm meets egg, forms an embryo, and a baby is the eventual result. But in the seventeenth century little was known about how offspring were created, and how they developed, a mysterious process given the overarching term "generation." No one had seen either sperm or egg, or any part of the process by which they meet. It was commonly believed—even by natural philosophers—that insects arose spontaneously out of dirt, excrement, or carrion, that women could give birth to animals or "monsters," and that certain kinds of birds grew on trees. In the 1660s the fellows of the Royal Society discussed how to produce baby vipers from the powdered parts of vipers, and even managed to procure "a glass-jar, full of the powder of the bodies of vipers, and a gallipot full of the powder of only the hearts and livers of vipers." Checking on these vessels over time, they

concluded that though the viper powder was now foul and full of "little moving creatures" (maggots, perhaps), it had not generated any baby vipers.

Since mating in domesticated animals can be controlled by separating the sexes or by castrating the males, and since human virgins do not become pregnant, it was clear, of course, that reproduction was linked to the sex act. But what exactly happened during and after the sex act was unknown, as was whether copulation was necessary for generation in insects, birds, reptiles, and other creatures.

European views on generation were still dominated by ancient thought on the topic. In his work *On the Generation of Animals*, Aristotle had concluded that while the mother's body contains the material necessary for creating her offspring, she requires the father's semen to start and guide the process. The male's semen provides the shape, or form of the embryo, as well as the cause of its formation, while the female's provides merely the stuff that is formed into an embryo by the semen. (The generation of insects was different—they arose spontaneously from decay, Aristotle believed.)

Later, the physician Hippocrates (ca. 460–370 BCE) held that both the female and the male contribute a kind of semen—the ejaculate of the man and the menstrual blood of the woman—and that both are responsible for the forming of the embryo. In the second century CE, Galen proposed a view similar to that of Hippocrates, but according to Galen the female's contribution is not her menstrual blood but an internal secretion similar to the male's semen. This claim had the benefit of suggesting to some writers on the topic that the woman must reach sexual climax, just as the man must, in order to conceive—and so for centuries the idea that sex should be a mutually enjoyable activity had a scientific imprimatur.

By the seventeenth century, not much had changed since ancient times. But by turning his microscope to the study of chick embryos, and seeing what was invisible to the naked eye—the embryo heart *before* blood began flowing through it—Malpighi had shown that the microscope could be a valuable tool in investigating generation. He was not the only one who realized this. In the Dutch Republic, the former university classmates Swammerdam and De Graaf were

each pursuing microscopical studies of the reproductive organs, try-
ing to find the hidden mechanisms of generation.

-5-

After he had settled in Delft around 1667, De Graaf continued his
anatomical work on the sex organs that he had begun in Leiden,
spending much time in the anatomical theater. In 1668 he published
a work showing that the testicle is not composed, as was then gener-
ally believed, of a spongy, pulpy, or "glandulous" substance, but that
it instead is a tangle of minute "vessels." To prove his point to the
Royal Society, De Graaf sent them a specimen: "the testicle of a dor-
mouse, unravelled by my method." An image of that specimen was
published in the *Philosophical Transactions* in October of 1669.

The publication of De Graaf's work set off a vicious dispute with
his one-time fellow student Swammerdam and their teacher Johannes
van Horne. Van Horne was also doing research on the testicle, and
had enlisted Swammerdam's aid in trying to clarify its structure by
the use of Swammerdam's unique method of injecting vessels with
colored wax to make them stand out as well as preserve them for
future study. Van Horne had realized, like De Graaf, that the testicle
was composed of tiny tubes or vessels. Having learned of De Graaf's
publication shortly before it appeared, Van Horne rushed into print
a summary of his own research showing the "thready" nature of the
organ. He explained that his failure to publish before De Graaf was
due to the "laziness of the engraver" and hinted that his former stu-
dent had stolen his work. De Graaf took offense and responded in
kind, accusing his former teacher of stealing *his* work. Swammerdam
threw oil on this priority fire by recalling that he had had discussions
with De Graaf about Van Horne's researches. Things grew nastier
when De Graaf published a treatise on the female reproductive organs
in 1672. De Graaf had conducted a series of dissections on female
rabbits shortly after mating. Unlike earlier writers since Hellenistic
times, De Graaf claimed that the sex organs of females of the higher
animals were not "inverted testicles," but were "ovaries," structures

containing eggs, or *ova* in Latin. (Harvey had previously observed eggs, and had argued that embryos arise from the egg alone, coining the slogan *ex ovo omnia*—from the egg comes everything. But he had ignored the ovaries, thinking they were rudimentary organs, like male nipples, serving no purpose.) De Graaf again gave no credit to Van Horne, who had earlier described the female ovary and had even suggested that female humans have eggs. Swammerdam attacked De Graaf once more for neglecting to acknowledge those who had priority for the discoveries. This time, Swammerdam claimed that *he* was the true discoverer of human eggs.

After more back-and-forth sniping between the two men, during which time each tried to convince the Royal Society fellows of his priority, the Royal Society decided to end the dispute over the discovery of eggs once and for all. A committee was appointed and after some delay reported that the first person to have seen eggs in viviparous organisms was not Van Horne, or De Graaf, or Swammerdam—but Steno, who had seen eggs (but without being certain what they were) in his 1667 paper describing his dissection of a dogfish. This report had the effect of emphasizing that priority in discovery went to those who published first. It also underlined the importance of a view of generation that was universal, one that would explain not only human generation but also the generation of other viviparous animals.

By the time the committee published its conclusions, De Graaf had already died, perhaps of suicide, at the age of only thirty-two. He is buried next to his infant son in the Oude Kerk in Delft. One of his last scientific acts was sending the letter introducing Leeuwenhoek to the Royal Society. Leeuwenhoek would later report that he had heard at the time of De Graaf's death that Swammerdam and De Graaf had had "such a sharp verbal altercation that not only did the latter fall ill, but this was also followed by his death"—that the dispute with his former friend had killed De Graaf. Years later Leeuwenhoek himself would make the most astounding discovery related to generation, one that would utterly transform our understanding of the origin of new life.

-6-

By the time Oldenburg received Leeuwenhoek's first letter, the Delft civil servant was forty-one years old. He had progressed from using a magnifying glass to look at fabric, to making his own single-lens microscopes, to turning his instruments on small organic and inorganic objects around him: tiny cheese mites, minuscule grains of chalk. In that first letter, Leeuwenhoek described mold, the sting of the bee, and the "nose" of the louse. The Royal Society secretary encouraged Leeuwenhoek to continue his studies and to send his results to London. He specifically suggested that Leeuwenhoek use his microscope to study blood and other bodily fluids. De Graaf had proposed in his letter of introduction that the Royal Society put some difficult questions to Leeuwenhoek and give him suggestions for further investigations, and over the years the fellows of the Royal Society did just that. Many of Leeuwenhoek's discoveries were due to investigations he began at the urging of the "curious Gentlemen dabblers" in London.

The Royal Society's interest in his investigations was just the encouragement Leeuwenhoek needed, and he threw himself into this study, often using himself as his own experimental subject. In his second letter to the Royal Society (the first addressed directly to Oldenburg), he described how a louse feeds, which he observed by putting "a hungry Lowse upon my hand, to observe her drawing blood from thence."

> The Lowse having fixt her sting in the skin, and now drawing blood, the blood passeth to the fore-part of the head with a fine stream, and then it falls into a larger round place, which I take to be filled with Air. This large room being, as to its fore-part, filled about half full with blood, does then propel its blood backward, and the Air forward again; and this is continued with great quickness, whilst the Lowse is drawing blood. . . .

His concentration must have been intense to allow him to remain still while the louse sucked up his blood, and to watch the progress of his vital fluid through the innards of the insect! Later, Leeuwenhoek would submit himself to more exposure to lice, placing newly hatched lice on his hand and allowing them to feed there, carefully charting the entire process. His interest in lice piqued, Leeuwenhoek went on to an even more gruesome experiment.

After locating three adult lice, he placed them on his calf, and then put on a tight stocking so that the lice were bound to his leg. He left the stocking on and refrained from washing his leg for six days. Removing the stocking at this time, Leeuwenhoek found over eighty eggs stuck to his leg hair, but no young lice. Leaving the eggs on his flesh, he somehow managed to get himself to put the stocking back on (I can't imagine doing so). After ten days had elapsed from the start of the experiment, he took off the stocking and, as he told a correspondent, "I saw at least twenty-five young lice running about." Understandably, "this spectacle of all the said young lice filled me with such aversion to the stocking that I threw it, along with all the lice in it, out the window." He then rubbed his whole leg with ice to make sure no lice could remain, rubbed with ice a second time, and finally put on clean stockings. After his careful description of this experiment, Leeuwenhoek calculated the reproduction rate of lice, concluding that on the body of a "Poor Person, who does not have a change of linen or garments," from two pairs of lice ten thousand young can be generated in only eight weeks. He signed off this letter with a pun about his "lousy discourse."

Using one's own body as an experimental laboratory was common practice in those days. Not long before Leeuwenhoek first wrote to the Royal Society, Isaac Newton was in Cambridge performing a particularly macabre self-experiment (or so he claimed)* in order to test his theory of the perception of colors:

---

* Opinion is divided on whether Newton actually did perform this experiment; it may have been what philosophers call a "thought experiment," imagining what *would* happen *if* he stuck a needle into his eye.

> I tooke a bodkine [needle] & put it betwixt my eye & [the] bone
> as neare to [the] backside of my eye as I could: & pressing my eye
> [with the] end of it (soe as to make [a] curvature in my eye) there
> appeared severall white darke & coloured circles.

After gingerly inserting a sharp needle between his eyeball and
orbital socket, Newton gently moved the needle, changing the nee-
dle's pressure on the eyeball. Newton's aim was to explore the anat-
omy of the eye and how that anatomy influences how we see. Newton
was also trying to discover the way in which apparent sensations
might in fact be the product of imagination and to answer the ques-
tion whether what one saw might be controlled by the nerves, and
thus perhaps by the soul itself, rather than by some mechanical pro-
cess of experience—questions that had earlier been raised by Des-
cartes. Newton would later present papers to the Royal Society based
on these grisly self-experiments.

Some of Leeuwenhoek's self-experiments were more enjoyable
than those involving lice and needles. One evening he drank "two
pounds of good French wine," followed the next day by another
pound and a half of "good French, new-Rhine, and old Upper
Moselle wine." On the next day he consumed a pound and a half of
tea, quickly, to make himself sweat. He examined his sweat with the
microscope to see whether the salt particles he had previously found
in wine would come through the skin's pores during perspiration. He
did not find salt particles in his sweat. (Most likely, he had to repeat
this experiment several times to be sure.)

Leeuwenhoek also observed his blood with his microscope, after
drawing a sample from his thumb. He expected, perhaps, to find salt
particles there. Instead, he observed numerous small "red globules,"
floating in what appeared to be a clear and crystalline fluid (it had, on
first examination, looked white and "wheylike," but later he realized
it was clear). To his surprise, Leeuwenhoek had discovered red blood
corpuscles.

Others had seen, with the aid of microscopes, that there was *some-
thing* in the blood: Kircher had reported seeing tiny "worms" in the
blood of plague victims, and Borel had described dolphin-shaped

"insects." They had probably seen stacks of adhering corpuscles known as rouleaux. Malpighi had discerned single red blood corpuscles as early as 1665, writing in 1666 that he had observed "red atoms" in the transparent blood vessels of a frog—but he had thought them to be fat globules, like those he had seen elsewhere in the body. Swammerdam saw them as well, without knowing what they were. Leeuwenhoek was the first to realize that these globules were particular to the blood, and that they gave blood its color. He initially reported his findings in a letter to Constantijn Huygens, reminding his friend that he had told him about this observation "when I was at your house some time ago."

Over the following years Leeuwenhoek would continue his investigation of red blood corpuscles, attempting to understand why blood clots and why it turns bright red when exposed to the air. He would later tell Hooke that he had "many times repeated Observations of my own blood." He looked at other specimens of blood besides his own, including the blood of a rabbit. Leeuwenhoek compared the size of a red blood cell to that of a "coarse" grain of sand, which he had determined to be about 1/30 of an inch. Since he said that one hundred red corpuscles were less than the size of a coarse grain of sand, that puts his estimate at less than 1/3000 of an inch, or less than 8.5 microns, which is impressively close to the modern measurement of 7.7 microns. Leeuwenhoek told Hooke that he knew his readers would find his calculated size "incredible," and so they did.

Others were trying to see these tiny corpuscles for themselves but, as Leeuwenhoek soon discovered, they were having trouble replicating his observations. Even when he sent to Christiaan Huygens in Paris "some of the small Glass-pipes" he had used to make the observations, the younger man was unable to see corpuscles, instead observing only other, macroscopic particles, probably the rouleaux. It would take four long years before the corpuscles were observed by others—first at the Leiden shop of the Musschenbroek brothers, who were already making and selling Leeuwenhoek-style single-lens microscopes by the 1670s, and later by Swammerdam and Christiaan Huygens. Each of these observers—like Leeuwenhoek—would see the red blood cells as globular, influenced by Descartes's popular

corpuscular philosophy, although they are in fact flatter and more concave.

The difficulty with replicating Leeuwenhoek's observations would become a recurring theme in the correspondence between Leeuwenhoek and the Royal Society. The trouble was due partly to his exceptional skill at preparing and observing specimens—a skill other observers did not share—as well as his unwillingness to divulge his exact methods. But the real problem was the novelty of his microscopical investigations. Others before had magnified the visible and seen previously unseen parts of tiny organisms and artifacts around us. But Leeuwenhoek had begun to surpass what others had done: he was going deeper, and seeing more, than anyone else had seen. His tiny speck of glass in a postage stamp–size bit of brass was becoming a doorway through which he glimpsed a new world.

-7-

The existence of this new world was announced in a letter Leewenhoek wrote to the Royal Society on September 7, 1674. But rather than being heralded with fanfare and self-congratulations, Leeuwenhoek's most astounding discovery was buried at the end of a twenty-six-page missive. Leeuwenhoek began the letter by describing his observations of the eyeball of a cow, which, like many of his specimens, he obtained from a butcher at the *vleeshal* across the Hippolytusbuurt. He had pierced the cornea of the cow's eye with a pin and examined the aqueous humor, the fluid that came out of the eye. He cut the crystalline lens—the cornea—into small pieces and affixed them to the pins of two microscopes. He reported that Swammerdam visited him twice during his examinations to observe the lens himself.

Leeuwenhoek also related that he communicated his observations to his neighbor 's Gravesande, who informed him of an ancient debate about the optic nerve: some anatomists had affirmed the optic nerve to be hollow, saying that they themselves had observed the hollowness, and that the "animal spirits" conveying the "visible

species"—what is seen by the eye—pass through the nerve to the brain. "I thereupon concluded with myself," Leeuwenhoek explained, "that, if there were such a cavity visible in that Nerve, that it might also be seen by me." To test this, he obtained three optic nerves of cows, again from the same helpful butcher, and viewed them with his instruments. "I could find no hollowness in them," Leeuwenhoek reported. Rather, "they were made up of many filamentous particles, of a very soft substance."

So that the fellows of the Royal Society could see for themselves, Leeuwenhoek prepared a specimen for them. He allowed the fleshy tissue to dry out until it hardened. Then, using a shaving razor, he cut slices of the optic nerve. These slices are about one-fifth of a millimeter (200 micrometers) (which was ten times thicker than the sections of plant specimens that he also sent to the Royal Society). We know Leeuwenhoek employed a shaving razor because he reported to the Royal Society that he used one to cut his slices and sections of specimens, noting that he would frequently resharpen it as he cut. Recently Brian Ford, who examined the specimens under an electron microscope, found some red blood cells on a section of elder pith prepared by Leeuwenhoek—suggesting that the blade used to slice it had previously cut Leeuwenhoek while he was shaving with it. The section of optic nerve remains at the Royal Society, still wrapped in its original paper with Leeuwenhoek's handwritten label.

After describing his observations of the cow's optic nerve, Leeuwenhoek passed on to a discussion of his use of a microscope during his visit to the chalk hills in England a few years earlier, and a long discourse on the variation between the different types of chalk and sand he observed there and in Delft.

It is only after twenty or so pages on various topics that Leeuwenhoek disclosed his truly revolutionary discovery. It is no wonder, lying so buried under all the other detailed observations, that his claim seems to have been ignored by the Royal Society fellows— some of whom may not, indeed, have read all the way to the end. About two leagues from Delft, Leeuwenhoek began, there is "an Inland-Sea, called Berkelse-Lake." In the winter the water is clear, but in the summer it becomes whitish, with small green clouds float-

ing within it. The lake, he noted, abounds with tasty fish. Passing by one day, and noticing the murkiness of the water, he took a sample home with the intention of discovering the cause of the cloudy water. Leeuwenhoek may have expected to see a variety of "globules" floating in the water, giving the lake a murky quality when viewed with the naked eye. But what he observed was different—and would transform the way that people saw the world.

Once he brought the sample of water home, Leeuwenhoek would have gone to his study and closed all the shutters except one, through which a beam of sunlight entered the dark room. He would have put a drop of water into a glass tube affixed to the back of one of his microscopes, lifting the device to his eye in the direction of the sunbeam. Screwing the specimen pin attached to the tube up and down, back and forth, he would have focused the instrument until the initially fuzzy image became clear. What he then saw must have shocked him—it may even have startled him so much that his hand holding the microscope shook. Perhaps he even spilled the water and needed to begin again.

The sight that so rattled Leeuwenhoek was a multiplicity of tiny particles of different shapes (not all of them globular) and sizes and colors. Unbelievably, the little particles were moving—and seemed to be moving themselves, by the use of minuscule legs and fins and hairs. These shapes were, therefore, living beings—living beings that had never even been imagined to exist.

It must have taken some time before Leeuwenhoek regained his composure enough to record his observations. When he did, he described these self-moving particles:

> Some of [them] were roundish; those that were somewhat bigger than others, were of an Oval figure: On these latter I saw two legs near the head, and two little fins on the other end of their body.* Others were somewhat larger than an Oval, and these were very slow in their motion, and few in number.† These little animals

---

* These are believed to have been Rotifers.
† These are believed to have been Ciliates.

[*diertgens*] had divers colours, some being whitish, others pellucid; others had green and very shining little scales: others again were green in the middle, and before and behind very white,* others grayish.

Imagine the shock of realizing, for the first time, that water contains a whole world of living creatures completely invisible to the naked eye. Leeuwenhoek must have looked again at the water without the microscope just to confirm that his eyes alone saw nothing. Then, again with the microscope, through which the invisible animals sprang into view once more. As he described it, "The motion of most of them in the water was so swift, and so various, upwards, downwards, and round about, that I confess I could not but wonder at it." And wonder at it he did, for hours at a time, until his arms hurt from holding up the microscope and his eyes ached from the effort of seeing through it. Trying to convey to his readers the infinitesimal size of these creatures, Leeuwenhoek estimated that they were, as he put it, "above a thousand times smaller than the smallest ones, which I have hitherto seen in the rind of chees, wheaten flower, mould, and the like." A thousand times smaller than any previously observed creatures, even creatures observed with a microscope!

In the history of civilization, this discovery must rank high on the list of radical transformations of our view of our world, and our place within it—even higher, perhaps, than Copernicus's claim that Earth is a planet, like the others, and does not have any special status as the literal center of the universe. What Leeuwenhoek had just realized is that there exists a new world of living beings, a world never before seen, never before even imagined—a world in the water we drink, perhaps even in the food we eat—even, it will turn out, inside our own bodies. This discovery would have profound implications for fields as diverse as medicine, brewing, literature, biology, anatomy, and microscopy. But first, it would have to be noticed, and accepted as true.

---

* These are thought to have been *Euglena viridis*, a flagellate whose discovery was originally attributed to John Harris in 1696.

-*8*-

Nothing was said in the meetings or publications of the Royal Society about Leeuwenhoek's "little animals" following the receipt of this letter. Meanwhile, Leeuwenhoek continued to keep the society apprised of his investigations of bovine optic nerves, red blood corpuscles, salt crystals, tiny (but macroscopic) vinegar eels, the leg of a louse, the roe of a cod, blood serum, the circulation of sap in an oak leaf, the veins in connective tissue between muscles. Finally, over a year later, on December 20, 1675, he pointedly reminded the fellows, "Last summer I carried out many observations on various waters and discovered in most of them a great many small animals that are incredibly minute." In his next letter, in January, he further prodded their memories: "I detected living creatures in water, that is ordinary rainwater . . . that comes up in the sand, and in the water of the canals that run through this town and through the country." He promised to send more observations about these creatures soon. He kept his pledge in a lengthy letter dated October 9, 1676.

By this time, Leeuwenhoek realized that he needed to be more assertive in his claims. He explained that the creatures he has observed in rainwater are "ten thousand times less [that is, smaller] than those [seen] by Mons. Swamerdam, and by him called *Water-fleas* or *Water-lice*, which may be perceived . . . with the naked eye." Later in the letter, we find an escalating extravagance of description:

> I imagine, that ten hundred thousand of these little Creatures do not equal an ordinary grain of Sand in bigness: And comparing them with a Cheese-mite (which may be seen to move with the naked eye) I make the proportion of one of these small Water-creatures to a Cheese-mite, to be like that of a Bee to a Horse: For, the circumference of one of these little Animals in water, is not so big as the thickness of a hair in a Cheese-mite.

Even the esteemed Swammerdam had observed nothing as small as what he, a simple civil servant, had seen. By comparing the size of the

creatures he saw to organic and inorganic objects visible to the naked eye (cheese mites, grains of sand), Leeuwenhoek tried to impart to his readers the incredible smallness of these new creatures. No one was accustomed to thinking in terms of such minuscule measurements. In later years Leeuwenhoek would be viewing creatures he reckoned to be one hundred million and even a billion times smaller than a coarse grain of sand.

Among these animalcules he espied larger and smaller ones: in one sample of rainwater "those very small *animalcula* did swim gently among one another, moving like as Gnats do in the Air; . . . these bigger ones, move more swiftly, tumbling round as 'twere, and then making a sudden downfall." Leeuwenhoek evinced an empathy for some of the creatures, which became tangled up because there were so many of them: "I have seen several hundreds of these poor creatures, within the space of a grain of gross sand, lye fast cluster'd together in a few filaments."

Not content to examine only rainwater, Leeuwenhoek also examined water from Delft's canals; full of civic pride, he noted that although he did find animalcules in the canal water, he found far fewer than in the rainwater. The water of the canals was so clean, Leeuwenhoek explained, since the canals were refreshed by water coming in from the river Maas by means of sluices, which was done periodically for the purpose of "conditioning," or cleaning, the water. He also tested the water of the well in his courtyard. Leeuwenhoek told the Royal Society that his well was surrounded by a high wall, so that sunlight never shone on the water. Leeuwenhoek was surprised at the number of creatures he found swimming within his own drinking water:

This water is in Summer time so cold, that you cannot possibly endure your hand in it for any reasonable time. Not thinking at all to meet with any living creatures in it, (it being of a good taste and clear) looking upon it in *Sept.* of the last year, I discover'd in it a great number of living animals very small, that were exceeding clear. . . .

He continued testing the well water for the rest of the year, noting that once winter came, he no longer saw any living animals in it; but he saw "his" animalcules again starting in July.

Even while on vacation, Leeuwenhoek's observations continued. At the end of July he "went to the Sea-Side, at Schevelingen" (today's Scheveningen). It was a working vacation, however: "Being on the beach and viewing some of the Sea-water very attentively, I discover'd divers living animals therein." He gave a man he met on the beach a new glass bottle that he had brought with him for this very purpose. He asked the man to go deep into the water—perhaps Leeuwenhoek could not swim, or perhaps he had a microscope with him and could not leave it on the sand in order to go far into the water himself. He instructed the man to wash the bottle well, "twice or thrice," and then fill it with the seawater. Leeuwenhoek then "tyed the bottle close with a clean bladder" and observed the water once he returned home shortly afterward. He observed the water daily until August 8, by which time the number of animals had decreased so much as to be "hardly discernible."

In this long letter, Leeuwenhoek also reported observing animalcules in melted snow. On April 26, he wrote, "I took 2½ ounces of Snow-water, which was about three years old, and which had stood all the time either in my Cellar or Study in a Glass-bottle well stopped." Apparently the snow had been collected three years earlier, and put into a bottle with an airtight stopper, in order to prevent any possible contamination from the air. This suggests that as early as the winter of 1673, several months before sending his first letter to the Royal Society, Leeuwenhoek had already perceived the possibility of observing little animals in the snow water, and had prepared and put aside snow water for a test of it to be conducted at a later time. Had he already seen little animals even before that time—a good year before his first letter announcing this discovery to the Royal Society? The fact that he put an airtight seal on the bottle to prevent contamination suggests that he knew some water did or might contain little animals. Why had the snow water lain, in its stoppered bottle, for so long before being tested? Was he waiting to develop better microscopes? Or had he just forgotten about it?

He used this three-year-old snow water for an experiment that would lead to another remarkable result: the first unmistakable sighting of bacteria. Leeuwenhoek made an infusion by adding about one-third of an ounce of pepper to water, and allowing it to sit in his study for three weeks. His purpose was to see whether he could learn anything about the cause of the pungent taste of pepper on our tongues—why pepper is so hot to the taste. He may have thought that he would see some Cartesian sharp corpuscles that could tear the tongue. Leeuwenhoek added some of the snow water to this pepper infusion and began observing, keeping detailed notes on what he saw. On April 24, 1676, he saw "an incredible number of very little animals of divers kinds." One kind of these is clearly bacteria: these animals "were incredibly small, and so small in my eye, that I judged, that if 100 of them lay stretched out one by another, they would not equal the *length* of a grain of course Sand; and according to this estimate, ten hundred thousand [one million] of them could not equal the dimensions of a *grain* of such course Sand."

He continued observing this pepper infusion until the first of June. In May he repeated the experiment, this time with ground peppercorns placed in a teacup with rainwater, which he observed from May 26 until June 12. On June 14, he pounded pepper grains very small and added them to water from his well. He observed this infusion from June 16 until July 20. He also made infusions of ginger, cloves, and nutmeg, again in "porcelain tea-cups." He tried peppercorns whole, ground to a fine powder, and coarsely ground, and white pepper as well as black pepper. We can imagine his study, its shelves and tables arrayed with stoppered flasks of melted snow, teacups filled with infusions of spices—of pepper, ginger, cloves, and nutmeg— from different dates made with diverse waters, each denoted by labels in his clear but elegant script, so that he would not forget which teacup held which solution.* One wonders why he made the infusions in teacups, rather than in glass flasks. Did the use of spices make him

---

* Today one can see the labels Leeuwenhoek wrote for specimens at the Royal Society at the Royal Society Library, so it is easy to imagine what these infusion labels would have looked like.

think of kitchen crockery? Did he take sips of the infusion over time, to check whether the pungent taste of the pepper and other spices increased or decreased as the infusion steeped, trying to correlate the pungency with the number of little animals? Leeuwenhoek does not say. But he does convey his sense of wonder in what he observed.

> For me this was among all the marvels that I have discovered in nature and the most marvellous of all, and I must say that, for my part, no more pleasant sight has yet met my eye than this of so many thousands of living creatures in one small drop of water, all huddling and moving, but each creature having his own motion.

On August 2 Leeuwenhoek compared the pepper infusion made with the rainwater to that made with the well water, and found the rainwater specimen clearer, the well water specimen more filled with little animals. He continued his observations until the ninth. Then, in the time-honored tradition of denizens of Europe, Leeuwenhoek went on vacation traveling in Brabant. He continued his observations when he returned on the eighteenth. While he was away, he seems to have missed his "little creatures"; once back, he noted "it was pretty to behold the motion, quivering and trembling all the time." (Leeuwenhoek's beloved "little dog, which was much admired by everybody for its long and purely white hair," died in 1674; these little creatures, seen only by him, seem like substitute pets to Leeuwenhoek. Later he would have a trained parrot.) Throughout, he kept a "diary," or a scientific log, recording both his observations and his emotions as he made them.

There is yet another revelation in this revolutionary document. Leeuwenhoek described spending time observing "vinegar eels," known now as Anguillula, nematodes that feed on bacteria in vinegar. Anguillula are about two millimeters long and visible to the naked eye. They were already known to exist and had been observed both with and without microscopes before. But what Leeuwenhoek observed with his microscope was new and astounding. He noticed that the number of eels kept increasing from day to day, even when no new vinegar or water was added, and even while the specimen was

kept in a covered flask. He "firmly imagined that the said little eels had thus increased by procreation." By "pulling asunder" some of the little eels, he saw thin, long particles that he took to be baby eels. He even watched as one of them "which came out first, lay and lived, and wrenched itself loose and remained alive a little while." This appears to be the first ever observation made on the "viviparity"—the live birth of offspring—in Anguillula. Leeuwenhoek was making his first foray into the study of generation. His next step would be even more astonishing, but that would not come for several more years.

-9-

After receiving Leeuwenhoek's letter of October 9, the Royal Society could no longer ignore Leeuwenhoek's claim to have discovered a previously invisible world of microscopic creatures. The letter was translated and read to the fellows over the course of three meetings of the society in early 1677. Oldenburg was instructed by the society to inquire about the methods used by Leeuwenhoek in observing these little animals, as well as his methods for calculating their numbers. The Royal Society fellows not only doubted the existence of these minute creatures but felt that, even if there were a whole invisible world of life forms, Leeuwenhoek must surely be exaggerating the numbers of tiny organisms he had seen. They requested that he explain his calculations.

Leeuwenhoek replied that he had used a grain of sand as a benchmark (he might even have put one into the tube he was observing). He could see that there were about one thousand creatures in the volume of water about the size of a sand grain. He calculated that, since one thousand grains could fit in a drop of water, there must be about one million little creatures in that drop. Leeuwenhoek showed how this method was similar to that used in more familiar cases, such as estimating the size of a flock of sheep by figuring that the animals are running alongside one another, so that the flock has a breadth of a certain number of sheep, and multiplying this number by a length determined in a similar manner. Later, when reviewing his method,

he calculated that there could be over eight million animalcules in one drop of water. This was staggering—imagine how many tiny animals there must be in a bucketful of water, or a well, or a lake! As Leeuwenhoek himself acknowledged, "This exceeds belief."

When the letter from Leeuwenhoek was reprinted in the *Transactions*, the Royal Society fellows took the precaution of adding a prefatory note: "This Phaenomenon, and some of the following ones seeming to be very extraordinary, the Author hath been desired to acquaint us with his method of observing, that others may confirm such Observations as these." The Royal Society would withhold its seal of approval until others were able to replicate Leeuwenhoek's observations. But in order to do this, they would need to know how he made those observations.

Leeuwenhoek, however, refused "to acquaint" the Royal Society "with his method of observing." He would tell the society neither the exact techniques he had used for making his observations nor the technical specifications of his microscopes. The fellows were infuriated with Leeuwenhoek for withholding this information from them. Who was this upstart, they must have thought, to refuse them instructions for replicating his wildly unlikely claims?

Like the artists of the St. Luke's Guild, like Torrentius, like Vermeer, Leeuwenhoek refused to divulge his secret techniques. This was not unusual at the time—even Evangelista Torricelli, when he became a master of polishing lenses in the early 1640s, refused to reveal his polishing methods—but Leeuwenhoek was caught in a pendulum swing going the other way. At that very moment the Royal Society was trying to assert openness, publicity, and repeatability as hallmarks of science. In part this was to set the "new science" apart from natural magic and alchemy, whose adherents used secrecy to elevate the mysteriousness of their endeavors and to restrict knowledge to a circle of initiated adepts. It is a mistake to view alchemy the way most of us do, as involving wizard-like figures bent over bubbling cauldrons (although there was some of that). Alchemists were really the first chemists, engaging in experiments and basing their arcane search for the "philosophers stone" that could turn any

substance into gold on known chemical principles. Yet they used the "hiding of names," or the technique of using cover names for ingredients or results, in cases where they deemed that a "veil of secrecy" was necessary to screen out readers unworthy or potentially abusive of the secret knowledge. This led to the reputation of alchemy as a mysterious—and even mystical—undertaking.

Already in Leeuwenhoek's time, the Royal Society deemed such obfuscation no longer appropriate for science. It had begun to stress the importance of replication and publicity—natural philosophers were now expected to inform the scientific community not only of results but also of the methods used to achieve the outcomes, allowing colleagues to repeat experiments and observations. Eventually, the alchemists were done in by this requirement, but it took time; in Leeuwenhoek's day there were still fellows of the Royal Society who dabbled in alchemy. Robert Boyle, for example, attempted to learn alchemy's secrets and methods. He went so far as to request that he be inducted into a secret society of adepts, only to learn that their castle was destroyed by a bomb right before the scheduled ceremony. He even wrote alchemical works and believed in the possibility of a philosopher's stone, hoping that it could not only turn base metals into gold but also attract "angels." (The Royal Society may not have realized the extent of Boyle's commitment to alchemy, because he hid it in his writings by the use of codes.)

Even in the eighteenth century practitioners of the alchemic arts could still be found among the fellows of the Royal Society. One of them, James Price, would claim in 1782 to have turned mercury into silver using a white powder and into gold using a red one. But by that time such claims were not to be tolerated. The president of the society, Sir Joseph Banks, denounced his work as "charlatanism" and demanded that he repeat the experiment in front of other fellows. In July 1783 Price invited fellows to his home for a demonstration, but on the appointed day he committed suicide by drinking poison—whether to avoid admitting he had lied, or to keep from revealing secrets to the uninitiated, no one ever learned.

Leeuwenhoek's desire to retain his secrets particularly rankled

the Royal Society leaders. At first he teased them, not stating outright that he refused to reveal his secrets, but answering Oldenburg's request for explanation by saying,

> At present I use quite a different method of observation, which is as reliable as can be invented (barring improvements) and if I should be inclined to make this method known, I do not doubt that you and all the Gentlemen Amateurs would esteem my instruments and method of observation.

But, as the Royal Society fellows soon realized, Leeuwenhoek would not be so inclined. "My method for seeing the very smallest animalcule," he would later firmly insist, "I do not impart to others."

He recognized that, because of this secrecy, it would be more challenging to convince the society of the truth of his observations. "The fault is mine," he admitted to Oldenburg, "since . . . I have the intention to keep the method I use secret from everybody." He did disclose that he was using a thin glass capillary tube in order to view the animalcules, but he would say nothing else about the type of microscope or lenses that he was using, the light source, or any other information that would be useful to someone trying to see for himself what Leeuwenhoek had observed. However, he invited fellows of the Royal Society to travel to Delft, where he would be happy to show them himself. Given that the Third Anglo-Dutch War had ended the year before, in 1674, it is a little surprising that the Royal Society did not send a delegation immediately to Delft to confirm the observation of something that was even more striking than Galileo's discovery of the satellites of Jupiter or the craters and mountains on Earth's moon.

Since the Royal Society would not come to Delft, Leeuwenhoek brought his observations to London—not by making the journey there himself, but by sending legal affidavits signed by witnesses who had looked through Leeuwenhoek's microscopes. One was signed by Aldert Hodenpijl, a Delft innkeeper; one was signed by Alexander Petrie, the pastor of the English congregation in Delft; one was attested by Benedictus Haan and M. Henricus Cordes, both

Lutheran pastors, one by the Delft notary Jan Boogert, along with Robert Poitevin, a doctor of medicine at the University of Montpellier, and W. V. Burch, a notary who was also an advocate in the court of Holland; and one by Robert Gordon, a medical student.

As befits religious leaders, the affidavit of Haan and Cordes starts off reminding the Royal Society fellows of the role of scientific inquiry in honoring and praising God, "the Creator of everything." Alluding to Leeuwenhoek's confidence in his abilities, the men note, "Our Antoni Lewenhoek does not stand in the rear of those who have displayed an almost incomparable eagerness in unveiling the secrets of nature with the greatest accuracy and exactitude." To find anyone capable of seeing more with a microscope than Leeuwenhoek would be like "claim[ing] more light from the sun." Getting, finally, to the point:

> Well, as eye-witnesses we affirm that we saw at least 200 living creatures in this 50th part of water [in a hollow tube as thick as a horse's hair]; little animals which moved and swam in the water, so that we could distinctly see that they were indeed animals and by no means something else.

The medical student, having viewed the little animals with Leeuwenhoek in early June, stated that he saw as many as twenty thousand of the creatures in a quantity of "pepper-water not exceeding the size of a grain of millet." In August, Hodenpijl, the innkeeper, claimed to see "above thirty thousand Living Creatures." Boogert, the notary of Vermeer's mother-in-law, and his two co-observers, attested that they saw each of ninety parts of water in a little tube contained more than five hundred little animals—forty-five thousand creatures in all. When the tube was emptied, they saw that the quantity of water "did not exceed the size of a grain of millet." At the end of August, Leeuwenhoek invited the Englishman Alexander Petrie to his house. Petrie noted in his attestation that when Leeuwenhoek added vinegar to the water, the animals stopped moving, "being killed by the vinegar."

*-10-*

While Leeuwenhoek was compiling his affidavits, the Royal Society was working on replicating his observations. On April 5, 1677, the society requested that one of its fellows, Nehemiah Grew, try to see what Leeuwenhoek had reported observing. Grew was famed for his microscopical study of plants, but his work with a microscope was drawing to a close; by December 1677 he would cease his microscopical studies. He may already, by April, have lost interest in the device. The Royal Society fellows waited in vain to hear something back from Grew. Finally, six months later, a year after Leeuwenhoek's letter, they asked Hooke to make a single-lens microscope like Leeuwenhoek's and attempt to see the animalcules with it.

Hooke, too, by this time, had abandoned his microscopical investigations. He was involved in experiments on the blood and lungs of living animals, which aimed to determine the unknown relation between respiration, heartbeat, and circulation of the blood. He developed new circular and inclining pendulums that could keep time as accurately as the longer, perpendicular ones, in his continuing quest to develop a watch that could keep precise time at sea, thus aiding captains in determining longitude. He worked on improving astronomical instruments and began making his own astronomical observations from his rooms at Gresham College. He presented a series of lectures on earthquakes. He had also become busy with his duties as a city surveyor, and had begun work as an architect, designing buildings—especially churches—as part of the effort to rebuild London after the Great Fire of 1666. Hooke was so busy with his various pursuits that he was neglecting his duties as curator of experiments for the Royal Society, so much so that in November of 1670 the society's council resolved to censure him for his neglect of office (this resolution was never carried out, however). In the following years Hooke continued his own experiments on light, arguing with Newton over the nature of this phenomenon, whether it was composed of waves—as Hooke believed—or particles—as Newton thought. (No

one realized that light comprised both waves and particles until the twentieth century.)

But when the Royal Society charged Hooke with replicating Leeuwenhoek's observations, Hooke jumped to the task. Quite possibly Hooke saw Leeuwenhoek's discovery as a challenge, something that he, the author of the *Micrographia*, should be able to confirm by being the second person to see living microscopic animals.

Taking Leeuwenhoek's hint about using very small glass tubes, on November 1, 1677, Hooke showed the society "a great many exceedingly small and thin pipes of glass of various sizes some ten times as big as the hair of a man's head others ten times less." Hooke rather disingenuously claimed that he had thought of using these tiny capillary tubes himself, when that was the one piece of information actually supplied by Leeuwenhoek in his March 23 letter.

Yet using this contrivance to examine water he obtained from a pump, Hooke was unable to see any tiny creatures (though they surely existed in abundance, given that London pump water came directly from the Thames, into which human and animal waste was dumped in profusion). Hooke proposed to try an infusion of pepper water. At the following week's meeting, he reported that even with stronger microscopes, and water in which pepper had been steeped for two days, no little creatures could be seen, though he did see the dust of the ground-up peppercorn. Apparently he was busy as well with other trials that week, next reporting on experiments to replicate the fine "French leather" that was "impervious to water." Finally, at the meeting of November 15, Hooke announced that he had been successful.

This time he had steeped whole black peppercorns in rainwater for nine or ten days. In this water he had seen "great numbers of exceedingly small animals swimming to and fro. . . . [T]hey were near an hundred thousand times less than a mite." Hooke demonstrated his observations to the fellows present at the meeting. As the meeting minutes record, "[The little animals] were observed to have all manner of motions to and fro in the water and by all who saw them they were verily believed to be animals and that there could be no fallacy in the appearance." The record of the meeting continues,

"They were seen by Mr Henshaw, Sir Christopher Wren, Sir John Hoskyns, Sir Jonas Moore, Dr Mapletoft, Mr Hill, Dr Croune, Dr Grew, Mr Aubrey, and divers others so that there was no longer any doubt of Mr Leewenhoeck's discovery."

Now that these distinguished men of the Royal Society had seen with their own eyes, "there was no longer any doubt," as the meeting minutes indicate, that Leeuwenhoek had discovered microscopic life. Hooke was even commanded to show the little creatures to Charles II; His Majesty was "very well pleased with the Observation," Hooke reported to Leeuwenhoek. As a snide comment on Leeuwenhoek's furtiveness, Hooke soon published a short tract in which he openly described a variety of methods that others could use for making their own observations of microscopic life. Snideness aside, Hooke's observations cleared the way for acceptance of Leeuwenhoek's discovery. "Seeing is believing," as the philosopher John Locke said of the Royal Society's replication of Leeuwenhoek's observations. Previously, "We had such stories written [to] us from Holland and laughed at them." Even years later many people would doubt Leeuwenhoek's findings. He knew this, and was resigned to it. "I'm well aware that these my writings will not be accepted by some, as they judge it to be impossible to make such discoveries," he confessed. "Among the ignorant, they're still saying about me that I'm a conjuror, and that I show people what don't exist." But Leeuwenhoek was not a magician, conjuring up illusions in a puff of smoke. He had seen, for the first time, the invisible living world.

PART TEN

# Generations



ℐN DECEMBER OF 1675, Johannes Vermeer died quite suddenly. He had, according to his widow, Catharina Bolnes, "fallen into a frenzy" of some kind, and in less than thirty-six hours had "gone from being healthy to being dead." Only forty-three years old, he may have had a stroke or a heart attack, perhaps brought on by the pressure of try-ing to pay off his debts and feed his ten children still at home, who ranged from less than two years old to eighteen. (Their eldest child, Maria, had recently married and left home.) Things had been tough for some years, ever since the war with France and the *rampjaar* of 1672. Vermeer's production of his own works had slowed to a crawl, and his business dealing in pictures had fallen off, until he was unable to sell any paintings at all. Over the summer he had taken on a huge debt—one thousand guilders ($13,568 today)—from the Amsterdam merchant Jacob Rombouts, using his mother-in-law's capital prop-erty as collateral for the loan, instead of holding on to it for her as he had promised.

Catharina had gone to the funeral at the Oude Kerk, where Ver-meer was buried in the family plot Maria Thins had purchased in 1661, a plot that already contained three of their children, who had died in 1667, 1669, and 1673. Catharina had watched as the grave site of the baby they had buried in June of 1673 was dug up, her husband placed into the frozen ground, the baby's little coffin lowered on top

of his father's. She was left in charge of her remaining family, but had no idea how she could support them. As her own mother would attest before a court, Catharina "had never concerned herself further or otherwise than with her housekeeping and her children." Now what would happen to them?

-1-

The city fathers were wondering the same. It took some time but, finally, in September of 1676, they drafted a writ: "Their worships the Sherriffs of the Town of Delft do hereby appoint Anthonij Leeuwenouck [sic] to be Trustee [curateur] for the estate and property of Catharina Bolnes, widow of the late Johannes Vermeer (in his lifetime Master Painter) and petitioner for writ of insolvency, for what he remained possessed of." Leeuwenhoek was given the job of overseeing the complicated and messy process of settling Vermeer's estate.

Leeuwenhoek's appointment as the executor of Vermeer's estate seems to be conclusive evidence of some kind of relationship between the two men. But Michael Montias, the foremost investigator of the documents in the Delft archive relating to Vermeer, has found three other cases in which Leeuwenhoek was appointed by the city council as the curateur of an estate. Because of this, Montias concludes that his appointment as the executor for Vermeer's estate was just a routine part of Leeuwenhoek's duties as a civil servant.

In Vermeer's and Leeuwenhoek's lifetime, however, there were about 2,500–3,000 deaths of adults in Delft per decade. In the fifty-year period in which Leeuwenhoek served in his civic position, then, there would have been between 12,500 and 15,000 adult deaths. Yet Leeuwenhoek was appointed executor only four times. Clearly this was not a routine responsibility of his position. What needs to be explained is *why* Leeuwenhoek was appointed those four times.

In doing a little more historical digging than Montias, I have found that in each of the three other cases in which Leeuwenhoek was appointed *curateur*, Leeuwenhoek had close connections to the person or the property involved, or both. So the existence of these

three other cases in which he was appointed executor is not evidence *against* Leeuwenhoek's personal connection with Vermeer, but is actually evidence *for* it.

One of the three cases Montias uncovered is that of a "Maria de Neij," who, owing to her "melancholic and somber thoughts," was found to be incapable of administering her own possessions. Leeuwenhoek was appointed on April 24, 1674, to oversee her property because of her psychological state—he was given a kind of power of attorney over her finances. There is no record at all of any Maria de Neij in the Delft archives; there is, however, a Maria de *Meij*. She was the sister of Barbara de Meij, Leeuwenhoek's first wife, making her Leeuwenhoek's sister-in-law. Maria de Meij was baptized in September of 1626, three years before Barbara, and later served as the godmother of Barbara and Antoni's daughter Maria. She was a schoolteacher who had remained unmarried until 1674, when she was forty-eight years old. On March 3, 1674, a marriage license was filed for Maria and Pijeter Schepens, a widower. But in December of that year, the license was amended to note that the couple had separated. Possibly, Maria was depressed enough six weeks into the marriage that her brother-in-law needed to be brought in to manage her affairs. Maria died a little over a year later, in January of 1676. On her burial certificate she is still listed as the "housewife of Pieter Schepens," suggesting that they had not divorced but were simply separated at the time of her death. Leeuwenhoek's daughter, Maria, inherited her aunt's house on the Oosteinde.

The same month he was appointed caretaker of his sister-in-law's estate, Leeuwenhoek was also given the power of attorney over the property of Bartholomeus Ritmejer, for unspecified reasons. I have found that Ritmejer was Delft's *wijnkoper*, or wine buyer. Leeuwenhoek may have known Ritmejer professionally, being a wine expert of sorts. Several years later, in 1679, Leeuwenhoek would be appointed the wine gauger for Delft, an important civic position requiring that the holder be familiar with both wine and measurement, as the wine gauger was the person responsible for testing wine for its purity and quality, and, for tax purposes, measuring the amounts being bought and sold. At the time of his appointment Leeuwenhoek had already

used wine in his work, observing samples with his microscope to try to find "vinegar eels" left over from the wine barrel's earlier use as a container for vinegar. Later, he would report observing "globules" in the lees of wine, the precipitate formed when wine was clarified. He would go on to look for salt particles in French wine, sherry, Moselle wine, Rheingau wine, Touraine wine, and others, and seek these globules in his own sweat after excessive drinking. So he may have been a customer of Ritmejer's, or may have been appointed trustee because he knew enough about wine to handle the wine buyer's property.

If we assume that Leeuwenhoek did know Vermeer, then he could also have known Ritmejer through the painter. In January of 1667 Ritmejer had married Catharina Gillisdr. Cramer. She was the daughter of Gillis Cramer, a wealthy silk merchant, and the sister of Johannes Gillisz. Cramer, who married Vermeer's daughter Maria in June of 1674, two months after Leeuwenhoek was appointed to oversee Ritmejer's property. (At the time of the marriage between Ritmejer and Catharina Cramer, the couple's address is given as being on the Verwersdijk, at the house later occupied by Johannes Cramer and Maria Vermeer.) Vermeer might have asked Leeuwenhoek to look after the financial situation of his daughter's prospective brother-in-law.

The year before, Leeuwenhoek had been given the task of overseeing the estate of the recently deceased Grietje Jans van Keijen, the wealthy widow of Willem Jansz. Kronenburch (also known as Kronenburg). Kronenburch, a successful merchant who had built up an impressive art collection, had died seven months earlier, and soon after his widow's death the paintings were sold at auction, possibly by Leeuwenhoek himself. (We know he would later auction Vermeer's pictures.) Kronenburch's collection included pictures by Fabritius, Couwenbergh, and Evert van Aelst.

There are two ways in which Leeuwenhoek might have been connected to the Kronenburch family. One is through the many artists in his family, who painted works that could have been collected by Kronenburch: either his mother's Van der Burch relatives, such as Hendrick van der Burch (ca. 1625–64), a painter who had the same name as Leeuwenhoek's grandfather and may have been named after

him; his Molijn stepfather and stepbrothers, all painters; Cornelis de Man, Leeuwenhoek's cousin by marriage; or his wife Cornelia's probable relative the painter Moses van Uyttenbroeck. With all these connections to artists, Leeuwenhoek might have been viewed as someone knowledgeable enough about the art of the day to take charge of selling the estate's collection. The other way that Leeuwenhoek might have known the Kronenburch family is through Vermeer. Kronenburch had served as a witness for a power of attorney granted to Gerruit Suijer by the art dealer Abraham de Cooge, who was an associate of Vermeer's father, Reynier; the two men had registered less than a year apart as the first two art dealers in the Guild of St. Luke. Vermeer would have known De Cooge in his own right, for De Cooge was elected headman of the St. Luke's Guild two times while Vermeer was a member: in 1665 and 1672 (during the latter appointment Vermeer served as co-headman with De Cooge). Since Kronenburch was an art collector, he may also have bought art from Vermeer himself.

In each of the three other cases in which Leeuwenhoek was appointed curator of an estate, he either knew the person involved, or had familiarity with the property of the estate. Leeuwenhoek's appointment as executor of Vermeer's estate was not random; there must have been some reason for it. The best explanation is the simplest—that they were acquaintances, if not friends.

-2-

Before an executor of the estate had been appointed, Catharina Bolnes and her mother were hard at work trying to protect what was left of Catharina's property. A month after Vermeer's death, on January 27, 1676, a deed was drawn up for the settlement of the huge debt owed by the family to the baker Hendrick van Buyten—617 guilders and 6 stuivers (about $8,400). That would have been for several years' worth of bread for the family, with an occasional treat of a cake or pastry. This is the baker who already had some of Vermeer's pictures, and to whom Monconys was sent to see some examples of Vermeer's

work. The deed states that Catharina "will pay off 50 guilders per annum. In exchange, two pictures of her husband's, in Van Buyten's possession, will be returned to her. If she does not fulfill her obligations, Van Buyten will be at liberty to sell the pictures." These two pictures are described as "one with two figures, one of which is writing a letter," and one in which "a person is playing the cither." The first may have been *Mistress and Maid*; the second, *The Guitar Player* or possibly *Woman with a Lute*. The baker noted that he agreed to this settlement because he was "moved by the serious request and the insistence" of Catharina. But he was careful to add that "should he be compelled to sell the pictures Catharina Bolnes will settle his possible loss on the sum 617 guilders and 6 stuivers." If the pictures were sold for less than this amount, Catharina Bolnes would be responsible for making up the remainder of the debt.

On February 22 or 24, 1676, Catharina transferred by deed the picture *The Art of Painting* to her mother, in settlement of a loan Vermeer had supposedly obtained from Maria Thins in July 1675. This may have been for the 2,900 guilders that Vermeer was supposed to give to Maria Thins but had instead used as collateral for the loan from Rombouts. Since Maria Thins was then forced to pay back the 1,000-guilder loan in order to get her capital property returned, the claim that Vermeer had borrowed that amount from Maria Thins was, in a roundabout way, correct. On the twenty-ninth of the month, Catharina had another deed drawn up, this one specifying that half of all of her possessions belonged to her outright, and half belonged jointly to her and her mother.

Later that day an inventory was taken of her property. The notary's clerk walked room by room through the house on the Oude Langendijck, noting all of the movable objects that belonged to Catharina Bolnes. In the left-hand column were listed possessions of Catharina in her own right, while in the right-hand column the possessions that Catharina and her mother, Maria Thins, shared "each to be the full extent of one half"—owned jointly. However, some of Catharina's most prized possessions had been hidden away, so that they were not recorded by the clerk; others were said to belong outright to Maria Thins, not shared between them, so they did not appear in the

inventory. On Catharina's side of the list were items such as clothing, mostly worn out, some cushions, blankets, kitchen crockery, "earthenware of little importance," beds, and other items not worth much. Catherina's goods also included two *tronien*, or faces, by Fabritius, a third painting by him, and two *tronien* by Van Hoogstraten, as well as unattributed portraits of Vermeer's father and mother. There were two "tronien painted in Turkish fashion," perhaps Vermeer's pictures of women clothed in what might have been taken for exotic dress: *Girl with a Pearl Earring* and *Study of a Young Woman*, both of whom are wearing turban-like headdresses. There is a line for a painting of a "Woman with a Necklace," perhaps Vermeer's *Woman with a Pearl Necklace. The Art of Painting* is not listed because it had already been transferred to the ownership of Maria Thins.

There were also five books in folio and twenty-five other volumes, a fairly large number for a family to own in those days. Unfortunately, we cannot know whether this collection included books on perspective or any of the works on optics that might have introduced Vermeer to the camera obscura. To Catherina were also assigned the painter's supplies: an easel, three palettes, a maulstick with an ivory knob, six wood panels, ten canvases, and three bundles of prints. There were no pieces of gold jewelry and no gilded jug, even though we know that these items were bequeathed to Catharina in 1657 and 1661. Perhaps they had already been sold off during the lean years. But possibly these were hidden from the eyes of the notary's clerk.

On April 24 and 30, Catharina Bolnes petitioned the court to declare a moratorium on her debts. This may be why some of the more valuable objects in the house had been concealed during the inventory. The petition stated,

> She, supplicant, charged with the care of eleven living children, because her aforementioned husband during the recent war with the King of France, a few years ago now, had been able to earn very little or hardly anything at all, but also the art that he had bought and with which he was trading had to be sold at great loss in order to feed his . . . children, owing to which he had then so far run into debts that she . . . is not able to pay all her creditors.

The court granted the "letters of cessation" the same day, essentially declaring Catharina personally bankrupt and stating that she was "repudiating" the estate of her husband, which would now have to be administered by a trustee assigned by the city's aldermen (the position to which Leeuwenhoek would be appointed).

The process of declaring oneself bankrupt or insolvent was a lengthy and complicated one. It was not uncommon: hundreds of people went bankrupt every year in Amsterdam alone. Even in 1656, at the height of his fame and talent, when demand for his paintings still outstripped supply, Rembrandt declared himself to be insolvent; he was living far beyond his means. The object of the bankruptcy proceeding, from the point of view of the state, was not to punish the delinquent debtor but to "rehabilitate" him and to repair the damage done to his creditors and the economic balance of the city as a whole, by showing that debts must be repaid. Generally, the city would charge that an agreed percentage of outstanding debts must be paid from the proceeds of an auction of the goods left by the deceased. Family fortunes—such as the dowry brought to the marriage by the bride—were exempt when the marriage settlement stated that the couple would keep their property separate. Three years after their marriage, Catharina Bolnes and Johannes Vermeer had signed a document stating that they wished to keep their assets separate; it may have been a condition of their moving in with Maria Thins, to ensure that her daughter's inheritance would not go to Vermeer if his wife died before him. The "curator" of an estate would decide the percentage of the debt that was to be repaid to creditors; this was based on how the debts were incurred (a debt to the baker to feed one's family was looked upon more indulgently than a debt to the haberdasher for silk ribbons and fine garments, for example). The percentage was also based on the future earnings capacity of the debtor. At the end of the process, the debtor and each of his creditors signed a "reconciliation" document, to show that their relationship had been repaired by the bankruptcy process.

-*3*-

Once Leeuwenhoek was appointed to the job of managing the Vermeer estate, at the end of September of 1676, he got right to work, even though at this time he was in the midst of his most thrilling observations. But first, on October 9, he drafted the long letter to the Royal Society detailing his many observations of animalcules in infusions of pepper and other spices, as well as in well water and snow water. Then he turned to the first knot he had to untangle for the Vermeers: the partition of the estates of Catharina's brother, Willem Bolnes, and Hendrik Hensbeeck, Willem and Catharina's cousin, who had become wealthy as the owner of a brickmaking factory in Gouda. Willem had died several months after Vermeer, and the money that he had inherited from Hensbeeck then passed to Catharina. Leeuwenhoek accepted to transfer the rights to Catharina's part of this inheritance to Maria Thins, in exchange for five hundred guilders to be paid by Maria Thins into the estate of her daughter. Leeuwenhoek requested (and received) sixty guilders for his services in this matter.

By this time Maria Thins had moved to The Hague, so Leeuwenhoek had to travel several times between The Hague and Delft to take care of this matter. It appears that Leeuwenhoek took the opportunity to visit Constantijn Huygens on some of these trips. In a letter to Oldenburg written in the summer of 1677, Leeuwenhoek referred to a visit to Huygens "about a year ago," when Huygens had given him a sample of moxa—a medicine used to cure the gout by burning it on the skin of the infected part. Leeuwenhoek reported that he was burning the moxa on his own skin to examine the burned flesh afterward; he was forced to stop the experiment—not because of the pain of the burning but because of the slow healing of the skin where he would cut it with a knife to get the sample of burned flesh to view with his microscope.

In November, Leeuwenhoek needed to intervene in another crisis for the estate. Earlier, twenty-six pictures from Maria Thins's house

on the Oude Langendijck had been seized by Jan Coelenbier, a Haarlem art dealer, on behalf of the Delft widow Jannetje Stevens. Stevens was a seller of woolen cloth and other "shop wares." Vermeer's estate owed Stevens 422 guilders for "various merchandise," and the pictures were taken as collateral for the debt. A number of these paintings were probably the ones noted in the inventory: those by Fabritius, Van Hoogstraten, and others, as well as several of Vermeer's own works, including *The Art of Painting*. It is likely that so many paintings were seized not because in total they were valued at the amount of the debt, 422 guilders (which would make them appraised at only about 20 guilders each), but because they were worth much more than the debt—so that Catharina Bolnes would be compelled to pay it. Leeuwenhoek negotiated with Stevens—whom he may have known from his days as a cloth salesman—to accept a lesser amount of cash from Catharina Bolnes. In February 1677, Leeuwenhoek and Stevens appeared before the aldermen of Delft to declare that if Catharina paid Stevens 342 guilders immediately, the pictures would be returned. The following month, since Catharina was unable to come up with the money, Leeuwenhoek himself paid the 342 guilders—out of his own pocket—in order to retrieve the paintings. This amount (about $5,090 today) was more than the yearly salary of a glassworker in the Dutch Republic, and even more than Leeuwenhoek's starting annual salary for his government position. It seems highly unlikely that a bureaucrat unconnected to Vermeer would have paid out so much of his own money to settle the painter's debt.

That debt now belonged to Leeuwenhoek. Without consulting Catharina or her mother, he publicly announced a sale of some of the paintings he had retrieved from Stevens, including *The Art of Painting*. Maria Thins protested the sale of *The Art of Painting*, arguing that it belonged to her, not to Vermeer's estate. Leeuwenhoek contended before the court that the sale must take place, since he had paid the money to retire the debt for her daughter. On March 15 Leeuwenhoek auctioned off that painting, and the others, at the meeting hall of the St. Luke's Guild. Unfortunately, no record was kept of the other paintings sold that day, or the price that was paid for any of them. Decades later, after the death of Leeuwenhoek's daughter

Maria, his own microscopes would be auctioned off in the very same meeting hall, the gold ones sold by their weight for melting down.

The hardest part of dealing with Vermeer's estate was arguing with Maria Thins about how the debts should be repaid and what property belonged to her and not her daughter. This bickering interfered with Leeuwenhoek's scientific pursuits. It is not surprising that he wrote no letters at all to the Royal Society in December or January, and only two in February. For these months, a not insignificant amount of Leeuwenhoek's time and energy was taken up with financial activities and arguments with Maria Thins.

Finally, a week after the auction of Vermeer's paintings, Leeuwenhoek was able to get back on track, writing the long letter to the Royal Society in which he answers the fellows' concerns about his method of computing the number of animalcules he observed with his microscope. He continued his investigations. Then, in November of 1677, he made one of his most astonishing discoveries: the existence of "living animalcules" in human semen.

-*4*-

Leeuwenhoek told the Royal Society of a visit paid to him by Johan Ham, a medical student at Leiden. Ham brought Leeuwenhoek a glass vial filled with what he said was semen "spontaneously discharged" from a man sick with gonorrhea. (Probably, it was the discharge symptomatic of the disease.) Ham had seen "living animalcules" in the semen, which he thought had arisen through putrefaction of the man's semen as a result of the disease. Leeuwenhoek, while giving Ham credit for being the first to see the tails of these creatures, noted that he had examined seminal fluid some years back at the request of Oldenburg and had seen "globules" in it. He had not pursued these investigations at the time because he found them to be "unseemly." But after Ham's visit he went back to his observations, deeming it worthwhile to examine the semen from a healthy man. Still, when he reported his findings to the Royal Society, he had his letter translated into Latin, to make it seem more scholarly—and he instructed

William Brouncker, president of the Royal Society, to suppress his results if they were judged "objectionable" to the fellows.

As with his observations of lice and blood, Leeuwenhoek used himself as a subject of investigation. He assured Lord Brouncker, "What I investigate is only what, without sinfully defiling myself, remains as a residue of conjugal coitus." He examined his own semen "immediately after ejaculation before six beats of the pulse had intervened." While history does not record what his wife Cornelia felt about this, she may have been game—Cornelia often helped her husband with his experiments, such as the time she carried a small box filled with silkworm eggs "in her Bosom night and day" in order to hatch silkworms for him. Leeuwenhoek observed "living animalcules" moving about in his fresh semen. Unlike Ham, Leeuwenhoek realized that these little animals in the semen did not arise from the decay of the seminal fluid caused by disease, but were present in the seminal fluid of all men. He judged their size to be one-millionth of a grain of sand. Astonishingly, he observed that "they moved forward owing to the motion of their tails like that of a snake or an eel swimming in water."

It was one thing to see globules floating in the blood. But now Leeuwenhoek had found self-moving creatures inside the male semen. Were these creatures alive, like the minuscule creatures he had observed in motion in water? Did men have living creatures inside their bodies? The consequences of this notion were staggering. Leeuwenhoek began to devote himself to a study of the sperm (a term taken from the Greek word for "seed").

One question Leeuwenhoek puzzled over was how these little animals arrived in the seminal fluid. While dissecting a male hare, Leewenhoek found his answer. He accidentally cut the vas deferens, the duct conveying the semen from the testicles. Leeuwenhoek found that the liquid oozing out of the severed vessel teemed with a multitude of sperm. Over the next years Leeuwenhoek would dissect many other animals, always finding sperm in the vas deferens and testicles. He realized that the sperm originated in the testicles and that producing sperm was their purpose. He would observe sperm in thirty animals in all, including rats, dogs, codfish, pikes, breams,

mussels, oysters, hares, roosters, frogs, and even insects: cockchafers, damselflies (dragonflies), grasshoppers, fleas, mites, and gnats. Leeuwenhoek examined the sperm of so many different animals that at one point, when Sir Hans Sloane of the Royal Society asked for further information on his sperm observations, Leeuwenhoek had no idea which type of sperm he desired to hear more about.

Leeuwenhoek's discovery of sperm in cockroaches, dragonflies, and other insects dealt a serious blow to the notion of spontaneous generation. He had found that even the lowliest insects do not arise from the muck but reproduce like the higher animals. "I am quite convinced that, just as it is impossible for the Stony Mountains to bear Horses or other Cattle," or "a Whale to spring from mud," Leeuwenhoek would exclaim, "so it is equally impossible for any Fly or other Moving Animal to be generated from decaying matter." He dismissed spontaneous generation as nothing but "old wives' tales of foolish things."

More dramatically, the discovery of sperm transformed the discussions of generation. Up to this point, only human and animal eggs had been observed, leading most natural philosophers to believe—like Harvey and De Graaf—that eggs, perhaps "nourished" by semen, were the source of the embryo. This position was known as ovulism. But now it was clear that sperm must play a crucial role—after all, they, not eggs, could move themselves and seemed to be living beings. Leeuwenhoek embarked on a campaign to prove that the sperm, not eggs, were the essential "instrument" of reproduction. In his second set of sperm observations sent to the Royal Society, in March of 1678, Leuwenhoek declared, "It is exclusively the male semen that forms the fetus and that all the woman may contribute only serves to receive the semen and feed it." He believed that the sperm was responsible for the formation of the embryo; the egg provided merely its nutrition. He later insisted, "Man comes not from an egg but from an animalcule that is found in male sperm." Indeed, Leeuwenhoek began to believe that the entire human was present, in some sense, inside the sperm (just as Malpighi had suspected that the chick was present in the fertilized egg). He began to spend hours upon hours trying to see the outlines of the "little man" or "homunculus" within

the tiny sperm. Sometimes, he thought he could catch a glimpse of him.

Nevertheless, Leeuwenhoek reacted with scorn when an article appeared in a French periodical in 1699, authored by a pseudonymous Dalenpatius, who claimed to have seen the complete human body inside the sperm. The article was accompanied by a drawing of a sperm, in which there was a little man, including "naked thighs, the legs, the chest, and both arms, and the skin, pulled up somewhat higher, covered the head as if with a cap." Leeuwenhoek wrote a long letter to the Royal Society scoffing at this and reminding the fellows that he had observed human sperm hundreds, even thousands, of times, and had never seen anything like what Dalenpatius depicted. He dismissed it as "pure imagination, and not the truth." Leeuwenhoek himself believed that the human creature is contained in the male sperm, but denied that we will ever be able to see it there. Unfortunately, Leeuwenhoek included the Dalenpatius drawing in his letter to the Royal Society; when it was published in a Dutch edition, the drawing was inserted in the wrong place, where Leeuwenhoek had intended to have one of his own drawings of sperm. So generations of historians have mistakenly believed that the "homunculus" drawing was Leeuwenhoek's, and have ridiculed him for thinking he saw the little man so clearly. "Although I have sometimes imagined," Leeuwenhoek explained, "that . . . there lies the head, and there, again, lie the shoulders and there the hips, but not having been able to judge of this with the slightest degree of certainty, I shall not, therefore, affirm this as definite." (Unlike Leeuwenhoek, Nicolaas Hartsoeker would not hold back from publishing, in 1694, an image of a homunculus in the human sperm.)

Although he could not see the little man in the human sperm, Leeuwenhoek remained convinced of his spermocentric theory of generation. He was swimming against the tide of the egg-based theory of generation proposed by Harvey and De Graaf, and he knew it. In order to prove his case for the primacy of the sperm in generation, he engaged in a gruesome series of dissections. He had a female dog in heat mate three times, afterward killing her. (He did this in his study, and invited 's Gravesande over to see for himself.) He mentions that his work was a little crude, having never seen a womb being

removed except by a butcher. Looking at the uterus with his micro-
scope, Leeuwenhoek found thousands of the little tadpole-like crea-
tures swimming near the openings of the fallopian tubes. He claimed
that the sperm swam up to the fallopian tubes, where they would
find "little veins" to which they could attach themselves and feed.
What Swammerdam and De Graaf had taken to be eggs, Leeuwen-
hoek argued, were the sperm that shed their tails and would "coag-
ulate into a round ball or globule." He continued to claim that the
only function of the ovary was to provide food for the spermatozoid,
declaring that he had discovered "the great secret of generation."

But people were skeptical of Leeuwenhoek's spermatocentric the-
ory. For one thing, they were unwilling to believe that so many
sperm were "wasted" in each episode of generation if they were really
the life-forming force. Leeuwenhoek had claimed that there were ten
times as many "little animals" in the ejaculate of a codfish than there
were humans on the face of the earth! (To make this calculation, he
said he used a mathematical manual by Adriaen Metius, the author
of the book opened on the table in front of Vermeer's *Astronomer.*)
Leeuwenhoek tried to convince his critics by pointing out that the fig
contains many thousands of seeds, yet from it only one tree develops.
We do not deny, he reminded them, that the fig comes from the tree.
To those who would doubt his claims regarding the vast number of
sperm in any sample of semen, Leeuwenhoek delicately pointed out
that they should recall how when he "wrote about the great number
of living creatures in water, even the Royal Society would not accept
it." Why God creates so many seeds, "we can only guess the reason,
which is incomprehensible to us." The end of the egg-versus-sperm
controversy would come only in 1759, when Kaspar Friedrich Wolff's
*Theoria generationis* described the "germ" of the fetus as the product
of both the sperm and the egg.

-5-

At the same time Leeuwenhoek was developing a new theory of gen-
eration, he continued working on Vermeer's estate. In early 1678,
while in the midst of his observations of the sperm of dogs and fish,

he had to take care of an inheritance of Catharina Bolnes concerning houses and land in and around Gouda. Catharina had inherited the house in which her father had lived and died in the Peperstraat in Gouda. Leeuwenhoek empowered the Thins family notary to sell the property on behalf of Vermeer's bankrupt estate, presumably to pay off remaining debts.

Maria Thins died at the end of 1680, in her house in the Oude Langendijck in Delft, to which she had recently returned. She was buried in the family plot she had purchased years earlier, taking its last remaining spot. Soon afterward Vermeer's widow and her minor children moved to Breda, near the border with the Spanish Netherlands, which had remained predominantly Catholic after the independence of the Dutch Republic. Catharina spent the rest of her life there, until her death at the end of 1687—which occurred, ironically, while on a visit to Delft. She had returned to see her daughter Maria, and was staying at the house Maria shared with her husband, Johannes Cramer, on the Verwersdijk. On December 30, at the age of fifty-six, she died, after receiving the last sacraments by Philippus de Pauw of the Jesuit Station of the Cross, the same priest who had administered to her mother eight years before. She was buried in the Nieuwe Kerk, across the Market Square from her husband, who had died thirteen years earlier.

-6-

In the years before his death, while Vermeer was suffering from his most extreme financial difficulties, his style had begun to change. More and more, Vermeer was incorporating abstract elements into his pictures. Vermeer was not alone in this development; many of the artists of the day, including Van Hoogstraten, Van Mieris, Caspar Netscher, and the Delft painters Cornelis de Man and Johannes Verkolje, were moving in the direction of abstractionism, stylization, and decoration. In earlier paintings Vermeer had used stylization to accent compositional elements or to enhance naturalistic effects: for example, the mere squiggles of paint standing in for the bits of thread

in the foreground of *The Lacemaker*. During the 1670s these styliza-
tions took on an independent existence, becoming more important to
the painting. In *The Guitar Player* we find many parts of the picture
depicted in a more abstract way, from the design of the rose set into
the sound hole of the instrument, the strings that seem to be vibrat-
ing, the forearms and hands that are also faintly blurred, as if they are
moving too, and the pearls, the picture frame, and the white fur on
the coat. This abstractionism is used to augment the optical effects of
the painting: in both the folds of the jacket and especially the skirt,
"bold and curious patterns" are created from the effect of the light
on the fabric. In the satin we have lost all sense of texture and form,
perceiving only patches of light and dark.

At the very end of his career Vermeer painted two works with
a similar subject, works that may have been intended as pendants:
*Young Woman Standing at a Virginal* and *Young Woman Seated at a Vir-
ginal*. Each depicts a woman near a virginal, a type of harpsichord.
They are not the same woman, though they are dressed similarly in a
yellow skirt, white puffed-sleeved blouse, and a blue jacket, which is
short in the first picture but long in the second. In both paintings the
woman looks at the viewer frankly, making direct eye contact—they
are quite unlike women in his earlier pictures, preoccupied with their
tasks and unaware of the viewer's approach. Gazing at these pictures,
we do not feel that we are eavesdropping or spying on the women;
rather, we sense that we are being invited to join them. Indeed, the
way the space opens up in front of the chair near the standing lady
beckons the viewer to come around it and sit down, and the boudoir
lighting surrounding the sitting woman beckons the viewer to come
in and engage in another activity altogether.

Some art historians feel that, in his last works, Vermeer lost the
brilliance of his finest middle-period paintings. One Vermeer expert
has said that in the later paintings, "the purity of his masterpieces
becomes over-refined; the warmth and humanity of his earlier paint-
ings is lost." In these pictures he sees a kind of flatness, or a slickness
of the paint. Another writer has said of Vermeer's pictures of women
at virginals that they feel like "un vin pétillant éventé"—sparkling
wine gone flat. To my eyes, however, Vermeer has merely contin-

ued his optical experiments, considering the way that different light conditions can be depicted and how they can be deployed to convey different moods. In *Young Woman Standing at a Virginal* the light is bright, not softly diffused as in many of his middle-period pictures, and the mood is cool and elegant. Vermeer emphasizes the crispness of the light by silhouetting a black ebony frame and the black edge of the virginal's lid against a white wall. He paints the edges of objects with sharply defined, rather than diffused, contours. Light gleams on the red ribbon on the woman's right sleeve, the back of her satin skirt, and the gilt frame of a landscape behind her. *Young Woman Seated at a Virginal* depicts a woman in a darker room; the shade is drawn so that there is little light here, creating a more intimate, even inviting, mood. What light there is lushly illuminates the girl's white neck, her left sleeve with its touch of white lace, and the folds of her blue satin skirt. The gold ribbon on her left sleeve positively sparkles. In each of the two pictures, a gold gilt frame is seen in different light, accounting for very different styles of paint application between the two, from the carefully depicted intricate carving of the French-style frame in the brighter picture to the more abstract "dabs and dashes" on the gilt frame in the darker one. What these paintings serve us is not flat champagne, but fruit of a mature painter, secure in his artistry, continuing in his optical experiments, pressing the limits of how to represent light and dark, reflection and shadow—experiments that lead him at times to a kind of abstractionism. Who knows where his optical method would have taken Vermeer next, had he had more time?

-7-

It has been said that it was only after the invention of photography that Vermeer's mastery could be truly appreciated—that only after the "ubiquitousness of photography" accustomed our eyes to seeing the world differently could people see the beauty in Vermeer's pictures. Today, our eyes are more "photographic," attuned to the characteristic look of photographs, in which the focus varies in dif-

ferent planes, contours are softened, highlights glimmer. According to this interpretation, the experience of viewing Vermeer's pictures in the prephotographic age would have been like that of viewing motion pictures for the first time: unsettling, strange, even perhaps (as for the audiences said to have fled from the 1895 film of an oncoming locomotive) a bit frightening.

But this is overly simplistic. Other painters had experimented with similar optical effects before; Titian, for example, especially in his later works, brought different parts of his paintings to a more finished look, mimicking the varying focus in different planes of vision. His method of suggesting the glint of light off of pearls resembles Vermeer's. Velázquez used mirrors and lenses to create optical effects in his works. Closer to Vermeer in space and time was Fabritius, whose painting *A View in Delft* from 1652 shows that he was exploring ways to challenge the assumption that standard perspective corresponds to our normal manner of seeing; the sweeping curvature of the work and its wide-angled view resembles nothing so much as a photographic panorama. De Hooch and the architectural painters were also infusing their pictures with optical effects in order to create the illusion of a three-dimensional space. Enough painters were using optics in this way in the 1650s and 1660s—especially in Delft— that people were accustomed to seeing pictures depicting the world in an optical way. We know that people were buying these paintings and enjoying them in their homes. The widespread interest in lenses and practical optics might have had something to do with this. Someone like Leeuwenhoek, who had already viewed fabrics through convex lenses, would have particularly appreciated art that was using lenses to see the world in this optical way. One can't help but wonder whether seeing such paintings inspired Leeuwenhoek's interest in using lenses for more than just assessing the value of fabrics.

But styles change, and artists move on to new explorations and techniques. Later, and elsewhere, these works would begin to look strange to a public no longer used to paintings that depicted the world this way. The look of pictures made with the camera obscura— or inspired by the insights gained from experimenting with it— began to seem unnatural in some ways. In the eighteenth century

G. J. 's Gravesande, a relative of Leeuwenhoek's neighbor and friend Cornelis 's Gravesande, said, of the Dutch artists' use of the camera obscura, "The effect of the camera is striking, but false." Perhaps this is why the baker Buyten could try to sell Monconys a Vermeer picture for six hundred guilders in 1663, but in 1813 Vermeer's *Art of Painting* would be sold (as a De Hooch) for only thirty guilders.

It may be no coincidence that Vermeer was "rediscovered," and became more widely known and wildly admired, in the mid-nineteenth century, soon after the birth of photography. In 1861 the Goncourt brothers in Paris said of Vermeer that he was "the only master who has made a living daguerreotype of the red-brick houses of that country." Of all the Dutch painters fascinated by the new way of seeing the world in the seventeenth century, it was Vermeer who made his whole career *about* optical phenomena, and the way optical instruments enabled us to see the world in a thrilling new light.

# Scientific Lion

ONE COOL SEPTEMBER morning in 1683, after taking his morning coffee, Leeuwenhoek cleaned his teeth, as he was accustomed to do every day. He rubbed his teeth and gums with salt and rinsed his mouth with water. Taking a quill pen sharpened at the end, he picked between his teeth to clean out the remains of his breakfast. He finished by vigorously wiping his teeth with a muslin cloth. At fifty-one years old, Leeuwenhoek was proud of his dental hygiene; he boasted that his teeth were so "clean and white" that "only a few people my age can compare with me."

However, on this morning he noticed something troubling: some white matter between his teeth, looking like nothing so much as the batter his maidservant mixed up to make their Sunday cakes. He scraped some of this matter from his teeth with the quill and—as he was by now wont to do with all curious substances—reached for a flask of rainwater he had previously found to be devoid of animalcules. He mixed this with the "batter" and a little of his spittle. Putting the concoction in a little glass tube attached to one of his microscopes, he peered at it closely. "I then again and again saw," he later reported, "to my great astonishment, that there were many very small living animalcules in the said matter, which moved very prettily." Some had "a strong and swift motion, and shot through the water or spittle like a pike." Others "spun around like a top." Still

other kinds "went forward so rapidly and whirled about among one another so densely" that it was like "a big swarm of gnats or flies flying about together." Leeuwenhoek realized, with some delight, that "there are living more animals in the unclean matter on the teeth in one's mouth than there are men in a whole Kingdom."

-1-

After Vermeer died, his compatriot, co-investigator into optics, and neighbor Leeuwenhoek had many milestones to come. His election as fellow of the Royal Society of London at the meeting of January 22, 1680, was one of his happiest moments. The society sent Leeuwenhoek a silver box containing a scroll announcing his appointment. Leeuwenhoek politely called it "so great but unmerited an honour and dignity." He was proud enough that when Verkolje painted him in 1686, with the same surveying instruments portrayed in Vermeer's *The Geographer*, Leeuwenhoek insisted that the certificate and silver box from the Royal Society be included as well. Once he knew he was being proposed for the fellowship, and would himself be a full-fledged fellow of the society, he stopped referring to the group as "curiuse Lieffhebbers"; now they (and he) were "geleerde Heeren Philosophen"—the learned philosophers. The great honor even caused Leeuwenhoek to adopt a new spelling of his name, leaving out the *c* before the *k* and adding a dignified "van"—becoming "Antoni van Leeuwenhoek" only in the mid-1680s. A bemused Constantijn Huygens the younger noted that the election to the Royal Society had "puffed up" Leeuwenhoek's vanity.

The Royal Society honored Van Leeuwenhoek not only for his many discoveries but also because he exemplified the Baconian approach to science that it endorsed. Like Bacon and the fellows of the Royal Society, Van Leeuwenhoek recognized the need to make careful observations rather than leap to conclusions based on theorizing. As Leibniz would later say, after meeting Van Leeuwenhoek on a visit to Delft while traveling from Paris to Hanover in 1676, "I care more for a Leeuwenhoek, who tells me what he sees, than a

Cartesian, who tells me what he thinks." Van Leeuwenhoek pointed to his Baconian, anti-Cartesian scientific method when he told the Royal Society that it was "better served by an accurate observation than with a whole volume of Speculations, since these are nothing but brain-work." He even exemplified the down-and-dirty aspect of Bacon's philosophy. Bacon, England's lord chancellor, is said to have died from pneumonia brought on by an impromptu experiment. Struck suddenly with the idea that cold might preserve meat, Bacon ordered his carriage to stop on a winter's night so that he could jump out, buy a newly disemboweled chicken, and stuff it with snow. As John Aubrey reported, "The Snow so chilled him that he immediately fell so extremely ill, that he could not return to his Lodging . . . but went to the Earle of Arundel's house at Highgate, where they put him into. . . a damp bed that had not been layn-in . . . which gave him such a cold that in 2 or 3 days as I remember Mr Hobbes told me, he died of Suffocation." Whether or not it is apocryphal, the story serves to illustrate Bacon's belief that no observation was too unimportant—or messy—to contribute to scientific knowledge. Van Leeuwenhoek followed in Bacon's footsteps with his fearless examination of almost anything: his own blood, urine, feces, tooth plaque, pus from wounds, and the gunk between his toes after not removing his stockings for two weeks, the shavings of callouses from the feet of laborers, the wax from ladies' ears, and lots and lots of semen. Van Leeuwenhoek's claim that he had a weak stomach, and that strong smells and "unclean sights" made him ill, is hard to accept after reading about the smells and sights he endured for the sake of science.

His discovery and examination of the animalcules in tooth plaque embodied his Baconian approach. Van Leeuwenhoek did not rest after finding the little animals in his own mouth. He next called for two women, most likely his wife Cornelia and daughter Maria, "who, I am convinced, daily cleaned their mouths," examining their spittle.* He then mixed their saliva with a little of the matter he scraped from

---

* Leeuwenhoek did not specify who the "two women" were whose teeth he examined, but since he stated that he knew they cleaned their teeth every day as carefully as he did, it is reasonable to assume they were women of his household.

between their teeth and discovered as many "living animalcules" as he had seen in his own plaque. And still he did not stop. He extended his examination to persons of different ages and sex whom he suspected of not cleaning their mouths as well as he and his family did.

This examination was always on his mind, so much so that when speaking with an old man, his eyes fell on his teeth which, Van Leeuwenhoek noticed, were "all coated over" with the white matter. He asked the man when he had last cleaned his teeth. The answer was that the man "had never washed his mouth in all his life." Less dedicated natural philosophers would have ended the discussion at this point, but Van Leeuwenhoek forged ahead, asking to take a scraping of the man's teeth. He mixed this matter with clean water. Looking at the mixture with his microscope, Van Leeuwenhoek reported, "I observed an incredible number of living animalcules, swimming more nimbly than I had ever seen up to that time." He was not surprised to learn that the old man had several rotting teeth.

In one final experiment, Van Leeuwenhoek checked the white stuff scraped from his own teeth after drinking coffee "so hot that it put me in a sweat." He found many fewer moving animalcules and concluded that, "being unable to bear the heat of the Coffee, [the animalcules] are killed by it." He found that adding vinegar to the water solution containing animalcules also caused them to stop moving.

By this careful, empirical method, Van Leeuwenhoek had discovered tiny living creatures in the mouth. He inferred that they caused what was called "stenching [stinking] breath." He suggested, but did not definitively conclude, that these animalcules could lead to tooth decay, as in the mouth of the old man who never cleaned his teeth. Van Leeuwenhoek found that they could be killed by hot liquids or by frequent rubbing of the teeth with salt and vinegar. Presumably he mentioned these conclusions to his friends in Delft. If so, they might have been spared an epidemic that was ravaging the teeth of many citizens in the Dutch Republic: a craving for sweets, fueled by the new availability of sugar from Brazil.

-2-

As Van Leeuwenhoek's fame grew, he was visited by more and more people passing through Delft—so many that sometimes he had to instruct his daughter to tell callers he was not at home. He could not receive everyone, or else (as he put it) he "would have no freedom, and would be like a slave." By this point, Van Leeuwenhoek required that his visitors bring letters of introduction from someone he knew. Even so, in the space of four days in 1711, he received twenty-six people, all of whom had the requisite letters, except for a duke, a count, and their tutor (whom he let in anyway). In 1680 Constantijn Huygens the younger wrote to his brother Christiaan, "Tout le monde court encore chez Leeuwenhoek comme le grande homme du siècle!" (The whole world still comes to pay homage to Leeuwenhoek as the great man of the century!)

Though he grumbled about the interruptions, Van Leeuwenhoek could not resist showing his observations to others, especially when scientific luminaries—and members of royal families—came knocking on his door. He prepared special microscopes with specimens already attached to them, so that he was ready to show them to visitors. He proudly announced that he had revealed to James, the Duke of York (the future James II of England), the sperm of a dog in October 1679. Van Leeuwenhoek reported, "His Highness admitted that he not only saw that they lived, but that he even could clearly distinguish their tails." Years later, he would recall also showing the future king the leg of a louse. The duke had been forced by his brother, King Charles II, to go into exile after an "Exclusion Bill" was put forward in Parliament to keep James from inheriting the throne because of his conversion to Roman Catholicism. In 1679 James had been living at The Hague with his daughter and son-in-law, the stadtholder Prince William of Orange; he left for Brussels soon after seeing Van Leeuwenhoek, and returned to England in 1680. On the death of his brother, in 1685, the Duke of York did inherit the throne, becoming James II, but he was soon deposed in the "Glorious Revolution"—by

none other than his son-in-law, who, becoming William III, ruled with James's daughter Mary.

Mary herself had come to visit, soon before leaving The Hague for England. She had arrived unannounced, and Van Leeuwenhoek was not in Delft, to his everlasting regret. But he was home when Peter the Great, czar of Russia, arrived in 1698. The czar had the eccentric habit of talking to sailors who would dock in St. Petersburg, and by doing so he had learned enough Dutch that when he visited England, Gilbert Burnet, the bishop of Salisbury, was deputed to use his knowledge of Dutch to communicate to him "such information of our religion and constitution as he was willing to receive." The czar, who displayed a keen interest in science, could also converse with Van Leeuwenhoek in his own language. One of Van Leeuwenhoek's friends later reported that when the czar left The Hague in a canal yacht, and passed by Delft, he sent two men to ask Van Leeuwenhoek to come meet him on his boat. The czar wanted especially to see Van Leeuwenhoek's "incomparable magnifying-glasses." Van Leeuwenhoek spent two hours on the boat, showing the czar many of his remarkable discoveries. The czar was most struck by "the marvelous circulation in the tail of an eel." He delightedly watched this sight again and again. At the end of their time together, the czar "shook Leeuwenhoek by the hand, and assured him of his special gratitude for letting him see such extreme small objects." (On a later visit to the Dutch Republic, in 1717, the czar toured the *hortus botanicus* with Boerhaave in Leiden and purchased Ruysch's celebrated and creepy cabinet for thirty thousand guilders, or over $2 million today—a cabinet that included Ruysch's preserved "little children . . . whom he has carefully preserved . . . so that they seem to be sleeping.")

Van Leeuwenhoek was particularly excited about showing visitors what he considered the most exciting spectacle of his entire career, the circulation of blood in the capillaries of tadpoles. By setting up a special tube behind the lens, in which he could place and hold the tail of a living tadpole, Van Leeuwenhoek observed the propulsion of the blood globules through the capillaries—some of which were so narrow that only one corpuscle at a time could pass through—and determined that this circulation was synchronized to the heartbeat of the animal. This led him to realize that the capillaries constituted the

final link between arteries and veins in the circulatory system. He began inviting various gentlemen to come and see this new spectacle for themselves. It was such a "beautiful sight," he believed, it should be shared with others. He was moved to publish two different designs of the special "aquatic microscope" he had designed for these observations, showing the frame that held a small tube into which the tail of the tadpole or a baby eel could be placed (he still neglected, however, to give any specifications for the lens used). But such viewings were also a way to remove doubt about what he saw, to allow others to confirm his observations without reproducing the experiments for themselves. Inviting observers, Van Leeuwenhoek admitted, was the best way to ensure that he "might suffer less contradiction."

Van Leeuwenhoek continued his observations, using the methods of investigation he had developed decades earlier. After first seeing sperm in 1677, he returned again and again to the sperm of different animals, still looking for the little creature inside. He discovered the banded pattern of muscle fibers in 1682. In the 1680s and 1690s he engaged in a series of microdissections of insects, studying the mouth and sting of bees and discovering that aphids reproduce by parthenogenesis, asexual reproduction: female aphids are born containing babies within. In 1684 Van Leeuwenhoek discovered the needle-shaped microscopic crystals of sodium urate that form in the tissue of gout patients, correctly inferring that the sharp, needle-like structure of the crystals is what causes the pain of the disease. He was the first to observe the microorganisms *Vorticella* and *Stentor*, as well as diatoms and sessile rotifers.

And he remained obsessed with vision. In 1713, when Van Leeuwenhoek was eighty-one, he persuaded the captain of a Greenland whaling ship to bring him back an enormous eye of a whale, which had been preserved in brandy. (He also requested, and received, the whale's penis, similarly preserved.) Van Leeuwenhoek cut sections of the cornea, trying to determine the number of layers in it. He thought it was made up of sixteen to eighteen thin layers, but found the sclerotic layer of the eye—the hard fibrous membrane that makes up the topmost layer of the eye, of which the cornea is the outermost part—very tough, and almost impossible to section, although he was using a very sharp knife.

-3-

Even today we must marvel at the discoveries made by Van Leeuwenhoek, and wonder how he could be so successful at observing microscopic organisms and structures with his single-lens instruments. He was constructing microscopes with excellent lenses, to be sure, but by the time his career was well under way microscopes equaling the magnification and resolution of his average instruments were readily available, for sale in England by the firm of Edward Culpepper and in the Netherlands by the Van Musschenbroek family. So there was more to Van Leeuwenhoek's success than just the quality of the microscopes he made. Could it have been the method of observing that he used?

Since Van Leeuwenhoek never revealed the exact methods he employed, we must speculate about them, just as we must speculate about the methods Rembrandt used to make his etchings so special and the optical experiments made by Vermeer. But we do have enough information to make some reasonable inferences.

In some of his early letters Van Leeuwenhoek revealed that he had been observing in his dark study. There were four windows in the room, which could be closed by two wooden shutters, one on each side. Sometimes he left a small opening in one shutter so that he could aim his microscope into the beam of light, like looking at the sky with a telescope, as he described it. But at times he used a different method. He would close the shutters completely, opening a little casement window above them if his lit candle began to bother him with its soot. Even then, he was careful to draw a curtain over the opened window. He explained that he shut up his window shutters to keep out the air so that any animalcules floating in it could not contaminate his water sample. But this setup may also have proved decisive for his discoveries.

Because Van Leeuwenhoek sometimes made his observations in a dark room with only a candle for illumination, and because he often described what he was seeing—like the blood corpuscles—as

looking like "grains of sand on a piece of dark taffeta," it appears that Van Leeuwenhoek at least occasionally used a method known as "dark ground illumination." This is an observation technique still used in microscopy today, as it is excellent for live and unstained biological specimens, such as a tissue culture or individual water-borne single-cell organisms. With this method, direct light is blocked so that only scattered light reaches the objective lens of the microscope. This would have been fairly simple for Leeuwenhoek to achieve. In the twentieth century the researcher Barnett Cohen succeeded in viewing blood corpuscles by using a Leeuwenhoek-like setup and dark-ground illumination. He put the blood in a capillary tube with a very small globe about two millimeters in diameter at the bottom, and trained the single-lens microscope on this tube. He used lateral (sideways) illumination, such as Van Leeuwenhoek could have achieved by putting a single candle on one side of his microscope while observing through it. In this way Cohen saw the blood corpuscles clearly against a dark background, exactly like grains of sand on black taffeta.

Cohen found that it was somewhat more difficult to observe a single bacterium in a tube of water in this manner, but it was possible to do so by putting a drop of water on the lens of the microscope. This drop of water acted as an additional lens that further magnifies the specimen. If Van Leeuwenhoek had used this method, it would have provided him with three levels of magnification: one provided by the lens of the microscope, another by the glass tube, and a third by a drop of water. We cannot know whether this does accurately replicate Van Leeuwenhoek's observational methods, but it is clear that he used some similar method, at least some of the time. Van Leeuwenhoek would later describe observing sperm by candlelight, with a small concave mirror to enhance the illumination. When Thomas Molyneux visited him on behalf of the Royal Society in 1685, he marveled at how his microscope surpassed all others he had ever used in its "extreme clearness and . . . representing all objects so extraordinary distinctly," even though the instrument had been used "in a dark room."

It is also possible that Van Leeuwenhoek sometimes used a type

of camera obscura—a kind later called a solar microscope. It is generally believed that this type of camera obscura microscope was not invented until Daniel Fahrenheit, the German glassblower and natural philosopher living in The Hague, designed it in 1736. But I think it likely that Van Leeuwenhoek constructed and used one earlier than this. A solar microscope consists of a mirror, two convex lenses fitted inside a tube, and a square wooden or metal mounting plate. The plate is positioned in a small opening in a closed window shutter, with the mirror outside and the tube inside. The mirror can be tilted in different positions to direct the sun's rays into the tube with the lenses. The room is kept dark. The mirror outside the shutter reflects the sun's rays into the tube, so that the light passes through the condensing lens, the specimen on a slide, and then the objective lens. As with a room-type camera obscura, an image of the specimen is projected onto a wall or screen opposite the shuttered window. Unlike most camera obscuras, this type casts a magnified image.

A solar microscope produces a bright and strongly contrasted image of the specimen, and allows the image to be visible to a number of observers at once. The image can be traced over, ensuring an easy way to draw the magnified specimen. In the second half of the eighteenth century, solar microscopes were used to entertain crowds with shows of gigantic, magnified fleas the "size of sheep," hair "as large as a broomstick," and the circulation of blood in the tail of a tadpole, which was, one observer noted, "like looking at a geographical map in which all the streams and rivers are animated by actual flowing water."

The solar microscope was, basically, a very small camera obscura attached to a scioptric ball, a universal ball joint that allows a microscope or camera obscura to be swiveled into any position. Often the scioptric ball was fitted into a small hole in a window shutter. Daniel Schwenter had invented the scioptric ball in 1636. After this it would have been simple to construct a microscope version of the scioptric ball and place it in a hole in a closed shutter. Histories of technology are written from remaining objects and documents, and since Van Leeuwenhoek never disclosed his methods or the construction of his best microscopes it is possible that history has overlooked his inven-

tion of an early solar microscope. A visitor to Delft wrote that besides the microscopes Van Leeuwenhoek had shown him, "he told me he has another sort, which he reserves solely for his own observations." In one of his letters to Oldenberg, Van Leeuwenhoek explained that though he is a poor draftsman, he has a special method of producing drawings that he was "resolved not to let anyone know." A solar microscope would have solved that problem, since the image could be simply traced over. Whether or not Van Leeuwenhoek intimately knew Vermeer, his connection to so many of Delft's artists could have led him to learn about the camera obscura. Some writers have casually conjectured—with no evidence—that Van Leeuwenhoek introduced Vermeer to the camera obscura. But it might have been the other way around, the artist showing the natural philosopher how to cast an image on a wall. And, ironically, Van Leeuwenhoek, not Vermeer, may have been the one tracing a camera obscura image.*

Although Van Leeuwenhoek sometimes made his own drawings, at other times he deployed artists to depict the images seen through his microscopes. He is scrupulous in giving them credit, though not by name. In the summer of 1698 he reported, "I sent for a painter who is very observant and also has an accurate eye." Van Leeuwenhoek put a little eel in the glass tube in front of the microscope and handed it to the painter. When he saw the circulation of blood through the vessels in the eel, "the Painter could not stop marvelling." Sometimes, the draftsmen saw what Van Leeuwenhoek himself could not see. Their expertise in perspective, as well as, perhaps, their experience in using mirrors, lenses, and camera obscuras in their own work, might have made them more suited to these observations than Van Leeuwenhoek himself. They might have had more experience than did Van Leeuwenhoek with looking through lenses—at least at the beginning of his investigations.

As we have seen, Van Leeuwenhoek had numerous connections to artists, through his mother's family, his stepfather and stepbrothers, and his second wife, Cornelia Swalmius. He was painted by Corne-

---

* Leeuwenhoek may also have been introduced to the camera obscura in his work as a surveyor.

lis de Man and Johannes Verkolje and, perhaps, by Vermeer himself. When he worked as a haberdasher, he might have sold material to be used in Alberti's veils to artists of the nearby Guild of St. Luke. So he had many opportunities to find draftsmen to help him. But Van Leeuwenhoek never revealed the names of his illustrators. Boitet, who wrote about Delft in 1729, claimed to know who made Van Leeuwenhoek's drawings. Tomas van der Wilt or Wildt (born 1659) was a painter in Delft who had been a pupil of Verkolje's. A member of the guild with Vermeer, Van der Wilt was particularly known for his talents in perspective. He painted *The Anatomy Lesson of Abraham van Bleyswijk*, among other works. His son, Willem, born in 1691, was said to be an exceptional draftsman, and Boitet says that Willem van der Wilt was Van Leeuwenhoek's *schilder*. "Nearly all the plates in the celebrated work of Mr. Leeuwenhoek were marvellously drawn from life by him through magnifying-glasses. . . . But he died in the flower of his life on 24 January 1727, at the age of 35." As Boitet was writing only two years after Willem's death, he is probably correct that he had done illustrations for Van Leeuwenhoek. But there must have been one or more illustrators before Willem, since his letters contained images from the 1670s, before Willem was even born. It is possible that Van Leeuwenhoek's first draftsman was Willem's father, Tomas van der Wilt.

-4-

But there was more to Van Leeuwenhoek's success than just his skill at making microscopes, his creativity in using light to make observations, and his willingness to deploy artists. His vision may also have been particularly suited for the task. In several of his letters, Van Leeuwenhoek mentions needing his spectacles to see something. If Van Leeuwenhoek was nearsighted, that condition would have made it easier for him to make observations through his kind of microscope. In the eye of a nearsighted person, the image of something seen focuses in front of the retina, and a lens is needed to move it

farther back onto the retina; that is why the nearsighted person wears glasses. But if the lens is instead provided by a microscope held quite close to the eye, the nearsighted observer would be able to focus closer, and for a longer period of time, on something held quite close to the eye, than could someone who was not nearsighted. The microscope would, in a sense, play the role of spectacles or contact lenses. For someone who has normal vision, an image seen without a lens would hit the retina as it should, and so spectacles are not needed to push the image farther back. For this person, using a single-lens microscope brought close to the eye would cause the image to be pushed behind the retina, making it appear blurry. It would be as if someone with perfect vision put on a pair of glasses made for a nearsighted person—it would be hard to see, and the effort of focusing correctly would cause eyestrain. That may be one reason why others using Leeuwenhoek-type microscopes could not spend the hours looking through them that he did.

Not only was his vision particularly suited to observing with his microscopes, but Van Leeuwenhoek was also immensely skilled at preparing and fixing his specimens so that he could see more structures within them. Tiny, solid objects could often be simply glued to the pin of the microscope, but even this took much work; in the course of several days Van Leeuwenhoek had to kill more than one hundred mosquitoes in order to display the mouth properly. Other specimens, such as sperm and insect muscle fibers, were allowed to dry on a piece of mica or thin glass and then fixed to the pin. Liquids such as his infusions, semen, and blood were viewed in thin glass tubes—so thin they sometimes measured only the width of a hair. Van Leeuwenhoek may have been the first person to stain microscopic specimens, a common practice today. Van Leeuwenhoek used a bright yellow infusion of saffron to stain cross sections of muscle fiber; because the stain is absorbed at different rates by various structures in the specimen, each one stands out clearly and is easier to see. With his shaving razor, he was somehow able to slice sections thin as a hair; a rival microscopist later expressed amazement at his incredible dexterity, even when Van Leeuwenhoek was seventy-eight

years old. After reviewing the specimens that Van Leeuwenhoek sent to the Royal Society, Brian Ford concluded in 2003 that they are "technically excellent," meeting modern-day standards of specimen preparation.

Van Leeuwenhoek was exceedingly talented at measurement. Since he was the first one to observe such tiny organisms, he had to devise new ways to determine and describe just how small they were. He developed a method for measuring microscopic structures and organisms by means of macroscopic (and common) objects like grains of sand, millet seeds, and hair. Sometimes he placed a brass ruler near the microscope in order to measure the width of a hair seen under the microscope. He could then employ the hair as a measuring device when he wanted to determine the size of microscopic objects. Eventually, he would deploy microscopic objects—red blood "globules," the "smallest animalcules in pepper-water"—as units of measure for the most minuscule organisms. Today's microscopists are amazed at how accurate his measurements were, given the lack of modern micrometers and other instruments now used for measuring microscopic objects.

In fact, Van Leeuwenhoek's measurements were so accurate that some confusion was caused by his reference to "a hair on my head" as a measuring device. By assuming that his measurements were correct, as were all of his others, it worked out that the hair he was using must have measured only about 43 microns (thousandths of a millimeter) in thickness. But actually, human hair is closer to 70 microns. After some bewilderment on the part of researchers, it was realized that the hair from Van Leeuwenhoek's head was actually a hair *from his wig*. In the Netherlands at the time, wigs were generally made of Angora goat hair, which are 43 microns in thickness. Once the proper hair was taken as his measuring device, the dimensions he had given were correct.

Perhaps most important to his success was the fact that Van Leeuwenhoek had an almost unlimited supply of patience for returning, again and again, to the same observations, sometimes for hours at a time. He speaks of spending long periods gazing at sights such as the

circulation of blood in the capillaries of the frog, the masses of sper-matozoa tangled up in animal semen, the mite that, as it lay stuck on the specimen pin behind the microscope, kept passing an egg back and forth from foot to foot. On observing the circulation of blood in the hind legs of a small frog in a glass tube, Van Leeuwenhoek said it "gave me so much pleasure that I looked at it again and again on several days." Of the movement of the cheeks of baby eels, he wrote, "This sight gives me more pleasure than if I were to see a big cabinet of curiosities, with many different horns, shells, sea-plants, etc., how-ever costly and curious one might call such a cabinet." His specimen collection comprised his own cabinet of curiosities.

Van Leeuwenhoek must have needed to rest his eyes between viewings, each of which, he says, lasted for hours. The amount of patience and concentration required for this extended observation was extreme. As he explained in a letter when he was eighty-eight years old, "Nor should I ever have attained thereto, but by continual Labor in the investigation of things, which are concealed from our naked Eyes, and towards which I have a much greater inclination, than what I observe in most other Men."

This intense concentration became more difficult as he got older, and Van Leeuwenhoek occasionally expressed fatigue. On viewing many different samples of sperm, he noted, "this multiple sight, which was contemplated by me as if I could not get enough of it, not only fatigued my eyes, but also gave me a headache." Yet until the end of his life Van Leeuwenhoek endured headaches and other ailments for the sake of observing those things "concealed from our naked eyes."

-5-

Van Leeuwenhoek continued his microscopic observations right up to his death. On March 19, 1723, at the age of ninety, he wrote to the Royal Society about the size of red blood cells, and on May 31 he sent a description of the histology of the diaphragm, which he had studied in sheep and oxen, trying to support his view that his own

illness involved an obstruction of that organ, and not "palpitations of the heart" as his physicians thought. Van Leeuwenhoek pointed out that when this "violent motion" in the chest lasted, he could feel no quickening of his pulse on his wrist. Yet by his dissections he determined that obstructions could "excite convulsive motions in the tendons" of the diaphragm. (The rare disorder characterized by rapid, involuntary contractions of the diaphragm is now known as Van Leeuwenhoek's disease.) In August, Van Leeuwenhoek suffered another attack. As he lay dying, "when his limbs were already grow-ing numb," and with his "lips stammering and well-nigh stiff," he summoned his friend Dr. Jan Hoogvliet to his bedside, and dictated two letters that he directed the doctor to convey to the Royal Soci-ety as a "final gift." He died on August 26 no longer only "From the Lion's Gate"—as the name Leeuwenhoek originally signified—but a true scientific lion.

He was buried in the Oude Kerk on August 31, 1723, "with 16 pall-bearers and with coaches and tollings of the bell at 3 inter-vals." His burial notice recorded that he was "lid van de koninklijke societeijt binnen Londen": a member of the Royal Society in Lon-don. Six weeks later his daughter Maria—who had never married, preferring to stay and take care of her father, a widower since Cor-nelia's death in 1694—sent the Royal Society a bequest of her father. He had put together for them a black-and-gold cabinet, which held thirty rectangular tin cases covered with black leather. In each case lay two gleaming silver microscopes—the silver "extracted from the ore," and the lenses ground, by Leeuwenhoek himself. Attached to each microscope was a prepared specimen, labeled in his own hand. In recognition of the gift, the Royal Society sent Maria a silver bowl engraved with the arms of the society. The microscopes, and their specimens, were cataloged and described by Martin Folkes in the *Philosophical Transactions* of the Royal Society. One hundred and twenty years later, the cabinet and its precious contents were lost, and have remained missing to this day.*

---

* This loss was discovered in April of 1855, when a member of the Royal Society requested to see the microscopes and was told they could not be found.

-*6*-

Already in 1662, Hooke had complained of a reaction against the microscope among natural philosphers, who were, he believed, "bored and disenchanted" by the device. Later, in 1743, the English naturalist and poet Henry Baker suggested that all the important microscopical discoveries had already been made (some by himself). With Van Leeuwenhoek's death, the number of publications about microscopic observations sharply declined. That was, however, simply because Leeuwenhoek had been writing so many letters to the Royal Society right up to the end. It was not that there was nothing new in nature to uncover. It was, rather, that by the time he died his microscope—like the telescope—had become a routine component of a natural philosopher's toolkit, neither more nor less exciting than other instruments, such as a ruler or a balance. Microscopes could be deployed or dispensed with, as required. In a sense this was the triumph of the new way of seeing: it became commonplace, no longer a thrilling oddity.

Among the general public, the knowledge that there was more than meets the eye led to a vogue for "toy" microscopes. Throughout the eighteenth and nineteenth centuries, manufacturers sold inexpensive microscopes prepackaged with "sliders," a selection of specimens mounted between mica or glass slides. These premounted specimens were like Leeuwenhoek's collection, made for ease of viewing. With these microscopes, as with the earlier flea glasses, people could see for themselves how strange the previously unseen realm was—both the microscopic world and the world of tiny insects enlarged beyond imagination.

As one microscopist of the eighteenth century would remark, this was a world that, with its monsters of bizarre form and motion, was more eccentric even than the distant Indies. Volvox, a tiny globe of five hundred to five thousand cells, perpetually rolling through the water with no fins or other obvious source of motion; amoeba, a membrane filled with crystalline globules—microscopic objects such

as these prompted the question "Now will you call such thing an animal?" When a Swiss tutor in Holland named Abraham Trembley observed freshwater hydra with a microscope in 1740—rediscovering a creature Leeuweenhoek had already seen at the start of the century—he astounded the world with his tales of the almost magical property of the organism: self-regeneration. "We cut them with scissors and knives, turned them inside-out like a stocking or a glove," observed another natural philosopher, and yet from their pieces offspring arose. As Baker remarked of such oddities, "these are truths the Belief whereof would have been looked upon some Years ago as only fit for *Bedlam*."

The existence of such strange creatures opened up new areas of scientific study and new possibilities for understanding subjects such as human anatomy and medicine. Van Leeuwenhoek had a kind of affection for the little animals he saw, even in his own drinking water and in the plaque of his teeth, and resisted the suggestion of Hans Sloane of the Royal Society that "tiny animals" might be found in the fluid exuded from smallpox pustules. Even when he found these creatures in his excrement while suffering from an intestinal disorder, he refused to believe that the animals might have made him sick. But others shuddered to think of the dangers that lurked, unseen, all around them. In 1696 a student at Leiden expressed his amazement that anyone could escape such prevalent and invisible contagion. An anxious Nicolaas Hartsoeker steeped himself in tobacco smoke, hoping to ward off the poisonous insects that, he thought, caused the plague, while the French naturalist René-Antoine Ferchault de Réaumur wondered about the creatures of profound smallness that might be ravaging his insides at that moment. The eighteenth-century Swedish botanist Carl Linnaeus, the founder of modern taxonomy and the system of identifying organisms by reference to their genus and species, would later propose that such little beings had caused more carnage than had all the wars of the past. What we cannot see, it turns out, *can* hurt us. Yet although natural philosophers fretted over these pathogens, and some of them "rediscovered" bacteria seen first by Leeuwenhoek, a sustained research program of seeking

microscopic causes for disease would not come until the nineteenth century—when Filippo Pacini proposed that the cholera that terrorized cities like London was caused by a microorganism (he published his work in 1854, but it was not widely known or accepted until several decades later).

This newly unveiled world of minuscule creatures lit up the imagination of writers. Huygens's friend Margaret Cavendish wrote an ode to "a world in an Eare-Ring," imagining a multitude of unseen worlds on earth. William Blake advised his readers "to see a World in a Grain of Sand," while Joseph Addison, the essayist and founder of *The Spectator*, remarked,

> Every part of matter is peopled, every green leaf swarms with inhabitants. There is scarce a single humour in the body of a man or of any animal, in which our glasses [microscopes] do not discover myriads of creatures. The surface of animals is also covered with animals which are, in the same manner, the basis of animals that live upon it.

The poet James Thomson reveled in "worlds in worlds," noting that God's wisdom kept the invisible animals that lurk everywhere from our naked sight because otherwise we would not eat or drink anything.

> *Where the pool*
> *Stands mantled o'er with green, invisible,*
> *Amid the floating verdure millions stray.*
> *Each liquid too, whether of acid taste,*
> *Potent, or mild, with various forms abounds.*
> *Nor is the lucid stream, nor the pure air,*
> *Tho' one transparent vacancy they seem,*
> *Devoid of theirs. Even animals subsist*
> *On animals, in infinite descent;*
> *And all so fine adjusted, that the loss*
> *Of the least species would disturb the whole.*

*Stranger than this th' inspective glass confirms*
*And to the curious gives th' amazing scenes*
*Of lessening life; by WISDOM kindly hid*
*From eye, and ear of man: for if at once*
*The worlds in worlds enclos'd were push'd to light,*
*Seen by his sharpen'd eye, and by his ear*
*Intensely bended heard, from the choice cate,*
*The freshest viands, and the brightest wines,*
*He'd turn abhorrent, and in dead of night,*
*When silence sleeps o'er all, be stun'd with noise.*

The discovery of this previously invisible world upset the faith of some—why would God spend so much effort on the intricate parts of animals that could not even be seen by man's naked vision? But for most believers, the new microscopic discoveries provided further fodder for their convictions. The unseen world offered an opportunity to experience a greater awe toward God, who had created even the lowly louse with such intricacy and beauty that men must wonder at the sight—and *could* wonder, now that they had microscopes with which to see it. Surely such complexity could not exist in a chaotic, godless universe, many theologians argued. The tiny beings and minuscule structures seen under the microscope became, just like the existence of distant planets and stars seen through telescopes, further proof of God's existence. In the nineteenth century, when a debate about the "plurality of worlds" raised questions about the existence of life elsewhere in the universe, the discovery of previously unseen worlds here on Earth was used to show that faith could survive the realization that the creatures we see with our naked eyes are not the only inhabitants of God's creation.

The discovery of microscopic life—coming sixty-four years after Galileo's most astounding telescopic observations—in a sense set things right in the cosmos. Galileo's discovery of lunar craters, Jupiter's four moons, and a multitude of previously unseen stars proved Copernicus's heliocentric theory and upended the universe as it had been thought to exist for millennia. Once again, after Van Leeuwenhoek, humans inhabiting Earth were located in the center of

God's creation. Not physically in the middle, as they were when it was believed that every other body in the universe circled around our planet, but metaphysically. Humans were now understood as hovering, visibly, between the two parts of God's creation that were invisible to the naked eye: those faraway stars seen with Galileo's telescopes, and those tiny creatures seen with Van Leeuwenhoek's microscopes.

# New Ways of Seeing

## -1-

*In* DELFT'S OUDE Kerk, the graves of Van Leeuwenhoek and Vermeer lie close together. The two men, who had been baptized a week apart across the Market Square in the Nieuwe Kerk, and who had spent their lives in such proximity, were close in death as well.

Like many of the artists and natural philosophers in Delft, both men had been engaged in optical experiments. Van Leeuwenhoek had devised a method of observation that was, in a sense, circular, just like the globules he had seen in his blood. After making an initial investigation of a part of an organism, or discovering a new kind of creature in a particular kind of liquid, Van Leeuwenhoek would return, again and again, to the same body part, or the same liquid, circling back multiple times. He discussed microscopical observations of optic nerves in ten letters to the Royal Society between 1674 and 1700 alone; he observed not only the optic nerve of cows but also that of horses, codfish, flies, shrimp, sheep, pigs, dogs, cats, hares, rabbits, and birds. He boasted that he had access to human eyes—perhaps from his friend the city anatomist 's Gravesande—and he examined the cornea of those as well, noting that there was a yellowish color to them that he had not observed in the eyes of cattle.

Van Leeuwenhoek observed the same or similar specimens mul-

tiple times with different microscopes and using different light sources—sunlight and candlelight—in order to ensure that he was viewing them with the correct instrument, and under the best light conditions. As he told the Royal Society, "I generally notice that we come closer to the truth the more often we concentrate our investigations on one and the same thing at different moments." It was a way of coming to better understand the object of study, but it was also a technique for learning more about the instruments being used and how they functioned under various optical conditions.

Van Leeuwenhoek, unlike others of his contemporaries who were using microscopes, was primarily interested not in anatomy, or in microscopic life, or in generation; his main scientific preoccupation was with the microscope as an optical instrument and the practical optics of the device—the way he could make light work with his vision to enable him to see the hitherto unseen world with tiny glass lenses. Although he never studied mathematical theories of optics, his interest was with visual perception itself. That is why, while other natural philosophers like Nehemiah Grew and Robert Hooke tired of the microscope, moving on to other investigative tools, Van Leeuwenhoek never did. And it is why he examined anything anyone brought him, from the vermin found in the grain stocks of the Dutch East India Company, to the hair he collected from barbers, to whatever animal parts were brought to him by the local butcher, to blood, skin, callouses, earwax, vomit, excrement, and other bodily effusions he could get his hands on from his own body and from family, maidservants, neighbors, and others he would meet on the streets.

Vermeer's "experimental method" was like Van Leeuwenhoek's, so much so that Van Leeuwenhoek himself must surely have noticed this while inventorying the painter's work as executor of his estate. Vermeer's way of returning, again and again, to similar scenes and similar compositions, was itself an experimental technique, like the astronomer's looking again and again at the same part of the sky, night after night, to record what remained the same and what changed, or like Van Leeuwenhoek's returning again and again to the optic nerve, to sperm, to his little animals in different kinds of infusions. Vermeer depicted a solitary woman, engaged in a domestic

task, no fewer than fourteen times. He painted maps in nine of his pictures. He explored the theme of a woman writing, or reading, or receiving a letter six times. He painted scenes of a man and woman engaged in some kind of meeting or transaction—perhaps monetary, perhaps not—six times. Music playing was another constant theme, occurring in eight pictures. He painted *tronien*, or portrait-like pictures of heads—including the famous *Girl with a Pearl Earring*—four times in a burst of energy in two to five years (between 1665 and 1667 or 1670). Vermeer set scenes in rooms with black and white tiles ten times, and depicted oriental carpets in eleven paintings, a blue-yellow-green tablecloth in fourteen, a yellow satin mantle in ten, a blue-gray robe in seven, a yellow-brown maid's jacket in six, and a yellow-black jacket in five.

This repetition does not evince a lack of imagination on Vermeer's part, but rather a desire to experiment with the optics involved in seeing the same object under different lighting conditions. Like Van Leeuwenhoek, Vermeer did not study formal optical theory, but explored the way the world appears to us through lenses as a way of understanding visual perception. This is why we need not posit that Vermeer traced his camera obscura image. He was using the device not as a drawing instrument but as an experimental apparatus, not so different from the way Van Leeuwenhoek used his microscope.

By returning again and again to the same subjects, themes, and compositions, Vermeer was exploring how different light conditions could change the emotion of a picture, as well as the colors of its parts. This method helped Vermeer learn more about how we see under different optical conditions and how paint can depict the same object under diverse circumstances of light and shadow. Recurring motifs are painted in different ways in each picture. Flesh tones, for example, are depicted in different colors depending on the light of each scene. The same is true for the tiled floors, which are not rendered identically in the ten paintings in which they appear. And we saw that Vermeer paints the same map (the Berkenrode-Blaeu map of Holland and West Friesland) three different ways in three pictures: *Cavalier and Young Woman*, *Woman in Blue Reading a Letter*, and *The Love Letter*. Each time he portrayed the map, Vermeer changed its position

within the composition, and altered the lighting and the color. The result is that it appears at first glance that Vermeer has painted three entirely distinct maps. But on closer inspection we realize that each representation is faithful to the original in its descriptive content and relative scale. It is, in fact, the same map, illustrated under different experimental—optical—conditions.

-2-

Both Vermeer and Van Leeuwenhoek were employing optical instruments as "artificial eyes" to supplement the natural organs of sight. Van Leeuwenhoek used his microscopes, and Vermeer lenses, mirrors, and the camera obscura, to see beyond the surfaces, beyond the immediately apparent—to see more than meets the eye. Both recognized that there was more to the natural world than what lay on the surface—and believed that it was part of his task as an "investigator of nature" to look deeper, to see what lies underneath. Both men were, in different ways, looking inside living things.

Francis Bacon had instructed the natural philosopher to "vex Nature"—in a Latin phrase sometimes translated more provocatively as "torture Nature"—in order to induce her to reveal her secrets. And in Bacon's day the study of organisms had usually involved something like torture, cutting animals open, often while still alive. Robert Hooke had expressed the hope that the microscope would do away with the need for cutting open living things. He had been repelled— as are we today—by his own investigation of respiration on living dogs, which involved cutting open a living dog, placing a tube down its throat, and pumping air through the tube while observing what happened in the dog's lungs. The victim suffered immensely; it had to be held down firmly by at least two assistants so that its desperate squirming would not impede the investigation. As Hooke admitted, "when we endeavour to pry into [Nature's] secrets by breaking open the doors upon her, and dissecting and mangling creatures whil'st there is life yet within them, we find her indeed at work, but put into such disorder by the violence offer'd." Hooke hoped that the micro-

scope would do away with the violence of vivisection, noting that "it may easily be imagin'd, how differing a thing we should find, if we could, as we can with a *Microscope*, in these smaller creatures, quietly peep in at the windows, without frighting her out of her usual bias."

It turned out, however, that the microscope encouraged looking inside living things, either through vivisection or dissection. As other investigators soon realized, it was necessary to cut open specimens—sometimes while still living—in order to learn much about them, even at the microscopic level. In at least some instances, Van Leeuwenhoek engaged in vivisection, as when he says he "took the testicle of a live rat." One poor mite lived for "eleven weeks and one day" impaled on the specimen pin behind Leeuwenhoek's microscope. More often, Leeuwenhoek looked inside creatures when they were already dead; he became a master at microdissection. He possessed an astonishing manipulative skill that enabled him to cut the thinnest slices of the smallest creatures; even today observers can hardly reproduce some of his dissections with the more advanced instruments and techniques available. Although Van Leeuwenhoek was cutting slices of optic nerves as early as his first letter to the Royal Society in 1673, his skill at dissection was more obvious later, in the 1680s and 1690s, when he was between forty-eight and sixty-eight years old. His 1680 dissection of the mite *Aleurobius* and the flea were among his first efforts to dissect tiny, living creatures. In 1683 and 1693 he was able to dissect the flea's trachea, male genital organs (this may have been the gut), ovary, and parts of the mouth. In 1685 he dissected a sheep fetus at three days, the size of a grain of sand, and at seventeen days—about the diameter of a standard number two pencil. Of the latter, Van Leeuwenhoek told the Royal Society that he carefully stretched it out and was able to distinguish all the vertebrae of the spinal column, the jawbone, blood vessels, nerves, and "quite distinctly saw the brains." He also opened the tiny abdomen, from which he "extracted several portions of the intestines."

Van Leeuwenhoek dissected the cornea of a calf's eye, taking off layer after layer of membrane, until he found that each cornea consisted of at least a hundred membranes overlapping each other like scales. He dissected oysters and found their sexual organs, as well as

their tiny larvae—he afterward ate his subjects, noting that they were "as savoury as ever I saw or tasted Oysters in my life!" Once he began his investigations into generation, he dissected reproductive organs of nearly every type of animal imaginable: roosters, hares, insects, fish, and dogs. Far from doing away with the violence of vivisection, the microscope offered new opportunities to cut open creatures and look inside. Nature was still being interrogated; parts of it were being tortured. But this seemed necessary in order to peer inside living things, to see what was otherwise invisible. Van Leeuwenhoek hoped that "those who investigate natural things will delve up those hitherto hidden matters deeper and deeper."

Vermeer was also looking inside, in a way that was perhaps more subtle but no less striking. This is especially apparent in his eleven pictures depicting solitary women absorbed in their tasks—paintings that are among those most beloved today. In works such as *The Milkmaid*, *Woman in Blue Reading a Letter*, *Woman with a Pearl Necklace*, *Woman with a Balance*, and *The Lacemaker*, we feel that we have come upon these women, who are unaware of our presence; we are eavesdropping on their activity, "quietly peep[ing] in at the window," just as Hooke had hoped to eavesdrop on his specimens, without any violence or interference. We sense not only that we are watching these women engaged in their occupations, but that we are witnessing a part of the inner life of these women, a contemplative side. These women of Vermeer's are full of thoughts, though we do not know what they are. This is especially the case in the six letter pictures. Reading a letter, or writing one, even receiving one, fills one with thoughts and emotions. The viewer of paintings such as *Woman in Blue Reading a Letter* or *Mistress and Maid* is eavesdropping on an inner state of mind and heart.

Just as Van Leeuwenhoek so masterfully employed optics to see with his microscope and peep in on his specimens, Vermeer exploited the optical qualities of his pictures to evoke the sensation of voyeurism. For instance, in *Woman in Blue Reading a Letter*, Vermeer was scrupulous in painting the shadows cast by the map on the wall and by the two chairs. This makes the scene look so real, with such

a sense of three-dimensional space, that we feel we have stumbled upon the woman reading. Her absorption in the letter is complete; she does not know we are there, intruding on her privacy. But the woman herself casts no shadow. She exists in the space of the picture, and yet outside of time; she is unaffected by the passage of time, by the movement of the sun across the sky. This keeps her apart from us, beings who do exist in time. So we see her, but we are not a part of the scene, or of her life. We are kept at a distance, quietly peeping in.

-3-

Both Van Leeuwenhoek and Vermeer were using optical devices to see what had previously been unseen. Van Leeuwenhoek saw microscopic creatures for the first time. He also saw structures of animals and plants that had never been seen: blood corpuscles, mold spores, and sperm. Hooke had proclaimed that the microscope would enable investigators to discover "new Worlds and *Terra-Incognita's* [*sic*]," just as Columbus had "discovered" a new world. After Van Leeuwenhoek it was no longer taken for granted that the world visible to the naked eye was all there was; lenses were now presumed to help us see deeper and farther. There was an acknowledged unseen part of nature no less thrilling than the seen.

Vermeer, too, was seeing what had not really been seen or, better, what had not been noticed—the way colors change under different conditions of light, even though our eyes seem to see them as unchanged, the way that a hand can look like a lump of flesh, depending on the light and our position relative to it, and the way shadows can be brown, green, yellow, or blue. The camera obscura helped Vermeer pay attention to optical qualities not usually noticed, to disrupt the painter's habits of seeing and depicting his figures. Most painters—and the viewers of their pictures—are willing to accept shorthand methods of recognizing and representing objects, such as the perfectly formed hand even in dark shadow, or the dress in a single color under varying conditions of light. But through the lens of the

camera obscura Vermeer would have seen, and noticed, what is usually missed—and this may be why Vermeer was not afraid to deform familiar objects, even though most painters avoided this effect.

And, like some of his fellow Dutch painters, Vermeer saw—with all of his attention—his women subjects, really saw them as individual women. In his pictures of women reading letters, being courted, playing music, or caught during their daily domestic chores, Vermeer captured their particular expressions, their movements and gestures. These women have a specificity that is lacking in the conventions of classical and baroque depictions. They are not idealized women offered to the male gaze, as we find in works by many earlier artists, but individual women seen as individuals by the painter.

-4-

The work of Van Leeuwenhoek and Vermeer exemplified a particular notion of seeing, one that emerged only in this period with the birth of optical instruments and the new theories of vision. This notion accepted that seeing was a complex matter—involving much more than just rays coming either to or from the viewer's eye. Beliefs, expectations, desires, and prior knowledge all play a role in how we see the world. As Galileo had said, one must use "the eyes of the mind as well as the eyes in the head" in order truly to see with the telescope. Andreas Colvius had similarly remarked, upon receiving one of the early microscopes of Christiaan Huygens, "who among the ancient philosophers had indeed penetrated into the secrets of nature with the eyes of both the body and the mind as did the savants of the present age?"

But the mind's role in seeing was a double-edged sword. On the one hand, being able to interpret the shapes and structures seen with the telescope and the microscope was a learned skill, something that took time. It was, as Van Leeuwenhoek realized, necessary to learn to see. Knowledge and beliefs could help prepare the eye, as when Galileo's knowledge of perspective theory—and his acceptance of Copernicus's sun-centered universe—allowed him to see the blotches on

the moon as craters. Like other microscopists, and like users of the telescope, Leeuwenhoek needed to learn how to use the knowledge he had to help him see with his device.

On the other hand, the mind's involvement in seeing could unduly influence what was seen, or not seen. Galileo's opponents, strong supporters of the Aristotelian cosmology, simply could not see the lunar craters. Van Leeuwenhoek realized that what one thinks he sees is related to what he wants to believe. Believing is seeing, sometimes. Van Leeuwenhoek needed to train himself to see what was there, not what he expected to find. When he viewed the corpuscles in blood, he saw them as globular, even though they are flatter, with a central concavity. It wasn't only Van Leeuwenhoek—everyone at the time who saw those structures in the blood reported seeing a globular form. Swammerdam, the instrument maker Musschenbroek, and the observers at the Royal Society all saw the corpuscles as globules, because that is what they expected to see. Indeed, at first Van Leeuwenhoek saw globules everywhere: in blood, in milk, in bile, salt, chalky earth, yeast, wine, hair, semen, and other specimens. To be sure, the observations were difficult. Even John Locke, observing the spermatozoa of a dog with Van Leeuwenhoek in 1678, had a hard time seeing the tails: "they seemed to me like very small beads," Locke admitted. Over time, Van Leeuwenhoek realized that he had been inclined to see globules as the building blocks of all matter because of his adherence to corpuscularism. He had to fight against that impulse. He would soon see the tails of the spermatozoa in semen—even pointing them out to Locke—and reject globules in muscle fiber and in tooth enamel.

Van Leeuwenhoek had learned that one's presuppositions could confuse observations made through lenses. That was why he counseled that the microscope user make many observations under different conditions in order to fight against this natural tendency. It was not enough to use the "simple Eye," he affirmed again and again, what was needed was "attentive observation"—especially with a microscope. Van Leeuwenhoek emphasized frequently how many times he made himself repeat observations before drawing conclusions and feeling secure about what he saw. It was such repeated and attentive

observations that led him to abandon his earlier observations of glob-
ules in all things. It also led him to reject, though reluctantly, the
idea that a sperm contained the entire adult animal in miniature—or,
at least, that he could see it there.

Artists, too, were using mirrors and lenses to engage in attentive
observation in order to learn to see. By looking at a composition on
the flat surface of a mirror, or through the slightly curved surface of
a lens, painters saw more clearly what had not been noticed before.
As Leonardo da Vinci had said, the painter could use a mirror to
help him "develop his senses." Vermeer used the camera obscura
to develop his sense of sight, to notice natural optical effects lesser
painters had missed: the color of shadows, the way an object changes
color depending on the lighting, how light glances off the nails of a
chair. He realized, too, that visual perception fills in missing details
when the viewer has certain expectations. Vermeer used this insight
when he began to paint patches of light and color, not fingers or noses
or eyes or clothing. In *Girl with a Pearl Earring*, for example, there is
no line at all following the profile of the girl's nose on the left-hand
side. The bridge of the nose is given exactly the same color and tone
as the cheek beyond. The lines of the right side of the nose and nos-
tril are nearly lost in shadow. And yet, we fill in what is missing, to
read in the form of a nose, because of our knowledge of shapes and
shadows and noses. The upturned face of the woman receiving a mis-
sive in *Mistress and Maid* is merely a blur of color, and yet we can read
concern, even worry, within its contours.

Similarly, in *Woman in Blue Reading a Letter*, Vermeer used ultra-
marine as a thin glaze over the ocher ground for the jacket. However,
in the deep shadows at the back of the jacket, he used mainly black,
which he layered over the ground. Vermeer mixed the black with the
blue glaze in some spots, in others used the black as a base for a touch
of blue pigment. Indeed, very little blue can be found in either the
highlighted part of the jacket or the part in shadow; he established
the jacket's overall blue color with a minimum of the precious blue
ultramarine paint. He relied on the visual habits of the viewer to
combine the various tonalities into a coherent, predominantly blue,

whole. It was because of his experimental study of visual perception that Vermeer could paint works depicting our visual experience so luminously.

-5-

The transformation of art and science that took place in the Dutch Republic in the seventeenth century—in great part due to two of its citizens, Vermeer and Van Leeuwenhoek—changed forever how people saw the world around them. It was not only the novelty of microscopic observations, experienced by a public who used "toy microscopes" and flea glasses to see the cheese mites crawling on the rinds of Goudas. Nor was it just the new way that light, shadow, and perspective were depicted—though not often with the bravura of Vermeer's works—in the millions of pictures purchased by eager buyers during this period. A broader shift had occurred, one that cleaves the history of perception into two: before this moment and after it. For the first time, people knew with certainty that there was more to the natural world than meets the naked eye. They learned that they could see this invisible world with optical devices. And, by using these instruments, they came to understand that we must learn to see—both with the new devices and with our own visual systems. These three ideas are fundamental to how we understand our world and the way we gain knowledge of it today.

Van Leeuwenhoek, and then other microscopists, proved the existence of a previously invisible part of nature. Once this breathtaking discovery had been assimilated, the race was on to fashion new, more powerful instruments to help us see even farther beyond the boundaries of the visible world. As Hooke had giddily predicted in the preface to his *Micrographia*, there seems to be no limit to instrument-aided perception. Since that time new technologies have continued to extend the visible world, just like the telescopes, microscopes, and camera obscuras of the seventeenth century. The Hubble Telescope has disclosed to us the way galaxies looked eleven

billion years ago. Electron microscopes can magnify up to one million times, revealing even the surface configuration of a single atom. The discovery of x-rays by Wilhelm Röntgen in 1895 allowed us to see inside opaque bodies for the first time. That such vision could be possible was almost as surprising to people as the existence of a world of microscopic creatures. With more recent imaging technologies, such as positron emission tomography (PET) scans, we can see the metabolic activity of cells in the body. Such technologies extend the visible world to realms unthinkably small, or far away, or deep inside.

The natural philosophers and the artists of the seventeenth century taught us that instruments could be used as extensions of our eyes, and that we could learn how to see with them, even if what we saw with them was not like anything we could see with the naked eye. Today's new instruments for seeing the invisible are even further removed from the act of naked vision than were the optical instruments of Vermeer and Leeuwenhoek's time. But by extending what it means to see, as their seventeenth-century counterparts did, today's scientists have opened up new parts of the universe to our knowledge. Telescopes that work outside the visible light spectrum, such as infrared telescopes, radio telescopes, x-ray telescopes, and the Hubble Telescope, have been used to see the cosmos in a way very different from that of the telescopes used by Galileo. The gorgeous images from the Hubble released to the public are not photographs taken from space, as they seem to be, but are woven together from incoming data by computers, and then colorized, in order to yield a form accessible—and pleasing—to our eyes.

And today we understand, even more fully than did our forebears in the seventeenth century, that using our own visual systems requires learning to see with them. As earlier writers had suggested, and as Van Leeuwenhoek had concluded after dissecting the optic nerve of a cow and examining it with his microscope, seeing takes place not only on the retina but also in the visual centers in the brain. Using functional magnetic resonance imaging (fMRI), scientists in our time can see the brain activity that occurs when a subject is presented with visual stimuli. Powerful electromagnets measure

brain activity by detecting changes in blood flow that correlate with changes in magnetic properties of blood; when an area of the brain is in use, the flow of oxygen-rich blood to that region increases, and when the area ceases its activity, oxygen-poor blood takes the place of the oxygen-rich blood.

Such studies have confirmed what Vermeer, Van Leeuwenhoek, and others of their time suspected. It is not only the employment of new technologies that requires learning to see—even the use of our natural visual system requires training. Neurophysiologists have shown that early visual experience is necessary for the development of mechanisms in the brain required for normal vision. In order to have depth perception, for example, mammals must develop the brain mechanisms to compute depth from the disparities of two visual images, one received by each eye. The brain mechanisms arise in the course of the early experience of seeing with two eyes correctly aligned. People who are born with a misalignment of the eyes—as in strabismus, or crossed-eyes—may never achieve stereoscopic vision, even if the problem is corrected later in life, because they lack that early experience. At the same time, some adults lacking stereoscopic vision have apparently been able to achieve a measure of it by diligently performing certain eye exercises every day for years—by learning how to see depth. And like Cheselden's thirteen-year-old boy, bestowed sight for the first time after cataract surgery, the few documented cases of patients whose blindness was "cured" indicate that the journey from blindness to sight is not an easy one, and requires a great deal of work—a blind man or woman given vision still must learn to see.

As in seventeenth-century Delft, it is today not only the scientists but also the artists who are experimenting with new perceptual technology. And as in the earlier time, critics question whether it is legitimate to use technologies in creating art. The rejection of the use of painting aids expressed by Leonardo and others of his day was based on notions of "virtuosity," that "fine art" requires only the hand—and eye—of the painter, that the use of any equipment was somehow a form of "cheating." This view was tested in the seventeenth century by Dutch artists who began to use lenses and other optical devices to

learn about how we see, and to use that knowledge to create works of art steeped in visual experience. But the opposition to the use of technology—the demand that the artist have "compasses in his eyes" and not in his hand—continued long after the time of Vermeer and persists today, seen in the resistance to the idea that painters like Vermeer might have experimented with any optical devices.

In the nineteenth century, when the photographic camera was invented, its creator Henry Fox Talbot insisted that it was a form of art, and early photographers captured images that they modeled on the style of contemporary paintings. Yet critics of the time were slow to accept photography as a new art form, seeing it only as a new technology, a "recording" device useful for science. Technologies that have arisen more recently, such as the computer and the scanner, have been deployed to create new kinds of art. Today's most recent innovations for seeing the world—Google Glass, 3-D imaging—are slowly entering the toolkit of artists, and undoubtedly some artists will be censured by critics unwilling to accept that technologies play a role in artistic creation. But artists—like Vermeer—have always relied upon science and technology to push the limits of their art, and they will always do so, especially when science opens up a new way of seeing the world.

# Dare to See!

〰〰〰〰〰〰〰〰〰〰〰〰〰〰〰〰〰〰〰〰〰〰〰〰〰〰〰〰〰〰〰〰〰〰〰〰〰〰〰〰〰〰

ON THE FRONTISPIECE of the final collection of Van Leeuwenhoek's letters published in his lifetime, we find a curious vignette. A man climbs a mountain whose summit is crowned with an overflowing cornucopia, representing knowledge. He is being helped to the top by a winged god holding a scythe—a common symbol for Time. As the motto for the image and his book Van Leeuwenhoek chose the phrase *Dum audes, ardua vinces*—When you dare, you will conquer the steep, as the usual translation has it. The intended meaning is clear: If you but dare, you will be rewarded with knowledge.

The idea that acquiring knowledge required audacious feats had roots that reached back to the beginning of the seventeenth century. In a 1618 emblem book—one of those illustrated didactic texts circulating around Europe in the sixteenth and seventeenth centuries— the Dutch lawyer Florentius Schoonhovius chose to encircle a portrait of himself with the words *Sapere aude*, Dare to know. But in Schoonhovius's volume, as in other emblem books of the time that used the phrase, daring to know was tempered by another motto, *Altum sapere periculosum*—It is dangerous to know high things—a warning against entering into religious controversies. Dare to know, then, but only within certain limits. This simultaneous encouraging and constraining of audacity could not last. Soon enough, *Sapere aude* became an exhortation to overcome constraints and come to know

*everything.* Pierre Gassendi, French priest, mathematician, and philosophical sparring partner of Descartes, adopted it as his own personal slogan. Fifty years after Van Leeuwenhoek's death, the philosopher Immanuel Kant used the motto both to define and to capture the spirit he called "Enlightenment (*Aufklärung*)."

In Van Leeuwenhoek's and Vermeer's time, it was acknowledged that daring to know required, first of all, daring to see. One enduring legacy of their age is the casting off of authority—both the authority of dogmatic religious systems and that of ancient texts and worldviews—in the attempt to know the natural world. The rejection of religious authority did not require the wholesale rejection of religion: Van Leeuwenhoek, like the other early microscopists, saw the glory of God in the tiny worlds he peered into, and Vermeer began and ended his career with pictures featuring religious iconography.* There is no clear parting of the ways between science and religion here, but it *is* a break from past scientific methods, and past ways of regarding religious authority. Knowledge of nature was now acknowledged to require seeing for oneself, not learning from the Bible or the texts of Aristotle filtered through medieval monks or, for that matter, the classic manuals on perspective theory. In this period natural philosophers and painters alike began to throw off the yoke of authority and tradition and focus on understanding nature on its own terms. Van Leeuwenhoek had dared to know, and by so daring had climbed to the top of the mountain of our senses and looked beyond. Without that kind of daring, modern science as we know it would not—could not—exist.

Vermeer, too, had dared to see, and dared to know. He and other like-minded painters—especially in the Dutch Republic—followed Van Hoogstraten's call to "investigate nature" for themselves. These painters began to look through magnifying glasses and convex lenses, examine mirror reflections, and experiment with camera obscuras to come to know the natural world and the life existing within it—people, fruits and flowers, insects, snails, even the lowly slug. Employing a camera obscura, Vermeer had dared to see what other, earlier

---

* *Christ in the House of Mary and Martha* (1654–55) and *Allegory of the Catholic Faith* (1670–74).

painters had missed. And he dared to record these sights on canvas, even at the expense of classical forms and traditional methods of depicting light, shadow, color, and perspective.

The most radical influence of the seventeenth century on our time is the realization that seeing requires more than simply opening one's eyes and passively receiving sense impressions—one needs to learn how to engage in attentive looking, often with instruments, to make sense of the world around us. In the age of Vermeer and Van Leeuwenhoek, "investigating nature" began to mean seeing it literally in a new light, with the lenses of a telescope, microscope, or camera obscura. This new way of seeing was transcribed in paint by Vermeer and his fellow Dutch artists, who created pictures in which light streams into dark rooms, as if to let sunshine sweep away the cobwebs of dusty ancient thought, rooms in which we see people caring for their children, reading letters, drinking wine, sweeping the floor, entertaining visitors. The legacy of this time is its insistence on daring to see—an undertaking that Van Leeuwenhoek and his microscopes, and Vermeer with his camera obscura, so brilliantly embraced.

IN VERMEER'S *The Astronomer*, a man, perhaps modeled on Van Leeuwenhoek, stands in his study, the bright sunlight suffusing into the darkened room and illuminating a celestial globe on the carpet-covered table. The natural philosopher grasps the globe in his large right hand, as if the very heavens—or the knowledge of the heavens—are within his grip. In the dark shadow behind him we see part of a painting by Hooke's master Peter Lely—a painting depicting Moses, who is described in the Acts of the Apostles as "learned in all the wisdom of Egypt." Ancient knowledge lies in the dark, while the new science is illuminated. Although we see no optical instrument in the painting, we know that, later this night, the astronomer will be taking a telescope to the sky to add to the knowledge that has already been mapped on the globe. In this image of past and future science, Vermeer puts the future into the light. It is the new way of seeing, he tells us, that will allow us to behold a new world.

# *Acknowledgments*

WRITING THIS BOOK has been, figuratively as well as literally, a beautiful experience. I am grateful to all those who helped make it possible.

I first mentioned the idea of writing about Leeuwenhoek and Vermeer while I was on the telephone with my friend Lisa Hellerstein during the Boxing Day blizzard of 2010 in New York City. Her enthusiasm then, and throughout the process of researching and writing the book, has been priceless, as is her friendship.

During my research trip to the Netherlands, Tiemen Cocquyt and Mieneke te Hennepe of the Boorhaeve Museum in Leiden spent the day with me, showed me the original Leeuwenhoek microscopes in the collection, and answered my questions about the optical technology of the day. Tiemen provided some useful sources of information and was kind enough to answer queries that arose while I was writing the book. I thank them, as well as Dirk van Delft of the museum for arranging our meeting. I am also grateful to Eveline Kaiser at the Gemeente Delft/Archief Delft for answering several questions and to Faye Cliné of the Mauritshuis for her kind assistance.

I had the invaluable opportunity to talk about microscopes old and new with two experts: Sara Schechner of the Collection of Historical Scientific Instruments at Harvard and Ned Friedman of Harvard University and the Arnold Arboretum. I still hope we will set up a microscope summit.

This book has also provided me with the excuse to take some wonderful classes at the Metropolitan Museum of Art. I thank the education department there, and the teachers of the two courses I joined,

Elizabeth Perkins and Ines Powell. Later I spent a lovely afternoon in the galleries with Elizabeth looking at pictures and discussing reflections, mirrors, and lenses. I also thank Maryan Ainsworth, Andrea Beyer, and Michael Gallagher for the gallery portions of the classes.

I've enjoyed the chance to meet and talk with artists who provided insight into the way they use technology to help them see the world in new ways. Thanks to Jerry Marks, who showed me his work using 3-D photography, and Gretchen Andrus Andrews, who chatted with me about her work with Google Glass. I also thank Donnée Festen in Amsterdam, who let me use a muller to mix paint at the Rembrandthuis and answered some questions about making pigment in the seventeenth century. Pablo Garcia has my gratitude for offering me his expertise on perspectographs and pantographs. He also generously shared with me—and my readers—his own images of drawing machines.

I am grateful to Bruno Giussani, Cynthia MacMullin, Eric Schliesser, Steffen Ducheyne, Phil Barnett, Amy Gohlany, Jeremy Bangs, Wim Klever, Kees Kaldenbach, Jim Lennox, Bob Richards, and Leila Rafla-Demetrious for conversations about the topics of this book and for answering some questions that arose while I worked on it. I thank Katalin Torok, once again, for a place to land in London, and Marc Nolan, Melissa Bender, Neil Schluger, and Magda Sobieszczyk for getting me back on my feet when illness nearly derailed this project. Thanks go to St. John's University, especially to Jeff Fagen and Paul Gaffney, for support of many kinds.

Oliver Sacks graciously invited me to his home for tea and a lively discussion of Vermeer, Leeuwenhoek, visual perception, and learning to see. Walter Liedtke of the Metropolitan Museum of Art has also been generous with his time. I am grateful to them both, not only for meeting with me but also for their writings, which have, in different ways, inspired me while writing the book.

Howard Morhaim, my wonderful agent and dear friend, provided advice, criticism, praise, and kindness in just the right recipe. In John Glusman I have found an editor par excellence whose brilliant insights transformed the book in a fundamental way, and made it so much better. It was like a kind of editorial alchemy. I also thank

John's assistant, Jonathan Baker; the book's designer, Brooke Koven; the production manager, Anna Oler; and the entire Norton team.

No book of this kind could be written without the expertise and assistance of librarians and archivists, and I am happy to acknowledge my gratitude to those at the following institutions in New York City: the New York Public Library, the Frick Research Library, the Watson Library of the Metropolitan Museum of Art, the New York Society Library, and St. John's University Library. I thank as well the librarians at the Royal Society of London, especially Joanna Corden for arranging the visit and Felicity Henderson for an impromptu discussion of Robert Hooke and ink. I am also grateful to the Six family for accepting my last-minute request to visit the Six Collection in Amsterdam.

Nor could a long-term project like this be successfully undertaken without the support of friends. In New York I am fortunate indeed to have a circle of women writers with whom I can both commiserate and celebrate the writing process: Lauren Belfer, Diane Cole, and Evie Manieri. They are beautiful writers and lovely human beings. My work—and my life—have been enriched by knowing them. Sarit Golub, David Greenberg, Leigh McGinty, Franses Simonovich, Pam and Ed Rappaport, Cynthia Rubin, and Somerset and Wieska Waters have provided encouragement and friendship at every step of the way.

My son, Leo Giorgini, helped me on this project in many *specific* ways, including improving some infelicitous section titles. He also gave me advice useful to any writer: always end the workday when you are happy with what you've written, so you are eager to get back to it the next morning. I think he's the real writer in the family.

Finally, this book is dedicated to John P. McCaskey. He's made my life as lovely and luminous as a Vermeer.

# Notes

*AB*        *Alle de brieven van Antoni van Leeuwenhoek = The Collected Letters of Antoni van Leeuwenhoek*, 15 vols.
AvL        Antoni van Leeuwenhoek
DTB Delft        Gemeentearchief Delft, Register of Baptisms, Marriages and Burials
MMA        Metropolitan Museum of Art, New York
RSL        Royal Society of London

## PROLOGUE: MORE THAN MEETS THE EYE

1    **In the small Dutch city**: On the location and layout of his study, see AvL to Oldenburg, Oct. 9, 1676, *Alle de breiven* [*AB*], 2:85.

1    **Like most of the windows**: See Swillens, *Johannes Vermeer*, p. 115.

2    **"the motion of . . . these animalcules"**: AvL to Oldenburg, Sept. 7, 1674, *AB*, 1:163–65.

3    **Earlier versions were simply**: According to some sources, the box-type camera obscura was developed around 1590–1600. See Delsaute, "The Camera Obscura and Painting," p. 111. By 1622 Cornelis Drebbel seems to have made box-type cameras and told Constantijn Huygens that he was merely modifying earlier designs. See part 5. Robert Boyle described a "portable darkened room" that he had built "some years ago" in his "Of the Systematicall and Cosmical Qualities of Things" (1669), and Johann Zahn depicted two kinds of box-type camera obscuras in his *Oculus artificialis teledioptricus* (1685–86). See Wenczel, "The Optical Camera Obscura II," pp. 17–18. Robert Hooke presented a portable-type camera obscura to the Royal Society of London in 1668, as well as later versions in 1680 and 1694. So there is no doubt that by 1674 a box-type camera would have been available to Vermeer, had he wanted to use one.

3    **The spectator, sitting inside**: See Delsaute, "The Camera Obscura and Painting," p. 111.

4    **"all painting is dead"**: Huygens made this comment in a letter to his parents after seeing the Dutch inventor Cornelis Drebbel in England demonstrate a camera he had constructed (a device Huygens purchased, brought back to Holland, and demonstrated to a number of artists). See letter of April 13, 1622, quoted in Wheelock, "Constantijn Huygens and Early Attitudes towards the Camera Obscura," p. 93.

5    **No longer would the reliance**: For a perceptive discussion see Wilson, *The Invisible World*, p. 24. As Pomata notes in "Observation Rising," although observational practices were being developed in astronomy, astrology, alchemy, and medicine in the second half of the fifteenth century, no firm term was attached to this practice; it was variously referred to as *experientia, experimentum, consideratia*, and, only sometimes, *observatio*. It was not until the mid-seventeenth century that the term *observatio* was more consistently applied.

5    **natural philosophers**: See Snyder, *Philosophical Breakfast Club*, for the history of the word "scientist."

5    **"Everything should, as far"**: Comenius, *Didactica magna* (1633–38), quoted in Wilson, *The Invisible World*, p. 25.

5    **"As *Glasses* [lenses] have"**: Hooke, *Micrographia*, preface, n.p.

6    **"seeing more with his"**: In 1710 the German diarist Zacharias von Uffenbach was told by Leeuwenhoek's daughter, Maria, that her father no longer wished to publish his observations, primarily because he was tired of being accused of seeing more through his imagination than through his lenses. Quoted in Ruestow, *The Microscope in the Dutch Republic*, p. 155n40.

6    **Indeed, these new devices**: See Malet, "Early Conceptualizations of the Telescope as an Optical Instrument," p. 260.

6    **"There is a new visible"**: Hooke, *Micrographia*, preface, n.p.

7    **The eccentric Jesuit priest**: Kircher, *Ars magna lucis et umbrae* (1646), pp. 834–35, cited in Ruestow, *The Microscope in the Dutch Republic*, p. 3. For more on Kircher, see Glassie, *A Man of Misconceptions*, and the essays in Findlen, ed., *The Last Man Who Knew Everything*.

8    **"sister of [natural] philosophy"**: Quotations from Van Hoogstraten's *Inleyding tot de Hooge Schoole der Schilderkonst; anders de zichtbaere werelt* [*Introduction to the Academy of Painting; or, the Visible World*] are from Weststeijn, *The Visible World*, p. 351, and Brusati, *Artifice and Illusion*, p. 94. Although the *Inleyding* was not published until 1678, three years after Vermeer's death, Van Hoogstraten wrote it largely in the 1660s, basing the book on ideas and experiments current in Rotterdam and Delft, including the latest optical theories. On this point, see Weststeijn, *The Visible World*, p. 439n76. Van Hoogstraten's idea was not an entirely new development in art theory; it followed from the Renaissance ideal that the highest challenge of art was mimesis, that is, the most persuasive representation of the visible world.

See, e.g., Westermann, "Vermeer and the Interior Imagination," p. 228, and Kemp, *The Science of Art*, p. 244. For a perceptive discussion of paintings as mirrors in Netherlandish art of the fifteenth and sixteenth centuries, see Yiu, "The Mirror and Painting in Early Renaissance Texts."

8    **"They are mirrors"**: Quoted in Weststeijn, *The Visible World*, p. 271.

8    **"Life seems to dwell"**: Quoted in Wheelock, *Vermeer and the Art of Painting*, p. 15.

8    **"the finest thing that ever"**: Quoted in Ruestow, *The Microscope in the Dutch Republic*, p. 73n53.

9    **"his creations can hardly"**: Comment made by Simon van Leeuwen, Leiden city historian, in 1672, quoted in Westermann, "Vermeer and the Interior Imagination," p. 228. On Dou as Rembrandt's first pupil, see C. Ford, "Introduction," p. 19.

9    **Because of the perceived**: See, esp., Kemp, *The Science of Art*, pp. 338–41.

9    **Galileo's conclusion was based**: See ibid., pp. 93–94, Panofsky, *Galileo as a Critic of the Arts*, pp. 4–5, and Reeves, *Painting the Heavens*, pp. 6–7.

9    **In short, Galileo recognized**. In a later work, the *Dialogue Concerning the Two Chief World Systems*, Galileo has the character Salviati mention several conjectures about the perception of light and dark areas that are clearly drawn from Leonardo da Vinci's *Trattata della pittura* (Treatise on painting), so we can be confident he was familiar with that work. See Reeves, *Painting the Heavens*, p. 116. Later Galileo would deploy his knowledge of perspective to argue that sunspots were on the surface of the sun and were not stars interposing themselves between the sun and the viewer, as Christoph Scheiner was claiming. See Kemp, *The Science of Art*, pp. 95–96. He used the artistic effect known by artists as "secondary light" to recognize and understand the phenomenon now known as earthshine—that is, that the dark and opaque Earth, when struck by the sun's rays, could send that light back into space and, during certain periods, onto the dim face of the moon. See Reeves, *Painting the Heavens*, p. 8.

9    **"In the moone I had"**: Quoted in Panek, *Seeing and Believing*, p. 57.

9    **Hoefnagel, like many**: See Ruestow, *The Microscope in the Dutch Republic*, p. 77n64. Huygens could not have studied with his uncle Joris Hoefnagel (Jacob's father), as some have said, because Joris died when Huygens was only four or five years old.

10    **This ability helped Christiaan**: See Huerta, *Giants of Delft*, p. 63.

10    **Leeuwenhoek, too, was steeped**: See, e.g., his letters to the RSL of Jan. 12, 1680, *AB*, 3:165, and Jan. 23, 1685, AB, 5:101–3.

10    **Across the North Sea**: See Birch, *The History of the Royal Society of London*, 1:10–12; 2:84, 227–31.

10    **"it was now proper"**: Gunther, *Early Science in Oxford*, quoted in Seymour, "Dark Chamber and Light-Filled Room," p. 324.

10    **Jacob Hoefnagel's engravings**: Hoefnagel's engravings of his father

Joris Hoefnagel's designs appeared in 1592 as *Archetypa studiaque patris Georgii Hoefnagelii*, when Jacob was seventeen or nineteen. See Ruestow, *The Microscope in the Dutch Republic*, p. 52.

11    **Another miniaturist-turned-naturalist**: Goedaert's work was published between 1662 and 1669. See Ruestow, *The Microscope in the Dutch Republic*, pp. 52–54, and Cobb, *Generation*, p. 138.

11    **Constantijn Huygens bemoaned**: Huygens's autobiography, quoted in Alpers, *The Art of Describing*, p. 7.

11    **Rachel Ruysch became famous**: See Israel, *The Dutch Republic*, p. 907.

11    **Leeuwenhoek himself worked**: See AvL to Oldenburg, Aug. 15, 1673, *AB*, 1:42–43, and AvL to RSL, Aug. 24, 1688, *AB*, 7:378–79.

## PART ONE: COUNTERFEITER OF NATURE

13    **This boy will, much later**: See baptismal record, DTB Delft 14, inv. 55, folio 119v. The Dutch transcription of the record in the Delft archives reads: "dito. 1 kint Joannis, vader Reynier Janssoon, moeder Dingum Balthasars., getuijgen Pr. Brammer, Jan Heijndrickxzoon and Maertge Jans." See Montias, *Vermeer and His Milieu*, pp. 64–65.

14    **Its ships roamed**: See Israel, *The Dutch Republic*, p. 934.

14    **The VOC would become**: Bok, "Society, Culture and Collecting in 17th Century Delft," p. 203.

14    **From South India**: Israel, *The Dutch Republic*, pp. 939–41.

14    **Some of these collectors**: See ibid., p. 903, and AvL to Hooke, Nov. 12, 1680, *AB*, 3:315–19.

15    **Dealers and artisans offered**: Liedtke, "Painting from 1600–1650," p. 89.

15    **Throughout the Dutch Republic**: Schama, *The Embarrassment of Riches*, p. 304.

15    **Refugees from the south**: See Israel, *The Dutch Republic*, p. 548.

15    **Painting became a considerable**: Ibid., p. 555.

15    **Between five and ten *million***: Bok, "Society, Culture and Collecting in 17th Century Delft," p. 205.

15    **The Netherlands was considered**: Israel, *The Dutch Republic*, p. 3.

15    **Even apart from the**: See, e.g., ibid., p. 274.

16    **Dutch drainage experts**: Ibid., p. 272.

16    **The Dutch also improved**: See ibid., pp. 2–3.

16    **Amsterdam would soon**: See Multhauf, "Light of Lamp-Lanterns."

16    **"In my opinion a better"**: Quoted in Schierbeek, *Measuring the Invisible World*, p. 15.

16    **"an island of plenty"**: Schama *The Embarrassment of Riches*, p. 323.

16    **Even in the eighteenth**: See ibid., pp. 168–69.

16    **what their counterparts**: See Israel, *The Dutch Republic*, p. 630. As Israel

also notes, rents and taxation were higher in Holland than elsewhere, but not twice as high.

17    **"not very rare to meet"**: Aglionby, *The Present State of the United Provinces*, p. 267.

17    **"pay the taxes willingly"**: Quoted in Multhauf, "The Light of Lamp-Lanterns," p. 240. For more on Temple's observations about poor relief, see Israel, *The Dutch Republic*, p. 355

17    **Voluntary contributions were**: See Liedtke, "Delft and the Delft School," p. 3.

17    **"The very Bedlam"**: Quoted in Israel, *The Dutch Republic*, p. 358.

18    **"Holland, that scarce"**: Quoted in Schama, *The Embarrassment of Riches*, pp. 262–63.

18    **"alluvium deposited by"**: Quoted ibid., p. 263.

18    **"a most sweet town"**: Pepys, *The Diary of Samuel Pepys*, May 18, 1660, 1: 147.

18    **The abundant peat**: In 1514, e.g., Delft brewers consumed about 22,000 tons of peat. See Unger, *Beer in the Middle Ages and the Renaissance*, p. 137.

19    **By the end of the**: Plomp, "Along the City Walls," pp. 550–53.

19    **Many buildings along**: See Swillens, *Johannes Vermeer*, p. 45.

20    **It was built between**: Plomp, "Along the City Walls," p. 553.

20    **the *vleeshal***: Leeuwenhoek would later remark on his frequent trips to "our Vlees-hal, less than one hundred feet from my house." AvL to RSL, March 19, 1694, *AB*, 10:55.

20    **In Delft, the renowned**: See Montias, *Vermeer and His Milieu*, p. 35.

21    **Visitors were given slippers**: *The Experienced and Knowledgeable Hollands Householder*, cited in Schama, *The Embarrassment of Riches*, pp. 376–77.

21    **Since the Middle Ages**: Montias, *Vermeer and His Milieu*, p. 8, and Swillens, *Johannes Vermeer*, p. 42.

21    **Because of this, beer**: Schama, *The Embarrassment of Riches*, p. 172.

21    **"The beauty and cleanliness"**: Quoted ibid., p. 376. For London, see Porter, *London*, p. 64.

21    **An influx of immigrants**: See Israel, *The Dutch Republic*, pp. 307–12. As Israel notes (p. 308), by 1600 immigrants amounted to 17 percent of the population in the Northern Netherlands.

22    **Designs for the tapestries**: See Swillens, *Johannes Vermeer*, p. 43, Israel, *The Dutch Republic*, p. 349, Montias, *Artists and Artisans in Delft*, p. 139, and Plomp, "Drawing and Printmaking," p. 171.

22    **Pottery works had also**: Israel, *The Dutch Republic*, p. 349.

22    **"Dutch Porcelain is nowhere"**: Quoted in Swillens, *Johannes Vermeer*, p. 42.

22    **The temporary interruption**: Plomp, "Drawing and Printmaking," p. 193.

22    **Once the manufacturers**: Schama, *The Embarrassment of Riches*, pp. 317–18, and Montias, *Artists and Artisans in Delft*, p. 312.

22    **By 1670 one-quarter**: Plomp, "Drawing and Printmaking," p. 193.

22    **As brewing in Delft**: See Swillens, *Johannes Vermeer*, pp. 42–43, quoting the names of factories from Bleyswijck.

23    **the counterfeiting of currency**: See Schama, *The Embarrassment of Riches*, pp. 336–67.

23    **By the end of the**: On the counterfeiting conspiracy, see Montias, *Vermeer and His Milieu*, ch. 2.

24    **Reynier had served his**: See Montias, *Vermeer and His Milieu*, p. 13 and 13n16.

24    **Reynier was still**: See Montias, *Vermeer and His Milieu*, p. 67. Montias says that Reynier stopped working in caffa in 1629, but in that case it would be odd that he is still referred to in the 1635 document as a caffa worker.

24    **On October 13, 1631**: Swillens, *Johannes Vermeer*, p. 18. That Johannes's father was a skilled specialist in the fabric industry and, later, an art dealer was typical at the time. While some of the noted artists who came to prominence during the Dutch Golden Age were sons of painters, most were sons of highly skilled specialists; very few were sons of manual laborers or fishermen. Johannes Torrentius was the son of a fur cutter, Pieter Saenredam the son of an engraver, Gerrit Dou the son of a glass painter who owned a glass workshop, and Frans van Mieris the son of a goldsmith (Israel, *The Dutch Republic*, p. 350). One of the greatest still-life painters of the day, Willem Kalf, was the son of a wealthy cloth merchant (ibid., p. 453).

24    **In the guild's entry book**: See Montias, *Vermeer and His Milieu*, pp. 8–9. This variability does make it difficult to trace people back in the Delft archives, as they are sometimes listed under different names, or the same name is spelled variously. That has led to misunderstandings about the historical record in some cases—misunderstandings I believe I have successfully cleared up.

24    **"Reynier" sounds, in Dutch**: Ibid., p. 61.

25    **More prosaically, Vermeer**: Liedtke, *Vermeer*, p. 15.

25    **Pick himself was**: Liedtke et al., *Vermeer and the Delft School*, p. 338.

25    **This was one of**: A taxation map from 1830, when Mechelen still stood, shows its frontage as well as that of the other buildings on the square. See Steadman, *Vermeer's Camera*, p. 98.

25    **Reynier purchased it for**: Montias, *Vermeer and His Milieu*, pp. 72–73.

25    **They spent much of their**: Schama, *The Embarrassment of Riches*, p. 312.

25    **The Calvinist clergy**: This statute was repealed only in 1658. See ibid., p. 330.

26    **"Pictures are very common"**: Quoted ibid., p. 318. However, Montias has claimed that paintings were not as common as is usually believed and were not universally present in the homes of the middle class. At least one-third of the inventories taken after death of households in the 50- to 150-guilder range possessed no paintings. That means, of course, that two-thirds did contain paintings. See Montias, *Artists and Artisans in Delft*, p. 269.

As he notes, foreign visitors were usually of the nobility or high bourgeoisie classes and did not tend to visit the homes of the middle classes.

26 **"The Dutch in the midst"**: Aglionby, *Choice Observations upon the Art of Painting*, preface, n.p.

26 **Of course, the wealthy**: Schama, *The Embarrassment of Riches*, p. 313.

26 **Eight years before**: Montias, *Vermeer and His Milieu*, pp. 56–57. Extrapolating from the numbers of paintings in family inventories in Delft, it is estimated that there were approximately 2.5 million paintings in Holland alone by 1650. Many were copies, or pictures of poor quality, but some 10 percent were original works of high quality. See Israel, *The Dutch Republic*, p. 555.

26 **A study of probate**: See Bok, "Society, Culture and Collecting in 17th Century Delft," p. 206.

26 **The guilds collected dues**: Israel, *The Dutch Republic*, p. 120.

27 **Afterward the guilds**: Ibid. See also Schama, *The Embarrassment of Riches*, pp. 178–79.

27 **"all those earning their living"**: Quoted in Montias, *Artists and Artisans in Delft*, p. 3.

27 **Dealers did get around this**: Bok, "Society, Culture and Collecting in 17th Century Delft," p. 209.

27 **He was learning**: Montias, *Vermeer and His Milieu*, p. 73.

28 **With whom could Vermeer**: Carel Fabritius, Rembrandt's finest student, had moved to Delft in 1650; his style, like that of Johannes later, shows a mastery of perspective and brilliant lighting. But Fabritius did not register with the guild until October 1652, only fourteen months before Johannes. Artists were required to be masters in the local guild before they could take on students; this provision was strictly enforced, so it is very unlikely that Johannes could have formally studied with Fabritius before October 1652. See Montias, *Vermeer and His Milieu*, p. 104, and *Artists and Artisans in Delft*, pp. 86–87.

28 **Johannes may have studied**: Montias, *Vermeer and His Milieu*, pp. 77–78.

28 **Providing free lessons**: Ibid., pp. 103–4.

28 **and how his father**: Liedtke, "Vermeer: Style and Observation," MMA, April 22, 2014.

28 **The cost of a local**: Montias, *Vermeer and His Milieu*, p. 73.

28 **Van Aelst's brilliance**: Houbraken said of Evert van Aelst that he was able to capture the "luster and reflection of iron armor, helmets, and other elaborate things." Quoted in Wheelock, "'Guillelmo' in Amsterdam," p. 38.

28 **This is seen in the**: Liedtke et al., *Delft and the Delft School*, p. 228.

29 **"he knew how to imitate"**: Houbraken after Willem van Aelst's death, quoted in Wheelock, "'Guillelmo' in Amsterdam," p. 48.

29 **Vermeer probably went**: Gowing and Montias do not think Vermeer went to Amsterdam, believing it likely that Vermeer's master was Abraham Bloemaert of Utrecht (Gowing, *Vermeer*, p. 9, and Montias, *Vermeer and His*

*Milieu*, pp. 106–7). Bloemaert was a relation of Vermeer's future mother-in-law, Maria Thins, and it is possible that Vermeer met Catharina through Bloemaert. However, in 1648 Bloemaert was already eighty-four years old and may not have been taking on new apprentices. Wheelock thinks Vermeer studied with Leonart Bramer, a prominent Catholic painter in Delft, who later interceded on his behalf with Maria Thins when he wanted to marry her daughter (*Perspective, Optics, and Delft Artists*, p. 267). Bramer was an acquaintance of Vermeer's parents, having witnessed a document signed by his mother and having dealings with his father, but Bramer's style, dark and brooding in the Italianate way, does not seem to have much in common with Vermeer's work. Bramer favored pictures featuring small figures dominated by their surroundings, much more like the paintings of one of his students, the painter of exquisite church interiors, Emanuel de Witte. (See also Montias, *Vermeer and His Milieu*, pp. 103–4.) However, as Wheelock notes, Bramer also painted murals, most of which have disappeared, but drawings for them suggest that the figures in these works were "large in scale and classically conceived," similar to Vermeer's early canvases ("Vermeer of Delft," pp. 17–18). Yet, as Liedtke points out, had Vermeer studied with a local master his entry fee to the St. Luke Guild would have been three, not six, guilders (*Vermeer*, p. 21).

29 **Johannes's trajectory as**: See Montias, *Vermeer and His Milieu*, pp. 105–6. More evidence for a stay in Amsterdam is the fact that, shortly after he returned to Delft, Johannes received a visit from another painter, Gerard Ter Borch, who seems to have come to Delft from The Hague to attend the younger man's wedding (it would have been a short ride on the canal towboat). Although Ter Borch was then living in The Hague, he had been in Amsterdam in the late 1640s and may have met Johannes there. Ter Borch's work shared stylistic affinities with Vermeer's, especially in their intimately nuanced interiors, focusing on women alone with their thoughts, sometimes being served by their maids—but Ter Borch was not in Amsterdam long enough to have taken on Vermeer as a formal apprentice. See ibid., pp. 102–3.

30 **Even after canvas came**: Groen, "Painting Technique in the 17th Century in Holland," p. 200.

30 **the inventory taken**: Death inventory translated and reproduced in Montias, *Vermeer and His Milieu*, pp. 339–40.

30 **The fineness of a canvas**: See Kirby, "The Painter's Trade in the 17th Century," p. 24.

30 **It is believed that**: See Levy-van Halm, "Where Did Vermeer Buy His Painting Materials?," p. 139.

30 **Even if Vermeer**: See Costaras, "A Study of the Materials and Techniques of Johannes Vermeer," p. 151.

30 **He would next brush**: See Wadum et al., *Vermeer Illuminated*, p. 10.

31 **For instance, in *A View***: See ibid., p. 11.

31 **In *Woman with a Pearl***: See Lawrenze-Landsberg, "Neutron-Auto-

radiology of Two Paintings by Jan Vermeer in the Gemäldegalerie Berlin,"
p. 216.

31     **The skin has underpainting**: Wadum et al., *Vermeer Illuminated*, p. 13.

31     **In *The Art of Painting***: Costaras, "A Study of the Materials and Tech-
niques of Johannes Vermeer," p. 152.

31     **Next, the final layers**: Wadum et al., *Vermeer Illuminated*, p. 13.

32     **Synthetic colors, such as**: Swillens, *Johannes Vermeer*, p. 123.

32     **In the early part**: Ter Brugghen, *Verlichtery kunst-boeck* (1616), p. 2, cited in
Levy-van Halm, "Where Did Vermeer Buy His Painting Materials?," p. 138.

32     **Half a century later**: Van Hoogstraten, *Inleyding*, p. 222, cited ibid.,
p. 141.

32     **In some cities, vermilion**: Ibid., p. 138.

33     **Each type of paint had**: See Swillens, *Johannes Vermeer*, p. 127.

33     **"Take two parts Quicksilver"**: Quoted ibid., p. 125.

33     **Crimson madder came**: Ibid., pp. 125–26.

34     **Mexico, its principal exporter**: As Ball points out, the original source
of the cochineal in the Middle Ages was Poland. See *Bright Earth*, p. 96.

34     **until Leeuwenhoek examined**: See AvL to RSL, Nov. 28, 1687, *AB*, 7:135.

34     **The paint color was sometimes**: See Levy-van Halms, "Where Did
Vermeer Buy His Painting Materials?," pp. 139–40.

34     **Johannes would use it**: See http://www.essentialvermeer.com/palette/
palette_carmine.html#.U3vLJMaVvwI.

34     **For the color blue**: Quoted in Swillens, *Johannes Vermeer*, p. 122.

34     **Johannes stayed away**: See Duparc and Wheelock (eds.), *Johannes Ver-
meer*, p. 90, and Costaras, "A Study of the Materials and Techniques of
Johannes Vermeer," p. 157.

35     **In Johannes's time**: Swillens, *Johannes Vermeer*, p. 122.

35     **In 1649 the inventory**: See Levy-van Halms, "Where Did Vermeer Buy
His Painting Materials?," p. 140.

35     **The concept of "fine painters"**: See Israel, *The Dutch Republic*, p. 560.

35     **They could come from**: Swillens, *Johannes Vermeer*, pp. 123–24.

35     **Lead white by itself**: Ibid., p. 126.

35     **The most intense black**: Ibid., p. 127.

35     **Johannes would have learned**: Lawrenze-Landsberg, "Neutron-Auto-
radiology of Two Paintings by Jan Vermeer in the Gemäldegalerie Berlin,"
p. 216.

36     **"must have had twenty-seven blacks"**: Vincent Van Gogh to Theo Van
Gogh, Oct. 20, 1885, www.vangoghletters.org/vg/letters/let536/letter.html.

36     **Consequently, the painter**: Swillens, *Johannes Vermeer*, p. 124.

36     **This had its own problems**: E.g., in *The Little Street* and *View of Delft*,
as well as the laurel wreath on the model's head in *Art of Painting*. See ibid.,
p. 130.

36     **When the painter was finished**: Ibid., p. 127.

36  **When the apprentice was deemed**: Noted in an apprenticeship contract executed in Delft in 1621. Quoted in Levy-van Halm, "Where Did Vermeer Buy His Painting Materials?," p. 70.

37  **The Delft city archives**: Montias, *Vermeer and His Milieu*, p. 99. For the transcript of the document, see p. 308. Liedtke believes, as I do, that by signing this document Thins was expressing that her approval for the marriage was contingent on Vermeer's conversion to Catholicism. See Liedtke, *Vermeer*, p. 17.

38  **Johannes and his family**: Although some writers have described Vermeer's family as "staunchly Protestant," his parents never registered as members of the Reformed Church; they probably were Protestants, but not so much as to wish to submit to ecclesiastical discipline. On the situation for Catholics in the Dutch Republic, see Kooi, *Calvinists and Catholics during Holland's Golden Age*, pp. 32–33.

38  **Restrictions on the practice**: See, e.g., Israel, *The Dutch Republic*, p. 515 and passim.

38  **Delft had a fairly large**: See ibid., p. 380; for total Delft population see p. 621.

39  **"[The Catholics] have increased"**: Quoted in Montias, *Vermeer and His Milieu*, 130.

39  **Hostility toward Catholics**: See Kooi, *Calvinists and Catholics during Holland's Golden Age*, p. 124.

39  **Although the local government**: Montias, *Vermeer and His Milieu*, p. 131.

39  **In 1649 the consistory**: Kooi, *Calvinists and Catholics during Holland's Golden Age*, p. 124.

39  **By the middle of the**: Montias, *Vermeer and His Milieu*, p. 131.

40  **"In our Netherlands, God"**: Quoted in Schama, *The Embarrassment of Riches*, p. 421.

41  **Because of these rights**: Ibid., pp. 404–8.

41  **After she moved to**: Swillens, *Johannes Vermeer*, pp. 20–21.

41  **It was easy for men**: See Israel, *The Dutch Republic*, p. 677.

41  **"the women are said"**: Quoted in Schama, *The Embarrassment of Riches*, p. 402; see also p. 438.

42  **This would be followed**: Ibid., pp. 444–45.

42  **One marriage manual**: Cited ibid., p. 424.

42  **"can see nothing of"**: Quoted in Israel, *The Dutch Republic*, p. 696.

42  **Van Hoogstraten would later**: See ibid., p. 350.

42  **The couple wed on April 20**: Their marriage license, dated two weeks after the wedding, records that they were married in Schipluy. See marriage license, DTB Delft 14, inv. 127, folio 48. Twenty years later their daughter Maria was married at the same church.

42  **They moved into rented**: The marriage license states that they were living "At Markt," meaning on the Market Square, two weeks after the wedding. See marriage license, DTB Delft 14, inv. 127, folio 48.

43  **In a time when paintings**: See Montias, *Vermeer and His Milieu*, pp.

33–34. Portraits, in particular, were known at the time as *conterfeytsel*. See, e.g., the death inventories reproduced in Biesboer, *Collections of Paintings in Haarlem, 1572–1745*, passim.

PART TWO: FROM THE LION'S CORNER

45   **In the baptismal records**: See DTB Delft 14, inv. 55, folio 119v.

46   **Many brewers were members**: Bok, "Society, Culture and Collecting in 17th Century Delft," pp. 198–99.

47   **"Let them freely play"**: Johan van Beverwijck, quoted in Schama, *The Embarrassment of Riches*, p. 557.

47   **Foreign visitors were**: Ibid., p. 485.

47   **"they are a little too indulgent"**: Aglionby, *The Present State of the United Provinces*, p. 230.

47   **Such anecdotal evidence**: Schama, *The Embarrassment of Riches*, pp. 522–23.

47   **Many years later Antoni**: See AvL to RSL, Oct. 12, 1685, *AB*, 5:353.

47   **Jacob Molijn, then in**: No other writers on Leeuwenhoek have mentioned, to my knowledge, the existence of this second painter stepbrother, yet it is clear from the records of the Delft archive that Gerrit Molijn was also the son of Jacob Molijn. For the ages of Jan and Jacob, see Montias, *Artists and Artisans in Delft*, pp. 334, 341, and Seters, "Can Antoni van Leeuwenhoek Have Attended School at Warmond?," p. 4.

48   **This branch of the Molijn**: According to the entry on Jacob Molijn in WikiDelft, http://www.wikidelft.nl/index.php?title=Jacob_Jansz._Molijn. In the Delft city archives, we find that Pieter Molijn witnessed a baptism in November 1622, buried his wife in July 1624, and then married Geertruijt de Rovere of Amsterdam in May 1627. They baptized a son, Jan, in May 1629. Pieter next appears in the Delft records five and ten years later, as witness to a baptism in 1635 and one in 1639, but it is not clear whether he was still residing in Delft by that time or simply returning for the baptisms, or indeed whether it is the same Pieter Molijn.

48   **Both the father, Jacob Molijn**: Montias has discovered that they both paid relatively high taxes, which means that they had high incomes (*Artists and Artisans in Delft*, p. 126n).

48   **Gerrit worked with his father**: See ibid., table A2, notes.

48   **In 1608 he was commissioned**: "Om te stellen tot onderscheyt voor die screten waer die mens ende die vrouwen gaen," see ibid., p. 148.

48   **In 1643 Antoni's older sister**: See Dobell, *Antony van Leeuwenhoek and His "Little Animals,"* pp. 21–23.

48   **Around the time of her**: See Seters, "Can Antoni van Leeuwenhoek Have Attended School at Warmond?," p. 5. Much of the information we have about Leeuwenhoek's early life comes from Boitet's *Beschryving der stadt Delft* (Description of the town of Delft) (1729).

48    **Warmond was known**: See Israel, *The Dutch Republic*, pp. 689 and 1021.

49    **Some Catholics in**: See ibid., p. 689. However, Seters notes that there were six boys of the Reformed religion boarding with the school's headmaster (compared with thirty Catholic boys), and he believes Leeuwenhoek was one of the six, and not Catholic. See Seters, "Can Antoni van Leeuwenhoek Have Attended School at Warmond?," pp. 8–9.

49    **The headmaster of the school**: See Seters, "Can Antoni van Leeuwenhoek Have Attended School at Warmond?," pp. 8–10.

49    **Attached to the Bagijnhof**: Montias, *Vermeer and His Milieu*, p. 129. The priests associated with the Bagijnhof were imbued with Jansenist doctrines more compatible with Protestant tenets than were the doctrines taught by Jesuits; but they were still Catholics.

50    **The sheriff's role was**: See Seters, "Can Antoni van Leeuwenhoek Have Attended School at Warmond?," p. 9.

50    **He agreed to accept Antoni**: Seters, "Antoni van Leeuwenhoek in Amsterdam," p. 36.

50    **Later, during the English-Dutch**: Ibid., p. 38.

50    **By the late seventeenth century**: See Osselton, *The Dumb Linguists*, p. 5.

50    **"If thou wilt see"**: Quoted in Mijers, "Scottish Students in the Netherlands."

51    **Because the Dutch Republic had**: An unusually large number of Scottish students were attending universities in the Netherlands for a kind of "study abroad" year: between 1680 and 1720 over one thousand were registered, though many others would attend classes without formal inscription in the university. On Scottish students in the Dutch Republic in this period, see Mijers, *"News from the Republick of Letters."*

51    **as well as with his wife**: Seters, "Antoni van Leeuwenhoek in Amsterdam," pp. 38–42.

51    **Davidson would most likely**: See "A History of the Scottish Languages, Parts 7 and 8," http://newsnetscotland.com/index.php/arts-and-culture/39 80-a-history-of-scottish-languages-parts-7-and-8, accessed May 5, 2014. A separate Scots language, as well as Gaelic, was spoken in the northern parts of Scotland. However, from the middle of the sixteenth century Scots began to become increasingly Anglicized. After the Reformation, Bibles printed in English were the vehicles for greater and greater acceptance of the English language in Scotland. This trend was codified by the Union of the Crowns in 1603, when the Scottish king James VI became King James I of England, Ireland, and Scotland, and English became the official language of the three countries. Scottish merchants and businessmen in the Dutch Republic would have spoken either English or Dutch in conducting their affairs.

51    **By 1653, when Antoni**: A deed signed in 1653 authorized Leeuwenhoek to conduct Davidson's business and have the right to sign documents in his name while he is absent from Amsterdam. See Seters, "Antoni van Leeuwenhoek in Amsterdam," p. 45.

51    **A young man like Antoni**: See Israel, *The Dutch Republic*, p. 328; population figures are from 1647.

52    **Even the size**: Boucher, http://courses.umass.edu/latour/Netherlands/boucher/index.html.

52    **"où l'on puisse jouir"**: Quoted in Israel, *The Dutch Republic*, p. 3.

52    **Immigrants from all over**: Schama, *The Embarrassment of Riches*, p. 582.

52    **There were only thirty-seven**: Israel, *The Dutch Republic*, p. 1015.

52    **Other "open" industries**: See Lucassan and Prak, "Guilds and Society in the Dutch Republic," pp. 63–64.

53    **The city became the hub**: Israel, *The Dutch Republic*, p. 556.

53    **Sometimes, Amsterdam took**: Schama, *The Embarrassment of Riches*, p. 231.

53    **"Where else on earth"**: Letter to Balzac, May 5, 1631, in Descartes, *Correspondence*, p. 32.

53    **Drapers like Davidson**: As recorded by Melchior Fokken in 1662; see Schama, *The Embarrassment of Riches*, p. 301.

54    **Delft, in the grip of**: See Montias, *Vermeer and His Milieu*, p. 138.

54    **At the time that Antoni**: Indeed, during the second half of the seventeenth century, only about 80–200 brothel keepers and prostitutes were prosecuted by the Amsterdam magistracy annually. See Israel, *The Dutch Republic*, p. 696.

54    **Some of the women**: See Van de Pol, "The Whore, the Bawd, and the Artist," p. 3.

54    **The apprentice was expected**: See Phillips, *Well-Being in Amsterdam's Golden Age*, p. 48.

54    **Those in the cloth trade**: Epstein, "Craft Guilds, Apprenticeship, and Technological Change in Pre-Industrial Europe," p. 701 and 701n65.

55    **For instance, the "Dutch Loom"**: See ibid., p. 706n80.

55    **The draper's apprentice**: See ibid., p. 668n13.

55    **It provided the only way**: The Dutch tradition of using lenses in the cloth industry has been cited as a reason for the particular openness to the use of lenses in science in the Netherlands. See Wilson, *The Invisible World*, pp. 217–18.

56    **When it was found**: D. Brewster, "On an Account of a Rock-Crystal Lens and Decomposed Glass Found in Nineveh." One recent scholar has gone so far as to suggest that the lens might have been used for astronomical observations. See David Whitehouse, "World's Oldest Telescope?," *BBC News*, at http://news.bbc.co.uk/2/hi/science/nature/380186.stm, accessed Oct. 1, 2012. For more on ancient lenses, see Sines and Sakellarakis, "Lenses in Antiquity." They believe the Nimrud glass is a lens with magnifying properties, but not of enough optical quality to be used for precise observations. Brian Ford dismisses the claim that this is a lens at all. See *Single Lens*, pp. 13–14.

56    **Aristophanes, in his play**: Sines and Sakellarakis, "Lenses in Antiquity," pp. 191–96.

56    **Precious stones ground**: Pliny the Elder, *Natural History*, 37.10.

56    **When the ability to**: Van Helden, *The Invention of the Telescope*, p. 10.

57    **At the time there was**: Ibid., p. 11.

57    **By the mid-fifteenth century**: See Burnett, *Descartes and the Hyperbolic Quest*, p. 9. See also Panek, *Seeing and Believing*, pp. 24–25.

57    **In his book *On the***: Aristotle, *On the Generation of Animals*, 5.1.780b–781a.

57    **In the sixteenth century**: Others had more explicitly discussed the use of lenses, sometimes in conjunction with mirrors, to see distant objects. For example, Della Porta, in his *Magia naturalis*, had mentioned a device that has sounded to some to be a proto-telescope. Van Helden, however, argues that Della Porta was speaking about a device to improve faulty vision, a version of spectacles. See Van Helden, *The Invention of the Telescope*, pp. 14–15.

58    **Only by about 1600, then**: Ibid., pp. 11–12.

58    **So both the idea behind**: Possibly there were very weak telescopes by the end of the sixteenth century in Italy—but these were so weak that they were considered "a hoax" (as Della Porta put it) or "a feeble thing" (as Raffael Gualterotti wrote to Galileo). See ibid., p. 19. Van Helden notes that there is a sense in which telescopes existed before anyone, even their inventors, realized it.

58    **Sachariassen told Beeckman**: Ibid., p. 8.

58    **Around the time Janssen**: Ibid., p 24. Elsewhere, in writings from the time, his name appears as Miotti. See Howell, *Epistolae Ho-Elianae*.

58    **We know that on September 25**: Reeves, *Galileo's Glassworks*, p. 2, and Van Helden, *The Invention of the Telescope*, pp. 25–26.

59    **Whoever he was, we know**: Reeves, *Galileo's Glassworks*, p. 10.

59    **From the tower**: See Ruestow, *The Microscope in the Dutch Republic*, p. 6.

59    **"From now on I can"**: Quoted in Van Helden, *The Invention of the Telescope*, p. 25.

59    **Before two more weeks**: Reeves, *Galileo's Glassworks*, pp. 2–3.

59    **Wisely, the States General**: Huerta, *Giants of Delft*, p. 33.

59    **Indeed, by this time**: Ruestow, *The Microscope in the Dutch Republic*, p. 6.

59    **The States General instead**: Van Helden, *The Invention of the Telescope*, p. 20.

60    **Metius was granted**: Reeves, *Galileo's Glassworks*, pp. 2–3.

60    **By then the instruments**: Ibid., pp. 4–5.

60    **In 1617 Galileo's**: See Burnett, *Descartes and the Hyperbolic Quest*, p. 5.

61    **This meant he would need**: Huerta, *Giants of Delft*, p. 130n43.

61    **In this way Galileo limited**: Van Helden, *The Invention of the Telescope*, p. 26.

61    **Galileo had been calling**: Panek, *Seeing and Believing*, p. 55.

61    **After a lavish banquet**: Huerta, *Giants of Delft*, p. 35.

61    **At the dinner**: Panek, *Seeing and Believing*, p. 55.

61    **"a certain insect"**: J. Wodderborn, *Quator problematum* (1610), translated and quoted in Fournier, "The Fabric of Life," p. 45.

62    **"inserting the points"**: Quoted in Huerta, *Giants of Delft*, p. 126n35.

62    **"observing minute objects"**: Quoted ibid., p. 21.

62    **Around the same time**: The Dutch diplomat Willem Boreel would later claim that Sacharias Janssen made the first microscope; he described seeing an instrument made by Janssen in 1619, constructed with a foot-and-a-half tube made of gilded brass that rose vertically from three dolphin-shaped legs. See Ruestow, *The Microscope in the Dutch Republic*, p. 7.

62    **"possessed Drebbel"**: Quoted in Tierie, *Cornelis Drebbel*, p. 27.

63    **"suddenly rose"**: Quoted ibid., pp. 60–61.

63    **In 1662 Boyle wrote**: See ibid., pp. 66–67.

64    **Magnification was increased**: Fournier, "The Fabric of Life," p. 21. See also Ruestow, *The Microscope in the Dutch Republic*, p. 7.

64    **The use of two convex**: Ruestow, *The Microscope in the Dutch Republic*, p. 7.

64    **After looking through one**: Huygens recollected this experience in 1630. Quoted ibid., pp. 8–9.

64    **"*periscope* or *occhiale*"**: Quoted in Freedberg, *The Eye of the Lynx*, p. 152.

65    **Cesi would later employ**: See Fournier, "The Fabric of Life," p. 46, and Freedberg, *The Eye of the Lynx*.

65    **"I should also mention"**: Faber to Cesi, April 13, 1625, quoted in Freedberg, *The Eye of the Lynx*, p. 153.

65    **For the next forty years**: Fournier, "The Fabric of Life," p. 34. See also Ruestow, *The Microscope in the Dutch Republic*, p. 39.

65    **Insects, in particular**: See Kircher, *Ars magna lucis et umbrae*, p. 834, and Borel, *De vero telescopii inventore*, p. 15, both cited in Ruestow, *The Microscope in the Dutch Republic*, pp. 38–39.

65    **Gioanbatista Odierna conducted**: Odierna, *L'occhio della mosca*. See Fournier, "The Fabric of Life," p. 47.

65    **Francesco Fontana delicately**: See Fontana, *Novae coelestium terrestrium*, pp. 148–49; cited in Ruestow, *The Microscope in the Dutch Republic*, p. 38.

PART THREE: FIRE AND LIGHT

67    **The subject of his portrait**: See Plomp, "Along the City Walls," p. 554.

68    **"as if the pools"**: From Bleyswijck's description, quoted in Swillens, *Johannes Vermeer*, p. 46. See also Liedtke et al., *Vermeer and the Delft School*, p. 486.

68    **All the windowpanes**: Swillens, *Johannes Vermeer*, 46–47, Montias, *Vermeer and His Milieu*, p. 137, and Israel, *The Dutch Republic*, p. 870.

68    **All that was left**: Liedtke et al., *Vermeer and the Delft School*, p. 486.

69    **Yet at least one was**: See Wheelock, *Perspective, Optics, and Delft Artists around 1650*, p. 193. Liedtke believes this was a painting on canvas, not a mural painted directly on the wall. See "Delft Painting 'in Perspective,'" p. 119.

69    **"a very fine and outstanding"**: Bleyswijck, *Beschryvinge der stadt Delft* (1667), quoted and translated in Wheelock, *Perspective, Optics, and Delft Artists around 1650*, p. 192.

69    **Van der Poel, haunted by**: Plomp, "Along the City Walls," p. 554.

69    **After depicting the obliterated**: Liedtke et al., *Vermeer and the Delft School*, pp. 325–26.

70    **Delft also hosted a brief**: See Israel, *The Dutch Republic*, p. 874, and Wheelock, *Perspective, Optics, and Delft Artists around 1650*, pp. 221–27.

71    **Vermeer and his wife**: See Montias, *Vermeer and His Milieu*, pp. 131–32.

72    **The latter was listed**: See Liedtke, "De Hooch and Vermeer," p. 151. Another picture, *Saint Praxedis*, a copy (with the addition of a crucifix in the saint's clasped hands) of a painting by the Florentine master Felice Ficherelli, has been championed as a very early work by Vermeer by Arthur Wheelock of the National Gallery in Washington (see Duparc and Wheelock, eds., *Johannes Vermeer*, pp. 86–89). Most other experts, including Wadum in "Contours of Vermeer" (pp. 215–19) and Blankert in *Vermeer of Delft*, have disputed the attribution. Liedtke, agreeing with this consensus, did not mention the work in his 2008 catalog (*Vermeer*). In June 2014, just as this book was going to press, the auction house Christie's announced that a scientific study had concluded that the painting was an authentic Vermeer. The conclusion was based on a study of the lead white pigment used in the ground painting, which, Christie's claimed, consisted of a lead ore common in Northern European painting and not in that of Southern Europe, including Italy. The composition of the paint was found to be similar to that used by Vermeer in *Diana and Her Companions*. However, it is not clear that enough is known about the trade in paint in Italy and the Netherlands in the seventeenth century to conclude that the attribution to Vermeer of *Saint Praxedis* is secure. Perhaps reflecting the uncertainty surrounding the picture, it was sold at auction on July 8 to an anonymous private collector for a little over $10 million, at the low end of its presale estimate. It seems that a "wait and see" attitude is prudent at this point. For the claim by Christie's, see the catalog listing at http://www.christies.com/presscenter/pdf/2014/Catalouge_Note_Johannes_Vermeer_Delft_1632_1675_Saint_Praxedis_lot_39.pdf, accessed July 16, 2014. See also "For Old Masters, It's All About the Name," *International New York Times*, July 11, 2014.

72    **Indeed, the similarities**: Wheelock, *Vermeer and the Art of Painting*, p. 36. Liedtke, too, says that Vermeer must have "made the rounds" in Amsterdam before painting this picture. See his *Vermeer*, p. 57.

73    **Most art historians believe**: See Liedtke, *Vermeer*, p. 60.

74    **In his next painting**: As Wheelock notes, however, the earlier paintings are not completely dissonant from this one and those that followed: running throughout Vermeer's oeuvre is the thread of quiet moments, either spent alone or in psychological interactions with others, rather than more active moments of physical interaction. See Wheelock, *Vermeer and the Art of Painting*, p. 27.

74    **Painters at the time generally**: Israel, *The Dutch Republic*, p. 556.

74    **In Delft, Christiaen**: Liedtke, *Vermeer*, p. 63, and Liedtke et al., *Vermeer and the Delft School*, p. 240.

74    **Gerrit van Honthorst**: Israel, *The Dutch Republic*, pp. 558–59.

74    **He may have been**: Montias, *Vermeer and His Milieu*, p. 146.

74    **Like many of these *bordeeltjes***: As Schama notes, the trope of the vicious old woman as insatiable and avaricious is at play here; once their own sexual activity ceases, these women "transfer its urge from lust to commerce, from sex to money." See Schama, *The Embarrassment of Riches*, pp. 430–31.

74    **What stands out is**: Liedtke suggests that the prostitute and her client were modeled by Vermeer's sister and brother-in-law. "Vermeer: Style and Observation," MMA, April 22, 2014.

75    **Chemical analysis has shown**: For more on vivianite in Vermeer's works and in Dutch painting, see Sheldon, "Blue and Yellow Pigments— The Hidden Colors of Light in Cuyp and Vermeer," and Richter, "Shedding Some New Light on the Blue Pigment 'Vivianite' in Technical Documentary Sources in Northern Europe."

75    **Indeed, in Medieval Latin**: Wheelock, *Perspective, Optics, and Delft Artists around 1650*, p. 28.

75    **It is a common misperception**: See Kemp, *The Science of Art*, p. 9, and Livingstone, *Vision and Art*, p. 115.

76    **Plato had a more complex**: See Plato, *Timaeus*, 35b–d. However, as Lindberg points out, both in this passage and more clearly in the *Theaetetus*, Plato suggests that there is a third emanation of rays, those from the body being viewed. See Lindberg, *Theories of Vision*, pp. 5–6.

76    **Later, Aristotle rejected**: Aristotle argued for the theory that rays are received from the object in his works on the senses (*De sensu*) and on biology (*De anima*), but took a somewhat more moderate position in *On the Generation of Animals* and even appeared, in his *Meteorologica*, to accept the theory that rays are emitted from the eye. See Lindberg, *Theories of Vision*, pp. 6–7, 217–18n39.

76    **"Here our eyes are"**: Huygens, *Ooghen-Troost* (1647), quoted in Weststeijn, *The Visible World*, p. 334.

76    **This cone, with its apex**: See Wheelock, *Perspective, Optics, and Delft Artists around 1650*, p. 30.

76    **A visible object's position**: See Lindberg, *Theories of Vision*, p. 13, and Wheelock, *Perspective, Optics, and Delft Artists around 1650*, p. 30.

76    **Although Euclid accepted**: See Lindberg, *Theories of Vision*, p. 59.

77    **Visual impressions received**: Wheelock, *Perspective, Optics, and Delft Artists around 1650*, p. 31.

77    **Galen adopted a bidirectional**: Lindberg, *Theories of Vision*, p. 63.

77    **The surface of the crystalline**: Wheelock, *Perspective, Optics, and Delft Artists around 1650*, p. 34.

77    **Alhazen insightfully**: See Lindberg, *Theories of Vision*, pp. 61–62 and 71. Lindberg notes that some ambiguity in Alhazen's writings has led other

scholars to believe that his view was more like Galen's, accepting an intro-mission-extramission sequence. Lindberg argues convincingly that he did not accept this. See ibid., pp. 65–66.

78    **Vision is transmitted not**: Ibid., pp. 74–79.

78    **This quality is then**: Ibid., p. 81.

78    **Another way of putting**: Ibid., p. 109.

78    **This notion of the "pyramid"**: The fact that the term *pyramidis* is used by Alberti does not necessarily signify a break from Euclid's depiction of a visual cone, because the term was used in Latin for both figures (without entailing a particular shape of the base). However, the rise of mathematical perspective theory seems to derive from discussions of the geometry of vision not only by Euclid but also by Alhazen and his followers. See ibid., pp.263–64n8.

78    **"consists of setting down"**: Manetti, *The Life of Brunelleschi*, p. 42.

79    **"the spectator felt he saw"**: Ibid., p. 44.

79    **Alberti refused to**: See Alberti, *On Painting*, p. 103. Wheelock, in *Perspective, Optics, and Delft Artists around 1650*, p. 5, believes that continuing debates in the sixteenth and early seventeenth centuries about optics and vision influenced views of the laws of perspective.

79    **The vanishing point**: Wheelock, *Perspective, Optics, and Delft Artists around 1650*, pp. 38–39.

79    **"window through which"**: Quoted in Panofsky, *The Codex Huygens*, p. 92.

79    **This innovation was possible**: As Lindberg claims, in *Theories of Vision*, p. 152, it is "beyond conjecture" that "the creators of linear perspective knew and utilized ancient and medieval optical theory."

80    **By devising laws**: Wheelock, *Perspective, Optics, and Delft Artists around 1650*, pp. 27–28.

80    **"I shall ride to Bologna"**: Quoted in Kemp, *The Science of Art*, pp. 54–55, emphasis added. See also p. 53, for "visual alchemy."

80    **Galileo weighed in**: See Panofsky, *Galileo as a Critic of the Arts*, p. 9.

81    **"so intensely foreshortened"**: See http://www.essentialvermeer.com/catalogue/procuress.html#.U3zIbMaVvwI.

81    **This mastery of one aspect**: Montias, *Vermeer and His Milieu*, p. 144.

81    **Vermeer would continue**: Huerta, *Giants of Delft*, p. 103, and Wheelock, *Perspective, Optics, and Delft Artists around 1650*, p. 262. See also part 5.

82    **"If you should desire"**: Quoted in Yiu, "The Mirror and Painting in Early Renaissance Texts," p. 192.

82    **In an imperfect mirror**: See Schechner, "Between Knowing and Doing," pp. 153–54.

82    **"Since you can see"**: Leonardo da Vinci, *The Notebooks of Leonardo da Vinci*, p. 264.

83    **Earlier, Alberti had**: See Yiu, "The Mirror and Painting in Early Renaissance Texts," p. 198.

83    **He could have learned**: Liedtke, "Delft Painting 'in Perspective,'" pp. 116–17.

83    **The use of a mirror**: See Liedtke, *Vermeer*, pp. 63–64.

84    **The artist looking at**: Kemp, *The Science of Art*, p. 169.

84    **"Nothing can be found"**: Alberti, *On Painting*, pp. 68–69.

84    **Numerous depictions and**: Wheelock, *Perspective, Optics, and Delft Artists around 1650*, p. 42; on Dürer see Andersen, *The Geometry of an Art*, p. 297.

85    **Tiny pinholes at the vantage**: By 1995 Wadum had found pinholes in thirteen of Vermeer's canvases. See Wadum, "Vermeer in Perspective," pp. 67–70. More recently, he told Liedtke that he found such pinholes in eighteen of Vermeer's pictures. Liedtke, "Vermeer: Style and Observations," MMA, April 22, 2014.

85    **This large-scale machine**: Kemp, *The Science of Art*, pp. 173–74.

85    **Cigoli was a friend of**: See Panofsky, *Galileo as a Critic of the Arts*, p. 5, and Kemp, *The Science of Art*, p. 94.

85    **At the same time**: See Huerta, *Giants of Delft*, p. 58, and Reeves, *Painting the Heavens*, p. 5.

86    **But its use seems**: On Cigoli's device, see Kemp, *Seen/Unseen*, pp. 248–49, and *The Science of Art*, pp. 179–80.

86    **This was difficult**: See Kemp, *The Science of Art*, pp. 178–80, 183.

87    **When Wren demonstrated**: See Wren, "Instrument for Drawing in Perspective," pp. 898–99.

87    **Kepler, following discoveries**: See Reeves, *Painting the Heavens*, p. 123.

88    **While it could make sense**: For more details, see Lindberg, *Theories of Vision*, pp. 188–93.

88    **In this way he drew**: See Malet, "Early Conceptualizations of the Telescope as an Optical Instrument," p. 254.

89    **No perspective theorist**: Wheelock, *Perspective, Optics, and Delft Artists around 1650*, p. 155.

89    **However, this clashed**: Ibid., pp. 323–24. See also p. 158.

89    **A kind of uneasy uncertainty**: Ibid., pp. 5–6, 15–16.

89    **This more casual attitude**: Still, Van Hoogstraten did agree with Alberti's book in many respects. Ibid., p. 25.

89    **This was not only because**: Ibid., p. 27. Kemp disagrees with this position, seeing much more of a serious engagement with geometrical perspective among Dutch artists. See Kemp, *The Science of Art*, esp. pp. 109–18.

89    **In 1678 Van Hoogstraten**: Wheelock, *Perspective, Optics, and Delft Artists around 1650*, p. 52. As Wheelock notes, some medical doctors still doubted the Keplerian theory of vision and its postulation of the retina as the seat of vision as late as the mid-seventeenth century.

89    **Van Hoogstraten had studied**: See ibid., p. 206.

90    **Accordingly, their interests**: As Kemp points out, there was a reaction against perspective theory elsewhere, including in Italy, not from the point of view of visual theories, but rather from the issue raised earlier by Leonardo

and Michelangelo about virtuosity. In 1607 Federigo Zuccaro wrote, "I say strongly . . . that the art of painting does not derive its principles from the mathematical sciences and has no need of recourse to them to learn the rules and means for its practice; for art is not the daughter of mathematics but of nature and design." Quoted in Kemp, *The Science of Art*, p. 85.

90    **Most artists would know:** Wheelock, *Perspective, Optics, and Delft Artists around 1650*, p. 8.

90    **There were exceptions:** Ibid., p. 17.

90    **A manuscript at the British Library:** William Bourne, "The property or Qualytyes of glaces Accordyng unto ye severall mackyng pollychynge & Grindyng of them," quoted ibid., p. 185n68.

90    **"With the concave lens":** Quoted in ibid., p. 161.

91    **There is evidence that:** See ibid., p. 160.

91    **It is unlikely, however:** For more on this debate, see Hockney, *Secret Knowledge*, Schechner, "Between Knowing and Doing," and all the articles in the journal *Early Science and Medicine* 10, no. 2 (2005).

91    **A painter would use:** Mary Merrifield, *Original Treatises on the Arts of Painting* (1849), cited in Wheelock, *Perspective, Optics, and Delft Artists around 1650*, p. 165.

92    **"look at the world":** See Lüthy, "Hockney's Secret Knowledge, Vanvitelli's Camera Obscura," p. 315, and Hockney, *Secret Knowledge*, p. 136.

92    **An inventory taken:** See Kemp, *The Science of Art*, p. 104. Velázquez was called a "second Caravaggio" because "he imitated nature so successfully." Antonio Palomino, quoted in Bailey, *Velázquez and the Surrender of Breda*, p. 35.

92    **Dou placed a concave lens:** Wheelock, *Perspective, Optics, and Delft Artists around 1650*, p. 166.

92    **With this device:** See Huerta *Giants of Delft*, p. 26.

92    **This technique would account:** See Wheelock, *Perspective, Optics, and Delft Artists around 1650*, p. 166.

92    **Jan van der Heyden:** Ibid., pp. 167–68.

92    **Fabritius almost certainly:** See ibid., pp. 194–205. Liedkte disagrees with this assessment, believing that the distortions arise because the painting was originally bent into a curved shape, possibly as part of a perspective box. See Liedtke, "Delft Painting 'in Perspective,'" p. 114.

92    **"every stone in the building":** Houbraken, *Groote Schouburgh*, 3:63, quoted in Wheelock, *Perspective, Optics, and Delft Artists around 1650*, p. 167. For help with the translation I am grateful to Steffen Ducheyne.

92    **Van der Heyden's painting:** See Kemp, *The Science of Art*, p. 206.

93    **He was also interested:** Kemp claims that Van der Heyden may also have used a camera obscura, since his pictures "share many of the tonal, coloristic and spatial qualities of camera images." See ibid., p. 196. On street lighting in Amsterdam, see Multhauf, "The Light of Lamp-Lanterns."

93    **Like Vermeer a son of:** See Liedtke, "Frans Hals," pp. 21, 17.

94    **Several of Leyster's works:** See Biesboer, "Judith Leyster," p. 77.

94   **Unlike Hals, Leyster**: See Broersen, "'Judita Leystar.'"
94   **Some of her paintings**: See also Biesboer, "Judith Leyster," p. 82.
94   **Dou, Van Mieris, and Gabriel Metsu**: Liedtke, "De Hooch and Vermeer," p. 151.
95   **This becomes most obvious**: Wheelock, "Johannes Vermeer," at http://www.britannica.com/EBchecked/topic/626156/Johannes-Vermeer/233666/Artistic-training-and-early-influences.
95   **In their works, visual**: Liedtke, "De Hooch and Vermeer," pp. 156, 164.
95   **Van Ruijven was a distant cousin**: Plomp, "Drawing and Printmaking in Delft," p. 178.
96   **Spiering and Van Ruijven were**: Another of the *fijnschilders*, Frans van Mieris the Elder, also received a yearly stipend from a patron in Leiden. Wheelock is uncertain, however, that Vermeer had a similar agreement with Van Ruijven, but I believe the evidence for that relation is strong. See Wheelock, "Vermeer of Delft: His Life and His Artistry," pp. 22–23.
96   **He did eventually own**: See Montias, *Vermeer and His Milieu*, pp. 134–35.
96   **In another indication**: See Westermann, "Vermeer and the Interior Imagination," pp. 224–25.
96   **This was a familiar theme**: See Schama, *The Embarrassment of Riches*, p. 208. When sold in Amsterdam on May 6, 1696, the picture was described in the catalog as depicting "a drunken, sleeping girl at a table." See Swillens, *Johannes Vermeer*, p. 57.
97   **Household manuals advised**: On maidservants in the Dutch Republic, see Schama, *The Embarrassment of Riches*, pp. 455–60, and Israel *The Dutch Republic*, p. 678.
98   **Rather than compensating**: On the probable use of a convex mirror or concave lens in these two paintings, see Wheelock, *Perspective, Optics, and Delft Artists around 1650*, pp. 275–76.

PART FOUR: LEARNING TO SEE

99   **The builder's debt**: The receipt, written in Leeuwenhoek's hand, is reproduced and translated in Dobell, *Antony van Leeuwenhoek and His "Little Animals,"* p. 30 and plate V. The builder Heijnsbroeck is noted in the archives of Rotterdam; the Delft archives show other Heijnsbroecks residing there. William Carr's 1691 account of the Rotterdam-to-Delft trip and its cost is quoted in Osselton, *The Dumb Linguists*, p. 28.
100  **Deborah de Meij**: Information about the London-based Elias de Mey is taken from *The Marriage, Baptismal, and Burial Records, 1571–1871 and Monumental Inscriptions of the Dutch Reformed Church, Austin Friars, London* (London, 1884).
101  **When the French religious**: Israel, *The Dutch Republic*, p. 686.
101  **The house and the interest**: Rooseboom, "Leeuwenhoek's Life in the Republic of United Netherlands," p. 19.

101 **For families whose total**: Schama, *The Embarrassment of Riches*, pp. 319–20.

102 **Leeuwenhoek was a large-framed**: AvL to Robert Hooke, Nov. 4, 1681, *AB*, 3:365. For the average height of Dutch men in the seventeenth century, see De Beer, "Observations on the History of Dutch Physical Stature," p. 49, where it is reported that the average was in the mid-160-centimeter range (about 5′ 4″–5′ 5″) but that 170 centimeters (5′ 6″) was not uncommon. The current guidelines from the National Institutes of Health estimate that a healthy weight for a man 5′ 6″ with a large frame is 156 pounds, so Leeuwenhoek would fall into that range if he was between 5′ 5″ and 5′ 6″ even by today's standards.

103 **"So, Naturalists observe"**: Swift, *On Poetry*, p. 20.

103 **"these small flea glasses"**: Descartes, *Optics*, 7th discourse, in *Discourse on Method, Optics, Geometry, and Meteorology*, p. 119.

103 **Notably, in the early 1660s**: See Wheelock, *Perspective, Optics, and Delft Artists around 1650*, p. 284. Nothing else is known of Johan de Wyck.

104 **Mydorge, a mathematician**: A. Baillet, *La vie de M. DesCartes*, cited ibid., pp. 22–23n.

104 **Descartes himself was**: See Burnett, *Descartes and the Hyperbolic Quest*.

104 **"good at two things"**: Harrington, preface to *The Prerogative of Popular Government* (1658), quoted in Webster, *The Great Instauration*, p. 170.

104 **Alternatively, this combination**: Much information on early grinding techniques can be found at http://www.practicalmachinist.com/vb/antique-machinery-history/spinozas-lathe-161086/. See also Zuylen, "The Microscopes of Antoni van Leeuwenhoek," p. 309.

105 **However, although the techniques**: Although the general methods remained the same, the quality of not only the glass but also the figuring and polishing of the lenses improved over the course of the seventeenth century. See Molesini, "The Optical Quality of 17th Century Lenses," p. 117.

105 **The best glass was found**: See Ruestow, *The Microscope in the Dutch Republic*, p. 17.

105 **As little as a single**: See ibid., p. 19, and Burnett, *Descartes and the Hyperbolic Quest*, p. 11.

105 **In 1616 Galileo's**: Letter to Galileo, April 23, 1616, cited in Molesini, "The Optical Quality of 17th Century Lenses," p. 120.

106 **Another possible technique**: See Hooke, *Micrographia*, xxii.

106 **in the smallest visible things**: Schott, *Magia universalis naturae et artis*, 1:472.

106 **Kircher used a small tube**: See Ruestow, *The Microscope in the Dutch Republic*, pp. 21–22.

107 **Leeuwenhoek later claimed**: Leeuwenhoek, *Sevende vervolg der brieven*, p. 91, cited ibid., p. 23n90.

107 **In Leiden, Johan van Musschenbroek**: Ruestow, *The Microscope in the Dutch Republic*, pp. 27–28.

107 **Leeuwenhoek may also have**: Berkel, "Intellectuals against Leeuwenhoek," p. 190.

108 **"hundreds and hundreds"**: In 1700 Leeuwenhoek said that he had made "hondert en hondert" (hundreds and hundreds) of microscopes. Leeuwenhoek, *Sevende vervolg der brieven*, p. 305, quoted in Ruestow, *The Microscope in the Dutch Republic*, p. 10n23.

108 **Some estimates have**: From an estimate made in 1933 of the catalog used for the sale of Leeuwenhoek's microscopes at auction two years after his daughter's death. See Zuylen, "The Microscopes of Antoni van Leeuwenhoek," p. 311.

108 **One single-lens microscope**: B. J. Ford, *Single Lens*, p. 6.

109 **"You then hold"**: AvL to Oldenburg, June 1674, quoted in http://kvond.wordpress.com/2008/06/25/van-leeuwenhoeks-view-of-technology-and-spinoza/ and http://lensonleeuwenhoek.net/content/illumination. See also Payne, *The Cleere Observer*, pp. 36–37.

109 **The best way to make**: See B. J. Ford, *Single Lens*, pp. 35–36.

110 **The focal length**: Zuylen, "The Microscopes of Antoni van Leeuwenhoek," pp. 211 13.

110 **He most likely began**: Tiemen Cocquyt of the Boehaave Museum in Leiden suggested to me that Leeuwenhoek may have used mirror fragments; on the polish, see ibid., pp. 317–19.

110 **By the late seventeenth century**: See Schechner, "Between Knowing and Doing," p. 156.

110 **It was found during**: Zuylen, "The Microscopes of Antoni van Leeuwenhoek," p. 316. In 1699 Leeuwenhoek wrote of his having ground his microscopes with increasing skill over the years, and in 1700 he mentioned making hundreds of instruments by grinding. Later he claimed that he had ground all his microscopes in the same grinding lap. See Ruestow, *The Microscope in the Dutch Republic*, p. 19. In 1695 Leeuwenhoek told Anthonie Heinsius, "Your Honor might perhaps think that I was an expert in Glass-blowing," but he declared that he was not. See AvL to Anthonie Heinsius, Aug. 18, 1695, *AB*, 11:63.

110 **It is nearly impossible**: Zuylen, "The Microscopes of Antoni van Leeuwenhoek," pp. 319, 322.

111 **And a bacterium would be**: B. J. Ford, *Single Lens*, pp. 3–4. Zuylen has suggested that Leeuwenhoek may have used blowing for making the high-powered lenses, and grinding/polishing for the low-powered ones. See Zuylen, "The Microscopes of Antoni van Leeuwenhoek," p. 322.

111 **This may not even**: See Ruestow, *The Microscope in the Dutch Republic*, pp. 14 and 14n39. The strongest of the twenty-six microscopes left to the Royal Society of London was reported to have a magnification of 200 times.

111 **"My Study stands"**: AvL to Oldenburg, Oct. 9, 1676, *AB*, 2:79.

111 **But since the outer**: See ibid., pp. 78–79 and 79n73, and Zuylen, "The Microscopes of Antoni van Leeuwenhoek," pp. 315–16.

112 **Like Leeuwenhoek, Spinoza**: Interesting work on Spinoza as a lens grinder can be found at the website http://kvond.wordpress.com.

113 **"Their Worships the Burgomasters"**: Quoted and translated in Dobell, *Antony van Leeuwenhoek and His "Little Animals,"* p. 32.

114 **Federico Cesi, in the first**: See Fournier, "The Fabric of Life," p. 47.

115 **the eye of a whale**: See Schama, *The Embarrassment of Riches*, p. 133.

115 **In one notable frenzy**: See *AB*, 1:31–35, 139–53, 195, 4:213–31.

115 **Is that process an innate**: Kemp suggests that this issue arose only in eighteenth-century theories of vision, but it was already present in the seventeenth century. Kemp, *The Science of Art*, p. 234.

115 **"All this"**: Quoted in Lindberg, *Theories of Vision*, p. 203.

116 **Molyneux concluded that**: Molyneux to Locke, quoted in Degenaar and Lokhorst, "Molyneux's Problem." For a detailed discussion of the debates surrounding this issue in the late seventeenth and eighteenth centuries, see Degenaar, *Molyneux's Problem*.

116 **Without past experience**: See Kemp, *The Science of Art*, p. 234.

116 **In 1709 George Berkeley**: Berkeley, *A New Theory of Vision* (1709), quoted ibid., p. 235.

116 **The English surgeon William Cheselden**: Cheselden was also known for his work *The Anatomy of the Human Body* (1713), which contained fifty-six copperplate engravings produced with the aid of a camera obscura. See Degenaar, *Molyneux's Problem*, p. 53n1, and Kemp, *Seen/Unseen*, pp. 252–53.

117 **"Expecting the pictures would"**: Cheselden, "An Account of Some Observations Made by a Young Gentleman," pp. 447–50. For a discussion of this case as providing evidence for the Molyneux problem and its solution by Locke and others, see Degenaar, *Molyneux's Problem*, pp. 53–86.

117 **The modern-day philosopher**: See Hacking, "Do We See through a Microscope," and *Representing and Intervening*, pp. 186–209. In the latter, however, Hacking incorrectly asserts that the microscope—unlike the telescope—did not generate philosophical paradox, because "everyone expected to find worlds within worlds here on earth" (p. 187).

117 **Interestingly, three years before**: Molyneux, *Dioptrica nova*, p. 281, quoted in Dobell, *Antony van Leeuwenhoek and His "Little Animals,"* pp. 59–60.

118 **"The instrument must be"**: Galileo, *Opere*, 10:277–78, quoted in Van Helden, "Introduction," p. 13.

119 **"of these kinds of Objects"**: Hooke, *Micrographia*, preface, n.p.

119 **Descartes spent years**: See Burnett, *Descartes and the Hyperbolic Quest*.

120 **Another difficulty in looking**: See Fournier, "The Fabric of Life," p. 22.

120 **The obstacle was compounded**: Ruestow, *The Microscope in the Dutch Republic*, pp. 16–19.

121 **In the nineteenth century**: James, "The Will to Believe."

121 **"not just the eyes"**: Galileo speaking about Orazio Grassi, quoted in Reeves, *Painting the Heavens*, p. 116.

122 **"color-charged, glistening"**: For the quotation, see Dillard, *Pilgrim at Tinker Creek*, p. 127.

122    **"For in fact"**: Huygens's autobiography, quoted in Alpers, *The Art of Describing*, pp. 6–7.

PART FIVE: *UT PICTURA, ITA VISIO*

124   **As Huygens later recalled**: This account of the day's events is taken closely from Huygens's description in his autobiography, which he wrote, in Latin, in 1629, when he was thirty-three. It seems to have been circulated among his friends, but was not published until long after his death, in the nineteenth century. On the autobiography, see Alpers, *The Art of Describing*, p. 2.

124   **"Are the little people"**: Translation of the Latin by John P. McCaskey. It has been argued that Huygens did not have a box-type camera obscura, but that he had set up his dining room as a room-type camera obscura (see Delsaute, "The Camera Obscura and Painting in the 16th and 17th Century," p. 113, and Liedtke, *Vermeer*, pp. 181–82). Huygens refers to the "white (or bright) plate within an enclosed space," which means a plate inside a space, or in a box. A box-type camera obscura could be used to project images of people seen outside, if it was placed on the window ledge or a table close to the window. Lüthy, in "Hockney's Secret Knowledge, Vanvitelli's Camera Obscura," suggests that Vanvitelli used a box-type camera obscura in this manner. Although it is often claimed that a portable box-type camera was not made until around 1660, I believe it probable that Drebbel had constructed one earlier, and that this is the type Huygens purchased from him. Steadman agrees that Huygens brought back a box-type camera from Drebbel, but denies that Vermeer used this kind of camera obscura. See *Vermeer's Camera*, pp. 18–19.

124   **"this cunning fox"**: See Wheelock, *Perspective, Optics, and Delft Artists around 1650*, p. 164.

124   **Torrentius's still-life paintings**: Modern x-ray analysis of one of Torrentius's sole remaining picture has shown that it was painted on a white ground, with black lines marking out the composition, which could have been done by tracing from a camera obscura projection. See Groen, "Painting Technique in the 17th Century in Holland and the Possible Use of the Camera Obscura by Vermeer," p. 203, and Wallert, "A Peculiar Emblematic Still-Life Painting from Johannes Torrentius."

124   **Although he continued**: Huygens's autobiography, quoted in Groen, "Painting Technique in the 17th Century in Holland and the Possible Use of the Camera Obscura by Vermeer," p. 195.

124   **Already by 1623 Huygens**: But he also wondered "by what negligence on the part of our painters it happens, that so pleasant and useful an aid to them in their own work should so far have been neglected by them." By the 1660s Huygens would not have had this complaint. Quoted in Wheelock, *Perspective, Optics, and Delft Artists around 1650*, p. 95.

125   **In order for the image**: See Kemp, *The Science of Art*, p. 189.

125   **He referred to the place**: See Needham, *Science and Civilization in China*, cited in J. Hammond, *The Camera Obscura*, p. 1.

125   **During a solar eclipse**: Chap. XI, 912b12–15. Before the nineteenth century, this work was thought to have been written in the fourth century BCE by Aristotle; since then, scholars have rejected this attribution. However, writers on the camera obscura continue to claim that this passage was written by Aristotle. See, e.g., J. Hammond, *The Camera Obscura*, pp. 3–4, and M. S. Hammond, "The Camera Obscura," p. 12. For a discussion of the evidence against Aristotle's authorship, see Aristotle, *Problems*, "Introduction."

126   **He noted that images**: See J. Hammond, *The Camera Obscura*, p. 5.

126   **In a discussion on**: See M. S. Hammond, "The Camera Obscura," pp. 30, 35.

126   **He hired other actors**: See J. Hammond, *The Camera Obscura*, p. 9.

126   **"The spectators that see not"**: Della Porta, *Magia naturalis*, quoted in J. Hammond, *The Camera Obscura*, p. 19.

126   **"For some days after"**: Quoted in J. Hammond, *The Camera Obscura*, p. 16.

127   **In 1292 Guillaume de Saint-Cloud**: See M. S. Hammond, "The Camera Obscura," p. 74.

127   **The solar eclipse of January 1544**: In 1544 and 1545, the astronomer Erasmus Reinhold, a professor at Wittenberg, also used a camera obscura to observe solar eclipses. See Huerta, *Giants of Delft*, p. 21, and Wenczel, "The Optical Camera Obscura II," p. 27. See also M. S. Hammond, "The Camera Obscura," p. 102.

127   **To observe sunspots, Galileo**: Kemp, *The Science of Art*, pp. 191–92.

127   **The first to suggest this**: Barbaro may have been preceded by Girolamo Cardano, who mentioned using a "glass," but it is unclear whether Cardano meant that a lens or a concave mirror should be used. See M. S. Hammond, "The Camera Obscura," p. 162.

127   **"make a hole of the size"**: Quoted in Wheelock, *Perspective, Optics, and Delft Artists around 1650*, pp. 137–38. See also Kemp, *The Science of Art*, p. 190.

128   **Actually, it was sharper**: See M. S. Hammond, "The Camera Obscura," p. 173, and Ruestow, *The Microscope in the Dutch Republic*, p. 18. Barbaro wrote, "When it pleases you to make the experiment you should choose the glasses which do best, and should cover the glass so much that you leave a little of the circumference in the middle, which should be clear and open, and you will see a still brighter effect." Quoted in Wheelock, *Perspective, Optics, and Delft Artists around 1650*, pp. 137–38.

128   **Barbaro himself suggested**: See M. S. Hammond, "The Camera Obscura," p. 172.

128   **"painters, astronomers, and"**: See ibid., p. 160.

128   **Reinerus Gemma Frisius**: See ibid., p. 193.

128 **Christoph Scheiner**: See ibid., p. 214.

129 **If a mirror was placed**: See ibid., p. 178.

129 **The use of a mirror**: See Camerota, "Looking for an Artificial Eye," p. 272.

129 **Around this time English**: See ibid., p. 274.

129 **Della Porta, who wrote**: M. S. Hammond, "The Camera Obscura," pp. 125–26.

129 **"One that is skilled"**: Della Porta, *Magia naturalis*, bk. 20 (2nd ed.), xvii.6, quoted in Wenczel, "The Optical Camera Obscura II," p. 15. Some writers have argued that Della Porta did not intend for artists to use the camera obscura, but meant to suggest only that it could be useful for the *picturae ignari*, those who are ignorant of the art of painting, but still wish to depict nature, or paint a portrait. See Delsaute, "The Camera Obscura and Paintings in the 16th and 17th Century," p. 113, and Gorman, "Projecting Nature in Early Modern Europe," p. 42.

130 **He believed that**: Della Porta, *Magia naturalis*, quoted in Wheelock, *Perspective, Optics, and Delft Artists around 1650*, p. 144. And see Kemp, *The Science of Art*, p. 191.

130 **Della Porta's book was**: See Wheelock, *Perspective, Optics, and Delft Artists around 1650*, pp. 143–44. Galileo's friend Cigoli also recommended the use of the camera obscura as an aid to painters in his 1612 treatise, *Prospettiva pratica*. See Camerota, "Looking for an Artificial Eye," p. 264.

130 **A man would go inside**: In his *Ars magna* (1646), Athanasius Kircher described a similar setup, a portable camera obscura that would be carried like a sedan chair on horizontal rails by two men. The artist would enter through a trapdoor at the bottom of the box. Kircher's student Gaspar Schott mentioned his teacher's device in his book *Magia universalis* (1657); in the 1677 edition he noted that he had heard from a traveler in Spain of a version of Kircher's device that was small enough to carry in the arms. See M. S. Hammond, "The Camera Obscura," p. 284.

130 **Kepler himself had coined**: Kepler had discussed the room-type camera obscura in a book published in 1604, the *Astronomiae pars optica* (The optical part of astronomy), but in that discussion he used the term "camera clausa," a closed chamber or room. There he described a room-type camera obscura, noting that Della Porta had discussed this setup but that "he did not add a demonstration," meaning that Della Porta did not seem to have used a camera obscura himself, whereas Kepler had. See Kepler, *Optics*, p. 67.

130 **Kepler used the term**: The full statement is as follows: "Let a convex lens block the single opening in a dark chamber [camera obscura]. A sheet of paper is placed at the focus [of the lens]. Now by all its rays which radiate onto the lens, a single point of the visible thing is collected again into a single point. Visible objects actually consist of infinitely many points. Therefore, infinitely many such points are painted on the paper, that is, the entire surface of the visible object is depicted there." Translation from M. S. Hammond, "The Camera Obscura," p. 212.

130 **Through a small aperture**: See ibid., p. 201; see also Straker, "Kepler's Optics."

131 **While he acknowledged**: Wotton, Dec. 1620, in *Reliquiae Wottoniae* (1651), quoted in Seymour, "Dark Chamber and Light-Filled Room," p. 324. See also Camerota, "Looking for an Artificial Eye," p. 284.

131 **Wotton, who had lived**: See Steadman, *Vermeer's Camera*, p. 19.

132 **"I need not perhaps tell"**: Boyle, "On the Systematicall and Cosmical Qualities of Things," n.p.

132 **Johann Zahn illustrated**: When Hooke demonstrated his cone-shaped device that fit over a user's head, he noted that it could be used as an instrument "to give us the true Draught of whatever he sees before him." M. S. Hammond claims that Zahn's two models were impractical for drawing, and were intended only as illustrations of optical principles. See "The Camera Obscura," pp. 299–302. Kemp says that Hooke invented a portable camera obscura around 1685, even though he did not present it to the Royal Society until Dec. 19, 1694. See Kemp, *The Science of Art*, p. 190, and Hooke, "An Instrument to Take the Draught or Picture of a Thing," p. 295.

132 **Huygens had mentioned**: Letter from Huygens to his parents, April 13, 1622, quoted in Wheelock, "Constantijn Huygens and Early Attitudes towards the Camera Obscura," p. 93.

132 **In his autobiography, written**: For these quotations from the autobiography, see ibid., p. 99.

133 **Huygens also noted**: See Alpers, *The Art of Describing*, p. 23.

133 **So the quality of the glass**: Cocquyt, "The Camera Obscura and the Availability of 17th Century Optics," p. 134.

134 **The lens must have**: Wirth, "The Camera Obscura as a Model of a New Concept of Mimesis in 17th Century Painting," pp. 158–59. Cocquyt and Wirth reproduced two seventeenth-century camera obscuras using a lens by Christiaan Huygens from 1655 and one by Giuseppe Compani from 1680, both with focal distances of about three meters. The image attained each time was bright and sharp; they conclude that the lenses of the day were more than adequate for use in a camera obscura, and "lens quality is not a sufficient argument for refuting the application of the camera obscura in this period." See Cocquyt, "The Camera Obscura and the Availability of 17th Century Optics," pp. 134–39; quotation on p. 139.

134 **By 1604 Kepler had reported**: Kepler witnessed a demonstration in which one of the rooms in the Dresden Kunstkammer (a collection of objects of various kinds, a sort of public "cabinet of curiosity") had been turned into a room-type camera obscura with a lens a foot in diameter; he reports on this demonstration in his *Ad Vitellionem paralipomena*, in *Optics*, p. 194. See Dupré, "Inside the Camera Obscura," p. 220, and Wirth, "The Camera Obscura as a Model of a New Concept of Mimesis in 17th Century Painting," p. 159n. We know that flat, square mirrors that size were being produced in Venice in the sixteenth century. Because it was by then possible to blow flat sheets of glass at least that large, it would have been possible to

grind a glass blank that size into a lens, though perhaps not a particularly good one. On the production of mirrors of this size in 1500, see Schechner, "Between Knowing and Doing," p. 156; on lenses, see Wirth, "The Camera Obscura as a Model of a New Concept of Mimesis in 17th Century Painting," pp. 160–61.

134 **By the mid-seventeenth century**: By the 1620s, then, the question regarding the Hockney-Falco thesis becomes not "Were optical projections possible?" but "How and when were they used by artists?" See Lüthy, "Hockney's Secret Knowledge, Vanvitelli's Camera Obscura," pp. 317–18.

134 **"one of the best optical"**: Quoted in Wheelock, *Perspective, Optics, and Delft Artists around 1650*, p. 156.

134 **The camera obscura allowed**: See Wheelock, "Constantijn Huygens and Early Attitudes towards the Camera Obscura," p. 99, and Weststeijn, *The Visible World*, p. 105.

135 **Swammerdam, who would**: Fournier, "The Fabric of Life," p. 82.

135 **His father also had**: Cobb, *Generation*, pp. 34–35.

136 **Alchemists were using**: For more on the alchemists and how they were early chemists, see Principe, *The Secrets of Alchemy*.

136 **Especially starting in the 1650s**: See Liedtke, "De Hooch and Vermeer," p. 145.

136 **One of the main motivations**: See Alpers, *The Art of Describing*, ch. 4, and Weststeijn, *The Visible World*, pp. 278–79.

136 **"imitate things as they"**: Quoted in Weststeijn, *The Visible World*, p. 274.

137 **The viewer of De Hooch's**: Liedtke, "De Hooch and Vermeer," p. 142.

137 **Like the natural philosophers**: See Kemp, *The Science of Art*, pp. 192–93. In a book published in 1641, Franciscus Junius had already used the mirror metaphor to argue that the painter must base his art solely on the images presented to him by the visible world. See Weststeijn, *The Visible World*, p. 273

137 **"a painter, whose work"**: Van Hoogstraten, quoted in Wheelock, *Vermeer and the Art of Painting*, p. 14.

137 **A century later Arnold Houbraken**: Mander and Houbraken, quoted in Ruestow, *The Microscope in the Dutch Republic*, p. 74n58.

137 **"making things that are *not*"**: Quoted in Weststeijn, *The Visible World*, p. 86.

137 **In his own pictures**: See Brusati, "Paradoxical Passages," pp. 59–61.

138 **Vermeer would use this device**: Liedtke, "Vermeer: Style and Observation," MMA Lecture, April 22, 2014.

138 **Like the drops of "dew"**: See Wadum, "Contours of Vermeer," p. 209.

138 **"transform a painter's imagination"**: Westermann, "Vermeer and the Interior Imagination," p. 228, quoting Willem Goeree's 1668 text on drawing.

138 **"saw hundreds of little barges"**: Van Hoogstraten, *Inleyding*, p. 263, quoted in Steadman, *Vermeer's Camera*, p. 22.

138   **"I am certain"**: Van Hoogstraten, *Inleyding*, p. 263, quoted in Wheelock, *Perspective, Optics, and Delft Artists around 1650*, p. 165.

139   **"There are some who look"**: Quoted in Kemp, *The Science of Art*, p. 163.

139   **Although Leonardo had**: See ibid., pp. 169–70.

139   **"I have no other calculator"**: Quoted ibid., p. 40.

139   **The science of art**: Ibid., p. 41.

140   **It is no accident that**: See M. S. Hammond, "The Camera Obscura," p. 226.

140   **"the retina is painted"**: "Retiformis tunica pingitur à radijs coloratis rerum visibilium." Kepler, *Dioptrice*, quoted in Alpers, *The Art of Describing*, p. 38. A debate between some Kepler scholars rages over the question whether Kepler was "mechanizing" the eye or "naturalizing" the camera obscura; I will not explore that controversy here. See Straker, "Kepler's Optics," for the first view, and Lindberg, *Theories of Vision*, for the second.

140   **Earlier, Leonardo had been**: Leonardo da Vinci, in a treatise of 1508–9 on vision and the function of the eye; see M. S. Hammond, "The Camera Obscura," pp. 136–37. See also Crombie, "The Mechanistic Hypothesis," p. 38, and Wheelock, "Constantijn Huygens and Early Attitudes towards the Camera Obscura," pp. 99–100. As Wheelock notes, Della Porta had made a similar comparison in his *Magia naturalis* (1589); he still claimed, however, that the organ of sight is the "crystalline sphere located in the middle of the eye" (quoted in Wheelock, *Perspective, Optics, and Delft Artists around 1650*, p. 49). Jean-François Niceron included an illustration of the eye as a camera obscura in his *Thaumaturgus opticus* (Paris, 1646).

140   **Galileo's friend Cigoli**: Camerota, "Looking for an Artifical Eye," p. 265.

140   **The comparison of the eye**: See Lefèvre, "The Optical Camera Obscura I," p. 8.

140   **Knowing that people**: Alhazen, for instance, recognized that the crystalline humor acts as a lens and that light rays passing through it are refracted. But he refused to accept the logical conclusion that the image would be inverted; he insisted on an upright image within the eye and thus reached false conclusions about the eye's anatomy. See Wheelock, *Perspective, Optics, and Delft Artists around 1650*, pp. 35–36. A. I. Sabra argues, however, that Alhazen did not understand the organ of sight as acting like a lens camera. See "Alhazen's Optics in Europe," pp. 53–56.

140   **"take the eye of a newly"**: Descartes, *La dioptrique*, in *Discourse on Method, Optics, Geometry, and Meteorology*, pp. 91–93.

141   **In 1625 the astronomer**: See Kepler's *Dioptrice*, Descartes's *La dioptrique*, Kemp, *The Science of Art*, p. 191, Delsaute, "The Camera Obscura and Paintings in the 16th and 17th Century," p. 116, Wenczel, "The Optical Camera Obscura II," p. 24, and M. S. Hammond, "The Camera Obscura," p. 230. Lindberg, however, downplays Kepler's comparison of the eye to the camera obscura, because he sees Kepler's theory of vision as the culmination of the medieval perspectivist tradition rather than a mechanistic view that

breaks from that tradition. See Lindberg, *Theories of Vision*, p. 206; on the point about Lindberg's view of Kepler as the culmination of the old tradition, see Dupré, "Inside the Camera Obscura," pp. 220–21. Kepler also compares the telescope to the eye, calling it an "artificial eye." See Malet, "Early Conceptualizations of the Telescope as an Optical Instrument," p. 245.

141   **"Something of this kind"**: Boyle, *Some Considerations Touching the Usefulness of Experimental Natural Philosophy*, pp. 95–97.

141   **Performing the same experiment**: AvL to RSL, April 30, 1694, *AB*, 10:127.

141   **In this sense the camera obscura**: Later this view of the eye as a camera would raise new problems about vision that needed solving—for example, the question of how the eye can focus, and the complications of binocular vision (issues arising from the fact that our visual arrangement consists of two separate lens/retina systems), questions that would exercise some of the most powerful minds of the late seventeenth and eighteenth centuries, including John Locke in England and Immanuel Kant in Germany. See Kemp, *The Science of Art*, p. 234. See also Lefèvre, "The Optical Camera Obscura I," p. 7.

142   **"La vision est la perception"**: Quoted in Wheelock *Perspective, Optics, and Delft Artists around 1650*, p. 156.

142   **Images seen through the camera obscura**: See ibid., p. 6. Earlier Kircher had spoken of *natura pictrix*, nature the painter; the visible world is but a painting, so our images of that world both on our retinas and in the camera obscura, also paintings, are the same type of thing as nature itself. Kircher, *Ars magna lucis et umbrae*, quoted in Gorman, "Projecting Nature in Early Modern Europe," p. 45.

142   **"exceptional and secret knowledge"**: Alberti, *Vita*, quoted in Yiu, "The Mirror and Painting in Early Renaissance Texts," p. 198.

143   **"forte secrete, & comme un"**: Hondius, *Perspectivae*, p. 19, quoted in Wheelock, *Perspective, Optics, and Delft Artists around 1650*, p. 164.

143   **"that which ravishes"**: J. Leurechon, *Recreation mathematique* (1626), quoted ibid., p. 95.

143   **Even the recipes for mixing**: See Kirby, "The Painter's Trade in the 17th Century," p. 10. Philip Ball discusses the intersection of alchemy's "secret books" with color production in the Middle Ages in *Bright Earth*, chap. 4.

143   **Of all the artists who**: Indeed, Martin Kemp believes that in Vermeer's case "the evidence about the use of optical devices [including the camera obscura] is about as secure as it could be." See Kemp, "Imitation, Optics, and Photography," p. 243. See also Kemp, *The Science of Art*, pp. 193–94. Other seventeenth-century Dutch painters who probably used the camera obscura include Van der Heyden. The painter Sir Joshua Reynolds would later describe Van der Heyden's work by saying that "his pictures have very much the effect of nature, seen through a camera obscura." Reynolds, quoted ibid., p. 198.

143   **It might have been Fabritius**: See Blankert, *Vermeer of Delft*, pp. 20–21.

144   **Passengers and goods incessantly**: See Plomp, "Along the City Walls," p. 551.

144   **"the scene's varied light effects"**: Westermann, "Vermeer and the Interior Imagination," p. 219, emphasis added.

144   **"taught the correct way"**: On Canaletto see Kemp, *The Science of Art*, p. 197; on Vanvitelli see Lüthy, "Hockney's Secret Knowledge, Vanvitelli's Camera Obscura," p. 315. The Museo Correr in Venice owns a camera obscura taken to have been Canaletto's instrument; it has the inscription *A. Canal*. While some dispute that this was his camera obscura, there are no doubts that Canaletto used one. See Lüthy, "Hockney's Secret Knowledge, Vanvitelli's Camera Obscura," p. 322. Interestingly, Canaletto would have known Vermeer's *The Music Lesson*, since it was owned by his Venetian patron, Consul Smith (but it was at that time incorrectly attributed to Van Mieris). See Gowing, *Vermeer*, p. 125.

144   **Vanvitelli would take**: On Vanvitelli's method, see Lüthy, "Hockney's Secret Knowledge, Vanvitelli's Camera Obscura," pp. 328–32. As noted earlier, I believe box-type camera obscuras existed since at least 1622. Seymour claims that Vermeer must have used a portable box-like apparatus, aimed out of a window of a house across the water from the port, but says that no such apparatus is thought to have existed in Vermeer's time. See Seymour, "Dark Chamber and Light-Filled Room," p. 326–27.

145   **But even if he did**: As, e.g., Gowing suggests for *Girl with a Pearl Earring*. See Gowing, *Vermeer*, pp. 137–38.

145   **In the seventeenth century**: Wadum et al., *Vermeer Illuminated*, p. 11.

145   **One reason it is clear**: See Wheelock, *Perspective, Optics, and Delft Artists around 1650*, pp. 296–97. Swillens argues, incorrectly in my opinion, that the picture was painted by tracing the camera image seen from the second story of a house across from the Rotterdam Gate. See Swillens, *Johannes Vermeer*, p. 90ff.

146   **"mutually complementary"**: See Wheelock, *Perspective, Optics, and Delft Artists around 1650*, p. 283.

146   **"mathematical net"**: Gowing, *Vermeer*, p. 18.

146   **In many of those pictures**: This is another reason for the sudden appearance of the black-and-white marble floors in genre paintings of the time. See Vergara, "Vermeer," p. 215.

146   **Vermeer in a sense one-ups**: Wheelock, *Perspective, Optics, and Delft Artists around 1650*, pp. 280–81.

146   **The two men, painting similar**: Liedtke, "De Hooch and Vermeer," p. 144. Neither man invented the "Delft-type" interior; this was a variation of a regional type that flourished in Rotterdam, Dordrecht, The Hague, and Leiden, as well as in Delft (see p. 137). De Hooch and Vermeer, however, refined this type, adding to it "more realistic qualities of space, light and atmosphere" (p. 156).

146   **De Hooch also "upped"**: See Liedtke, "De Hooch and Vermeer," p. 142.

146 **if "the painter imitates"**: Niceron, *La perspective curieuse*, quoted in "Vermeer and the Camera Obscura," http://www.essentialvermeer.com/camera_obscura/co_three.html#.U31KwMaVvwI.

147 **The artist is in the**: See Livingstone, *Vision and Art*, p. 100.

147 **Vermeer's sudden facility**: As noted earlier, Wadum provides an alternative explanation for this: Vermeer's discovery of the system of using a pin and string to mark out the orthogonals. See also Costaras, "A Study of the Materials and Techniques of Johannes Vermeer," p. 152. However, the artist Carsten Wirth has argued that the pinholes could have been the starting point for rendering accurate perspective, but would not have been sufficient for it. See Wirth, "The Camera Obscura as a Model of a New Concept of Mimesis in 17th Century Painting," p. 192.

147 **But by looking**: See Westermann, "Vermeer and the Interior Imagination."

148 **Vermeer's familiarity**: Gowing believes that Vermeer was alone among those painters who used a camera obscura in "putting it to the service of style rather than the accumulation of facts." See Gowing, *Vermeer*, p. 23.

149 **The effect is the appearance**: Wheelock, *Perspective, Optics, and Delft Artists around 1650*, pp. 295–96.

149 **The richness of color**: See ibid., p. 296.

149 **So does the intensity**: Liedtke, *Vermeer*, p. 47.

149 **Claude Monet would later**: Livingstone, *Vision and Art*, p. 95.

149 **We see this in**: See Swillens, *Johannes Vermeer*, pp. 138–40, and Wheelock, *Vermeer and the Art of Painting*, p. 12.

150 **Like camera obscura images**: See Westermann, "Vermeer and the Interior Imagination," p. 226.

150 **Similarly, in *Mistress and Maid***: See Wheelock, *Vermeer and the Art of Painting*, p. 142.

150 **Vermeer learned that by**: Ibid., p. 165.

150 **The skirt's edge was established**: See Costaras, "A Study of the Materials and Techniques of Johannes Vermeer," p. 156.

150 **Vermeer captured this effect**: Wheelock, *Perspective, Optics, and Delft Artists around 1650*, p. 277. Swillens believes that the painting depicts the old men's and women's almshouses, which were demolished to make way for the new quarters of the St. Luke's Guild in 1661. See Swillens, *Johannes Vermeer*, p. 95. However, Montias disagrees, pointing out that one of the buildings was not actually demolished, but merely superficially remodeled, and that this building had its main axis parallel to the street, whereas the house represented in the picture has its narrow side facing the street. See Montias, *Vermeer and His Milieu*, p. 149 and 149n53.

151 **However, in order to succeed**: See Ruestow, *The Microscope in the Dutch Republic*, p. 18.

151 **In *The Milkmaid***: See Wheelock, *Perspective, Optics, and Delft Artists around 1650*, p. 295.

151 **These occur only**: See Kemp, *The Science of Art*, p. 94: "In his later works

the luminous dabs are exploited as a form of painterly shorthand which is at once optical in origin and artificially contrived in application." And see Wheelock, *Perspective, Optics, and Delft Artists around 1650*, p. 295. Swillens, however, insisted that Vermeer used this technique "only there where such light-effects can occur." See Swillens, *Johannes Vermeer*, p. 134.

152 **"the painter who draws merely"**: Quoted in Yiu, "The Mirror and Painting in Early Renaissance Texts," p. 208.

152 **"Has this been done"**: Wadum, "Contours of Vermeer," pp. 212–13. (Wadum is now at the National Gallery of Denmark.)

153 **"the painter [with] the camera"**: Wirth, "The Camera Obscura as a Model of a New Concept of Mimesis in 17th Century Painting," p. 177.

154 **"extraordinary geometrical coincidence"**: Steadman, *Vermeer's Camera*, pp. 101–3.

154 **not meant to be photographic**: On the view that paintings in the seventeenth-century Dutch Republic were not intended as photographically accurate depictions of domestic life, see Schama, *An Embarrassment of Riches*, pp. 9–10.

154 **One of the few places**: See Liedtke, "Painting in Delft from about 1600–1650," p. 5.

154 **Like Turkish carpets**: See Franits, *Dutch Seventeenth-Century Genre Painting*, pp. 186–87, Vergara, "Vermeer," p. 215, and Westermann, "Vermeer and the Interior Imagination."

155 **Indeed, there is no evidence**: Liedtke, "De Hooch and Vermeer," p. 140.

155 **This tradition of imaginary**: See Liedtke, "Painting in Delft from about 1600–1650," pp. 77–83. For the earlier use of tiled floors in paintings, see Gombrich, *Art and Illusion*, p. 261.

155 **Rather, the flowers**: As, for instance, in the fenced-in section of a garden displayed in a painting by Hendrick van der Berch (see catalog no. 12, Liedtke et al., *Vermeer and the Delft School*, p. 218).

156 **Another, even simpler**: See also Liedtke's review of Steadman's *Vermeer's Camera*. As Liedtke notes, there is a sense in which Steadman's whole argument is circular, relying on the assumption that the pictures are photographic replicas of the room and its contents in order to prove that they are tracings from a camera image.

156 **There is much evidence**: See Simon, " 'Three-quarters, Kit-cats and Half-lengths.' "

156 **Many of Vermeer's paintings**: Costaras, "A Study of the Materials and Techniques of Johannes Vermeer," pp. 148–50.

156 **In either case**: In his "Vermeer's Camera: Afterthoughts, and a Reply to Critics," Steadman addresses these criticisms and others, but does not in fact resolve them. To take just one example, he dismisses the argument that Vermeer might have used standard-sized canvases by claiming, "The six canvases under consideration here are particularly varied in size." These canvases, however, are quite close in size, with only one of them differing by more than a few centimeters in any one dimension. This can be seen in

Steadman's own figure in *Vermeer's Camera*, p. 104. Moreover, all but one of the paintings are clustered closely around the 1:1.4 ratio typical of Vermeer's canvases.

156 **His object would**: See Wheelock, *Vermeer and the Art of Painting*, pp. 18–19. Wirth similarly argues that painters would have used the camera obscura image not for locating lines and points but for modulating light values; he considers that a more "painterly application" of the device. See Wirth, "The Camera Obscura as a Model of a New Concept of Mimesis in 17th Century Painting," p. 152.

157 **Since the ideal**: See Wadum, "Contours of Vermeer," p. 212. As Wadum notes, Vermeer's interiors are like this; they are a "mise-en-scène, with curtains, special light effects, and a composition with a strong spatial illusion. We, the spectators, are also staged by the artist and often placed behind a *repoussoir* in the background."

157 **He was not merely**: Wirth, who has experimented with painting with the camera obscura, offers this description: "It places the viewer in the eye itself, letting him look at the retina. . . . The retina is replaced by the canvas. With the camera this is the workplace of the painter, who has shifted his task from a *retroactive reproduction* of nature to the *evocation* of its manifestations. . . . The eye of the painter is located within another, artificial eye, a *studiolo* of visual perception." See Wirth, "The Camera Obscura as a Model of a New Concept of Mimesis in 17th Century Painting," pp. 151–52.

## PART SIX: MATHEMATICAL ARTISTS

159 **Even the brisk furrows**: See Wheelock, ed. *Johannes Vermeer*, p. 170.

160 **a "mathematical artist"**: See Liedtke, *Vermeer*, p. 150.

160 **Could the model be**: See Duparc and Wheelock, eds., *Johannes Vermeer*, p. 172, Brook, *Vermeer's Hat*, p. 85, and Westermann, "Vermeer and the Interior Imagination."

160 **The group portrait**: See editors' note, *AB*, 1:398–401n.

160 **According to the report**: "Om dit werk meer luister bij te zetten." Boitet's *Beschryving der stadt Delft* (1729), p. 765, quoted in Ruestow, *The Microscope in the Dutch Republic*, p. 160.

161 **Leeuwenhoek later observed two**: See AvL to Hooke, Nov. 12, 1680, *AB*, 3:313–15, 313n36.

161 **Leeuwenhoek was related to**: See DTB Delft 14, inv. 5, folio 89, cited at http://lensonleeuwenhoek.net/content/cousin-cornelia-jans-van-halmael -married-anthony-cornelis-de-man.

161 **Boitet reports that Leeuwenhoek**: Boitet, *Beschryving der stadt Delft*, (1729), pp. 765–70, cited in Wheelock, *Perspective, Optics, and Delft Artists around 1650*, p. 284.

161 **Forasmuch as Antony**: Quoted in Dobell, *Antony van Leeuwenhoek and His "Little Animals,"* p. 34.

162　**Leeuwenhoek commented on**: AvL to Jan Meerman, burgomaster of Delft, March 14, 1713, quoted ibid., p. 35.

162　**Later, his correspondence**: See Ruestow, *The Microscope in the Dutch Republic*, p. 158.

162　**The book is Adriaen Metius's**: See Welu, "Vermeer's Astronomer."

162　**In the seventeenth century**: Liedtke, *Vermeer*, p. 150.

162　**The pictures were originally**: Now *The Astronomer* is a little smaller, 50 by 45 centimeters versus 53 by 46.5 centimeters. However, the reproduction in the catalog of a 1792 sale in Paris shows a greater part of the wall and the chair, suggesting that the canvas had previously been larger, and cut down on the right at a later date. See Swillens, *Johannes Vermeer*, p. 58. Liedtke has suggested that the paintings were originally commissioned by Adriaen Paets I, a director of the East India Company (see *Vermeer*, p. 152).

163　**Several treatises on comets**: See Huerta, *Giants of Delft*, p. 119.

164　**Although the production**: Because of this difference, Van Helden sees the perspective glass as a precursor to the telescope rather than to the camera obscura. See Van Helden, *The Invention of the Telescope*, p. 33.

164　**Thomas Harriot used**: See Camerota, "Looking for an Artifical Eye," 274–75.

164　**Leeuwenhoek was already**: See Montias, *Vermeer and His Milieu*, pp. 318–19. Although Larson may have obtained the painting while in Delft, or from a Delft art dealer in The Hague, as Liedtke suggests, the point remains that Vermeer's work was known outside of Delft. See Liedtke, "Delft and the Delft School," p. 7.

165　**The guildhall was**: Swillens, *Johannes Vermeer*, pp. 35–37.

165　**The board of the guild**: See Swillens, *Johannes Vermeer*, p. 38. In 1662 Cornelis de Man—who later included Leeuwenhoek in his anatomy guild picture—was the second painter chosen with Vermeer for the board.

165　**The board was responsible**: Swillens, *Johannes Vermeer*, p. 39.

165　**Each year the guild**: On the administration of the guilds in Amsterdam, see Phillips, *Well-Being in Amsterdam's Golden Age*, p. 47. For the administration specifically of Delft's St. Luke's Guild, see Montias, *Vermeer and His Milieu*, p. 135.

165　**Unfortunately for Vermeer's**: See Bailey, *Vermeer*, pp. 12–13.

166　**"all these gentlemen"**: Quoted in Schama, *The Embarrassment of Riches*, p. 180.

166　**"I do not believe"**: Quoted ibid., p. 190.

166　**His father, François**: See *AB*, 2:440–41, "Biographical Register."

167　**In the decades since**: See Adelheid Rech, "Constantijn Huygens, Lord of Zuilichem (1596–1687)," at http://www.essentialvermeer.com/history/huygens.html.

168　**The new law**: See Israel, *The Dutch Republic*, p. 791.

168　**They had a companionate**: See Jardine, *Going Dutch*, pp. 149–52.

168　**"If Madame de Zulichem"**: Quoted ibid., pp. 153–54.

169　**Huygens regularly did**: Duarte was approached by the stadtholder to

contribute funds for his political activity. See Schama, *The Embarrassment of Riches*, p. 593. Huygens may have been a go-between for that transaction.

169 **Later, Gaspar's son**: Liedtke, "Delft and the Delft School," p. 9.

169 **or, more likely**: See Montias, *Vermeer and His Milieu*, p. 257.

169 **It has been suggested**: See Jardine, *Going Dutch*, p. 167, and Jardine, "The Correspondence between Constantijn Huygens and Dorothea van Dorp," p. 9.

170 **Cavendish went on to write**: See Akkerman and Corporaal, "Mad Science beyond Flattery," p. 1.

170 **Virginia Woolf would** : Woolf, *A Room of One's Own*, quoted ibid.

170 **He told Henry Oldenburg**: Huygens to Oldenburg, 1674, quoted in Jorink, *Reading the Book of Nature in the Dutch Golden Age*, p. 5.

171 **Huygens negotiated with**: Jardine, *Going Dutch*, p. 83.

172 **He also painted a portrait**: See Israel, *The Dutch Republic*, pp. 561, 523, and Brusati, *Artifice and Illusion*, p. 145.

172 **"I have agreeable tidings"**: Huygens, *Daghwerck*, quoted in Alpers, *The Art of Describing*, p. 11.

172 **"And discerning everything"**: Ibid., pp. 16–17.

173 **Huygens explicitly compared**: See ibid., p. 24.

173 **Recalling his experience**: Ibid., pp. 6–7.

173 **By the early 1670s**: See Ruestow, *The Microscope in the Dutch Republic*, p. 162.

173 **The trip between The Hague**: See Liedtke, "Delft and the Delft School," p. 3.

173 **While Leeuwenhoek was in**: See, e.g., AvL to Lambert van Velthuysen, June 13, 1679, *AB*, 3:83: "When Mr. Constantine Huygens van Zuylichem was recently at the audit-offices of Delfland, he called on me in the morning and in the afternoon."

173 **In the correspondence between**: See *AB*, 1:66–67, 122–23, 206–7, 2:228–29, 3:82–83, and 7:360–63. See also Ruestow, *The Microscope in the Dutch Republic*, p. 149.

173 **"To the picture of Ant."**: Verse reprinted in *AB*, 6:89n4.

174 **Huygens's connection to Vermeer**: Liedtke says it is "almost unthinkable" that Vermeer and Huygens were not in contact. See "Delft and the Delft School," p. 14.

174 **Most likely, they all**: See Huerte, *Giants of Delft*, p. 105, and Broos, "Un celebre peijntre nommé Verme[e]r," p. 50. Liedtke quotes it slightly differently: Berkhout "made the trip to Delft on a yacht, as did Monsr. De Zuylichem" (Constantijn Huygens) and other dignitaries. See *Vermeer*, p. 144 Both versions place Huygens in Delft with Vermeer's visitor.

174 **"the most extraordinary"**: Quoted in Vergara, "Vermeer," p. 206.

174 **"to discourse on this"**: Quoted in Liedtke, *Vermeer*, p. 144.

175 **During his travels he**: See Schwartz, "Vermeer and the Camera Obscura," p. 173.

175 **While in London**: See Weld, *A History of the Royal Society*, 1: 169–70.

175 **On that visit Monconys**: Monconys, *Journal des voyages*, 2:17–18, and Steadman, *Vermeer's Camera*, p. 57.

175 **The first volume**: Schwartz, "Vermeer and the Camera Obscura," p. 172.

175 **Monconys traveled to Delft**: Liedtke suggests that the original reason for Monconys's visit was his interest in Catholic affairs. See "Delft and the Delft School," p. 12.

175 **On his way to Amsterdam**: Monconys, *Journal des voyages*, 2:145, 153, 161, and Steadman, *Vermeer's Camera*, p. 56.

175 **"In Delft I saw"**: "A Delphis je vis le Peintre Vermer qui n'avoit point de ses ouvrages; mais nous en vismes chez un Boulanger qu'on avoit payé de six cents livres, quoiqu'il n'y eust qu'une figure, qui j'aurois trop payer de six pistols." *Voyages* (1676), 2:149, quoted and translated in Swillens, *Johannes Vermeer*, p. 26.

176 **Apparently, even at this**: See Liedtke, "Delft and the Delft School," p. 12.

177 **There were two rooms upstairs**: The death inventory first lists a room "above in the back room" and then "in the front room," making it clear that this "front room," where the painting supplies were, was also "above," and not on the ground floor, as Steadman maintains. See *Vermeer's Camera*, p. 61.

177 **There was probably another room**: Description of house as noted in the inventory taken after Vermeer's death, dated Feb. 29, 1676. See Montias, *Vermeer and His Milieu*, pp. 154–55.

177 **"not more than one hundred"**: AvL to RSL, March 19, 1674, *AB*, 10:55.

177 **In the back of**: AvL to F. A. van Renswoude, July 10, 1695, *AB*, 10:279. After his second marriage Leeuwenhoek would own another piece of property with a large garden, but in this letter his reference to bringing flowers into the house from the garden suggests that his home in Delft had a garden as well.

178 **on the ground floor**: Judging by a letter in which Leeuwenhoek describes examining his semen after "conjugal coitus" within less than six beats of the heart. AvL to Lord Brouncker, Nov. 1677, *AB*, 2:281–93.

178 **family group portraits**: See Schama, *The Embarrassment of Riches*, pp. 517–22.

178 **Sometimes children were painted**: Bol (1659) in the Six Collection, Amsterdam.

178 **Heijman Jacobi exemplified**: Schama, *The Embarrassment of Riches*, p. 517.

179 **Only then would the tax collector**: Ibid., p. 521.

PART SEVEN: A TREASURE-HOUSE OF NATURE

182 **the globules overlapped**: Leeuwenhoek describes this trip and his observations in a letter to Oldenburg, Sept. 7, 1674, *AB*, 1:159. Dobell believes, as

do I, that Leeuwenhoek had a microscope with him on the trip to England, while Brian Ford thinks that it was his exposure to Hooke's *Micrographia* on that visit which first aroused his interest in microscopes. See Dobell, *Antony van Leeuwenhoek and His "Little Animals,"* p. 51, B. J. Ford, *Single Lens*, pp. 39–40, and Ruestow, *The Microscope in the Dutch Republic*, p. 148n3.

182 **The travel between**: For more on the Dutch in London, see Harkness, *The Jewel House.*

182 **"mad for war"**: Quoted in Israel, *The Dutch Republic*, p. 766.

183 **Peace was signed**: Ibid., p. 773.

183 **"baked, 'tis red"**: In Leeuwenhoek's time the term "porcelain" was applied more widely than now. Now porcelain refers to a ceramic product made mostly of kaolin (of a nonporous body), which is more or less transparent. Earthenware, by contrast, refers to pottery, composed of various kinds of clay, the body of which is porous. Leeuwenhoek's comment that particles of clay are finer than particles of sand is correct, and he was also right that the Delft clay contained organic impurities. See editors' note, *AB*, 1:163n44.

184 **The society planned to meet**: On the founding of the Royal Society of London, see Sprat, *History of the Royal Society*, p. 93.

184 **They sent emissaries**: Ibid., pp. 156, 169, 170.

184 **"to consider about all sorts"**: See Weld, *A History of the Royal Society*, 1:108, and Birch, *The History of the Royal Society*, 1:20.

184 **"bring in a history"**: Birch, *The History of the Royal Society*, 1:10–12.

185 **"broken eggs into two"**: Ibid., 2:84, 227–30.

185 **Around this time**: See Blanc's review of *The Visible World*, p. 278.

185 **"this almost divine art"**: Birch, *The History of the Royal Society*, 2:230–31.

185 **"A contrivance to make"**: *Philosophical Transactions* (3): 741. See also M. S. Hammond, "The Camera Obscura," pp. 295–96.

186 **"Seat of Learning"**: Sprat, *History of the Royal Society*, p. 68.

186 **"to separate the knowledge"**: Ibid., p. 62.

186 **"vex" nature**: Bacon, "Plan of the Work," in *The Works of Francis Bacon*, 1:141.

187 **"The anatomist showed"**: Galileo, *Dialogue Concerning the Two Chief World Systems*, p. 108, emphasis added.

187 **"world on paper"**: Quoted in Panek, *Seeing and Believing*, p. 55.

187 **"I profess both to learn"**: Quoted in ibid., p. 73.

187 **Leeuwenhoek would later**: See AvL to RSL, Jan. 5, 1685, *AB*, 5:64–65.

188 **"It is obvious that"**: Descartes, *Principles of Philosophy*, pt. 2, sec. 42, in *The Philosphical Writings of Descartes*, 1:62. For further discussion see Slowick, "Descartes's Physics," Garber, *Descartes' Metaphysical Physics*, and Hattab, "Concurrence or Divergence?"

188 **"no phenomena of nature"**: Descartes, *Principles of Philosophy*, pt. 4, sec. 199, in *The Philosphical Writings of Descartes*, 1:282–83.

188 **"I confess the excellent"**: Sprat, *History of the Royal Society*, pp. 95–96.

188 **many a natural philosopher**: See Fournier, "The Fabric of Life," p. 85.

189 **"grosse trials"**: Sprat, *History of the Royal Society*, pp. 311–12.

189 **"the demonstrations are so"**: Descartes, *Principles of Philosophy*, pt. 2, 7th rule, in *The Philosophical Writings of Descartes*, 1:245. He makes similar comments elsewhere; see, e.g., "Description of the Human Body," ibid., p. 317. While Descartes's scientific method went against the empiricism of the day, his mechanism and corpuscularist physics did not; I discuss this aspect of his work and its influence on seventeenth-century science in part 9.

189 **"we behold with astonishment"**: Bacon discussed the microscope in his 1620 book *Novum Organum*, bk. 2, aphorism 39, in *The Works of Francis Bacon*, 4:192–93. While he here seems to downplay the usefulness of the invention, he admits that "if it could be extended to . . . the minutiae of larger bodies, so that the texture of a linen cloth could be seen like network, and thus the latent minutiae and inequalities of gems, liquors, urine, blood, wounds, etc. could be distinguished, great advantages might doubtless be derived from the discovery." Bacon thus divined—and perhaps inspired—how the microscope would soon be used. It should be remembered that microscopes had barely been invented when Bacon wrote that "the subtlety of experiments is far greater than that of the sense itself, even when assisted by exquisite instruments" ("Plan of the Work," ibid., p. 26).

189 **"true and lawful goal"**: Bacon, *Novum Organum*, bk. 1, aphorism 81, in *The Works of Francis Bacon*, 4:79.

189 **But Bacon believed that**: See Ruestow, *The Microscope in the Dutch Republic*, p. 37.

190 **"where sight ceases"**: Bacon, *Novum Organum*, bk. 1, aphorism 50, in *The Works of Francis Bacon*, 4:58.

190 **Even before his reputation**: See Rees, "Baconianism."

190 **While Huygens did not**: By the end of the decade Huygens was being "pestered" by the medical botanist Jan Brosterhuysen for a copy of Bacon's *Sylva sylvarum*, his work comprising lists of proposed experiments and observations that became his most widely read work in his day. See ibid., pp. 108–9.

190 **"I have looked up"**: Huygens's autobiography, quoted in Alpers, *The Art of Describing*, pp. 4–5.

190 **"sacred respect"**: Huygens's autobiography, quoted in Jorink, *Reading the Book of Nature*, p. 4.

190 **Huygens agreed with**: Another early reader of Bacon's works in the Dutch Republic was Isaac Beeckman, who was a director of the Latin school in Rotterdam, then head of the university in Dordrecht. Between 1623 and 1628 Beeckman took careful and copious notes on Bacon's aphorisms in the *Novum Organum*, and on Bacon's experiments in the *Sylva*, commenting on when Bacon got things wrong, in Beeckman's opinion, with the note "*Verulamij errors.*" Beeckman preferred Descartes's rationalist, nonempirical approach. See Dibon, "Sur la réception," p. 95.

190 **Gruter's brother Isaac**: Rees, "Baconianism," p. 109.

190 **Isaac also put out**: See Dibon, "Sur la réception," pp. 99–100.

191 **"The father of Experimental Philosophy"**: Quoted in Weld, *A History of the Royal Society*, 1:328.

191 **Philosophical systems, Petty**: Petty, *The Advice of William Petty to Samuel Hartlib* (1648), cited in Webster, *The Great Instauration*, p. 147.

191 **"They have one place"**: Sprat, *History of the Royal Society*, pp. 88–89; see also Jardine, *Going Dutch*, p. 81.

191 **"Let no man"**: Bacon, *Advancement of Learning*, bk. 1, in *The Works of Francis Bacon*, 3:268.

192 **"which is before our eyes"**: Quoted in Ruestow, *The Microscope in the Dutch Republic*, p. 57.

192 **"We know [God]"**: Quoted in Weststeijn, *The Visible World*, p. 110. The Confession of Faith, known as the Belgic Confession, was first written in 1561.

192 **As Jacob Cats**: Cited in Ruestow, *The Microscope in the Dutch Republic*, p. 57.

192 **"came to attain almost"**: Webster, *The Great Instauration*, p. 335.

192 **"the *Power, Wisdom*"**: See Sprat, *History of the Royal Society*, p. 82.

192 **"It is the glory of God"**: Proverbs 25:2, quoted in Bacon, preface to *The Great Instauration*, in *The Works of Francis Bacon*, 4:20.

192 **"Wisdome of the great"**: Wren, *Monarchy Asserted* (1659), quoted in Webster, *The Great Instauration*, p. 170.

193 **"God has deposited"**: Quoted in Jorink, *Reading the Book of Nature*, p. 4.

193 **nothing in the universe**: Cited in Ruestow, *The Microscope in the Dutch Republic*, pp. 57–58.

193 **While some wondered**: In 1705, Leeuwenhoek told the Royal Society of a visitor who had puzzled over this question of the purpose of microscopic structures. See ibid., p. 79.

193 **behold what was**: Cited in Malet, "Early Conceptualizations of the Telescope as an Optical Instrument," p. 242.

193 **"At last mortals may"**: Huygens, *De gedichten*, quoted in Alpers, *The Art of Describing*, p. 17.

193 **"God's invisibility becomes"**: Quoted in Fournier, "The Fabric of Life," p. 83. The French natural philosopher Peirsec similarly admitted that his study of the eggs of fleas and lice with the microscope caused him to "admire in the highest degree the effects of divine providence, which was far more incomprehensible to us when that aid to our eyes was wanting." Letter to Girolamo Aleandrea, June 7, 1622, quoted ibid., p. 46

193 **"no better way to glorify"**: AvL to Nicolaas Witsen, March 8, 1696, *AB*, 11:239. See also *AB*, 3:396–97, 6:306–9, 338–39, 7:116–17, 378–79.

193 **"often burst out with"**: AvL to RSL, Oct. 15, 1693, *AB*, 9:237.

193 **"Nothing can compel"**: Huygens's autobiography, quoted in Alpers, *The Art of Describing*, p. 9, emphasis added.

194 **When the Royal Society**: As Sprat points out, the original charter of the Royal Society indicated that two "Curators" were to be appointed to oversee experiments. Sprat, *History of the Royal Society*, p. 145.

194 **This latter usage appears**: *Dictionary of Greek and Roman Antiquities*, ed. William Smith (1870), cited in http://incisive.nu/2010/the-curate-and-the-curator/#note-661-2. See also "curator, n.," *OED Online*, http://www.oed.com/view/Entry/45960?redirectedFrom=curator, accessed May 6, 2014.

195 **The first *History***: "Account of Athanasii Kircheri China Illustrata," *Philosophical Transactions* 2 (1665–78): 484–88, and Sprat, *History of the Royal Society*, p. 251.

195 **Only much later would**: "curator, n.," *OED Online*.

195 **Suffering from a variety**: Inwood, *The Forgotten Genius*, p. 8.

195 **"Mr. Hooke observed"**: Quoted ibid., p. 7.

196 **"invented thirty several"**: Quoted ibid., pp. 9-10.

196 **Although an air pump**: See ibid., p. 19, and Shapin and Schaffer, *Leviathan and the Air-Pump*.

196 **"to furnish [the group]"**: Quoted in Inwood, *The Forgotten Genius*, p. 28.

197 **"the most ill-natured"**: Quoted in Weld, *A History of the Royal Society*, 1:293–94.

197 **"I know [Hooke]"**: Quoted in Jardine, *Going Dutch*, p. 296.

197 **From the time of its**: See Fournier, "The Fabric of Life," pp. 48–50.

198 **He had previously presented**: See ibid., p. 52.

198 **I with . . . [a] sharp Penknife**: Hooke, *Micrographia*, p. 113.

198 **By his careful sectioning**: See Fournier, "The Fabric of Life," pp. 34–35.

199 **at the start of 1665**: More precisely, the book was published at the end of 1664, but the title page was imprinted with the date 1665. See ibid., p. 51. Pepys says he saw it in a bindery in Jan. 1665.

199 **"the most ingenious book"**: Quoted in Inwood, *The Forgotten Genius*, p. 57.

199 **Eight of the observations**: Fournier, "The Fabric of Life," p. 53, and Inwood, *The Forgotten Genius*, p. 63.

199 **"The Rules YOU have"**: Hooke, *Micrographia*, preface, n.p.

200 **Like Bacon, Hooke**: See Huerta, *Giants of Delft*, p. 19.

200 **"a supplying of their"**: Hooke, *Micrographia*, preface, n.p.

200 **"the subtilty of the"**: Ibid.

200 **as big as a cat**: Quoted in Ruestow, *The Microscope in the Dutch Republic*, p. 76. See also Fournier, "The Fabric of Life," p. 54. For an opposing view claiming that the images played only a secondary role to the text, see Dennis, "Graphical Understanding."

200 **In these drawings**: Weld says Wren "assisted" Hooke with the book, and notes that Wren did all the drawings for Dr. Willis's *Treatise on the Brain* (see Weld, *A History of the Royal Society*, 1:273). Webster claims Wren drafted illustrations of microscopical objects, later used by Hooke in the book (see Webster, *The Great Instauration*, p. 170). Hooke praised Wren effusively in his preface, saying that "since the time of Archimedes, there scarce ever met in one man, in so great a perfection, such a Mechanical Hand, and so Philosophical a Mind," but does not directly say that Wren made the drawings (see Hooke, *Micrographia*, preface, n.p.).

200 **This was in marked**: Fournier, "The Fabric of Life," p. 54.

201 **"How exceeding curious"**: Hooke, *Micrographia*, p. 180.

201 **During this period books**: As noted by Jardine, *Going Dutch*, p. 291.

201 **The Royal Society's**: Ibid., pp. 264–65.

202 **Christiaan Huygens translated**: Ruestow, *The Microscope in the Dutch Republic*, p. 22–23n89.

202 **The book was well known**: See ibid., p. 23n90, and Jorink, "In the Twilight Zone," p. 153.

202 **Constantijn Huygens, for example**: Osselton, *The Dumb Linguists*, p. 25.

202 **The French philosopher Pierre Bayle**: See Israel, *The Dutch Republic*, p. 1039.

202 **"many of them speake"**: Quoted in Osselton, *The Dumb Linguists*, p. 13.

203 **He would later comment**: AvL to RSL, Sept. 10, 1697, *AB*, 12:219.

203 **Later in his career**: See, e.g., AvL to Robert Boyle, July 28, 1676, *AB*, 2:47.

203 **In both, subjects**: See Damsteegt, "Language and Leeuwenhoek," p. 17n6.

203 **Leeuwenhoek also revealed**: See Ruestow, *The Microscope in the Dutch Republic*, p. 166. See also B. J. Ford, *Single Lens*, p. 59.

203 **In 1675 he remarked**: See AvL to Oldenburg, Dec. 20, 1675, *AB*, 1:343.

203 **He would soon ask**: See AvL to Oldenburg, Jan. 22, 1676, *AB*, 1:343.

203 **In one letter Leeuwenhoek**: See Damsteegt, "Language and Leeuwenhoek," p. 19. Waller is best known for being the editor of Hooke's posthumously published works. He was also a skilled illustrator who often drew images to accompany articles published in the Royal Society's *Transactions*. See Kusukawa, "Picturing Knowledge in the Early Royal Society."

203 **He would have heard**: Brian Ford believes that Leeuwenhoek began to make microscopes only after his exposure to *Micrographia* while in London; this would mean that Leeuwenhoek was lying when he later claimed to be making microscopes from 1659 and to have examined the English chalk with one during his trip in the late 1660s. See B. J. Ford, *Single Lens*, pp. 39–40, and Ruestow, *The Microscope in the Dutch Republic*, p. 23n90. However, while it is certainly possible that Leeuwenhoek was not being truthful about these details, in the absence of evidence in favor of such dissembling it seems more reasonable to assume he was telling the truth. In either case it is clear that he knew *Micrographia* by 1674, because in that year he described sections he made of various samples—these are the same objects, listed in the same order, as those appearing on one page of Hooke's book. See B. J. Ford, *Single Lens*, p. 59.

204 **"A piece of the finest"**: Hooke, *Micrographia*, p. 5.

204 **The sight of colored**: Ibid., p. 7.

204 **Like Leeuwenhoek, Hooke**: As Felicity Henderson explains on her website *Hooke's London*, "In March 1674 he wrote 'at Barrets made tryall of Golding flowerd Shift wch succeeded.'—which (I think!) means that they

tried applying gold leaf to a shift already printed with a flower pattern. As late as 1679 Hooke was still discussing cloth printing with Barrett: 'At Barrets, with him to Garways [ie. Garraway's coffeehouse]. Discoursd to him the way of staining Sattin with Lead moulds and copper plates.'" See http://hookeslondon.com/2013/08/27/artists-and-craftsmen-2/#more-161.

205 **"good *plano convex*"**: For these quotes about microscope making, see Hooke, *Micrographia*, preface, n.p.

206 **And, because of the need**: See Ruestow, *The Microscope in the Dutch Republic*, p. 16.

206 **Hartsoeker declared the single-lens**: See ibid., p. 15.

206 **Until the nineteenth century**: B. J. Ford, *Single Lens*, p. 124.

206 **Indeed, as late as 1854**: See ibid., p. 5.

PART EIGHT: YEAR OF CATASTROPHE

207 **More recently, he had**: See Jorink, "In the Twilight Zone," p. 131.

207 **A member of the city government**: See Fournier, "The Fabric of Life," p. 23, and Jorink, "In the Twilight Zone," p. 154.

207 **They pulled on the ropes**: See Israel, *The Dutch Republic*, pp. 798–99.

208 **Though the plan had**: See ibid., pp. 796–99.

208 **"strong, high rampart"**: Boitet, *Beschrijving der stadt Delft*, quoted in Swillens, *Johannes Vermeer*, p. 30.

209 **Most members of the marksmen**: Israel, *The Dutch Republic*, pp. 121–22.

209 **These weekday services**: See ibid., p. 644.

210 **The regents of the provinces**: See ibid.,pp. 799–801.

210 **Participants in this mob**: Ibid., p. 803.

210 **A phrase was coined**: See Dreiskämper, *Redeloos, radeloos, reddeloos*, p. 7, and Klever, "Spinoza's Life and Works," p. 40.

210 **On September 10**: Israel, *The Dutch Republic*, p. 806.

210 **Under the command**: Ibid., p. 797.

211 **The young Prince William**: See ibid., pp. 808–14.

211 **Once Dutch merchant ships**: Ibid., pp. 818–19.

211 **Taxes were raised**: Swillens, *Johannes Vermeer*, p. 29.

212 **"especially paintings and such"**: Israel, *The Dutch Republic*, p. 881, quoting Gerrit Uylenburgh. Uylenburgh's particular financial troubles had much to do with his selling fake master paintings to the Great Elector of Brandenburg, Friederich Wilhelm. I discuss this further in section 5, below.

212 **He had to offer**: See Montias, *Artists and Artisans in Delft*, p. 215.

212 **Unable to pay**: See Montias, *Vermeer and His Milieu*, p. 318. Although De Cocq also sold artists' supplies, such as linseed oil and turpentine, it appears that Vermeer owed him money for medications.

212 **These effects become most**: Gowing, *Vermeer*, p. 25.

212 **Indeed, Vermeer's highlighting**: See Liedtke, "De Hooch and Vermeer," p. 155.

212 **However, Vermeer's method**: See Huerta, *Giants of Delft*, p. 99.

213 **Over these layers**: Wheelock, *Vermeer and the Art of Painting*, p. 68.

213 **He next bordered**: See Huerta, *Giants of Delft*, p. 50.

213 **Sometimes, as in *Young Woman***: Wadum, "Contours of Vermeer," p. 205.

213 **He was also a master**: See Wheelock, "Vermeer of Delft,", p. 25.

213 **The secondary shadow**: Wheelock, *Vermeer and the Art of Painting*, p. 12.

213 **In *Woman with a Balance***: See Gifford, "Painting Light," pp. 187–88.

214 **Finally, he added**: Wheelock, *Vermeer and the Art of Painting*, pp. 11–12.

214 **To suggest the objects**: See Gifford, "Painting Light," p. 190.

214 **Elsewhere in the picture**: Liedtke, *Vermeer*, p. 48.

214 **In the lead bars**: See Wheelock, *Vermeer and the Art of Painting*, p. 93, and Gifford, "Painting Light," pp. 190–91.

214 **In the viola's red**: Gifford, "Painting Light," pp. 192–93.

214 **He suggested this**: Ibid., p. 194.

215 **"He recorded light effects"**: Ibid., p. 195.

215 **"sat in a dark closet"**: Liedtke, *Vermeer*, p. 49.

215 **at least three months**: Walter Liedtke, MMA gallery lecture, June 20, 2013.

216 **This beading effect**: Costaras, "A Study of the Materials and Techniques of Johannes Vermeer," p. 156.

216 **like that of Titian**: On Titian's method, Andrea Bayer, curator at the MMA, gallery lecture, Oct. 10, 2013.

216 **It is estimated that**: Walter Liedtke, MMA gallery lecture, June 20, 2013. Montias believes that he painted between forty-five and sixty pictures, at the rate of two to three a year. See Montias, *Vermeer and His Milieu*, pp. 184–85.

216 **In earlier years, when**: Montias estimates that Vermeer's income in a good year was as high as 1,500 guilders, plus rent-free accommodations. Ibid.

216 **But later, during**: See Liedtke, *Vermeer*, p. 12.

216 **"mania for maps"**: Thoré-Bürger (1866), quoted in Welu, "Vermeer: His Cartographic Sources," p. 529.

217 **Maps became so common**: See ibid., p. 534.

217 **Map production throughout**: Huerta, *Giants of Delft*, p. 20.

217 **By making this adjustment**: See Liedtke, *Vermeer*, p. 113, and http://www.essentialvermeer.com/catalogue/woman_in_blue_reading_a_letter.html.

218 **A comparison of that map**: See Welu, "Vermeer: His Cartographic Sources," p. 530.

218 **The map shows the Zyp**: See ibid., p. 534.

218 **Although it was not**: Ibid., pp. 532–34. Welu notes that a corner of the map can be seen in the upper left foreground of *The Love Letter* as well, though this is far from obvious on viewing the picture.

219   **These were related endeavors**: See Liedtke, *Vermeer*, p. 150, and Welu, "Vermeer's Astronomer," p. 263.

219   **Holland's greatest mapmaker**: Welu, "Vermeer's Astronomer," p. 263.

219   **Vermeer meticulously re-creates**: See Welu, "Vermeer: His Cartographic Sources," p. 545.

219   **If Vermeer owned**: Ibid., p. 546.

219   **A map on the wall**: See Welu, "Vermeer's Astronomer," p. 265.

220   **Two unidentified maps**: Liedtke, *Vermeer*, p. 150.

220   **The map in Vermeer's**: One can see across the top of the map the note that the map was made by Nicolem Piscatorem, or Nicolas Piscator, which was one name that Nicolas Visscher called himself (his father sometimes used Nicolas Jansz. Piscator). See Welu, "The Map in Vermeer's 'Art of Painting,'" p. 9.

220   **This map was, for centuries**: Welu, "Vermeer: His Cartographic Sources," p. 536.

220   **The Visscher map appears**: See ibid., pp. 538–39.

220   **It also features several**: Alpers, *The Art of Describing*, p. 121.

220   **Vermeer shows the map**: See Welu, "The Map in Vermeer's 'Art of Painting,'" p. 12.

220   **These elements, such as**: Ibid., p. 9.

220   **Vermeer's mastery at depicting**: Welu, "Vermeer: His Cartographic Sources," p. 536.

220   **The map presents to us**: See Steadman, *Vermeer's Camera*, p. 39.

221   **The seventeen provinces**: Welu, "Vermeer: His Cartographic Sources," p. 540.

221   **The great mapmaker Jacobus Hondius**: See Alpers, *The Art of Describing*, p. 256n2.

221   **Cornelis Drebbel, for instance**: Ibid., p. 127.

221   **Claes Visscher was not only**: Ibid., p. 128.

222   **Mapmaking was considered**: See Welu, "The Map in Vermeer's 'Art of Painting,'" pp. 17–19.

222   **"How wonderful a good"**: Van Hoogstraten, *Inleyding*, p. 7, quoted in Alpers, *The Art of Describing*, p. 141.

222   **to bring objects before**: As Alpers has perceptively noted in ibid., p. 133.

222   **"Those chartes being"**: Quoted ibid., p. 157.

222   **Placing maps within pictures**: Ibid., p. 159; see also p. 147.

222   **Mapping grew out of**: Ibid., p. 147.

223   **Van Hoogstraten would go on**: Yalcin, "Van Hoogstraten's Success in Britain," p. 166.

223   **Bacon's idea of science**: See Van Hoogstraten, *Inleyding*, p. 188, cited ibid., p. 182n30.

223   **The group watched experimental**: Ibid., p. 175.

223   **Van Hoogstraten's overriding**: Weststeijn, *The Universal Art of Samuel van Hoogstraten*, p. 31.

224 **"to unroll the volume"**: Van Hoogstraten, *Inleyding*, p. 70, quoting from Bacon, preface to *Historia naturalis* [i.e., the *Sylva sylvarum*] (1622). For both, see Weststeijn, *The Visible World*, p. 110.

224 **This view resonated**: See Weststeijn, *The Visible World*, p. 297.

224 **Bacon, too, had written**: Bacon, *Advancement of Learning*, bk. 1, in *The Works of Francis Bacon*, 3:265.

224 **Like Calvin and Bacon**: It has been argued that Calvinism and the "two books" doctrine not only brought about a new science and philosophy but also contributed to the development of the realistic visual arts in the Dutch Republic. See Weststeijn, *The Visible World*, p. 111.

224 **"since [painting] is onely"**: Henry Peachem, *The Compleat Gentleman* (1634), quoted ibid., p. 112.

224 **"in the continued mirroring"**: Van Hoogstraten, *Inleyding*, p. 346, quoted in Weststeijn, *The Universal Art of Samuel van Hoogstraten*, p. 31.

224 **"nowadays human sensibility"**: Quoted in Weststeijn, *The Visible World*, p. 112.

224 **Van Hoogstraten began**: The manuscript was, at some point, in the hands of his student Arnold Houbraken, but it was never published, and its whereabouts today are unknown. See Horn, "Great Respect and Complete Bafflement," pp. 210–16.

224 **The invisible world lying**: On this point see Weststeijn, *The Universal Art of Samuel van Hoogstraten*, pp. 9–10.

225 **Rembrandt, like Van Hoogstraten**: See Weststeijn, *The Visible World*, pp. 318, 324–25.

225 **Besides Vermeer, serving**: Paul, "Cultivating Virtuosity," p. 19.

226 **At that time Italian**: Bok, "Society, Culture and Collecting in 17th Century Delft," p. 208.

226 **Most Italian paintings**: In his survey of death inventories, Montias has found that few paintings by Italian masters were in Delft in Vermeer's time: there were only ten paintings by Italian masters out of two thousand paintings by known artists in inventories taken between 1610 and 1679. See ibid., p. 209.

227 **"not only were not excellent"**: On this episode see Montias, *Vermeer and His Milieu*, pp. 207–8, and Swillens, *Johannes Vermeer*, p. 29.

PART NINE: THE INVISIBLE WORLD

229 **Oldenburg must have**: This remarkable event was reported by both Pepys (in a diary entry of June 25, 1667) and Evelyn (in a diary entry of Aug. 8, 1667). Evelyn noted that on that day he had "visited Mr. Oldenburg, a close prisoner in the Tower, being suspected of writing intelligence [state secrets]." See Weld, *A History of the Royal Society*, 1:204.

230 **"That it may be"**: Translated and quoted in Dobell, *Antony van Leeuwenhoek and His "Little Animals,"* pp. 40–41.

231  **It is believed that Leeuwenhoek**: In the "Biographical Register" of *AB*, vol. 2, the editors state as a fact that Leeuwenhoek owned these two portraits (see p. 469). But evidence for this claim is hard to come by. The provenance of both of these portraits is murky. The Hals portrait was listed in the death inventory of Hendrik Swalmius, who died in June of 1652. See Biesboer, *Collections of Paintings in Haarlem, 1572–1745*, p. 164. Where the painting went after that is unknown; it suddenly appeared at a Sotheby's auction in 1934 as the property of a Scottish collector (see Detroit Institute of Arts website for known provenance: http://www.dia.org/object-info/52ff45ec-bcd3-4579 -9926-48c15fef11dc.aspx?position=1). The portrait could have been left to Cornelia by Hendrik Swalmius. The Rembrandt portrait seems to have been left to Eleazar Swalmius's grandson Johannes Dilburgh, who died in 1696 (see Montias, *Art at Auction in 17th Century Amsterdam*, pp. 167–68); it next is known to have belonged to the brother of Louis XIV, Louis Philippe II, Duc d'Orléans, in 1727. So this one is unlikely to have been owned by Leeuwenhoek and his wife, though they may have had it on a short loan.

231  **But it was De Graaf**: See Ruestow, *The Microscope in the Dutch Republic*, p. 149.

231  **He would eventually become**: See Israel, *The Dutch Republic*, p. 907. For more on Ruysch see Margócsy, "A Philosophy of Wax."

232  **Leeuwenhoek would later**: AvL to RSL, Jan. 14, 1678, *AB*, 2:311–13.

232  **Catholics tended to know**: See Israel, *The Dutch Republic*, p. 641.

232  **Although the Dutch Republic**: The Holland Society of Science was founded in 1752, the Zeeland Society of Sciences in 1765. See Israel, *The Dutch Republic*, p. 1065.

233  *Liefhebbers* **can be translated**: See Jorink, *Reading the Book of Nature*, p. 9.

233  **The term was employed**: See Weststeijn, *The Universal Art of Samuel van Hoogstraten*, p. 22.

233  **At the time, natural philosophers**: On the professionalization of scientists in the nineteenth century, see Snyder, *The Philosophical Breakfast Club*.

233  **Leeuwenhoek thought of himself**: *Liefhebber* had two meanings in Dutch at the time. One was "amateur" or "dabbler." But it was also the term used for those citizens who chose not to register themselves as members of the Dutch Reformed Church. Catholics and other non-Protestants—like Vermeer after his marriage, and Baruch Spinoza—were *liefhebbers*, but so were many Protestants who did not wish to submit themselves to the ecclesiastical discipline of the Reformed Church, as one did not need to be officially a member of the Reformed Church to get baptized, married, or buried in the church. See Kooi, *Calvinists and Catholics during Holland's Golden Age*, pp. 32–33.

233  **Soon after Leeuwenhoek wrote**: See Ruestow, *The Microscope in the Dutch Republic*, p. 149.

233  **"He is a person unlearned"**: Quoted in Dobell, *Antony van Leeuwenhoek and His "Little Animals,"* pp. 43–44.

233 **During these fifty years**: See Weld, *A History of the Royal Society*, 1:243–45.

233 **Most of his letters**: See Ruestow, *The Microscope in the Dutch Republic*, p. 150.

234 **"unarranged promiscuously"**: AvL to Oldenburg, Feb. 11, 1675, *AB*, 1:233.

235 **"discover their interior"**: Cavendish, *Observations on Experimental Philosophy*, preface, n.p.

235 **He was using a microscope**: See Fournier, "The Fabric of Life," pp. 69ff.

236 **"The operations of animals"**: Borelli, translated and quoted ibid., p. 79.

236 **Like Beeckman, Descartes**: See Ruestow, *The Microscope in the Dutch Republic*, p. 39.

237 **"the heavenly machine"**: Kepler and Boyle quoted in Panek, *Seeing and Believing*, p. 85.

237 **In his inaugural lecture**: Cited in Wilson, *The Invisible World*, pp. 13–14.

237 **Later, when Leeuwenhoek**: See Ruestow, *The Microscope in the Dutch Republic*, p. 67, and Fournier, "The Fabric of Life," pp. 126–27.

237 **He subsequently concluded**: AvL to RSL, Feb. 1, 1692, *AB*, 8:245.

237 **Leeuwenhoek could have known**: Snelders, "Antoni van Leeuwenhoek's Mechanistic View of the World," p. 62.

237 **Some writers, however**: See Meli, "Machines and the Body," pp. 54–56.

238 **"descend into the interior"**: Joannes de Raey, *Clavis philosophiae naturalis* (1654), quoted in Ruestow, *The Microscope in the Dutch Republic*, p. 41.

238 **"come to know the structure"**: Quoted in Wilson, *The Invisible World*, p. 14.

238 **By the 1680s, microscopical**: Such as Govard Bidloo, *Anatomia humani corporis* (1685) and Steven Blanckaert, *De nieuw hervormde anatomie* (1686). See Ruestow, *The Microscope in the Dutch Republic*, p. 83n13.

238 **"rummaging through"**: Pierre Bayle, *Nouvelles de la République des lettres* (1686), quoted ibid., p. 41.

239 **Members of the public**: See Rupp, "Matters of Life and Death," pp. 263–69.

239 **"nor was it spurned"**: Francesco Cavazza, *Le scuolo dell' antico studio Bolognese* (1896), quoted in Wilson, *The Invisible World*, p. 24.

239 **The Leiden theater possessed**: Rupp, "Matters of Life and Death," p. 272.

239 **The Delft theater displayed**: Ibid., pp. 275–76.

240 **By such methods**: See Fournier, "The Fabric of Life," p. 68.

240 **He was the first**: Ibid., p. 69.

240 **By the end of the**: For more on the Bologna silkworm industry during this period, see Poni, "Per la storia del distretto industriale serico di Bologna (secolo XVI–XIX)."

241 **He also detected**: Fournier, "The Fabric of Life," p. 72.

241 **In 1669 he published**: See Weld, *A History of the Royal Society*, 1: 227.

241   **Margaret Cavendish could**: "The Silk-worm digs her Grave as she doth spin / And makes her Winding-sheet to lap her in: / And from her Bowels takes a heap of Silk, / Which on her Body as a Tomb is built: / Out of her ashes do her young ones rise; / Having bequeath'd her Life to them, she dyes." *Nature's Pictures Drawn by Fancie's Pencil to the Life*.

241   **"the parts belonging"**: Malpighi, *De bombyce* (The silkworm), quoted in Fournier, "The Fabric of Life," p. 72.

241   **Aristotle had correctly noted**: See Ruestow, *The Microscope in the Dutch Republic*, p. 232.

242   **"lies concealed in"**: See Fournier, "The Fabric of Life," p. 74, Cobb, *Generation*, pp. 234–35, and Ruestow, *The Microscope in the Dutch Republic*, pp. 237–40.

242   **"a glass-jar, full"**: Minutes of the meeting of July 31, 1660, in Weld, *A History of the Royal Society*, 1:113.

243   **This claim had the benefit**: On Aristotle, Hippocrates, and Galen, see Cobb, *Generation*, pp. 14–16.

244   **After he had settled**: See Rupp, "Matters of Life and Death."

244   **An image of that specimen**: Birch, *The History of the Royal Society*, 2:397.

244   **the "thready" nature**: Quotations from Van Horne and De Graaf in Cobb, *Generation*, p. 113.

244   **Swammerdam threw oil**: See Swammerdam, *Miraculum naturae sive uteri muliebris fabrica* (1672), cited in Ruestow, *The Microscope in the Dutch Republic*, p. 47.

245   **But he had ignored**: See Lindeboom, "Leeuwenhoek and the Problem of Sexual Reproduction," p. 131.

245   **It also underlined**: See Cobb, *Generation*, pp. 183–86.

245   **Leeuwenhoek would later report**: AvL to Royal Society and to George Garden, March 19, 1694, *AB*, 10:59. As Cobb notes, another source claims that this argument took place at Leeuwenhoek's house: "Albrecht von Haller says that there was a quarrel between de Graaf and Swammerdam at the home of Antonie van Leeuwenhoek, in consequence of which de Graaf died within twenty-four hours." However (as Cobb also points out), Haller gave no source for this story (see Cobb, *Generation*, p. 285n73).

246   **Many of Leeuwenhoek's**: See *AB*, 1:92ff, 2:206–7, 210ff, 290–91, 326–27, 3:146–47, 422–23, 4:152–53, 6:18–19, 312–13, 7:136–39.

246   **"a hungry Lowse upon"**: AvL to Oldenburg, Aug. 15, 1673, *AB*, 1:55.

246   **"The Lowse having fixt"**: Ibid.

247   **"lousy discourse"**: AvL to Frederik Adriaan van Reede van Renswoude, Feb. 20, 1696, *AB*, 7:179–217.

248   **"I tooke a bodkine**: Newton, "An experiment to put pressure on the eye," Cambridge University Library, Ms. Add. 3995, p. 15, available at http://www.lib.cam.ac.uk/exhibitions/Footprints_of_the_Lion/private_scholar.html.

248   **"two pounds of good"**: See AvL to RSL, Oct. 12, 1685, *AB*, 5:315–17

248 **Instead, he observed**: Ruestow, *The Microscope in the Dutch Republic*, p. 188.

249 **Malpighi had discerned**: Ibid.

249 **"when I was at your"**: AvL to Constantijn Huygens, April 5, 1674, *AB*, 1:67.

249 **"many times repeated"**: AvL to Hooke, Jan. 14, 1678, *AB*, 2:307.

249 **He looked at other**: See Cole, "Leeuwenhoek's Zoological Researches, Part I," p. 20.

249 **Since he said that**: See Dobell, *Antony van Leeuwenhoek and His "Little Animals,"* p. 335.

249 **Leeuwenhoek told Hooke**: AvL to Hooke, April 5, 1674, *AB*, 1:67.

249 **Even when he sent**: AvL to Oldenburg, July 6, 1674, *AB*, 1:123–25. The rouleaux occur either because of problems with preparing the blood specimen for observing or because of the presence of one of several diseases that involve a high level of abnormal globulins or fibrinogen in the blood.

249 **It would take four**: See Ruestow, *The Microscope in the Dutch Republic*, pp. 188n54, 194.

251 **"I thereupon concluded"**: AvL to Oldenburg, Sept. 7, 1674, *AB*, 1:139–53.

251 **Recently Brian Ford**: B. J. Ford, *Single Lens*, pp. 47–49.

251 **After describing his**: AvL to Oldenburgh, Sept. 7, 1674, *AB*, 1:161–63.

252 **Some of [them] were**: Ibid., p. 165.

253 **"above a thousand times"**: Ibid., pp. 163–65.

254 **"Last summer I"**: AvL to Oldenburg, Dec. 20, 1675, *AB*, 1:331.

254 **"I detected living"**: AvL to Oldenburg, Jan. 22, 1676, *AB*, 1:347.

254 **"I imagine, that"**: AvL to Oldenburg, Oct. 9, 1676, *AB*, 2:75. (This letter was written in the hand of another, but signed by Leeuwenhoek.)

255 **In later years Leeuwenhoek**: See *AB*, 3:12–93, 332–33, 5:20–21, and Ruestow, *The Microscope in the Dutch Republic*, p. 180. Leeuwenhoek had estimated a coarse grain of sand to be 1/30 of an inch in diameter. See Dobell, *Antony van Leeuwenhoek and His "Little Animals,"* p. 335.

255 **"I have seen several hundreds"**: AvL to Oldenburg, Oct. 9, 1676, *AB*, 2:61–77.

255 **"This water is in Summer"**: AvL to Oldenburg, Oct. 9, 1676, *AB*, 2:85–87.

258 **"For me this was"**: The descriptions of this experiment are ibid., pp. 95–115.

258 **"it was pretty"**: Ibid., p. 117.

258 **Leeuwenhoek's beloved "little dog"**: AvL to Oldenburg, Feb. 22, 1676, *AB*, 1:361. On the parrot, see AvL to RSL, Oct. 15, 1693, *AB*, 9:209.

259 **This appears to be**: AvL to Oldenburg, Oct. 9, 1676, *AB*, 2:125–29.

259 **Oldenburg was instructed**: See Ruestow, *The Microscope in the Dutch Republic*, p. 154.

259 **He could see that**: See AvL to Oldenburg, March 23, 1677, *AB*, 2:197–99.

259 **figuring that the animals**: Ibid.

260 **"This exceeds belief"**: AvL to Oldenburg, Oct. 5, 1677, *AB*, 2:255.

260 **This was not unusual**: On Torricelli and secrecy, see Molesini, "The Optical Quality of 17th Century Lenses," p. 119.

261 **The Royal Society may not**: See Principe, *The Secrets of Alchemy*, p. 117, and *The Aspiring Adept*, pp. 115–34.

261 **In July 1783 Price**: See Principe, *The Secrets of Alchemy*, pp. 88–89.

262 **"At present I use"**: AvL to Oldenburg, Jan. 22, 1675, *AB*, 1:211.

262 **"My method for seeing"**: AvL to Oldenburg, Oct. 9, 1676, *AB*, 2:125–29.

262 **"The fault is mine"**: AvL to Oldenburg, March 26, 1675, *AB*, 1:293–95.

262 **He did disclose that**: AvL to Oldenburg, March 23, 1677, *AB*, 2:199–201. Leeuwenhoek states clearly that he introduces the water into a "clean little glass tube." See also Dobell, *Antony van Leeuwenhoek and His "Little Animals,"* p. 169, and Ruestow, *The Microscope in the Dutch Republic*, p. 154.

262 **However, he invited**: AvL to Oldenburg, March 26, 1675, *AB*, 1:279.

262 **sending legal affidavits**: They were attached to AvL's letter to Oldenburg, Oct. 5, 1677, *AB*, 2:256–71.

263 **"Well, as eye-witnesses"**: Affidavit signed by B. Haan (Delft) and H. Cordes (The Hague), dated May 18, 1677, *AB*, 2:257–61.

263 **"pepper-water not exceeding the size"**: Affidavit signed by R. Gordon, June 2, 1677, *AB*, 2:263.

263 **"above thirty thousand Living"**: Affidavit signed by A. Hodenpijl, Aug. 13, 1677, *AB*, 2:267.

263 **"did not exceed"**: Affidavit signed by J. Boogert, R. Poitevin, and W. V. Burch, Aug. 21, 1677, *AB*, 2:267.

263 **"being killed by the vinegar"**: Affidavit signed by A. Petrie, Aug. 30, 1677, *AB*, 2:274.

264 **Grew was famed**: See Fournier, "The Fabric of Life," p. 99.

264 **Hooke was so busy**: See Inwood, *The Forgotten Genius*, chap. 9.

265 **Hooke rather disingenuously**: For Hooke's claim see Birch, *The History of the Royal Society*, 3:347–48.

265 **Apparently he was busy**: Ibid., p. 349.

265 **"[The little animals] were observed"**: Ibid., p. 352.

266 **"very well pleased"**: Quoted in Dobell, *Antony van Leeuwenhoek and His "Little Animals,"* p. 184.

266 **As a snide comment on**: Hooke, *Microscopium: or, Some New Discoveries Made with and Concerning Microscopes* (1678), included in Hooke, *Lectures and Collections*.

266 **"We had such stories"**: John Locke, quoted in Wilson, *The Invisible World*, p. 237.

266 **"Among the ignorant"**: Leeuwenhoek, *Send-brief* XXXII, p. 317, quoted in Dobell, *Antony van Leeuwenhoek and His "Little Animals,"* p. 76.

PART TEN: GENERATIONS

267 **"fallen into a frenzy"**: Attestation of Catharina Vermeer to the city council, reproduced in Montias, *Vermeer and His Milieu*, appendix B, pp. 344–45.

267 **Over the summer he**: See ibid., pp. 212–14. Maria Thins not only lost the interest on the 2,900 guilders capital but was forced to pay back the loan later in order to retrieve the collateral sum.

267 **Catharina had watched**: The burial registers of the Oude Kerk record that Vermeer was buried on Dec. 15, 1675; it is incorrectly stated in the margin that Vermeer left "eight minor" children. In fact, Johannes and Catharina had ten minor children living at home at the time of his death. The register of graves noted that "on December 1675 Johan Vermeer was laid in his grave and the above-mentioned infant [*baerkint*] was placed on the coffin of the aforementioned Vermeer." Vermeer's infant was buried on June 27, 1673. Burial register, DTB 14 inv. 42, folio 77v. See also Montias, *Vermeer and His Milieu*, p. 213 and appendix B, p. 337.

268 **As her own mother**: Doc. no. 382, July 27, 1677, translated and reprinted in Montias, *Vermeer and His Milieu*, appendix B, p. 351.

268 **"Their worships the Sherriffs"**: Doc. no. 370, Sept. 30, 1676, translated and reprinted in ibid., p. 346.

268 **Because of this, Montias**: See Montias, "Recent Archival Research on Vermeer," pp. 101–2.

268 **In Vermeer's and Leeuwenhoek's**: According to Montias himself; see his *Artists and Artisans in Delft*, p. 223.

269 **She was a schoolteacher**: Her burial notice states "stadschool in Achtersack"—which suggests that she had been at the school on the Achtersack road. It is possible she worked at the school in a different capacity. DTB Delft 14, inv. 42, folio 155.

269 **But in December**: The marriage license is DTB Delft 14, inv. 74, folio 5. The amended document states "scheidingen 9e. keurboek." *Scheidingen* generally referred to a separation or divorce, and the "9e keurboek" would have been the ninth volume of the resolutions of the city council.

269 **Leeuwenhoek's daughter**: ORA (Old Judicial Archive) Delft, inv. 281–83, folio 408R1, cited at http://lensonleeuwenhoek.net/content/daughter -maria-named-will-her-aunt-maria-de-meij.

270 **He would go on**: See AvL to Hooke, Nov. 12, 1680, *AB*, 3: 281–85, and AvL to RSL, Jan. 5, 1685, *AB*, 5:29–59.

270 **Vermeer might have asked**: By 1674, however, Catharina Cramer had died and Ritmejer was now married to Alette van Sprinckhuijse, who was a neighbor of Vermeer's on the Oude Langendijck. Still, Vermeer may have had questions about the handling of Catharina Cramer's estate, vis-à-vis his soon-to-be son-in-law.

270  **We know he would later**: See Montias, *Artists and Artisans in Delft*, p. 203n.

271  **Vermeer would have known**: See ibid., p. 370.

271  **That would have been**: At the time white bread was selling for about eleven pounds per guilder, or one loaf for two stuivers and ten pennies. The amount owed to Van Buyten corresponds to about eight thousand pounds of white bread. Vermeer's large family could well have consumed six to eight pounds of bread per day, meaning that the debt to Van Buyten was probably for two or three years' worth of bread deliveries. For the price of bread, see Montias, *Vermeer and His Milieu*, pp. 217–18, and n. 7.

272  **If the pictures were sold**: Montias, *Vermeer and His Milieu*, pp. 216–18 and appendix B, p. 338.

272  **On February 22 or 24**: Ibid., pp. 338–39.

272  **On the twenty-ninth**: See ibid., pp. 339–44.

273  **But possibly these**: Ibid., pp. 220–22.

273  **"She, supplicant, charged"**: Ibid., pp. 344–45.

274  **It was not uncommon**: See C. Ford, "Introduction," pp. 21–24.

274  **Three years after**: See Montias, *Vermeer and His Milieu*, p. 100.

274  **At the end of the**: See Schama, *The Embarrassment of Riches*, p. 334.

275  **Leeuwenhoek requested**: See Montias, *Vermeer and His Milieu*, pp. 226–27.

275  **Leeuwenhoek reported that**: See AvL to Oldenburg, May 14, 1677, *AB*, 2:229–31.

275  **In November, Leeuwenhoek**: See Montias, *Vermeer and His Milieu*, p. 219.

276  **In February 1677**: Ibid., p. 228 and appendix B, pp. 348–49. See also Wheelock, *Perspective, Optics, and Delft Artists around 1650*, p. 266.

276  **On March 15**: Swillens, *Johannes Vermeer*, p. 191, appendixes 17 and 18, and Wheelock, *Perspective, Optics, and Delft Artists around 1650*, p. 266.

276  **Decades later, after**: See Ruestow, *The Microscope in the Dutch Republic*, p. 151.

277  **Probably, it was**: See ibid., p. 217.

277  **Ham had seen**: See Hall, "The Leeuwenhoek Lecture," p. 259.

278  **"What I investigate"**: AvL to Lord Brouncker, Nov. 1677, *AB*, 2:281–93.

278  **While history does not**: See AvL to RSL, July 11, 1687, *AB*, 6:319.

278  **"they moved forward"**: AvL to Lord Brouncker, Nov. 1677, *AB*, 2:281–93.

278  **He realized that**: See *AB*, 3:8–19, 202–9, 324–25.

278  **He would observe sperm**: See, e.g., AvL to Grew, April 25, 1679, *AB*, 3:3–9, AvL to Hooke, Jan. 12, 1680, *AB*, 3:145, and AvL to Hooke, Nov. 12, 1680, *AB*, 3:315–31.

279  **Leeuwenhoek examined**: See AvL to Hans Sloane, June 14, 1700, *AB*, 13:111.

279  **He had found**: See AvL to RSL, May 14, 1686, *AB*, 6:63–65, and Aug. 6, 1687, *AB*, 7:7–15.

279  **"I am quite convinced"**: AvL to RSL, Oct. 17, 1687, *AB*, 7:113, and AvL to RSL, April 30, 1694, *AB*, 10:93.

279  **"old wives' tales of foolish"**: AvL to Antonio Magliabecchi, 1695, *AB*, 11:47.

279  **"It is exclusively"**: AvL to Grew, March 18, 1678, in *AB*, 2:331.

279  **He believed that the sperm**: See Lindeboom, "Leeuwenhoek and the Problem of Sexual Reproduction," pp. 147–49.

279  **"Man comes not from"**: AvL to Wren, Jan. 22, 1683, *AB*, 4:11. This translation is taken from Cobb, *Generation*, p. 208; it differs slightly from the translation in *AB*.

280  **The article was accompanied**: It has been suggested that the article was intended as a satire, but that Leeuwenhoek did not realize this. See Lindeboom, "Leeuwenhoek and the Problem of Sexual Reproduction," p. 149.

280  **Leeuwenhoek himself believed**: AvL to RSL, June 9, 1699, *AB*, 12:293–305.

280  **"Although I have sometimes"**: AvL to RSL, July 13, 1685, *AB*, 5:237. In the same letter, Leeuwenhoek allowed himself to hope that at some point "we have the good fortune to come across an animal whose male seeds will be so large that we can recognize in it the figure of the creature from which it has come." That may be why he asked a whaling ship's captain to obtain for him the penis of a whale.

280  **He did this in his**: AvL to RSL, March 30, 1685, *AB*, 5:157–59.

281  **Looking at the uterus**: AvL to the RSL, Jan. 23, 1685, *AB*, 5:137.

281  **He continued to claim**: AvL to Wren, Jan. 22, 1683, *AB*, 4:11, and AvL to RSL, March 30, 1685, *AB*, 5:139.

281  **"the great secret of generation"**: AvL to Francis Aston, Sept. 17, 1683, *AB*, 4:123.

281  **Leeuwenhoek had claimed**: AvL to Grew, April 25, 1679, *AB*, 3:25–35.

281  **"wrote about the great"**: Ibid., p. 23.

281  **"we can only guess"**: AvL to RSL, July 10, 1696, *AB*, 11:321.

282  **She was buried**: See Montias, *Vermeer and His Milieu*, p. 237.

282  **Vermeer was not alone**: Liedtke, "De Hooch and Vermeer," p. 168.

283  **In the satin we have**: Liedtke, *Vermeer*, p. 172. The same can be said for the blue satin overskirt of *Young Woman Seated at a Virginal*.

283  **"the purity of his masterpieces"**: Wheelock, *Perspective, Optics, and Delft Artists around 1650*, p. 262.

283  **"un vin pétillant éventé**: Michael Taylor, *Les mensonges de Vermeer*, quoted in Bell, "The Mysterious Women of Vermeer," p. 86.

284  **In each of the two**: See also Liedtke, *Vermeer*, pp. 170–71.

284  **It has been said**: See Mayor, "The Photographic Eye," p. 20.

285  **Closer to Vermeer**: See Kemp, *The Science of Art*, p. 213.

286  **Perhaps this is why**: In 1813 *The Art of Painting* was sold to Count Johann Rudolf Czerni by a "saddler," as a picture by Pieter de Hoogh, for thirty guilders. See Swillens, *Johannes Vermeer*, p. 61.

286  **"the only master who"**: Goncourt and Goncourt, *Journal*, 1:727.

PART ELEVEN: SCIENTIFIC LION

287  **"I then again and again"**: All quotations pertaining to his teeth-cleaning habits in the first two paragraphs are taken from the letter from AvL to Francis Aston, Sept. 17, 1683, *AB*, 4:127–29.

288  **"there are living more animals"**: AvL to RSL, Sept. 16, 1692, *AB*, 9:135–37.

288  **The society sent Leeuwenhoek**: See Dobell, *Antony van Leeuwenhoek and His "Little Animals,"* pp. 46–50.

288  **"so great but unmerited"**: AvL to RSL, May 13, 1680, *AB*, 3:221.

288  **The great honor even**: The "van" first appears in a letter to the Royal Society of Jan. 5, 1685, *AB*, vol. 5: 1–67.

288  **A bemused Constantijn Huygens**: See Ruestow, *The Microscope in the Dutch Republic*, p. 160.

288  **As Leibniz would later**: Leibniz to Constantijn Huygens, quoted ibid., p. 67. On Leibniz's trip to Amsterdam and Delft, see Nadler, *The Best of All Possible Worlds*, p. 218.

289  **Van Leeuwenhoek pointed**: AvL to RSL, Jan. 5, 1685, *AB*, 5:64.

289  **"The Snow so chilled him"**: Aubrey, *Brief Lives*, p. 16.

290  **"I observed an incredible"**: AvL to RSL, Sept. 16, 1692, *AB*, 9:133.

290  **"being unable to bear"**: Ibid., p. 135.

290  **He found that adding**: Ibid., p. 133.

290  **ravaging the teeth**: See Schama, *The Embarrassment of Riches*, pp. 165–66.

291  **"would have no freedom"**: AvL to RSL, Jan. 14, 1710, AvL letters, RSL folio 125r, quoted in Ruestow, *The Microscope in the Dutch Republic*, p. 150.

291  **Even so, in the space**: AvL to J. Petiver, Aug. 18, 1711, AvL letters, RSL fol. 140r, quoted ibid.

291  **"Tout le monde court encore"**: Letter from Constantijn Huygens Jr. to Christiaan Huygens, Aug. 13, 1680, quoted in Schierbeek, *Measuring the Invisible World*, p. 35.

291  **"His Highness admitted"**: AvL to Hooke, Oct. 13, 1679, *AB*, 3:107–9.

291  **Years later, he would**: AvL to RSL, Aug. 6, 1687, *AB*, 7:41.

292  **She had arrived**: AvL to Mary, Queen of Britain, Dedication to the *Derde Vervolg der Brieven* (1693). Reproduced in *AB*, 9:173.

292  **"such information of our"**: Osselton, *The Dumb Linguists*, pp. 10–11.

292  **"shook Leeuwenhoek by"**: Gerard van Loon in 1731, quoted in Dobell, *Antony van Leeuwenhoek and His "Little Animals,"* p. 55.

292  **On a later visit**: Israel, *The Dutch Republic*, pp. 1044–45. Description of the "little children" quoted in Rupp, "Matters of Life and Death," p. 278.

293  **He began inviting**: See AvL to RSL, Sept. 7, 1688, *AB*, 8:7–57, and Fournier, "The Fabric of Life," p. 37.

293  **He was moved**: See AvL to Boyle, Jan. 12, 1689, *AB*, 7:83–93.

293  **"might suffer less"**: See Ruestow, *The Microscope in the Dutch Republic*, p. 155, and *AB*, 7:276–77, 8:23–25, 34–37, 48–49, 54–57, 80–81.

293 **He thought it was made**: See Cole, "Leeuwenhoek's Zoological Researches, Part I," p. 44.

294 **He was constructing**: See Fournier, "The Fabric of Life," p. 117.

294 **He explained that he**: "But I will not deny that there may be living creatures in the air, which are so small as to escape our sight; I only say that I have not seen them." AvL to Oldenburg, Oct. 9, 1676, *AB*, 2:157.

295 **This drop of water acted**: See Cohen, "On Leeuwenhoek's Method of Seeing Bacteria," p. 343.

295 **Van Leeuwenhoek would later describe**: See Ruestow, *The Microscope in the Dutch Republic*, p. 256n139.

295 **"extreme clearness and"**: Molyneux to RSL, Feb. 13, 1685, MS RSL, no. 2445, reproduced in Dobell, *Antony van Leeuwenhoek and His "Little Animals,"* pp. 57–58.

296 **It is generally believed**: See Stafford et al., *Devices of Wonder*, p. 215.

296 **"like looking at"**: Jean-Antoine Nollet, quoted ibid., pp. 215–16.

297 **"he told me he has"**: Molyneux to RSL, Feb. 13, 1685, MS RSL, no. 2445, reproduced in Dobell, *Antony van Leeuwenhoek and His "Little Animals,"* pp. 57–58.

297 **"resolved not to let"**: AvL to Oldenburg, March 26, 1675, *AB*, 1:293–95.

297 **"the Painter could not"**: See AvL to Anthonie Heinsius, Sept. 20, 1698, *AB*, 12:242.

298 **Tomas van der Wilt**: See Montias, *Artists and Artisans in Delft*, p. 171.

298 **"Nearly all the plates"**: See Boitet, *Beschryving der stadt Delf*, pp. 790–91, cited in Dobell, *Antony van Leeuwenhoek and His "Little Animals,"* pp. 343–44. Dobell suggests that Leeuwenhoek's first draftsman was Willem's father, Tomas van der Wilt.

298 **In several of his letters**: AvL to Francis Aston, Dec. 28, 1683, *AB*, 4:177–81, and AvL to RSL, Oct. 17, 1687, *AB*, 7:99.

299 **Tiny, solid objects**: See Ruestow, *The Microscope in the Dutch Republic*, p. 150.

299 **With his shaving razor**: See ibid., pp. 152–53.

300 **After reviewing the specimens**: See Huerta, *Giants of Delft*, pp. 31–32.

300 **He could then employ**: See AvL to Hooke, Nov. 12, 1680, *AB*, 3:311.

300 **Once the proper hair**: See B. J. Ford, *Single Lens*, p. 41n.

300 **He speaks of spending**: See Ruestow, *The Microscope in the Dutch Republic*, p. 156.

301 **"gave me so much"**: AvL to Hans Sloane, Jan. 2, 1700, *AB*, 13:17.

301 **"This sight gives me"**: AvL to RSL, July 10, 1696, *AB*, 11:311.

301 **"Nor should I ever"**: AvL to RSL, June 27, 1721, published in *Philosophical Transactions* 31 (1720–21): 203.

301 **"this multiple sight"**: AvL to RSL, April 15, 1701, *AB*, 13:297.

302 **"excite convulsive motions"**: Leewenhoek to RSL, May 31, 1723, quoted in Dobell, *Antony van Leeuwenhoek and His "Little Animals,"* p. 91.

302 **The rare disorder**: See Rankin, "Van Leeuwenhoek's Disease," p. 1434.

302 **"lips stammering and well-nigh"**: As reported by Boitet, *Beschryving*

388 / *Notes*

*der stadt Delf*, p. 768, and Hoogvliet to RSL, Sept, 4, 1723, both quoted in Dobell, *Antony van Leeuwenhoek and His "Little Animals*," pp. 92–93.

302 **"with 16 pall-bearers"**: As recorded in the church register and quoted ibid., p. 99.

302 **His burial notice**: DTB Delft 14, inv. 48, folio 8v.

302 **Attached to each microscope**: Leeuwenhoek had prepared the cabinet by Aug. 2, 1701, when he described it in a letter to the Royal Society, cited ibid. p. 96.

303 **Already in 1662, Hooke**: See Wilson, *The Invisible World*, p. 67.

303 **Later, in 1743, the English**: In his *Microscope Made Easy*, cited ibid., p. 227.

303 **It was, rather, that**: Most standard histories of the microscope claim that in the eighteenth century there was a decline in microscopy, with few studies employing the tool until the nineteenth century. See, e.g., Wilson, *The Invisible World*, Ruestow, *The Microscope in the Dutch Republic*, and Fournier, "The Fabric of Life." However, more recent work convincingly refutes that position. See Schickore, *The Microscope and the Eye*, and Ratcliff, *The Quest for the Invisible*.

303 **Microscopes could be deployed**: Ratcliff, in *The Quest for the Invisible*, traces this to the development of a "shared quest" for microscopical studies. Rather than concentrating on invisible animalcules that could not be seen by everyone with a microscope, natural philosophers began to reshape microscopical investigation to favor the examination of tiny, but visible, organic things, which were easier to observe. The project changed from "See for yourself" to "Let's see together."

304 **"Now will you call"**: Quoted in Ruestow, *The Microscope in the Dutch Republic*, p. 26.

304 **"We cut them with"**: Quoted ibid., pp. 272–73.

304 **"these are truths"**: Quoted ibid., p. 273.

304 **The existence of such**: As Ruestow notes, some natural philosophers doubted that the microscopic objects seen by Leeuwenhoek and others were, in fact, living beings. See ibid., pp. 260–61.

304 **Van Leeuwenhoek had a kind**: See ibid., p. 263n19.

304 **Even when he found**: See AvL to Hooke, Nov. 4, 1681, *AB*, 3:367–71.

304 **The eighteenth-century Swedish botanist**: Ruestow, *The Microscope in the Dutch Republic*, p. 263.

305 **he published his work**: Pacini, *Osservazioni microscopiche e deduzioni patologiche sul cholera asiatico*.

305 **Huygens's friend Margaret Cavendish**: Cavendish, "A World in an Eare-Ring," from *Poems and Fancies* (1653).

305 **"to see a World in"**: Blake, "Auguries of Innocence" (1803, pub. 1863).

305 **"Every part of matter"**: *The Works of Joseph Addison*, 4:40.

305 **"Where the pool"**: James Thomson, *The Seasons* (1730).

PART TWELVE: NEW WAYS OF SEEING

309 **Van Leeuwenhoek had devised**: Leeuwenhoek's method is called "concentric" by Berkel, "Intellectuals against Leeuwenhoek," p. 200, and Huerta, *Giants of Delft*, passim.

309 **He boasted that he**: AvL to RSL, July 25, 1684, *AB*, 4:281.

310 **"I generally notice"**: AvL to RSL, July 25, 1707, quoted in Berkel, "Intellectuals against Leeuwenhoek," p. 200.

310 **Vermeer's way of returning**: Descargues makes a similar point in *Vermeer*, p. 105.

311 **The same is true**: See Costaras, "A Study of the Materials and Techniques of Johannes Vermeer," p. 161.

312 **Francis Bacon had instructed**: Bacon wrote "naturae constrictae et vexatae." *Instauratio Magna*, in *The Works of Francis Bacon*, 1: 141; English translation as "nature under constraint and vexed" in "Plan of the Work," in *The Works of Francis Bacon*, 4:29. The historian of science Carolyn Merchant went too far when she claimed that Bacon said the natural philosopher must "torture" or even "rape" Nature. On this claim and the subsequent debate around it, see Pesic, "Wrestling with Proteus."

312 **"when we endeavour"**: Hooke, *Micrographia*, p. 186 Hooke himself had generally refrained from cutting into specimens during his microscopical investigations, the only exceptions in *Micrographia* being the cross-sectioning of the cork and dissection of the eye of the drone fly.

313 **"took the testicle"**: AvL to Hooke, April 5, 1680, *AB*, 3:203.

313 **"eleven weeks and one day"**: See AvL to Royal Society, Dec. 20, 1693, *AB*, 9:317.

313 **"quite distinctly saw"**: AvL to RSL, March 30, 1685, *AB*, 5:183.

313 **Van Leeuwenhoek dissected**: AvL to RSL, Aug. 12, 1692, *AB*, 9:81.

314 **"as savoury as ever"**: AvL to Frederik Adriaan van Reede van Renswoude, July 16, 1696, *AB*, 12:3–5.

314 **"those who investigate"**: AvL to Nicolas Witsen, March 8, 1696, *AB*, 11:239.

315 **"new Worlds and"**: Hooke, *Micrographia*, preface, n.p.

315 **But through the lens**: See Gowing, *Vermeer*, pp. 22–23.

316 **These women have**: See Schama, *The Embarrassment of Riches*, p. 413.

316 **"who among the ancient"**: See Ruestow, *The Microscope in the Dutch Republic*, p. 37.

317 **"they seemed to me"**: Quoted in *Wilson, The Invisible World*, p. 237.

317 **He would soon see**: At first, just like Hooke and Swammerdam, Leeuwenhoek saw the microscopic fibers of striated muscle as a "string of globules." By 1682, though, he reported seeing striations or a series of rings around the fibers and proposed that they were wrinkles related to the function of the fibers. Later, in 1714, he saw that the striations were not a series of circular folds but rather a spiral wound about the fiber. See Ruestow, *The*

*Microscope in the Dutch Republic*, pp. 185–86. On tooth enamel, see AvL to RSL, May 31, 1678, *AB*, 2:366–69. See also Fournier, "The Fabric of Life," pp. 127–29, and Snelders, "Antoni van Leeuwenhoek's Mechanistic View of the World," p. 66.

317 **Van Leeuwenhoek had learned**: This realization came earlier than Daston and Lunbeck suggest when they write that "starting in the 1820s prominent scientific writers" feared that "overly engaged scientists might contaminate observation with their preferred theories." See Daston and Lunbeck, "Observation Observed," pp. 3–4.

317 **"simple Eye" . . . "attentive observation"**: See AvL to RSL, June 13, 1687, *AB*, 6:309.

317 **Van Leeuwenhoek emphasized**: See *AB*, 1:110–11, 3:208–9, 430–31.

318 **He relied on the visual**: See Wheelock, *Vermeer and the Art of Painting*, p. 12.

319 **The Hubble Telescope has**: See "Hubble explores the origins of modern galaxies: Astronomers see true shapes of galaxies 11 billion years back in time," Aug. 15, 2013, at http://www.spacetelescope.org/news/heic1315/, accessed April 29, 2014. See also Kemp, *Seen/Unseen*, p. 241.

320 **As earlier writers had**: See Livingstone, *Vision and Art*, pp. 6–8.

320 **Using functional magnetic**: Similar changes in the brain have been found in subjects instructed to *think about* seeing something. See, e.g., Le Bihan et al., "Activation of Human Primary Visual Cortex during Visual Recall."

321 **At the same time, some**: See Sacks, *The Mind's Eye*, pp. 111–43.

321 **And like Cheselden's**: Those stories do not always end well. See, e.g., Sacks "To See or Not to See," in *An Anthropologist on Mars*.

EPILOGUE: DARE TO SEE!

323 **On the frontispiece**: *Epistolae ad Societatem Regiam Anglicam* (Letters to the Royal Society), published in Leiden in 1719.

323 **As the motto for**: See Ginzburg, "The High and the Low," p. 68.

323 *Sapere aude*: The phrase is from Horace's epistle to Lollius. Horace addresses these words to a "fool" who is waiting for the water to dry up before daring to cross a stream. The passage originally referred to common sense—don't be silly, the water is not going to dry up, just cross it! But by the early seventeenth century, *Sapere aude* was becoming a catchphrase for daring to seek knowledge. See Ginzburg, "The High and the Low," p. 66.

323 **But in Schoonhovius's volume**: On this point, see ibid., p. 64.

324 **Fifty years after Van Leeuwenhoek's**: Kant, "On the Question, What Is Enlightenment?" For more on the role of the Scientific Revolution in laying the groundwork for the Enlightenment, see Pagden, *The Enlightenment*.

325 **In the dark shadow**: See Duparc and Wheelock, eds., *Johannes Vermeer*, p. 189n2.

# Bibliography

Addison, Joseph. 1877. *The Works of Joseph Addison.* 4 vols. London: George Bell and Sons.

Aglionby, William. 1671. *The Present State of the United Provinces of the Low-Countries as to the Government, Laws, Forces, Riches, Manners, Customes, Revenue, and Territory of the Dutch, in Three Books.* London: Printed for John Starkey.

———. 1719. *Choice Observations upon the Art of Painting.* London: Printed for R. King.

Akkerman, Nadine, and Marguerite Corporaal. 2004. "Mad Science beyond Flattery: The Correspondence of Margaret Cavendish and Constantijn Huygens." *Early Modern Literary Studies*, special issue, 14 (May): 1–21.

Alberti, Leon Battista. [ca. 1435] 1956. *On Painting.* Translated and edited by John R. Spencer. New Haven: Yale University Press.

Alpers, Svetlana. 1983. *The Art of Describing: Dutch Art in the Seventeenth Century.* Chicago: University of Chicago Press.

Andersen, Kirsti. 2007. *The Geometry of an Art: The History of the Mathematical Theory of Perspective from Alberti to Monge.* New York and London: Springer.

Aristotle. 1942. *Aristotle: Generation of Animals.* Edited by A. L. Peck. Cambridge, Mass. Harvard University Press.

———. 2011. *Aristotle: Problems.* Vol. 1, Books 1–19. Translated by Robert Mayhew. Cambridge, Mass: Harvard University Press.

Aubrey, John, 1957. *Brief Lives.* Ann Arbor: University of Michigan Press.

Bacon, Francis. 1870. *The Works of Francis Bacon.* Edited by James Spedding, Robert Leslie Ellis, and Douglas Denon Heath. 7 vols. London: Longmans.

Bailey, Anthony. 2002. *Vermeer: A View of Delft.* New York: Henry Holt.

———. *Velázquez and the Surrender of Breda.* New York: Henry Holt.

Ball, Philip. 2003. *Bright Earth: Art and the Invention of Color.* Chicago: University of Chicago Press.

Bell, Julian. 2011. "The Mysterious Women of Vermeer." Review of *Vermeer's Women: Secrets and Silence* (exhibition catalog). *New York Review of Books*, 58 (20): 86.

Berger, John. 1972. *Ways of Seeing.* London: BBC; Harmondsworth, UK: Penguin Books.

Berghof, Alice Crawford. 2010. "'Nearest the Tangible Earth': Rembrandt, Samuel van Hoogstraten, George Berkely, and the Optics of Touch." In Hendrix and Carman, eds., *Renaissance Theories of Vision*, 187–211.

Berkel, K. van. 1982. "Intellectuals against Leeuwenhoek." In Palm and Snelders, eds., *Antoni van Leeuwenhoek, 1632–1723*, 187–209.

Biesboer, Pieter. 1993. "Judith Leyster: Painter of 'Modern Figures.'" In Welu and Biesboer, eds., *Judith Leyster*, 75–92.

———. 2001. *Collections of Paintings in Haarlem, 1572–1745*. Los Angeles: Getty Publications.

Birch, Thomas. 1756. *The History of the Royal Society of London for Improving of Natural Knowledge, from Its First Rise . . .* 4 vols. London: Printed for A. Millar.

Blanc, Jan. 2007. Review of *The Visible World: Samuel Van Hoogstraten's Art Theory and the Legitimization of Painting in the Dutch Golden Age*, by Thijs Weststeijn. *Simiolus: Netherlands Quarterly for the History of Art* 33 (4): 276–82.

Blankert, Albert. 1978. *Vermeer of Delft: Complete Edition of the Paintings*. Oxford: Phaidon.

———. 1995. "Vermeer's Modern Themes and Their Traditions." In Duparc and Wheelock, eds., *Johannes Vermeer*, 31–45.

Bok, Marten Jan. 2001. "Society, Culture and Collecting in 17th Century Delft." In Liedtke, Plomp, and Rüger, eds, *Vermeer and the Delft School*, 196–210.

Boucher, Jocelyn. 2012. "Amsterdam's Urban History." Accessed Oct. 12, 2012. http://courses.umass.edu/latour/Netherlands/boucher/index.html.

Boyle, Robert. 1663. *Some Considerations Touching the Usefulness of Experimental Natural Philosophy*. Oxford: Oxford Hall.

———. 1671. *Tracts Written by the Honourable Robert Boyle about the Cosmicall Qualities of Things, Cosmical Suspitions, the Temperature of the Submarine Regions, the Temperature of the Subterraneall Regions, the Bottom of the Sea . . .* Oxford: Printed by W. H. for Ric. Davis.

Brewster, David. 1852. "On an Account of a Rock-Crystal Lens and Decomposed Glass Found at Nineveh." *Athenaeum* no. 1298 (September 11): 979.

Broersen, Ellen. 1993. "'Judita Leystar': A Painter of 'Good, Keen, Sense.'" In Welu and Biesboer, eds., *Judith Leyster*, 15–38.

Brook, Timothy. 2008. *Vermeer's Hat: The Seventeenth Century and the Dawn of the Global World*. New York: Bloomsbury.

Broos, Ben. 1995. "'Un celebre peijntre nommé Verme[e]r.'" In Duparc and Wheelock, eds., *Johannes Vermeer*, 47–66.

Brusati, Celeste. 1995. *Artifice and Illusion: The Art and Writing of Samuel van Hoogstraten*. Chicago: University of Chicago Press.

———. 2013. "Paradoxical Passages: The Work of Framing in the Art of Samuel van Hoogstraten." In Weststeijn, ed., *The Universal Art of Samuel van Hoogstraten (1627–1678)*, 53–76.

Buchwald, Jed Z., and Mordechai Feingold. 2013. *Newton and the Origin of Civilization*. Princeton, N.J.: Princeton University Press.

Burnett, D. Graham. 2005. *Descartes and the Hyperbolic Quest: Lens Making Machines and Their Significance in the Seventeenth Century.* Philadelphia: American Philosophical Society.

Camerota, Filippo. 2005. "Looking for an Artificial Eye: On the Borderline between Painting and Topography." *Early Science and Medicine* 10 (2): 263–85.

Cavendish, Margaret, Duchess of Newcastle. 1653. *Poems and Fancies.* Reprint, Menston: Scolar Press, 1970.

——. 1656. *Nature's Pictures Drawn by Fancie's Pencil to the Life.* London: J. Martin and J. Allestyre.

——. 1666. *Observations upon Experimental Philosophy to Which Is Added the Description of a New Blazing World.* London: Printed by A. Maxwell.

Chen-Morris, Raz. 2013. "'The Qualities of Nothing': Shakespearean Mirrors and Kepler's Visual Economy of Science." In *Science in the Age of the Baroque*, edited by O. Gal and R. Chen-Morris, 99–118. Dordrecht: Springer.

Cheselden, William. 1728. "An Account of Some Observations Made by a Young Gentleman, Who Was Born Blind." *Philosophical Transactions* 35: 447–50.

Clark, Stuart. 2007. *Vanities of the Eye: Vision in Early Modern European Culture.* Oxford: Oxford University Press.

Cobb, Matthew. 2002. "Malpighi, Swammerdam and the Colorful Silkworm: Replication and Visual Representation in Early Modern Science." *Annals of Science* 59: 111–47.

——. 2006. *Generation: The Seventeenth-Century Scientists Who Unraveled the Secrets of Sex, Life, and Growth.* New York: Bloomsbury

Cocquyt, Tiemen. 2007. "The Camera Obscura and the Availability of 17th Century Optics: Some Notes and an Account of a Test." In Lefèvre, ed., *Inside the Camera Obscura*, 129–40.

Cohen, Barnett. 1937. "On Leeuwenhoek's Method of Seeing Bacteria." *Journal of Bacteriology* 34 (3): 343–46.

Cole, F. J. 1937. "Leeuwenhoek's Zoological Researches Parts I and II." *Annals of Science* 2: 1–46, 185–235.

Cook, Harold J. 2007. *Matters of Exchange: Commerce, Medicine, and Science in the Dutch Golden Age.* New Haven: Yale University Press.

Costaras, Nicola. 1998. "A Study of the Materials and Techniques of Johannes Vermeer." In Gaskell and Jonker, eds., *Vermeer Studies*, 145–67.

Crombie, A.C. 1967. "The Mechanistic Hypothesis and the Study of Vision: Some Optical Ideas as a Background of the Invention of the Microscope." In *Historical Aspects of Microscopy*, edited by Savile Bradbury and Gerard L'Estrange Turner, 3–112. Cambridge: Heffer.

Damsteegt, B. C. 1982. "Language and Leeuwenhoek." In Palm and Snelders, eds., *Antoni van Leeuwenhoek, 1632–1723*, 13–28.

Daston, Lorraine, and Peter Galison. 1992. "The Image of Objectivity." *Representations* 40: 81–128.

Daston, Lorraine, and Elizabeth Lunbeck. 2011. "Observation Observed." In Daston and Lunbeck, eds., *Histories of Scientific Observation*, 1–9.

————, eds. 2011. *Histories of Scientific Observation*. Chicago: University of Chicago Press.

De Beer, Hans. 2004. "Observations on the History of Dutch Physical Stature from the Late-Middle Ages to the Present." *Economics and Human Biology* 2: 45–55.

Degenaar, Marjolein. 1996. *Molyneux's Problem: Three Centuries of Discussion on the Perception of Forms*. Dordrecht: Kluwer.

Degenaar, Marjolein, and Gert-Jan Lokhorst. 2011. "Molyneux's Problem." *Stanford Encyclopedia of Philosophy*. At http://plato.stanford.edu/archives/fall2011/entries/molyneux-problem/.

Delsaute, Jean-Luc. 1998. "The Camera Obscura and Painting in the 16th and 17th Century." In Gaskell and Jonker, eds., *Vermeer Studies*, 111–23.

Dennis, Michael Aaron. 1989. "Graphical Understanding: Instruments and Interpretation in Robert Hooke's *Micrographia*." *Science in Context* 3: 309–64.

Descargues, Pierre. 1966. *Vermeer: Biographical and Critical Study*. Geneva: Skira.

Descartes, René. 1985. *The Philosophical Writings of Descartes*. Vol. 1. Edited by John Cottingham, Robert Stoothoff, and Dugald Murdoch. Cambridge: Cambridge University Press.

————. 1991. *The Philosophical Writings of Descartes*. Vol. 3, *The Correspondence*. Edited by John Cottingham, Robert Stoothoff, Dugald Murdoch and Anthony Kenny. Cambridge: Cambridge University Press.

————. 1998. *The World and Other Writings*. Edited by Stephen Gaukroger. Cambridge: Cambridge University Press.

————. 2001. *Discourse on Method, Optics, Geometry, and Meteorology*. Edited by Paul J. Olscamp. Indianapolis: Hackett.

Dibon, Paul. 1984. "Sur la réception de l'oeuvre de F. Bacon en Hollande dans la première moitié du XVIIᵉ siècle." In *Francis Bacon: Terminologia e fortuna nel XVII secolo*, edited by Maria Fattori. Rome: Edizioni dell'Ateneo.

Dillard, Annie. 1998. *Pilgrim at Tinker Creek*. New York: Harper Perennial Modern Classics.

Dobell, Clifford. 1932. *Antony van Leeuwenhoek and His "Little Animals": Being Some Account of the Father of Protozoology & Bacteriology and His Multifarious Discoveries in These Disciplines*. Reprint, New York: Russell and Russell, 1958.

Douglas-Ittu, Kevin von. "Website on Spinoza's Optical Theories, Practices and Likely Experiences." http://kvond.wordpress.com/spinozas-foci-articles-spinoza-optics-lens-grinding/.

Dreiskämper, Petra. 1998. *Redeloos, radeloos, reddeloos: De geschiedenis van het rampjaar 1672*. Hilversum: Verloren.

Duparc, Frederik J., and Arthur K. Wheelock, eds. 1995. *Johannes Vermeer*. Washington, D.C.: National Gallery of Art; The Hague: Royal Cabinet of Paintings Mauritshuis; New Haven: Yale University Press.

Dupré, Sven. 2008. "Inside the Camera Obscura: Kepler's Experiment and Theory of Optical Imagery." *Early Science and Medicine* 13 (3): 219–44.

Epstein, S. R. 1998. "Craft Guilds, Apprenticeship, and Technological Change in Pre-Industrial Europe." *Journal of Economic History* 58: 684–713.

Findlen, Paula, ed. 2004. *Athanasius Kircher: The Last Man Who Knew Everything*. New York: Routledge.

Ford, Brian J. 1985. *Single Lens: The Story of the Simple Microscope*. New York: Harper and Row.

———. 1991. *The Leeuwenhoek Legacy*. Bristol: Biopress; London: Farrand Press.

Ford, Charles. 2007. "Introduction." In *Lives of Rembrandt: Baldinucci and Houbraken*, edited by Charles Ford, 7–26. London: Pallas Publications.

Fournier, Marian. 1991. "The Fabric of Life: The Rise and Decline of Seventeenth-Century Microscopy." Ph.D. diss., Twente University of Technology.

Franits, Wayne E., ed. 1997. *Looking at Seventeenth-Century Dutch Art: Realism Reconsidered*. Cambridge: Cambridge University Press.

———, ed. 2001. *The Cambridge Companion to Vermeer*. Cambridge: Cambridge University Press.

———. 2004. *Dutch Seventeenth-Century Genre Painting: Its Stylistic and Thematic Evolution*. New Haven: Yale University Press.

Freedberg, David. 2002. *The Eye of the Lynx: Galileo, His Friends, and the Beginnings of Modern Natural History*. Chicago: University of Chicago Press.

Galilei, Galileo. 1967. *Dialogue Concerning the Two Chief World Systems*. Edited by Stillman Drake. Berkeley: University of California Press.

———. 1989. *Sidereus Nuncius; or, The Sidereal Messenger*. Edited by Albert Van Helden. Chicago: University of Chicago Press.

Garber, Daniel. 1992. *Descartes' Metaphysical Physics*. Chicago: University of Chicago Press.

Garrett, Don, ed. 1996. *The Cambridge Companion to Spinoza*. Cambridge: Cambridge University Press.

Gaskell, Ivan, and Michiel Jonker, eds. 1998. *Vermeer Studies*. Washington, D.C.: National Gallery of Art; New Haven: Yale University Press.

Gaukroger, Stephen. 1995. *Descartes: An Intellectual Biography*. Oxford: Clarendon Press; New York: Oxford University Press.

Gifford, Melanie. 1998. "Painting Light: Recent Observations on Vermeer's Technique." In Gaskell and Jonker, eds., *Vermeer Studies*, 185–99 .

Ginzburg, Carlo. 1989. "The High and the Low: The Theme of Forbidden Knowledge in the 16th and 17th Centuries." In *Clues, Myths, and the Historical Method*, edited by Carlo Ginzburg, 54–69. Baltimore, Md.: Johns Hopkins University Press.

Glassie, John. 2012. *A Man of Misconceptions: The Life of an Eccentric in an Age of Change*. New York: Riverhead.

Gombrich, E. H. 1961. *Art and Illusion: A Study in the Psychology of Pictorial Representation*. Princeton, N.J: Princeton University Press.

Goncourt, Edmond, and Jules Goncourt. 1989. *Journal des Goncourt*. 3 vols. Edited by Robert Ricatte. Paris: Laffant.

Gorman, Michael John. 2007. "Projecting Nature in Early Modern Europe." In Lefèvre, ed., *Inside the Camera Obscura*, 31–50.

Gowing, Lawrence. 1997. *Vermeer*. Berkeley: University of California Press.

Groen, Karin. 2007. "Painting Technique in the 17th Century in Holland

and the Possible Use of the Camera Obscura by Vermeer." In Lefèvre, ed., *Inside the Camera Obscura*, 195–210.

Hacking, Ian. 1981. "Do We See through a Microscope?" *Pacific Philosophical Quarterly* 62: 305–22.

———. 1995. *Representing and Intervening: Introductory Topics in the Philosophy of Natural Science*. Cambridge: Cambridge University Press.

Hall, A. R. 1989. "The Leeuwenhoek Lecture, 1988: Antoni van Leeuwenhoek 1632–1723," *Notes and Records of the Royal Society of London* 43: 249–73.

Hammond, John H. 1981. *The Camera Obscura: A Chronicle*. Bristol: Hilger.

Hammond, Mary Sayer. 1986. "The Camera Obscura: A Chapter in the Pre-History of Photography." Ph.D. diss., Ohio State University.

Harkness, Deborah E. 2008. *The Jewel House: Elizabethan London and the Scientific Revolution*. New Haven: Yale University Press.

Hattab, Helen. 2007. "Concurrence or Divergence? Reconciling Descartes's Metaphysics with His Physics." *Journal of the History of Philosophy* 45: 49–78.

Hendrix, John Shannon, and Charles H. Carman, eds. 2010. *Renaissance Theories of Vision*. Farnham, UK; Burlington, Vt.: Ashgate Publications.

Hockney, David. 2006. *Secret Knowledge: Rediscovering the Lost Techniques of the Old Masters*. Expanded ed. New York: Studio.

Hoffman, Donald D. 2000. *Visual Intelligence: How We Create What We See*. New York: W. W. Norton.

Hooke, Robert. 1665. *Micrographia; or, Some Physiological Descriptions of Minute Bodies Made by Magnifying Glasses, with Observations and Inquiries Thereupon*. London: Royal Society.

———. 1678. *Lectures and Collections: Cometa, Containing Observations of the Comet in April 1677 and Microscopium*. London: J. Martyn.

———. 1726. "An Instrument to Take the Draught or Picture of a Thing." In *Philosophical Experiments and Observations of the Late Eminent Dr. Robert Hooke, S.R.S. and Geom. Prof. Gresh., and Other Eminent Virtuoso's in His Time*, edited by William Derham, 292–96. London: W. and J. Innys.

Horn, Hendrik J. 2013. "Great Respect and Complete Bafflement: Arnold Houbraken's Mixed Opinion of Samuel van Hoogstraten." In Weststeijn, ed., *The Universal Art of Samuel van Hoogstraten*, 209–40.

Houbraken, Arnold. 2007. "Rembrandt." In *Lives of Rembrandt, Baldinucci and Houbraken*, edited by Charles Ford, 51–94. London: Pallas Publications.

Howell, James. 1907. *Epistolae Ho-Elianae: The Familiar Letters of James Howell*. Edited by Agnes Repplier. Boston: Houghton, Mifflin.

Huerta, Robert D. 2003. *Giants of Delft: Johannes Vermeer and the Natural Philosophers: The Parallel Search for Knowledge during the Age of Discovery*. Lewisburg, Pa.: Bucknell University Press; London: Associated University Presses.

Inwood, Stephen. 2003. *The Forgotten Genius: The Biography of Robert Hooke, 1635–1703*. San Francisco: MacAdam/Cage Pub.

Israel, Jonathan I. 1995. *The Dutch Republic: Its Rise, Greatness and Fall, 1477–1806*. Oxford: Clarendon Press.

———. 2011. *Democratic Enlightenment: Philosophy, Revolution, and Human Rights, 1750–1790*. New York: Oxford University Press.

James, William. 1956. *The Will to Believe: And Other Essays in Popular Philosophy, [and] Human Immortality, Two Supposed Objections to the Doctrine*. New York: Dover Publications.

Jardine, Lisa. 2004. *The Curious Life of Robert Hooke: The Man Who Measured London*. New York: HarperCollins.

———. 2008. *Going Dutch: How England Plundered Holland's Glory*. New York: Harper.

———. 2009. "The Correspondence between Constantijn Huygens and Dorothea van Dorp." *Lives and Letters* 1 (1): 1–22.

Joby, Christopher Richard. 2007. *Calvinism and the Arts: A Re Assessment*. Leuven and Dudley, Mass.: Peeters.

Jorink, Eric. 2010. *Reading the Book of Nature in the Dutch Golden Age, 1575–1715*. Leiden and Boston: Brill.

———. 2012. "In the Twilight Zone: Isaac Vossius and the Scientific Communities in France, England and the Dutch Republic." In *Isaac Vossius (1618–1689): Between Science and Scholarship*, edited by Eric Jorink and Dirk van Miert, 119–56. London: Brill.

Jorink, Eric, and Ad Maas, eds. 2012. *Newton and the Netherlands: How Isaac Newton Was Fashioned in the Dutch Republic*. Amsterdam: Leiden University Press.

Kaldenbach, Kees. 2001. "Plans of 17th Century Delft with Locations of Major Monuments and Addresses of Artists and Patrons." In Liedtke, Plomp, and Rüger, eds., *Vermeer and the Delft School*, 557–65.

Kant, Immanuel. 1991. "On the Question, What Is Enlightenment?" In *Kant's Political Writings*, edited by H. S. Reiss, 54–60. Cambridge: Cambridge University Press.

Kemp, Martin. 1990. *The Science of Art: Optical Themes in Western Art from Brunelleschi to Seurat*. New Haven: Yale University Press.

———. 2006. *Seen/Unseen: Art, Science, and Intuition from Leonardo to the Hubble Telescope*. Oxford: Oxford University Press.

———. 2007. "Imitation, Optics, and Photography: Some Gross Hypotheses." In Lefèvre, ed., *Inside the Camera Obscura*, 243–64.

Kepler, Johannes. 2000. *Optics: Paralipomena to Witelo & Optical Part of Astronomy*. Edited by William H. Donahue. Santa Fe: Green Lion Press.

Kirby, Jo. 1999. "The Painter's Trade in the 17th Century: Theory and Practice." *National Gallery Technical Bulletin* 20: 5–49.

Klever, W. N. A. 1996. "Spinoza's Life and Works." In Garrett, ed., *Cambridge Companion to Spinoza*, 13–60.

Kooi, Christine. 2012. *Calvinists and Catholics during Holland's Golden Age: Heretics and Idolaters*. Cambridge: Cambridge University Press.

Kruif, Paul de. 2002. *Microbe Hunters*. 3rd ed. San Diego: Mariner Books.

Kusukawa, Sachiko. 2011. "Picturing Knowledge in the Early Royal Society:

The Examples of Richard Waller and Henry Hunt." *Notes and Records of the Royal Society* 65 (3): 273–94.

Lawrenze-Landsberg, Claudia. 2007. "Neutron-Autoradiology of Two Paintings by Jan Vermeer in the Gemäldegalerie Berlin." In Lefèvre, ed., *Inside the Camera Obscura*, 211–26.

Le Bihan, D., R. Turner, and T. A. Zeffiro. 1993. "Activation of Human Primary Visual Cortex during Visual Recall: A Magnetic Resonance Imaging Study." *Proceedings of the National Academy of Sciences USA* 90 (Dec.): 11802–5.

Leeuwenhoek, Antoni van. 1939–99. *Alle de brieven van Antoni van Leeuwenhoek = The Collected Letters of Antoni van Leeuwenhoek.* Edited by Koninklijke Nederlandse Akademie van Wetenschappen, Leeuwenhoek-Commissie. 15 vols. Amsterdam: Swets & Zeitlinger.

Lefèvre, Wolfgang, ed. 2007. *Inside the Camera Obscura: Optics and Art under the Spell of the Projected Image.* Berlin: Max-Planck-Inst. für Wissenschaftsgeschichte.

———. 2007. "The Optical Camera Obscura I: A Short Exposition." In Lefèvre, ed., *Inside the Camera Obscura*, 5–11.

Leonardo da Vinci. 1970. *The Notebooks of Leonardo da Vinci.* Edited and translated by Jean Paul Richter. 2 vols. Mineola, New York: Dover Publications.

Levy-van Halm, Koos. 1993. "Judith Leyster: The Making of a Master." In Welu and Biesboer, eds., *Judith Leyster*, 69–74.

———. 1998. "Where Did Vermeer Buy His Painting Materials? Theory and Practice." In Gaskell and Jonker, eds., *Vermeer Studies*, 137–43.

Liedtke, Walter A. 1979. Review of *Perspective, Optics, and Delft Artists around 1650*, by Arthur Wheelock. *Art Bulletin* 61: 490–96.

———. 2001. "Delft and the Arts before 1600." In Liedtke, Plomp, and Rüger, eds., *Vermeer and the Delft School*, 20–41.

———. 2001. "Delft and the Delft School: An Introduction." In Liedtke, Plomp, and Rüger, eds., *Vermeer and the Delft School*, 2–19.

———. 2001. "Delft Painting 'in Perspective': Carel Fabritius, Leonaert Bramer, and the Architectural and Townscape Painters from about 1650 Onward." In Liedtke, Plomp, and Rüger, eds., *Vermeer and the Delft School*, 98–129.

———. 2001. "Genre Painting in Delft after 1650: De Hooch and Vermeer." In Liedtke, Plomp, and Rüger, eds., *Vermeer and the Delft School*, 130–69.

———. 2001. "Painting in Delft from about 1600–1650." In Liedtke, Plomp, and Rüger, eds., *Vermeer and the Delft School*, 42–97.

———. 2001. Review of *Vermeer's Camera*, by Philip Steadman. *Burlington Magazine* 143: 642–43.

———. 2008. *Vermeer: The Complete Paintings.* Ghent: Ludion; New York: Harry N. Abrams.

———. 2011. "Frans Hals: Style and Substance." *Metropolitan Museum of Art Bulletin* 69 (1): 5–48.

Liedtke, Walter A., Michiel C. Plomp, and Axel Rüger, eds. 2001. *Vermeer and*

*the Delft School*. New York: Metropolitan Museum of Art; New Haven: Yale University Press, 2001.

Lindberg, David C. 1976. *Theories of Vision from Al-Kindi to Kepler*. Chicago: University of Chicago Press.

Lindeboom, G. A. 1982. "Leeuwenhoek and the Problem of Sexual Reproduction." In Palm and Snelders, eds., *Antoni van Leeuwenhoek, 1632–1723*, 129–52.

Livingstone, Margaret S. 2008. *Vision and Art: The Biology of Seeing*. New York: Harry N. Abrams.

Lucassan, Jan, and Maarten Prak. 1998. "Guilds and Society in the Dutch Republic (16th–18th C.)." In Núñez and Epstein, eds., *Guilds, Economy and Society*, 63 78.

Lüthy, Christophe. 2005. "Hockney's Secret Knowledge, Vanvitelli's Camera Obscura." *Early Science and Medicine* 10 (2): 315–39.

Maas, Ad. 2012. "'The Man Who Erased Himself': Willem Jacob 's Gravesande and the Enlightenment." In Jorink and Maas, eds., *Newton and the Netherlands*, 113–37.

Malet, Antoni. 2005. "Early Conceptualizations of the Telescope as an Optical Instrument." *Early Science and Medicine* 10 (2): 237–62.

Manetti, Antonio. 1970. *The Life of Brunelleschi*. Edited by Howard Saalman, translated by Catherine Enggass. University Park: Pennsylvania State University Press.

Margócsy, Dániel. 2014. "A Philosophy of Wax: The Anatomy of Frederik Ruysch." In *The Morbid Anatomy Anthology*, edited by Joanna Ebenstein and Colin Dickey. New York: Morbid Anatomy Press, 92–111.

Mayor, Alpheus Hyatt. 1946. "The Photographic Eye." *Metropolitan Museum of Art Bulletin* 5: 15–26.

Meli, Domenico Bertoloni. 2013. "Machines and the Body: Between Anatomy and Pathology." In *L'automate: Modèle, métaphore, machine, merveille*, edited by B. Roukhomovsky and S. Roux, 53–68. Pessac: Presses universitaires de Bordeaux.

Mijers, Esther. 2012. *"News from the Republick of Letters": Scottish Students, Charles Mackie, and the United Provinces, 1650–1750*. Leiden: Brill.

Molesini, Giuseppe. 2007. "The Optical Quality of 17th Century Lenses." In Lefèvre, ed., *Inside the Camera Obscura*, 117–26.

Monconys, Balthasar de. 1665. *Journal des voyages de Monsieur de Monconys . . . Où les sçavants trouveront un nombre infini de nouveautez, en machines de mathematique, experiences physiques, raisonemens de la belle philosophie, curiositez de chymie, & conversations des illustres de ce siecle*. Lyon: H. Boissart & G. Remeus.

Montias, John Michael. 1980. "Vermeer and His Milieu: Conclusions of an Archival Study." *Oud Holland* 94: 44–62.

———. 1982. *Artists and Artisans in Delft: A Socio-Economic Study of the Seventeenth Century*. Princeton, N.J.: Princeton University Press.

———. 1989. *Vermeer and His Milieu: A Web of Social History.* Princeton, N.J.: Princeton University Press.

———. 1998. "Recent Archival Research on Vermeer." In Gaskell and Jonker, eds., *Vermeer Studies,* 93–110.

———. 2002. *Art at Auction in 17th Century Amsterdam.* Amsterdam: Amsterdam University Press.

Multhauf, Lettie S. 1985. "The Light of Lamp-Lanterns: Street Lighting in 17th Century Amsterdam." *Technology and Culture* 26 (2): 236–52.

Nadler, Steven M. 1999. *Spinoza: A Life.* Cambridge: Cambridge University Press.

———. 2010. *The Best of All Possible Worlds: A Story of Philosophers, God, and Evil in the Age of Reason.* Princeton, N.J.: Princeton University Press.

Newcastle, Margaret Cavendish, Duchess of. *See* Cavendish, Margaret, Duchess of Newcastle.

Núñez, Clara Eugenia, and S. R. Epstein, eds. 1998. *Guilds, Economy and Society.* Sevilla: Secretariado de Publicaciones, Universidad de Sevilla.

Nye, Andrea. 1999. *The Princess and the Philosopher: Letters of Elisabeth of the Palatine to René Descartes.* Lanham, Md.: Rowman & Littlefield.

Osselton, N. E. 1973. *The Dumb Linguists. A Study of the Earliest English and Dutch Dictionaries.* Leiden: Leiden University Press.

Pacini, Filippo. 1854. *Osservazioni microscopiche e deduzioni patologiche sul cholera asiatico.* Firenze: Tipografia di Federigo Bencini.

Pagden, Anthony. 2013. *The Enlightenment: And Why It Still Matters.* New York: Random House.

Palm, L. C., and H. A. M. Snelders, eds. 1982. *Antoni van Leeuwenhoek, 1632–1723: Studies on the Life and Work of the Delft Scientist Commemorating the 350th Anniversary of His Birthday.* Amsterdam: Rodopi.

Panek, Richard. 1998. *Seeing and Believing: How the Telescope Opened Our Eyes and Minds to the Heavens.* New York: Viking.

Panofsky, Erwin. 1940. *The Codex Huygens and Leonardo da Vinci's Art Theory.* London: Warburg Institute.

———. 1954. *Galileo as a Critic of the Arts.* The Hague: M. Nijhoff.

Paul, Tanya. 2012. "Cultivating Virtuosity: A Biographical Portrait of Willem van Aelst." In Paul, Clifton, and Wheelock, eds., *Elegance and Refinement,* 11–24.

Paul, Tanya, James Clifton, and Arthur K. Wheelock, eds. 2012. *Elegance and Refinement: The Still-Life Paintings of Willem van Aelst.* New York: Skira Rizzoli.

Payne, Alma Smith. 1970. *The Cleere Observer: A Biography of Antoni van Leeuwenhoek.* London: Macmillan.

Pepys, Samuel. 1904. *The Diary of Samuel Pepys.* Edited by Henry B. Wheatley and Mynors Bright. 8 vols. London: George Bell and Sons.

Pesic, Peter. 1999. "Wrestling with Proteus: Francis Bacon and the 'Torture' of Nature." *ISIS* 90: 81–94.

Phillips, Derek L. 2008. *Well-Being in Amsterdam's Golden Age*. Amsterdam: Pallas Publications.

Plomp, Michiel C. 2001. "Along the City Walls: An Imaginary Walk through 17th Century Delft." In Liedtke, Plomp, and Rüger, eds., *Vermeer and the Delft School*, 548–56.

———. 2001. "Drawing and Printmaking in Delft during the 17th Century." In Liedtke, Plomp, and Rüger, eds., *Vermeer and the Delft School*, 170–95.

Pomata, Gianna. 2011. "Observation Rising." In Daston and Lunbeck, eds., *Histories of Scientific Observation*, 45–80.

Poni, Carlo. 1990. "Per la storia del distretto industriale serico di Bologna (secoli XVI–XIX)." *Quaderni Storici* 73: 93–167.

Porter, Roy. 1995. *London, a Social History*. Cambridge, Mass.: Harvard University Press.

Principe, Lawrence. 1998. *The Aspiring Adept: Robert Boyle and His Alchemical Quest: Including Boyle's "Lost" Dialogue on the Transmutation of Metals*. Princeton, N.J.: Princeton University Press.

———. 2013. *The Secrets of Alchemy*. Chicago: University of Chicago Press.

Rankin, John A. 2011. "Van Leeuwenhoek's Disease." *American Journal of Respiratory and Critical Care Medicine*, 183: 1434.

Ratcliff, Marc. 2009. *The Quest for the Invisible: Microscopy in the Enlightenment*. Farnham, UK; Burlington, Vt.: Ashgate Publications.

Rees, Graham. 2000. "Baconianism." In *Encyclopedia of the Scientific Revolution*, edited by Wilbur Applebaum, 108–11. New York: Garland.

Reeves, Eileen Adair. 1997. *Painting the Heavens: Art and Science in the Age of Galileo*. Princeton, N.J.: Princeton University Press.

———. 2008. *Galileo's Glassworks: The Telescope and the Mirror*. Cambridge, Mass.: Harvard University Press.

Richter, Mark. 2007. "Shedding Some New Light on the Blue Pigment 'Vivianite' in Technical Documentary Sources in Northern Europe." *Art Matters* 4: 37–53.

Rooseboom, Maria. 1959. "Leeuwenhoek's Life in the Republic of United Netherlands." In Schierbeek, *Measuring the Invisible World: The Life and Works of Antoni van Leeuwenhoek*, 13–42.

Ruestow, Edward G. 1983. "Images and Ideas: Leeuwenhoek's Perception of the Spermatozoa." *Journal of the History of Biology* 16: 185–224.

———. 1984. "Leeuwenhoek and the Campaign against Spontaneous Generation." *Journal of the History of Biology* 17: 225–48.

———. 1996. *The Microscope in the Dutch Republic: The Shaping of Discovery*. Cambridge: Cambridge University Press.

Rupp, Jan C. C. 1990. "Matters of Life and Death: The Social and Cultural Conditions of the Rise of Anatomical Theaters, with Special Reference to 17th Century Holland." *History of Science* 28: 263–87.

Sabra, A. I. 2007. "Alhazen's Optics in Europe: Some Notes on What It Said, and What It Did Not Say." In Lefèvre, ed., *Inside the Camera Obscura*, 53–57.

Sacks, Oliver. 1995. *An Anthropologist on Mars: Seven Paradoxical Tales*. New York: Random House.

———. 2010. *The Mind's Eye*. New York: Random House.

Schama, Simon. 1997. *The Embarrassment of Riches: An Interpretation of Dutch Culture in the Golden Age*. New York: Vintage Books.

———. 1999. *Rembrandt's Eyes*. New York: Alfred A. Knopf.

Schechner, Sara J. 2005. "Between Knowing and Doing: Mirrors and Their Imperfections in the Renaissance." *Early Science and Medicine* 10 (2): 137–62.

Schickore, Jutta. 2007. *The Microscope and the Eye: A History of Reflections, 1740–1870*. Chicago: University of Chicago Press.

Schierbeek, A. 1959. *Measuring the Invisible World: The Life and Works of Antoni van Leeuwenhoek*. London and New York: Abelard-Schulman.

Schott, Gaspar. 1657. *Magia universalis naturae et artis*. Würzburg.

Schwartz, Heinrich. 1966. "Vermeer and the Camera Obscura." *Pantheon* 24: 170–79.

Seters, W. H. van. 1951. "Antoni van Leeuwenhoek in Amsterdam." *Notes and Records of the Royal Society* 9 (1): 36–45.

———. 1982. "Can Antoni van Leeuwenhoek Have Attended School at Warmond?" In Palm and Snelders, eds., *Antoni van Leeuwenhoek, 1632–1723*, 3–11.

Seymour, Charles. 1964. "Dark Chamber and Light-Filled Room: Vermeer and the Camera Obscura." *Art Bulletin* 46: 323–31.

Shapin, Steven, and Simon Schaffer. 1985. *Leviathan and the Air-Pump: Hobbes, Boyle, and the Experimental Life*. Princeton, N.J.: Princeton University Press.

Shapiro, Alan E. 2007. "Images: Real and Virtual, Projected and Perceived, from Kepler to Dechales." In Lefèvre, ed., *Inside the Camera Obscura*, 75–94.

Sheldon, Libby. 2007. "Blue and Yellow Pigments—The Hidden Colors of Light in Cuyp and Vermeer." *Art Matters* 4: 97–102.

Shorto, Russell. 2013. *Amsterdam: A History of the World's Most Liberal City*. New York: Doubleday.

Simon, Jacob. 2013. "'Three-quarters, Kit-cats and Half-lengths': British Portrait Painters and Their Canvas Sizes, 1625–1850." http://www.npg.org.uk/research/programmes/artists-their-materials-and-suppliers/three-quarters-kit-cats-and-half-lengths-british-portrait-painters-and-their-canvas-sizes-1625-1850.php.

Sines, George, and Yannis A. Sakellarakis. 1987. "Lenses in Antiquity." *American Journal of Archaeology* 91 (2): 191–96.

Slowick, Edward. "Descartes's Physics." 2013. In *Stanford Encyclopedia of Philosophy*, edited by Edward N. Zolta. http://plato.stanford.edu/archives/fall2013/entries/descartes-physics/.

Smith, Pamela H. 2004. *The Body of the Artisan: Art and Experience in the Scientific Revolution*. Chicago: University of Chicago Press.

Snelders, H. A. M. 1982. "Antoni van Leeuwenhoek's Mechanistic View of the World." In Palm and Snelders, eds., *Antoni van Leeuwenhoek, 1632–1723*, 57–78.

Snyder, Laura J. 2011. *The Philosophical Breakfast Club: Four Remarkable Friends Who Transformed Science and Changed the World*. New York: Broadway Books.

Sprat, Thomas. 1667. *The History of the Royal Society of London, for the Improving of Natural Knowledge*. London: J. Martyn.

Stafford, Barbara, Frances Terpak, and Isotta Poggi. 2001. *Devices of Wonder: From the World in a Box to Images on a Screen*. Los Angeles: Getty Research Institute.

Staubermann, Klaus. 2007. "Comments on 17th Century Lenses and Projections." In Lefèvre, ed., *Inside the Camera Obscura*, 141–45.

Steadman, Philip. 2001. *Vermeer's Camera: Uncovering the Truth behind the Masterpieces*. Oxford: Oxford University Press.

———. 2002. "Vermeer's Camera: Afterthoughts, and a Reply to Critics." http://www.vermeerscamera.co.uk/reply.htm.

———. 2007. "Gerrit Dou and the Concave Mirror." In Lefèvre, ed., *Inside the Camera Obscura*, 227–42.

Straker, S. M. 1970. "Kepler's Optics: A Study in the Development of 17th Century Natural Philosophy." Ph.D. diss., Indiana University.

Sutton, Peter. 1980. "Hedrick van der Burch." *Burlington Magazine* 122: 315–26.

Swift, Jonathan. 1733. *On Poetry: A Rhapsody*. London.

Swillens, P. T. A. 1950. *Johannes Vermeer: Painter of Delft, 1632–1675*. Utrecht: Spectrum.

Tierie, Gerrit. 1932. *Cornelis Drebbel (1572–1633)*. Amsterdam: H. J. Paris.

Torras, Jaume. 1998. "Craft Guilds and Rural Industries in Early Modern Spain." In Núñez and Epstein, eds., *Guilds, Economy and Society*, 25–36.

Tsuji, Shigeru. 1990. "Brunelleschi and the Camera Obscura: The Discovery of Pictorial Perspective." *Art History* 13 (3): 276–92.

Tudor, Faye. 2010. "'All in Him Selfe as in a Glass He Sees': Mirrors and Vision in the Renaissance." In Hendrix and Carman, eds., *Renaissance Theories of Vision*, 171–86.

Unger, Richard W. 2004. *Beer in the Middle Ages and the Renaissance*. Philadelphia: University of Pennsylvania Press.

Van de Pol, Lotte C. 2010. "The Whore, the Bawd, and the Artist: The Reality and Imagery of 17th Century Dutch Prostitution." *Journal of Historians of Netherlandish Art* 2: 1–12.

Van Helden, Albert. 1977. *The Invention of the Telescope*. Philadelphia: American Philosophical Society.

———. 1989. "Introduction." In Galileo Galilei, *Sidereus Nuncius; or, The Sidereal Messenger*, edited by Albert Van Helden, 1–24. Chicago: University of Chicago Press.

Vergara, Alejandro. 2003. "Vermeer: Context and Uniqueness. Dutch Painting of Domestic Interiors, 1650–1675." In Vergara and Westermann, eds., *Vermeer y el interior holandés*, 201–18.

Vergara, Alejandro, and Mariët Westermann, eds. 2003. *Vermeer y el interior holandés: Del 19 de febrero al 18 de mayo, Museo Nacional del Prado, Madrid, 2003*. Madrid: Museo Nacional del Prado.

Wadum, Jørgen. 1995. "Vermeer in Perspective." In Duparc and Wheelock, eds., *Johannes Vermeer*, 67–79.

———. 1998. "Contours of Vermeer." In Gaskell and Jonker, eds., *Vermeer Studies*, 201–23.

Wadum, Jørgen, René Hoppenbrouwers, and Luuk Struick van der Loeff. 1995. *Vermeer Illuminated: A Report on the* View of Delft *and the* Girl with a Pearl Earring *by Johannes Vermeer*. The Hague: V + K Publishers/Inmerc.

Wallert, Arie. 2007. "A Peculiar Emblematic Still-Life Painting from Johannes Torrentius." *Art Matters* 4: 54–67.

Webster, Charles. 1976. *The Great Instauration: Science, Medicine and Reform, 1626–1660*. New York: Holmes & Meier.

Weld, Charles Richard. 1848. *A History of the Royal Society*. 2 vols. London: Parker.

Welu, James A. 1975. "Vermeer: His Cartographic Sources." *Art Bulletin* 57 (4): 529–47.

———. 1978. "The Map in Vermeer's 'Art of Painting.'" *Imago Mundi* 30: 9–30.

———. 1986. "Vermeer's Astronomer: Observations on an Open Book." *Art Bulletin* 68 (2): 263–67.

Welu, James A., and Pieter Biesboer, eds. 1993. *Judith Leyster: A Dutch Master and Her World*. New Haven: Yale University Press.

Wenczel, Norma. 2007. "The Optical Camera Obscura II: Images and Texts." In Lefèvre, ed., *Inside the Camera Obscura*, 13–30.

Westermann, Mariët. 1996. *A Wordly Art: The Dutch Republic, 1585–1718*. New Haven: Yale University Press.

———. 2003. "Vermeer and the Interior Imagination." In Vergara and Westermann, eds., *Vermeer y el interior holandés*, 219–34.

———. 2004. *Johannes Vermeer (1632–1675)*. Amsterdam: Waanders Publishers/ Rijksmuseum.

Weststeijn, Thijs, 2008. *The Visible World: Samuel van Hoogstraten's Art Theory and the Legitimation of Painting in the Dutch Golden Age*. Amsterdam: Amsterdam University Press.

———, ed. 2013. *The Universal Art of Samuel van Hoogstraten (1627–1678): Painter, Writer, and Courtier*. Amsterdam: Amsterdam University Press.

Wheelock, Arthur K. 1977. "Constantijn Huygens and Early Attitudes towards the Camera Obscura." *History of Photography* 1 (2): 93–103.

———. 1977. *Perspective, Optics, and Delft Artists around 1650*. New York: Garland.

———. 1988. *Jan Vermeer*. New York: Harry N. Abrams.

———. 1995. *Vermeer and the Art of Painting*. New Haven: Yale University Press.

———. 1995. "Vermeer of Delft: His Life and His Artistry." In Duparc and Wheelock, eds., *Johannes Vermeer*, pp. 15–30.

———. 2012. "'Guillelmo' in Amsterdam: Van Aelst's Painterly Style in Amsterdam." In Paul, Clifton, and Wheelock, eds., *Elegance and Refinement*, 37–49.

————. 2014. "Johannes Vermeer." *Encyclopedia Britannica Online*. Accessed Dec. 18, 2013. http://www.britannica.com/EBchecked/topic/626156/Johannes -Vermeer/233666/Artistic-training-and-early-influences.

Wilson, Catherine. 1995. *The Invisible World: Early Modern Philosophy and the Invention of the Microscope*. Princeton, N.J.: Princeton University Press.

Wirth, Carsten. 2007. "The Camera Obscura as a Model of a New Concept of Mimesis in 17th Century Painting." In Lefèvre, ed., *Inside the Camera Obscura*, 149–94.

Wittkower, Rudolf. 1963. *Born under Saturn: The Character and Conduct of Artists: A Documented History from Antiquity to the French Revolution*. London: Weidenfeld and Nicolson.

Wolf, Bryan Jay. 2001. *Vermeer and the Invention of Seeing*. Chicago: University of Chicago Press.

Wotton, Henry. 1907. *The Life and Letters of Sir Henry Wotton*, edited by Logan Pearsall Smith. 2 vols. Oxford: Clarendon Press.

Wren, Christopher. 1669. "An Instrument for Drawing in Perspective." *Philosophical Transactions* 4: 898–99.

Yalcin, Fatma. 2013. "Van Hoogstraten's Success in Britain." In Weststeijn, ed., *The Universal Art of Samuel van Hoogstraten (1627–1678)*, 161–82.

Yiu, Yvonne. 2005. "The Mirrror and Painting in Early Renaissance Texts." *Early Science and Medicine* 10 (2): 187–210.

Zuylen, J. van. 1981. "The Microscopes of Antoni van Leeuwenhoek." *Journal of Microscopy* 121 (3): 309–28.

————. 1982. "The Microscopes of Antoni van Leeuwenhoek." In Palm and Snelders, eds., *Antoni van Leeuwenhoek, 1632–1723*, 29–55.

# Index

Page numbers beginning with 331 refer to endnotes.